#2

The University of Winnipeg

Library

Donated by

Dr. Robert J. Young
Department of History

BRITISH ROMANTIC ART

British Romantic Art

RAYMOND LISTER

LONDON · G. BELL & SONS · 1973

© RAYMOND LISTER 1973
PUBLISHED BY G. BELL & SONS LTD,
YORK HOUSE, 6 PORTUGAL STREET, LONDON, WC2

PRINTED IN GREAT BRITAIN
BY W & J MACKAY LIMITED, CHATHAM

ISBN 0 7135 1728 X

Contents

List of Illustrations

ACKNOWLEDGEMENTS

I should like to record my appreciation of the help in my researches that I have received from many friends, especially Sir Geoffrey Keynes, Keith Andrews, Charles Cudworth, David Gould, and Reginald Williams. And I should like to thank my wife, Pamela, for much help and encouragement.

R. L.
LINTON,
CAMBRIDGESHIRE.
1971

To Laurence Whistler
in Friendship and Admiration

CHAPTER ONE

The Spirit of Romanticism

> This world of Imagination is the world of Eternity; it is the divine
> bosom into which we shall all go after the death of the Vegetated
> body. This World of Imagination is Infinite & Eternal, whereas the
> world of Generation, or Vegetation, is Finite & Temporal. There
> Exist in that Eternal World the Permanent Realities of Every Thing
> which we see reflected in this Vegetable Glass of Nature. All Things
> are comprehended in their Eternal Forms in the divine body of the
> Saviour, the True Vine of Eternity, The Human Imagination . . .
> William Blake, *A Vision of the Last Judgment*[1]

ROMANTICISM is a notoriously evasive term; indeed, the one thing
about it upon which everyone seems to agree is the impossibility of
defining it.[2] Yet, if we are to understand what it is about, some attempt
must be made to grasp its meaning, even if by the time we have finished we
have overlaid our attempt with qualifications. But a definition, in the
dictionary sense, is impossible and undesirable.

Certain things and certain activities are Romantic, and it is more im-
portant to understand why they are Romantic than to pin down Romanti-
cism like a moth on an entomologist's board. Why, for instance, it is
Romantic to build an aqueduct over a valley in Wales; to revel in the
sublimity of the mountains surrounding it; to make minutely exact water-
colours of flowers and leaves growing there. Why it is Romantic to travel
to remote and exotic countries; to write and illustrate books about them; to
study the phenomena and the arts to be found here. Why it is Romantic to
study the past and to paint pictures of historical subjects; to invent systems

[1] Keynes, Geoffrey (ed.), *The Complete Writings of William Blake*, 1966, 605–
6. Brief details of William Blake and of other British artists and foreign artists
closely associated with the English School, and mentioned in the text, will be
found in the *Reference Section*.

[2] cf., for example, Praz, Mario, *The Romantic Agony* (tr. Angus Davidson),
1954, 1 et seq.; Hough, Graham, *The Romantic Poets*, 1967, 7 et seq.; Furst,
Lilian R., *Romanticism*, 1969, 1–13.

of notation for recording dancing or the movements of machinery; to delve into the supernatural, into the human mind and emotions, into sexual perversions; to attempt to penetrate the mysteries of every branch of Nature. In short why it is Romantic to examine and revel in all aspects of human activity and of the phenomena of the world in which we live; to cultivate every part of the human psyche and every aspect of our bodily sensations.

If these things are Romantic, and most people would agree that they are, then it is obvious that one central fact of Romanticism is its preoccupation with, and expression of, the individual and of the particular. This is an idea succinctly stated in many parts of his works by William Blake, one of the greatest of English Romantic artists:

> General Knowledge is Remote Knowledge; it is in Particulars that Wisdom consists & Happiness too.[1]

> *He who would do good to another must do it in Minute Particulars:*
> *General Good is the plea of the scoundrel, hypocrite & flatterer,*
> *For Art & Science cannot exist but in minutely organised Particulars*
> *And not in generalising Demonstrations of the Rational Power.*[2]

Those quotations illustrate how, in one way, Romanticism differs from Classicism, the reverse of which it is often taken to be; for, in this sense, Romanticism is concerned with particulars, Classicism with generalities.

Before going further, it will be as well if we examine some antecedents of Romanticism, and some of the influences that were brought to bear on its development.[3] First Neoclassicism. This was the artistic expression of the philosophic Enlightenment of the eighteenth century—a system of thought dominated by reason and empiricism. The vocabulary of this artistic expression was found in a return to what its exponents saw as original principles; principles that were, they thought, inherent in Classic

[1] *A Vision of the Last Judgment*: Keynes, 611.

[2] *Jerusalem*: ibid., 687.

[3] The duration of the Romantic era is almost as difficult to define as Romanticism itself. There are Romantic elements in every period; but the period in which it was most strongly dominant was from about 1750 to about 1850, and it is to that period which I refer when I mention the "Romantic era" in these pages. It is virtually impossible to put limits on the era, and, in places, it must be understood that each of those limits will have to be ignored.

art. It was a cult of aesthetic perfectionism, as expressed by one of its greatest apostles, Johann Joachim Winckelmann (1717–68), the German archaeologist and art critic,[1] who set his ideal of beauty in the context of ancient Greece:

> By no people has beauty been so highly esteemed as by the Greeks. The priests of a youthful Jupiter at Ægæ, of the Ismenian Apollo, and the priest who at Tanagra led the procession of Mercury, bearing a lamb upon his shoulders, were always youths to whom the prize of beauty had been awarded. The citizens of Egesta erected a monument to a certain Philip, who was not their fellow-citizen, but of Croton, for his distinguished beauty; and the people made offerings at it. In an ancient song, ascribed to Simonides or Epicharmus, of four wishes, the first was health, the second beauty. And as beauty was so longed for and prized by the Greeks, every beautiful person sought to become known to the whole people by this distinction, and above all to approve himself to the artists, because they awarded the prize; and this was for the artists an occasion for having supreme beauty ever before their eyes. Beauty even gave a right to fame; and we find in Greek histories the most beautiful people distinguished. Some were famous for the beauty of one single part of their form; as Demetrius Phalereus, for his beautiful eyebrows, was called *Charito-blepharos*. It seems to have been thought that the procreation of beautiful children might have been promoted by prizes. This is shown by the existence of contests for beauty, which in ancient times were established by Cypselus, King of Arcadia, by the river Alpheus; and, at the feast of Apollo of Philæ, a prize was offered to the youths for the deftest kiss. This was decided by an umpire; as also at Megara, by the grave of Diocles. At Sparta, and at Lesbos, in the temple of Juno, and among the Parrhasii, there were contests for beauty among women. The general esteem for beauty went so far, that the Spartan women set up in their bed-chambers a Nireus, a Narcissus, or a Hyacinth, that they might bear beautiful children.[2]

Such perfection was the ideal of the Neoclassicists. Yet superficially some manifestations of Neoclassicism are almost indistinguishable from Romanticism: despite the fact that Romanticism is often represented as the antithesis of Neoclassicism, it also to some extent contained Neoclassic elements, for in many respects the two movements had similar aims,

[1] See life by B. Vallentin, 1931.
[2] Translation from "Winckelmann" in *The Renaissance*, 1873, by Walter Pater (1839–94).

[5]

philosophies and styles. Both, for example, challenged established contemporary authority; both looked, in part at least, to the past for inspiration. But although there were some similarities, there were more contrasts, and the Romantic insistence on the particular is one of the most important.

Another difference lies between the dominant decorousness and repose of Neoclassicism, and the dominant excitement and movement of Romanticism—the work of Jacques-Louis David[1] contrasted with that of John Henry Fuseli; the Petit Trianon[2] at Versailles contrasted with Strawberry Hill;[3] the paintings of Jean-Auguste-Dominique Ingres[4] contrasted with those of William Blake; the cool, regularly-proportioned features of Denis Diderot[5] as shown in a marble bust by Jean-Antoine Houdon,[6] contrasted with the scowling, brooding, lion-maned bust of Beethoven, created from a life mask, by Franz Klein.[7] Or Bach's music, observing musical order, contrasted with Beethoven's masterful compositions, observing that order only where their creator wished it.

Much of the impetus of the Romantic movement was English in origin. For French influence, after a long period, during which it had led European taste and culture, decayed as the French monarchical system decayed, and, at about the middle of the eighteenth century, England, with its more progressive social system, assumed political and economic leadership. Where, in France, the decline in monarchical influence led to revolution and bloodshed, in England, the land of moderation and of compromise, a similar decline merely opened the way to more intensive commercial enterprise by the bourgeoisie. The bourgeoisie also, in time, shared with monarch and aristocracy the government of the country, which naturally led to considerable blurring of class divisions. It also gave rise to a new reading

[1] French painter (1748–1825). In his youth he was a Neoclassicist, but later painted "propaganda" pictures, extolling the Revolution and Napoleonism.

[2] The favourite residence of Marie Antoinette, built 1761–68 to the design of Ange-Jacques Gabriel (1698–1782).

[3] Villa at Twickenham. Bought in 1747 by Horace Walpole who began in 1750 to transform it into the Gothic style.

[4] French painter (1780–1867). A main upholder of classicism. His work is, among much else, notable for its purity of line.

[5] Denis Diderot (1713–84), the most important eighteenth-century French writer on art.

[6] (1741–1828). The leading French sculptor of the eighteenth century.

[7] 1779–1836, Austrian sculptor. The Beethoven bust was made in 1812.

public, thus freeing authors from dependence on aristocratic patronage and giving them, for the first time, freedom of expression without risk. This meant an increase in the number of books containing radical views: books, in short, which helped to turn people's outlook from aristocratic, reserved and intellectual Classicism, to plebeian, extroverted and emotional Romanticism—from distillations to elemental particulars.

This essentially middle-class movement was, as I have said, first apparent in England, where Romantic individualism found expression in a radicalism which protested against aristocratic and state absolutism, and supported the individual against authority; and in particular which encouraged the expression of his emotions, impulses and moods: emotions, impulses and moods which, for the first time, the bourgeois really discovered in his own composition. Among its artistic manifestations were the Ossianic poems of James Macpherson (1736–96),[1] the *Night Thoughts* of Edward Young,[2] the "Rowley" poems of Thomas Chatterton (1752–70),[3] and the novels of Fielding (1707–54) and Richardson (1689–1761). Indeed Romanticism was at first a literary movement, although before the dawn of the nineteenth century it had begun to influence all forms of art, thought and politics. Yet Romantic visual art remained under the influence of literature (which is one reason why book illustration was one of its most important aspects), and in order fully to appreciate Romantic art it is necessary to have some knowledge of contemporary writing.

The development of Romanticism was encouraged, too, by British enterprise in world discovery, in archaeology, and in scientific and philosophic development. Captain Cook (1728–79) in navigation; Stukeley in archaeology;[4] Isaac Newton (1642–1727), Robert Boyle and Joseph Priestley[5] in science; John Locke (1632–1704) and David Hume (1711–76) in

[1] See also p. 45.

[2] English writer and parson (1683–1765). His didactic poem *The Complaint, or Night Thoughts on Life, Death, and Immortality* was published 1742–45. It is in nine books and contains about 10,000 lines of blank verse. There were many editions.

[3] For the "Rowley" poems, see p. 45.

[4] William Stukeley (1687–1765), antiquary. His most famous book is *Stonehenge* (1740).

[5] Natural philosopher and chemist (1627–91); chemist and philosopher, discoverer of oxygen (1733–1804).

philosophy: these are typical of the people who helped to open new human attitudes in these branches of knowledge, and to provide means whereby the particular—that essentially Romantic aspect—could be studied in the world, in phenomena, in history and in Man.

The very term "Romanticism" originated in England, where, at least until the early eighteenth century, it was used derisively, to describe false and fictitious absurdities, such as imaginary tales of the days of chivalry. But, by the beginning of the second decade of the eighteenth century, with a growing interest in the Middle Ages, the Elizabethan Age and the Gothic style, its status improved. Thereafter "Romantic" was equated with "interesting", "imaginative", and even "beautiful", in addition to being associated with tales of love and chivalry, and with scenes and landscapes like those described in them. At about this time the term was imported from England into France, and not long afterwards into Germany. But the word did not inaugurate the movement; the movement, in course of time, acquired the word, which at this distance in time seems to us to be particularly apt.

One must not think of English Romantic art in complete isolation. Romanticism may have been originally an English phenomenon; it may have developed differently here than elsewhere; but there was mutual influence between England and the Continent. Our poets, expecially Byron, enjoyed a world-wide reputation; our painters, especially Turner and Constable, had enormous influence on the development of French painting. On the other hand, there was a reciprocal continental influence on English art. Among artists who worked here for long periods, Fuseli, Agasse and Angelica Kauffmann were Swiss; de Loutherbourg was Alsation; Zoffany was a German. Posthumous influence came from many foreign artists, especially from Claude,[1] Rosa[2] and Poussin.[3] In literature, Jean-Jacques Rousseau, Goethe, Heine and many others influenced and conditioned English Romanticism, although French influence was interrupted for a time by the Napoleonic Wars. English artists, however, in some branches of painting, exerted an even greater influence than they

[1] Claude Gellée or Lorraine (1600–82), French painter of poetic landscapes.
[2] Salvator Rosa (1615–73), Italian landscape painter, noted for his wild subjects.
[3] Nicolas Poussin (1593/4–1665), French landscape painter, noted particularly for classical subjects.

received. In particular was this true of historical painting, especially in accurate reconstructions of scenes, both from past epochs and from contemporary sources—Bonington's "Doge's Palace, Venice"[1] (Plate 99) and Gavin Hamilton's "Priam pleading with Achilles for the body of Hector"[2] exemplify the one; Copley's "Watson and the Shark"[3] (Plate 1) exemplifies the other. Traces of such works may be found in the *oeuvres* of Delacroix, Géricault and Courbet,[4] which show also the influence of paintings such as George Stubbs's "Lion attacking a horse",[5] (Plate 2) with its essentially Romantic view of "breathless Nature's dark abyss".[6] It requires little imagination to discern a spirit similar to that expressed in Stubbs's picture, in Delacroix's "Horse terrified by a storm"[7] and in his "Horse attacked by a panther."[8] It is known that Géricault owned prints by Stubbs. That the influence of yet another English artist, Sir Edwin Landseer, is present in the work of Courbet, is evident if, for example, we compare Courbet's "The Roebuck in the forest"[9] with Landseer's "The Challenge"[10] (Plate 7).

Much of this English influence on French painting was reinforced by the opinions of François Chateaubriand (1768–1848), who was a refugee in England during the Revolution. He was completely seduced by the English landscape, and berated his compatriot artists for paying insufficient attention to the glories of Nature.

Delacroix and Géricault, both of whom paid short visits to England and exhibited here, influenced English artists. Much of Etty's work shows

[1] National Gallery of Canada, Ottawa.

[2] Tate Gallery, London.

[3] Detroit Institute of Arts. The picture shows Sir Brook Watson (1735–1807) as a boy, being attacked by a shark in the harbour at Havana. He lost a leg in the encounter. Incidentally, although Copley was an American, he settled in London in 1776, and became an R.A. in 1779. So, for our present purpose, he may be considered an artist of the English school.

[4] Eugène Delacroix (1798–1863), Théodore Géricault (1791–1824), Jean Désiré Gustave Courbet (1819–77). French Romantic painters.

[5] Collection of Mr and Mrs Paul Mellon.

[6] William Wordsworth, *Lines on the Expected Dissolution of Mr. Fox.*

[7] Museum of Fine Arts, Budapest.

[8] Cabinet des Dessins, Louvre, Paris.

[9] The Louvre, Paris.

[10] Collection of the Duke of Northumberland.

Delacroix's influence: "Britomart redemes fair Amoret",[1] for instance, shows something of the erotic turmoil of Delacroix's "Death of Sardanapalus";[2] and even passages of their brushwork are similar—compare for example that in Delacroix's "St. George and the Dragon"[3] and Etty's "Venus and Cupid".[4] The influence of these two artists is to be found also in the work of Landseer, David Scott, Ford Madox Brown and of many others.

The German Nazarener—early nineteenth-century painters of religious and historical subjects—influenced a certain class of British Romantic painting; this is especially evident in the work of Daniel Maclise, who had met members of the group in Rome in 1827; and in that of William Dyce, and of the Pre-Raphaelites, whose work had the same purity of line and loving concentration on detail as were present in the work of the German painters. The purity of line in the Nazarener's work had, in turn, been partly inspired by the outline illustrations to Dante and Homer, made by the English artist, John Flaxman,[5] which had also influenced European Neoclassical art. So here, again, was an exchange of influences between England and the Continent.

Such interchange continued throughout the Romantic period. Many English pictures were exhibited in Parisian Salons between 1817 and 1840. At the 1824 Salon, Constable exhibited three landscapes, including his "Hay Wain"[6] (Plate 8), and there were works by several other English artists, including Bonington. It is known that both Delacroix and Géricault were deeply impressed by what they saw there. But, at almost every Salon, English pictures were to be seen, painted from subjects that found deep response in French Romantic art: portraits; historical scenes; animals; ruins; landscape; episodes from poets such as Shakespeare, Milton, Byron and Scott.

[1] Lady Lever Art Gallery, Port Sunlight.

[2] The Louvre.

[3] The Louvre.

[4] The Fairhaven Collection, Anglesey Abbey, Cambridgeshire.

[5] Flaxman's illustrations to Dante were engraved by Tommasso Piroli (1752?–1824) and published in 1793. His *Iliad of Homer*, also engraved by Piroli, appeared in the same year; in a later edition, published in 1805, there were three plates by William Blake.

[6] National Gallery, London.

If, in these paragraphs concerning European and British Romanticism, we have concentrated largely upon French art, it does not mean that the only reciprocal influences were to be found there. German painting we have briefly mentioned and, to return to this for a moment, who can fail to see some degree of similarity in the artistic aims of Turner and those of Caspar David Friedrich (1774–1840); between the work of Francis Danby and that of Carl Gustav Carus (1789–1869); or between that of John William Inchold and Friedrich Georg Kersting (1785–1847). In fact, the influence of English Romanticism was felt throughout Europe, and strong reciprocal influence was felt here.

Continental travel, by British artists, also conditioned English Romanticism. Lear in Italy and Greece; John Robert Cozens and Turner in Switzerland; Prout in Belgium; Wilkie in Spain, Bonington in France and Italy; Lewis in the Middle East; Ruskin and Palmer in Italy; Holman Hunt in Egypt and Palestine: one could continue the list for pages. It is such contact with authentic exotic scenes that gives a certain type of Romantic art its strength.

The development of Romanticism took place in an era of surging turmoil —America had broken with England, the French Revolution raged, soon to be superseded by the savagery of the Napoleonic Wars; lesser manifestations of unrest were evident everywhere. Thus men, whether they liked it or not, were swept into the revolutionary vortex. Yet, out of this turmoil, Man craved an order which would enable him to live in peace, using new ideas of social justice, religion and politics. Above all, it was the artist, with his finely-tuned sensibilities and gifts, who could give utterance to these feelings and desires, in the creation of such masterpieces as Beethoven's Eroica Symphony, Goethe's *Werther*,[1] and Antoine Jean Gros's portrait of Napoleon.[2]

In England the spirit of revolt, as with most other things, was modified. Such violent and bloody scenes as those of the Terror did not occur here, because, for one thing, there had never been the extreme social repression that had obtained in France; and, for another thing, such excesses were

[1] *The Sorrows of Young Werther* was first published in 1774. A revised edition was published in 1787.

[2] "Napoleon crossing the bridge at Arcola". In the Louvre. Gros's dates are 1771–1835.

out of character with the compromising element inherent in Englishness. Political unrest certainly existed in England, and for a time the French Revolution had sympathisers here; but their ideas were soon replaced by patriotic enthusiasm during the Napoleonic Wars. After the defeat of Napoleon at Waterloo, however, revolutionary sentiments were again aired among Romantics, but it was not until the last period of the Romantic era that violence was seen here; and then it was muted. It was as if the nation teetered along the brink, and then withdrew aghast. There was the Peterloo Massacre of 1819;[1] there were Chartist-inspired demonstrations in the North between 1838 and 1849; all over England, agricultural machinery and stocks were burned by farm workers between 1830 and 1832.[2] But these were relatively minor matters, small and weak lappings on the farthest reaches of the continental tide. So that, although Blake walked for a time in the streets of London, wearing the red bonnet of liberty, although his prophetic books teemed with revolutionary symbols; although Byron and Shelley sang of new freedoms, and Wordsworth and Coleridge for a time accepted the aims of the French Revolution; all settled down eventually to a typically English compromise, and voluntary social reforms forestalled real revolution. Yet this should not blind us to the idealism of some English revolutionaries of the time. The Promethean figure of Byron may be taken as the exemplar here; for his revolutionary politics became almost an extension of his poetry, culminating in the sacrifice of his life while helping Greece to fight for its independence; he was aware, at the same time, of the probable fate that was in store for him:

> *For what is poesy but to create*
> *From overfeeling, good and ill; and aim*
> *At an external life beyond our fate,*
> *And be the new Prometheus of new man,*
> *Bestowing fire from heaven, and then, too late,*
> *Finding the pleasure given repaid with pain.*[3]

Prometheus symbolised defiance, and much Romantic art is remarkable for its defiant note—such are Shelley's *Declaration of Rights* (1812),

[1] The very fact that the word "massacre" could be used here, where only eleven lives were lost, is some indication of the mildness of English revolutionary activities.

[2] cf. Hobsbawm, E. J. and Rudé, George, *Captain Swing*, 1969.

[3] *The Prophecy of Dante*, Canto IV, 1.11.

Byron's *The Vision of Judgment* (1822), and John Martin's painting of *The Bard* (1817), itself an illustration of an earlier ode (1757) by Gray, which told of a curse put upon Edward I by a Welsh bard before he plunged to suicide. Blake's work is full of defiance. The character, Orc, who appears in the prophetic books, is a personification of revolution, and both this character and the more important one of Los,[1] have much of Prometheus in them. But Blake's revolt was not merely against rulers and governments, but against conventional religion and morality; it was more spiritual than political.

In the present context, Prometheus may also, to some extent, be equated with Blake's Satan, a spirit of evil it is true, but one whose greatest attribute is energy, an essential component in the human psyche, and one from which stems revolution. The Satan of Romanticism is directly descended from Milton's Satan in *Paradise Lost*. Of this Satan, Shelley wrote: "Milton's Devil as a moral being is as far superior to his God, as one who perseveres in some purpose which he has conceived to be excellent in spite of adversity and torture, is to one who in the old security of undoubted triumph inflicts the most horrible revenge upon his enemy, not from any mistaken notion of inducing him to repent of a perseverance in enmity, but with the alleged design of exasperating him to deserve new torments."[2] Or, as Blake wrote in *The Marriage of Heaven and Hell*: "In the Book of Job, Milton's Messiah is call'd Satan."[3]

The Satanic type in human form was perfected by Byron in several of his characters, in whom we may observe the Fiend of earlier times transformed into an elegant, if still terrifying figure, remote from the bestial, sometimes comic Devil of conventional Christianity.

> *Dark and unearthly is the scowl*
> *That glares beneath his dusky cowl.*
> *The flash of that dilating eye*
> *Reveals too much of times gone by;*
> *Though varying, indistinct its hue,*
> *Oft will his glance the gazer rue,*
> *For in it lurks that nameless spell,*
> *Which speaks, itself unspeakable,*

[1] Intuition or Imagination.
[2] *A Defence of Poetry.*
[3] Keynes, 150.

A spirit yet unquell'd and high,
That claims and keeps ascendancy;
And like the bird whose pinions quake,
But cannot fly the gazing snake,
Will others quail beneath his look,
Nor 'scape the glance they scarce can brook.
From him the half-affrighted Friar
When met alone would fain retire,
As if that eye and bitter smile
Transferr'd to others fear and guile:
Not oft to smile descendeth he,
And when he doth 'tis sad to see
That he but mocks at Misery.
How that pale lip will curl and quiver!
Then fix once more as if for ever;
As if his sorrow or disdain
Forbade him e'er to smile again.
Well were it so—such ghastly mirth
From joyaunce ne'er derived its birth.
But sadder still it were to trace
What once were feelings in that face:
Time hath not yet the features fix'd,
But brighter traits with evil mix'd;
And there are hues not always faded,
Which speak a mind not all degraded
Even by the crimes through which it waded:
The common crowd but see the gloom
Of wayward deeds, and fitting doom;
The close observer can espy
A noble soul, and lineage high:
Alas! though both bestow'd in vain,
Which Grief could change, and Guilt could stain,
It was no vulgar tenement
To which such lofty gifts were lent,
And still with little less than dread
On such the sight is riveted.[1]

If to this we add Blake's description of the binding of the child Orc, we arrive once more at the image of Prometheus: the Satanic energy held captive by forces which fear it, while it struggles to take its place and exercise its power over the human spirit:

[1] *The Giaour* (1813), 1.832.

O sorrow & pain!
A tight'ning girdle grew
Around his bosom. In sobbings
He burst the girdle in twain;
But still another girdle
Oppress'd his bosom. In sobbings
Again he burst it. Again
Another girdle succeeds.
The girdle was form'd by day,
By night was burst in twain.

These falling down on the rock
Into an iron Chain
In each other link by link lock'd.

They took Orc to the top of a mountain.
O how Enitharmon wept!
They chain'd his young limbs to the rock
With the Chain of Jealousy
Beneath Urizen's deathful shadow.[1]

On the other hand, Blake would never have written, as Swinburne did, of, "The supreme evil, God",[2] for Blake would not have mixed his symbols in that way. Moreover, despite his unconventional thought and his forthright manner of expression, Blake was a deeply religious man, to whom, "Good is the passive that obeys Reason. Evil is the active springing from Energy."[3] By which it follows that God is equated with the passive obeying reason; and Satan with the active springing from energy.

But in much Romanticism there is an anti-religious, or at least an anti-Christian bias, which is bound up with the Prometheus figure, victimised by God or the gods, like the satyr Marsyas, flayed by Apollo, the victor in a musical contest, in which it was agreed that the winner should do as he liked with the loser.

As with Blake, so with his follower, Edward Calvert, whom his friend,

[1] *The First Book of Urizen*: Keynes, 233. Broadly speaking, in Blake's mythological system, Urizen is the intellectual faculty.

[2] *Atalanta in Calydon* by Algernon Charles Swinburne, was first published in 1865. The line quoted is at the end of a verse of one of the choruses. See [1883] edn., 47.

[3] *The Marriage of Heaven and Hell*: Keynes, 149.

Samuel Palmer admonished for his "naughty disobedient heresies."[1] Calvert, after a period of intense and mystical Christianity—which permeated his remarkable engravings, all executed between 1827 and 1831—turned to paganism, though he did try to unite the teachings of Socrates and Jesus. This indecision or catholicity (depending on how one looks at it) is in the true tradition of Romanticism. So also, for that matter, is the intensely Christian vision of Samuel Palmer, in which the pastoral and agricultural landscape of south-east England is transformed and bathed in a gentle mystical illumination:

> Note that when you go to Dulwich it is not enough on coming home to make recollections in which shall be united the scattered parts about those sweet fields into a sentimental and Dulwich looking whole. No. But considering Dulwich as the gate into the world of vision one must try behind the hills to bring up a mystic glimmer like that which lights our dreams. And those same hills (hard task) should give us promise that the country beyond them is Paradise—[2]

The religious tendencies of Romantic artists were often polytheistic: Blake's mythical figures, and Keats's and Shelley's use of Greek myths are examples. Much of this arose from a contemporary upsurge of Neoplatonism, which was given impetus by the writings of the prophet of the philosophy, Thomas Taylor.[3] The influence of Neoplatonism could be seen in such passages as this from Blake's *Marriage of Heaven and Hell:*[4]

The ancient Poets animated all sensible objects with Gods or Geniuses, calling them by the names and adorning them with the properties of woods, rivers, mountains, lakes, cities, nations, and whatever their enlarged & numerous senses could perceive.

And particularly they studied the genius of each city & country, placing it under its mental deity;

Till a system was formed, which some took advantage of, & enslav'd the vulgar by attempting to realize or abstract the mental deities from their objects: thus began Priesthood;

[1] Richmond MSS.

[2] Palmer, Samuel, *1824–25 Sketchbook*. Facsimile, with an introduction and commentary by Martin Butlin, 1962.

[3] Thomas Taylor (1758–1835), Platonist and writer. See *Selected Writings*, ed. Kathleen Raine and George Mills Harper, 1969. Concerning polytheism see 41 *et seq.*

[4] Keynes, 153.

Choosing forms of worship from poetic tales.
And at length they pronounc'd that the Gods had order'd such things.
Thus men forgot that All deities reside in the human breast.

This mythopoeic, yet humanistic approach symbolises and conveys that sense of association with a greater unity, which identifies the physical with the spiritual, the human with the deity, the conscious with the unconscious, the Many with the One, according to one's beliefs or point of view, and as typified by Wordsworth in *The Prelude*:

> *Ye Presences of Nature in the sky*
> *And on the earth! Ye Visions of the hills!*
> *And Souls of lonely places!*[1]

I have already said several times that Romanticism is concerned with the particular, and the most important aspect of the particular is the individual: especially the artist, who, in Romantic eyes, was a seer, a prophet, an interpreter of mystery, a being in whom were combined intellect, intuition, feeling and sensation. These are attributes that should be present in all men, but to the Romantic, the artist—be he poet, painter or musician—possessed them in the most delicately adjusted balance, so that he, above all men, held the keys to truth. It was with great cogency that Blake quoted, after the preface to his prophetic book *Milton*, this sentence from the eleventh chapter of *Numbers*: "Would to God that all the Lord's people were prophets." And just as the basis of religious mysticism is love of God, so the basis of artistic prophecy[2] is the love of Art, and—because Art is Man's psyche manifest—love of Man. In the Romantic's eyes it was the love of the artist that fertilised the seed of inspiration, giving birth to rich interpretations of human experience and achievement in the form of works of art.

[1] Book I, 1.464.

[2] The word "prophecy" is here to be understood in the sense in which Blake used it: "Every honest man is a Prophet; he utters his opinion both of private & public matters. Thus: If you go on So, the result is So. He never says, such a thing shall happen let you do what you will. A Prophet is a Seer, not an Arbitrary Dictator." *Annotations to Watson*: Keynes, 392.

[17]

Love in its many forms is a central theme of Romanticism. Not only is it a means of artistic creation *per se*, but it is a pathway to a deeper realisation of individual personality, a gateway to beauty and to mystical experience. Few artists have expressed these ideas so well as Blake's friend, Edward Calvert, in his engravings "The Cyder Feast" and "The Chamber Idyll"[1] (Plates 3 and 4). Few poets have expressed them so well as Keats in *Endymion* or in his *Ode to Pysche*,[2] with its Claude-like setting:

> *Yes, I will be thy priest, and build a fane*
> *In some untrodden region of my mind,*
> *Where branched thoughts, new grown with pleasant pain,*
> *Instead of pines shall murmur in the wind:*
> *Far, far around shall those dark-cluster'd trees*
> *Fledge the wild-ridged mountains steep by steep;*
> *And there by zephyrs, streams, and birds, and bees,*
> *The moss-lain Dryads shall be lull'd to sleep;*
> *And in the midst of this wide quietness*
> *A rosy sanctuary will I dress*
> *With the wreath'd trellis of a working brain,*
> *With buds, and bells, and stars without a name,*
> *With all the gardener Fancy e'er could feign,*
> *Who breeding flowers, will never breed the same:*
> *And there shall be for thee all soft delight*
> *That shadowy thought can win,*
> *A bright torch, and a casement ope at night,*
> *To let the warm Love in!*

Love, too, gave to Romanticism one of its most persistent symbols, the fatal woman, the type stemming from Salome, and Leonardo's "La Gioconda",[3] described by Walter Pater in a famous passage:[4]

Hers is the head upon which all "the ends of the world are come," and the eyelids are a little weary. It is a beauty wrought out from within upon the flesh, the deposit, little cell by cell, of strange thoughts and fantastic reveries and exquisite passions. Set it for a moment beside one of those white Greek goddesses or beautiful women of antiquity, and how would they be troubled by this beauty,

[1] Calvert's engravings are all reproduced in Lister, Raymond, *Edward Calvert*, 1962, and in Calvert, Edward, *Eleven Engravings*, Cambridge, 1966.

[2] *Endymion* was first published in 1818; *Ode to Psyche* in 1820.

[3] The Louvre.

[4] From "Leonardo da Vinci" in *The Renaissance*, 1873.

into which the soul with all its maladies has passed! All the thoughts and experience of the world have etched and moulded there, in that which they have of power to refine and make expressive the outward form, the animalism of Greece, the lust of Rome, the mysticism of the middle age with its spiritual ambition and imaginative loves, the return of the Pagan world, the sins of the Borgias. She is older than the rocks among which she sits; like the vampire, she has been dead many times, and learned the secrets of the grave; and has been a diver in deep seas, and keeps their fallen day about her; and trafficked for strange webs with Eastern merchants; and, as Leda, was the mother of Helen of Troy, and, as Saint Anne, the mother of Mary; and all this has been to her but as the sound of lyres and flutes, and lives only in the delicacy with which it has moulded the changing lineaments, and tinged the eyelids and the hands.

So she continues through the ages—as Ondine, La Sylphide, Odile, Carmen; or in the type of Blake's Vala, or the Eternal Feminine in Swinburne's *Laus Veneris*;[1] or as Keats's *La Belle Dame Sans Merci*.[2] All of these figures are symbols of Destiny pursuing Man; unlike, but akin to, God pursuing the poet, in Francis Thompson's *Hound of Heaven* (1893), to the masterful opening theme in the first movement of Beethoven's "Emperor" Concerto, or to Gerard Manley Hopkins's throbbing cry at the beginning of *The Wreck of the Deutschland*:[3]

> *Thou mastering me*
> *God! giver of breath and bread;*
> *World's strand, sway of the sea;*
> *Lord of living and dead;*
> *Thou hast bound bones and veins in me, fastened me flesh,*
> *And after it almost unmade, what with dread,*
> *Thy doing: and dost thou touch me afresh?*
> *Over again I feel thy finger and find thee.*

The pursuit of Man by a fatal woman and by a deity are, of course, qualitatively different, obverse and reverse of the same image. But one must take neither too literally. Destiny, whatever its outward form, is the

[1] *Laus Veneris* appeared in *Poems and Ballads* (1866).

[2] First published in the *Indicator* 10 May 1820.

[3] *The Wreck of the Deutschland* was dedicated, "To the happy memory of five Franciscan nuns exiles by the Falck Laws drowned between midnight and morning of Dec. 7th, 1875." *The Poems of Gerard Manley Hopkins* (ed. W. H. Gardner and N. H. Mackenzie) fourth edn., 1967, 51. Reprinted by permission of Oxford University Press, by arrangement with the Society of Jesus.

unavoidable fate of man, whether he is driven to it by spiritual, emotional or physical fury: Romantics happen to have expressed the idea in a variety of forms.

Sometimes these forms were perverse, the destiny homosexual or androgynous. Possible reflections of this may be seen in Cosway's portrait of Horace Beckford[1] at the age of thirteen, which might as well be, with its pretty face and swelling buttocks, a portrait of a girl in a travesty role; and in Sir Francis Grant's equestrian portrait of Master James Keith Fraser,[2] (Plate 9), who has as pretty and feminine a face as, and indeed remarkably like, that of Giovanna d'Aragona, painted about 1518 by a follower of Raphael.[3]

Apart from his urge towards destiny, the artist is a "man possessed"; it is an attribute he shares alone with the madman. And, although his possession is not necessarily madness, its mechanics, so to speak, are of the same order. There have been, and there doubtless will be, mad artists— Richard Dadd, John Clare and William Cowper for instance—but they are exceptions. The "possession" of an artist implies an obsession which takes over his creative function, just as Etty was obsessed with the nude, Stubbs with the horse, Fuseli with the erotic, Turner with light, and Martin with immensity. Such obsessions are beyond the control of the artist, welling up from within his subconscious and unconscious minds. In this way, he becomes merged with the whole human unconscious—a faculty greater than his own, because it contains his own. That is one reason why certain artists are so much more moving than others: Beethoven in his great symphonies and quartets; Blake in his illuminated books; Coleridge in *The Ancient Mariner* (1798); Palmer in his Shoreham studies. All of these; for they are a release of deep human emotions and feelings, but emotions and feelings which can be expressed adequately and transformed into art only through the technique of a superlative artist.

But it is not only through great and obvious works of art that they may be expressed, but sometimes through smaller and relatively unimportant works by little-known artists: a miniature by Ebenezer Gerard, a Norwich painter, with its brooding, rugged and striking subject—a fine example of

[1] Pierpont Morgan Library, New York.
[2] Collection of Mr and Mrs Paul Mellon.
[3] The Louvre.

Romantic portraiture with deep psychological emphasis (Plate 11);[1] the perfection of a small wood-engraving of a piping shepherd, by Charlton Nesbit, a pupil of Thomas Bewick, conveying in a few square inches an idyllic glimpse of the pastoral spirit that imbued so much of the Romantic movement (Plate 12); a silhouette portrait by Augustin Edouart, a simple piece of black paper cut out with scissors, but giving the very essence of the sitter's character (Plate 13).[2]

Despite the Romantic's belief in individuality, he believed also in an unseen order beyond the visible world. As Blake wrote: "The tree which moves some to tears of joy is in the Eyes of others only a Green thing that stands in the way."[3] It is the artist who sees the mystical body of the tree, which moves him to tears of joy. Or, to put it another way, he perceives the unknown in the known. To enable him to do this he sometimes creates chaos in order to re-define creation; as does Beethoven in the final movement of his Ninth Symphony, where the chaos of the opening bars is mastered, and becomes re-defined as a triumphant Ode to Joy. Returning to Blake, we are, in his greatest work *Jerusalem*, given the saga of Man's recovery of his lost soul, which begins in chaos, until its true essence is grasped, enabling him to perceive the One:

> *I must Create a System or be enslav'd by another Man's.*
> *I will not Reason & Compare: my business is to Create.*[4]

There, indeed, we have one of the essentials of Romanticism. Let man follow his own imagination, wherever it may lead him. Throw logic aside. To quote Blake again: "No bird soars too high, if he soars with his own wings."[5]

This concentration had dangers. Individual spontaneity and expression, so encouraged, so freely expressed, could and did lead to solipsism and eccentricity, even to madness. The mad and bizarre artist was considered to be of especial interest and value. Excessive introspection, love of strangeness and weirdness, drug addiction, sexual perversion and deviation, witchcraft, reckless experiment: all had their place in Romanticism. But,

[1] Private collection.
[2] Ibid.
[3] Letter to Dr John Trusler: Keynes, 793.
[4] *Jerusalem*: ibid., 629.
[5] *The Marriage of Heaven and Hell*: Keynes, 151.

as in many other aspects of the movement, such manifestations were less apparent in England than on the Continent. We had our opium-takers in De Quincey, Coleridge and Crabbe; our sexual deviationists in Byron, "Monk" Lewis and Fuseli; our madmen in Dadd, Cowper and Clare. But on the whole we escaped not only such extremists as De Sade and Sacher-Masoch,[1] but also the destructive force of much that was present in German Romanticism.

The Romantics were preoccupied, too, with melancholy, gloom and death. The number of paintings in which death is either the subject, or in which it looms in the background, is large: Wright's "The old man and death"[2] (Plate 10), Blake's "Court of death",[3] Turner's "Peace: Burial of Wilkie at sea"[4] (Plate 14) are but three examples among many. As for literature, the examples are legion. Blair's *Grave*[5] may provide a typical passage:

> *Death's shafts fly thick. Here falls the village swain,*
> *And here his pamper'd lord! The cup goes round,*
> *And who so artful as to put it by?*
> *'Tis long since death had the majority,*
> *Yet, strange, the living lay it not to heart!*
> *See yonder maker of the dead man's bed,*
> *The sexton, hoary-headed chronicle!*
> *Of hard unmeaning face, down which ne'er stole*
> *A gentle tear; with mattock in his hand*
> *Digs through whole rows of kindred and acquaintance,*
> *By far his juniors! Scarce a scull's cast up*
> *But well he knew it's owner, and can tell*
> *Some passage of his life. Thus hand in hand*
> *The sot has walk'd with Death twice twenty years;*
> *And yet ne'er younker on the green laughs louder,*
> *Or clubs a smuttier tale: when drunkards meet,*
> *None sings a merrier catch, or lends a hand*
> *More willing to his cup. Poor wretch! he minds not*

[1] Donatien Alphonse François, Marquis de Sade (1740–1814), and Leopold von Sacher-Masoch (1836–95), after whom are named the sexual perversions of sadism and masochism.

[2] Wadsworth Athenaeum, Hartford, Connecticut.

[3] Colour print (1795). Tate Gallery.

[4] Tate Gallery.

[5] Robert Blair (1699–1746). *The Grave* was first published in 1743.

> *That soon some trusty brother of the trade*
> *Shall do for him what he has done for thousands.*

However, we must be careful not to confound extreme cases of eccentricity and gloom with genuine expressions of, and preoccupation with, the subconscious and unconscious, as manifested in the work of such painters and writers as Blake, Fuseli and Coleridge. And what is even more important, we must not dismiss a thing because it is unfamiliar, and, with this in mind, it would be well to keep before us this passage by Walter Pater: "It is the addition of strangeness that constitutes the Romantic character in art . . . It is the addition of curiosity to the desire of beauty that constitutes the Romantic temper . . . The essential elements, then of the Romantic spirit are curiosity and the love of beauty."[1]

In Romantic eyes, the artist had universal influence. Shelley said as much in *A Defence of Poetry*. Poets, he wrote, "are not only the authors of language and of music, of the dance, and architecture, and statuary, and painting; they are the institutors of laws and the founders of civil society, and the inventors of the arts of life, and the teachers who draw into a certain propinquity with the beautiful and the true, that partial apprehension of the agencies of the invisible world which is called religion . . . Poets, according to the circumstances of the age and nation in which they appeared, were called, in the earlier epochs of the world, legislators or prophets: a poet essentially comprises and unites both these characters. For he not only beholds intensely the present as it is, and discovers those laws according to which present things ought to be ordered, but he beholds the future in the present, and his thoughts are the germs of the flower and the fruit of latest time. Not that I assert poets to be prophets in the gross sense of the word, or that they can foretell the form as surely as they foreknow the spirit of events: such is the pretence of superstition, which would make poetry an attribute of prophecy, rather than prophecy an attribute of poetry. A poet participates in the eternal, the infinite, and the one; as far as relates to his conceptions, time and place and number are not."

Shelley spoke, of course, from the viewpoint of the poet, but the Romantic view of the painter is exactly the same. In Blake's words: "Jesus & his Apostles & Disciples were all Artists . . . The Old & New Testaments are the Great Code of Art. Art is the Tree of Life. God is

[1] *Macmillan's Magazine* No. XXXV.

Jesus . . . The Whole Business of Man Is The Arts, & All Things Common."[1]

In this sense, the Romantic composer, poet and painter are partakers of the Divine Imagination—God in Man; they are creators, not mere interpreters, as they were largely understood to have been by an earlier generation. "I describe what I imagine", said Keats.[2] And sometimes the artist describes in more than one medium what he imagined, for a large number of Romantics were both writers and painters. Rossetti, Smetham, Bewick, Turner, Palmer, Hopkins, Barnes,[3] Lear, Haydon, all shared this to some extent; but most remarkable of all was Blake, who was poet, painter, printer and engraver, and brilliant in each medium.

The Romantic artists were members of what Hart Crane, the American poet, called "the visionary company of love": an inspired company of "men possessed", ranging in poetry from the psalmists, through Dante, Spenser, Shakespeare and Milton, to Keats, Shelley, Byron and Wordsworth; in music from the boy David, through Monteverdi, Scarlatti and Mozart, to Beethoven, Chopin and Weber; in painting from the cave-artists of Altamira, through Giotto, Fouquet, Michelangelo and Claude, to Constable, Turner, Palmer and Rossetti. They form a company who derive their strength from the imagination of the individual, not from abstract and materialistic rules, whether propounded in science by Newton, or in philosophy by Locke. This idea is well summed up by Blake, in his *Song of Los*, in which the children of Los pass on the false philosophy and religion of Urizen to mankind, and drive away the imaginative arts, until Orc delivers the world from error, arising "like a pillar of fire above the Alps".[4] But before that deliverance had come to pass, abstract law and restrictive religion had reigned:

> *Thus the terrible race of Los & Enitharmon gave*
> *Laws & Religions to the sons of Har, binding them more*
> *And more to Earth, closing and restraining,*
> *Till a Philosophy of Five Senses was complete.*
> *Urizen wept & gave it into the hands of Newton & Locke.*[5]

[1] *The Laocoön*: Keynes, 777.

[2] Letter to George Keats, 18 September 1819. Rollins, Hyder Edward, *The Letters of John Keats, 1814–21*, Cambridge, 1958, II, 200.

[3] William Barnes (1801–86), Dorset poet.

[4] Keynes, 248. [5] ibid, 246.

To the Romantic, the imagination was no abstraction, but a very present reality. Nor was it a mere product of the intellectual faculty, but a super sense which afforded an insight "behind the veil": an insight which gave the artist a peculiar perception or inspiration by means of which he could begin to create his work. Human imagination is the only true reality; the materialism of Locke and Newton is fallacious:

> Mental Things are alone Real; what is call'd Corporeal, Nobody Knows of its Dwelling Place: it is in Fallacy, and its Existence an Imposture. Where is the Existence Out of Mind or Thought? Where is it but in the Mind of a Fool?[1]

This being so, Romantics felt compelled to explore the recesses of the human mind, in which every detail, every aberration, every function and malfunction, was of interest, because it provided a pathway into creative imagination—"every Minute Particular is Holy."[2] These "minute particulars" are what many of the forms of Romantic art symbolize; there is no abstraction, no generalization—only particularization. It is the art of the individual, the seer who has penetrated the veil:

> *And all should cry, Beware! Beware!*
> *His flashing eyes, his floating hair!*
> *Weave a circle round him thrice,*
> *And close your eyes with holy dread,*
> *For he on honey-dew hath fed,*
> *And drunk the milk of Paradise.*[3]

For this imaginative penetration the appetite of the Romantics was insatiable. There was no end to the mysteries of the human mind, and everything that it embraced or comprehended—art, nature, landscape, history, invention, religion—all came within the Romantics' sphere of interest. In Blake's *Gates of Paradise* (1793), one plate shows a tiny figure at the foot of an enormously long ladder, propped against a crescent moon. It is inscribed, "I want! I want!" and it well conveys this mood of insatiety, a mood which has never been absent from Man's questing mind, but which was particularly evident during the Romantic period. It is in this sense that we may discern a Romantic spirit, albeit removed by a couple of centuries from the Romantic age, in Donne's lines:

[1] Blake, *A Vision of the Last Judgment*: Keynes, 617.
[2] Blake, *Jerusalem*: Keynes, 708. [3] Coleridge, *Kubla Khan* (1816).

> *Goe, and catch a falling starre,*
> *Get with child a mandrake roote,*
> *Tell me, where all past yeares are,*
> *Or who cleft the Devils foot . . .*

By the same token, the artist was also a Promethean figure, stealing fire from heaven, and teaching Man to defy the gods and rebel against his fate. Not only that, but Prometheus provides, as it were, a bridge to the self-deification grown out of excessive individualism, found in some Romantics —Shelley for instance—who used mythology as a communication between the demands of ordinary, everyday life, and the depths of the artist's own psyche. Blake is an obvious example, although his was not so much self-deification as self-analysis, for his prophetic figures are no other than the elemental components of the human mind, warring against one another for supremacy, rarely nicely balanced: Urizen, the intellect; Los, imagination or the creative function; Orc or Luvah, feeling; Tharmas, sensation.[1] In Blake's work these, and many other comparable figures, symbolize the unending drama of Man's soul and mind.

That soul and that mind were also symbolized, in the Romantic imagination, by the Aeolian harp, placed in the wind to transform every passing zephyr into harmonies. As Shelley wrote in *A Defence of Poetry*:

> Man is an instrument over which a series of external and internal impressions are driven, like the alternations of an ever-changing wind over an Aeolian lyre, which move it by their motion to ever-changing melody. But there is a principle within the human being, and perhaps within all sentient beings, which acts otherwise than in a lyre, and produces not melody alone, but harmony, by an internal adjustment of the sounds and motions thus excited to the impressions which excite them. It is as if the lyre could accomodate its chords to the motions of that which strikes them, in a determined proportion of sound; even as the musician can accomodate his voice to the sound of the lyre.[2]

[1] It is impossible to tie these figures down to exact and unalterable meanings. Thus, as we have seen, Orc can mean "revolt" as well as "feeling"; similar variations apply to all of them.

[2] Later, in the same essay, Shelley uses another musical simile, describing the poet as "a nightingale, who sits in darkness and sings to cheer its own solitude with sweet sounds; his auditors are as men entranced by the melody of an unseen musician, who feel that they are moved and softened, yet know not whence or why."

There are various types of Aeolian harp,[1] but the usual one is in the form of a long, light, slender box, with a sloping and perforated top, above which are arranged some twelve strings, although the number varies. The whole is surmounted by a removable board, forming a slot over the strings. The instrument is placed in a sash window, the sash itself holding it in place, and the draught blows over the strings, causing them to vibrate and make chords of music, sometimes strange, sometimes beautiful, but always enchanting. This symbolized the creative function of the Romantic writer, composer or painter, who thus, almost despite himself, drew artistic forms from the cosmos.[2]

The Aeolian harp was often mentioned in Romantic literature. It appears in Gray's *The Progress of Poetry* (1759); in Wordsworth's *The Prelude* (1805); in Shelley's *Prometheus Unbound* (1820); in Coleridge's *The Eolian Harp* (1795) and *Dejection* (1802), where it is called a lute; and in Thomson's *Castle of Indolence* (1748):

> *A certain music, never known before,*
> *Here soothed the pensive melancholy mind;*
> *Full easily obtained. Behoves no more,*
> *But sidelong to the gently-waving wind*
> *To lay the well-tuned instrument reclined;*
> *From which, with airy fingers light,*
> *Beyond each mortal touch the most refined,*
> *The god of winds drew sounds of deep delight:*
> *Whence, with just cause, The Harp of Aeolus it hight.*[3]

One poet, Robert Bloomfield,[4] the Suffolk author of *The Farmer's Boy*, even made Aeolian harps, one of which, made in 1808 for Prince Frederick

[1] See Bonner, Stephen (ed.), *Aeolian Harp*, Cambridge, 1970–71, 4 vols.

[2] An Aeolian harp was owned by Eleanor Butler and Sarah Ponsonby, the "Ladies of Llangollen", whose relationship (almost certainly Lesbian) was referred to by contemporaries as a "Romantic friendship". See Mavor, Elizabeth, *The Ladies of Llangollen*, 1971, 88, 142.

[3] Canto I, Stanza XL. In passing it may be mentioned that when Keats saw for the first time the nude statue of Pauline Borghese (née Bonaparte) by the Italian sculptor, Antonio Canova (1757–1822), he dubbed it "the Aeolian Harp". Lowell, Amy, *John Keats*, Boston and New York, 1929, II, 504. The statue is in the Borghese Gallery, Rome.

[4] Robert Bloomfield (1766–1823) was a village shoemaker who became a fashionable poet. Later he lost his money, and died in great poverty.

Duleep Singh, is in the Moyses Hall Museum at Bury St. Edmunds.

The symbol of the Aeolian harp could be paralleled in nature. The famous *Uamh Bhin* or Fingal's cave, on the Isle of Mull, contains a formation, an underwater hole in its depths below the basalt columns which form its cathedral-like walls. This causes air to be trapped, and eerie "musical" sounds to be emitted, which can be heard outside the cave. Romantics seized upon the symbolism of Fingal's Cave and translated it into art—Mendelssohn in his overture *The Hebrides*, Scott in *The Lord of the Isles*, Turner in an oil-painting which showed a steamship outside the Cave, buffeting its way through the waves.[1] This last in particular was deeply Romantic in conception, combining Nature (the cave, the sea, the weather) with a preoccupation with the inventive wonders of the present (the steamship): Promethean man defying, with his invention, the natural hazards thrown in his path by the gods. But Scott also showed a Romantic spirit when he visited the island in a rowing boat, accompanied by a piper, and with colours fluttering in the wind. During the trip he wrote a poem for the local Laird:

> *Staffa, king of all kind fellows,*
> *Well befall thy hills and valleys,*
> *Lakes and inlets, deeps and shallows,*
> *Cliffs of darkness, caves of wonder,*
> *Echoing the Atlantic's thunder.*

Macpherson and Keats wrote of Fingal's Cave, James Hogg, the Ettrick shepherd[2] visited it, and so did William Wordsworth and Thomas Campbell.[3] It is likely that they would have seen it as symbolising the same things as the Aeolian harp: nature awakening art, as it does in the "man possessed".

The idea of nature awakening art provides a striking contrast with another aspect of Romanticism: art awakened by industry, invention and science. For one thing, there were the effects, on the Romantic mind, of the Industrial Revolution, which caused men to be torn from the land and thrust into urban society; which caused towns to gobble up rural areas; which caused the clean natural air to be defiled by pollution from factories

[1] Private collection.

[2] James Hogg (1770–1835), poet and shepherd. He supplied to Scott material for his *Border Minstrelsy*.

[3] Thomas Campbell (1777–1844), poet and author of *Pleasures of Hope*.

and mills. The dangers were not at first apparent to everybody. Only seers like Blake could fully appreciate them:

> *And all the Arts of Life they chang'd into the Arts of Death in Albion.*
> *The hour-glass contemn'd because its simple workmanship*
> *Was like the workmanship of the plowman, & the water wheel*
> *That raises water into cisterns, broken & burn'd with fire*
> *Because its workmanship was like the workmanship of the shepherd;*
> *And in their stead, intricate wheels invented, wheel without wheel,*
> *To perplex youth in their outgoings & to bind to labours in Albion*
> *Of day & night the myriads of eternity: that they may grind*
> *And polish brass & iron hour after hour, laborious task,*
> *Kept ignorant of its use: that they might spend the days of wisdom*
> *In sorrowful drudgery to obtain a scanty pittance of bread,*
> *In ignorance to view a small portion & think that All,*
> *And call it Demonstration, blind to all the simple rules of life.*[1]

Yet, in general, Romantics revelled in the newly discovered machines and inventions, and in the industrial landscapes that went with them. There was a great preoccupation with science and technology. It provided subject matter for poems, as in Erasmus Darwin's *Botanic Garden*;[2] for paintings, as in the *oeuvre* of Cotman, Turner and Wright of Derby; it inspired many of the effects in the canvases of Martin. Some inventions, like the magic lantern, the Eidophusikon,[3] and the panorama, helped to satisfy a Romantic craving for remote and historical scenes. Charles Babbage[4] even invented a system of notating the movements of machinery, and by so doing, gave it the possibility of an aesthetic, placing it, in an analytic sense, on a level with dancing and music. The "machine aesthetic" is an essentially modern conception, but Cocteau's dictum, that "it is a weakness not to comprehend the beauty of a machine", was adumbrated by the Romantics.[5]

[1] *Jerusalem*: Keynes, 700.

[2] Erasmus Darwin (1731–1802). His poem *The Botanic Garden* was published in two parts, the second part being published first: Part I "The Economy of Vegetation" appeared in 1791, and was preceded by Part II "The Loves of the Plants" in 1789.

[3] See pages 140–43.

[4] Charles Babbage (1792–1871), mathematician and inventor. See page 138.

[5] cf. Hultén, K. G. Pontus, *The Machine as seen at the end of the mechanical age*, New York, 1968.

In time, other Romantics besides Blake began to see dangers in science and technology. Wordsworth, addressing Coleridge in *The Prelude*, writes:

> *Science appears but what in truth she is,*
> *Not as our glory and our absolute boast,*
> *But as a succedaneum, and a prop*
> *To our infirmity.*[1]

Some it drove to suicide, like the young Arthur Elliott in Winwood Reade's last book *The Outcast* (1875), who, after reading Malthus's *Essay on Population* and Darwin's *Origin of Species*, was overwhelmed by doubt of the goodness of God, and killed himself. Others, like Philip Henry Gosse, tried, much to the detriment of their scientific reputation, to reconcile the scientific evidence of evolution and the results of geological research, with the six-days creation of the Book of Genesis.[2] Yet Gosse was also a true Romantic, as may be seen from his illustrations to his books (Plate 63); they have that particularization, that minute accuracy of representation, that sense of communion with Nature, which may be seen also in the work of George Stubbs and Thomas Bewick.

By the new scientific discoveries, Man's image was transformed from that of a superior being at the centre of the Universe, into that of a puny creature on a tiny planet orbiting around a minor star, in a lesser galaxy, in a void that passed all comprehension. He had become a victim of fate, tied down in an overwhelming immensity; which brings us again to the image of Prometheus, chained to his rock, and to the defiant individuality that will force Man to break his bonds and dance in Satanic energy and exultation, like Blake's figure in his print "The Dance of Albion" (Plate 15). Or, on the other hand, it will cause some to recoil and to discern the wholeness of Nature in the apparent vacuum, in the most minute microscopic organism, and in the greatest star, finding culmination in Tennyson's

> *. . . God, which ever lives and loves,*
> *One God, one law, one element,*
> *And one far-off divine event,*
> *To which the whole creation moves.*[3]

[1] Book II, l.212.

[2] See Gosse's *Omphalos: an attempt to untie the geological knot*; London, 1857.

[3] Closing lines of *In Memoriam A.H.H.*, 1850, by Alfred, Lord Tennyson (1809–92).

This sublime view of Nature may serve to bring us to that important constituent in English Romanticism—the landscape. Landscape is more especially important since, as we have just seen, the Industrial Revolution was beginning to have a destructive effect upon it, and this caused many Romantics to see a strikingly poignant beauty in it, to interpret it in mystical terms; to see it, too, as a reflection or image of Man himself, even Promethean Man defying the evil, or at best the ugliness of the industrialism that was beginning to despoil his heritage.

Long before the dawn of the Romantic era, the English were aware of the aesthetic value of their landscape, but the first stirrings of a truly Romantic view of it are to be found in the poetry of John Milton. Who can fail to discern Romantic accents in these lines from *L'Allegro* :[1]

> *Streit mine eye hath caught new pleasures*
> *Whilst the Lantskip round it measures,*
> *Russet Lawns, and Fallows Gray,*
> *Where the nibling flocks do stray,*
> *Mountains on whose barren brest*
> *The labouring clouds do often rest:*
> *Meadows trim with Daisies pide,*
> *Shallow Brooks, and Rivers wide.*
> *Towers, and Battlements it sees*
> *Boosom'd high in tufted Trees,*
> *Where perhaps som beauty lies,*
> *The Cynosure of neighbouring eyes.*
> *Hard by, a Cottage chimney smokes,*
> *From betwixt two aged Okes . . .*

These stirrings, encouraged by the work of the great French landscapists, Poussin and Claude, were taken further in the poems of James Thomson and John Dyer,[2] which contain those elements of sublimity, grandeur and mystery that are so important in Romantic landscape. Dyer is chiefly remembered now for his *Grongar Hill* (1726), in which occurs the following passage, packed with Romantic overtones; a description of the landscape, followed by a particularization of its hidden elements, and concluding with a moral reflection:

> *Below me, trees unnumbered rise,*
> *Beautiful in various dyes:*

[1] l. 69. [2] Welsh poet, 1699–1758.

[31]

The gloomy pine, the poplar blue,
The yellow beech, the sable yew,
The slender fir, that taper grows,
The sturdy oak with broad-spread boughs.
And beyond the purple grove,
Haunt of Phillis, queen of love!
Gaudy as the opening dawn,
Lies a long and level lawn,
On which a dark hill, steep and high,
Holds and charms the wandering eye!
Deep are his feet in Towy's flood,
His sides are clothed with waving wood,
And ancient towers crown his brow,
That cast an aweful look below;
Whose ragged walls the ivy creeps,
And with her arms from falling keeps;
So both a safety from the wind
On mutual dependence find.

'Tis now the raven's bleak abode;
'Tis now th' apartment of the toad;
And there the fox securely feeds;
And there the poisonous adder breeds
Concealed in ruins, moss, and weeds:
While, ever and anon, there falls
Huge heaps of hoary mouldered walls.
Yet time has seen that lifts the low,
And level lays the lofty brow,
Has seen this broken pile complete,
Big with the vanity of state;
But transient is the smile of fate!
A little rule, a little sway,
A sunbeam in a winter's day,
Is all the proud and mighty have,
Between the cradle and the grave![1]

Similar descriptions appear elsewhere in Dyer's work, particularly in *The Ruins of Rome* (1740), where vastness, precursory of Martin's boundlessness, is mingled with more picturesque elements, as in this description of *The Baths of Caracalla*:

[1] l. 58.

The stately pines, that spread their branches wide
In the dun ruins of its ample halls,
Appear but tufts; as may whate'er is high
Sink in comparison, minute and vile.
 These, and number'd, yet their brows uplift,
Rent of their graces; as Britannia's oaks
On Merlin's mount, or Snowden's rugged sides,
Stand in the clouds, their branches scatter'd round,
After the tempest.[1]

James Thomson, also, brought a Claudian air to his poetry, which in its turn, influenced English painting. The influence of Claude is present in his *Seasons* (1726–39) and in *The Castle of Indolence* (1748), an allegorical poem in the manner of Spenser, set in this peaceful scene:[2]

Was nought around but images of rest:
Sleep-soothing groves, and quiet lawns between;
And flowery beds that slumbrous influence kest,
From poppies breathed; and beds of pleasant green,
Where never yet was creeping creature seen.
Meanwhile unnumbered glittering streamlets played,
And hurlèd everywhere their waters sheen;
That, as they bickered through the sunny glade,
Though restless still themselves, a lulling murmur made.

Joined to the prattle of the purling rills,
Were heard the lowing herds along the vale,
And flocks loud-bleating from the distant hills,
And vacant shepherds piping in the dale:
And now and then sweet Philomel would wail,
Or stock-doves plain amid the forest deep,
That drowsy rustled to the sighing gale;
And still a coil the grass hopper did keep:
Yet all these sounds yblent inclinèd all to sleep.

In this context the works of Andrew Marvell are of some importance; in many of his poems he shows a deep understanding of landscape, nature and the picturesque, as in *Bermudas* and *The Garden* (1681):

What wond'rous Life is this I lead!
Ripe Apples drop about my head;
The Luscious Clusters of the Vine
Upon my Mouth do crush their Wine;

[1] l. 309. [2] Canto I, Stanzas III and IV.

The Nectaren, and curious Peach,
Into my hands themselves do reach;
Stumbling on Melons, as I pass,
Insnar'd with Flow'rs, I fall on Grass.

Mean while the Mind, from pleasure less,
Withdraws into its happiness:
The Mind, that Ocean where each kind
Does streight its own resemblance find;
Yet it creates, transcending these,
Far other Worlds, and other Seas;
Annihilating all that's made
To a green Thought in a green Shade.

If much of this landscape verse is picturesque rather than Romantic, it is because the picturesque was a precursor of Romanticism. The picturesque was nature as painters saw it—the very word comes from the Italian *pittoresco*, which means "in the manner of painters". The picturesque was scenery that caught the eye, compelling the beholder to admire it; it was landscape free from discordant elements; it was landscape almost sacred. Such landscape is found in the work of Titian,[1] as for instance in his picture "Venus and Cupid with a lute-player" in the Fitzwilliam Museum. It is present to an even greater extent in the paintings of Domenichino;[2] it is present in the works of Tintoretto,[3] as in his delectable "Adam and Eve" in the Accademia at Venice; and in the work of Giorgione,[4] as in his "Fête Champetre" in the Louvre. Poussin made use of it in painting after painting; Claude perfected it in his "Enchanted Castle"[5] especially. It is present in the work of Salvator Rosa, where it provides settings for banditti; but Rosa's landscapes are wild and savage, and therefore closer to Romanticism than to the picturesque.

As a movement in its own right, the picturesque was a mainly English phenomenon, which throve in these islands for the hundred years beginning about 1730. It caused painters and poets to visit such places as Snowdonia, the Alps and the Dolomites, and the Lake District of north-

[1] Tiziano Vecelli, called Titian (*c.* 1487/90–1576), Venetian painter.
[2] Domenico Zampieri Domenichino (1581–1641), Bolognese painter.
[3] Jacopo Tintoretto (1518–94), Venetian painter.
[4] Giorgione de Castelfranco (1477–1510), Venetian painter.
[5] "Landscape with Psyche at the Palace of Cupid", otherwise known as "The Enchanted Castle". Trustees of T. C. Lloyd.

west England. It led, too, to the publication of works such as William Gilpin's *Tours* of various parts of Britain.[1] Gilpin illustrated his *Tours* with delightful aquatints that, while taking liberties with the subjects they portray, certainly accentuate their picturesqueness; even bandits, in the manner of Rosa, were added if Gilpin deemed them suitable.

Important influence on the development of the picturesque came from the writings of Anthony Ashley Cooper, third Earl of Shaftesbury, who wrote of the joys of natural beauty:[2]

> I shall no longer resist the passion growing in me for things of a *natural* kind; where neither *art*, nor the *conceit* or *caprice* of man has spoil'd their *genuine order*, by breaking in upon that *primitive state*. Even the rude *rocks*, the mossy *caverns*, the irregular unwrought *grotto's*, and broken *falls* of waters, with all the horrid graces of the *wilderness* it-self, as representing NATURE more, will be the more engaging, and appear with a magnificence beyond the formal mockery of princely gardens.

Still greater influence came from Edmund Burke's *A Philosophical Enquiry into the Origin of our Ideas of the Sublime and Beautiful*, which was first published in 1756. This work helped also to direct the development of the picturesque towards Romanticism, as this passage will demonstrate:

> No passion so effectually robs the mind of all its powers of acting and reasoning as fear. For fear being on apprehension of pain or death, it operates in a manner that resembles actual pain. Whatever therefore is terrible, with regard to sight, is sublime too, whether this cause of terror, be endued with greatness of dimensions or not; for it is impossible to look on any thing as trifling, or contemptible, that may be dangerous. There are many animals, who though far from being large, are yet capable of raising ideas of the sublime, because they are considered as objects of terror. As serpents and poisnous animals of almost all kinds. And to things of great dimensions, if we annex an adventitious idea of terror, they become without comparison greater. A level plain of vast extent on land, is certainly no mean idea; the prospect of such a plain may be as extensive as a prospect of the ocean; but can it ever fill the mind with any thing so great as the

[1] His series of illustrated picturesque "tours" included *The Wye and South Wales* (1782), *The Lakes* (1789), *The Highlands* (1800), and several others.

[2] *The Moralists, a philosophical rhapsody* 1709, 255.

ocean itself? This is owing to several causes, but it is owing to none more than this, that this ocean is an object of no small terror. Indeed terror is in all cases whatsoever, either more openly or latently the ruling principle of the sublime.[1]

Although they are both mainly concerned with the picturesque, those two passages, from Shaftesbury and from Burke, illustrate the essential difference between the picturesque and Romanticism. In the first, the full concentration is upon the scenery itself, or at any rate upon the elements in it, before they have been spoiled by "the conceit or caprice of man". In the second, the theme concerns the effect of scenery and its elements on the human mind and emotions. In other words, the picturesque invites the beholder of a scene or prospect to enjoy it, to contemplate it for the sake of its inherent beauty, interest or painterly qualities; but the Romantic uses the scene as a spur to the beholder to delve into his own psyche and to analyse its effect upon his emotions.

Therefore Romanticism, while building in part upon the same foundations as the picturesque, raised a vastly different structure. Landscape in Romantic painting became charged with emotion, sublimity and grandeur, as in Joseph Wright's "Arkwright's cotton mill"[2] Turner's "Norham Castle",[3] or Palmer's "Valley thick with corn"[4] (Plate 16). Its parallel in literature is to be found, not unnaturally, in descriptions in Gothic novels, rather than in the poetry of the picturesque. In Mrs Ann Radcliffe's *The Mysteries of Udolpho*,[5] for instance, where the Pyrenees are seen in sublime and forbidding terms:

> From Beaujeu the road had constantly ascended, conducting the travellers into the higher regions of the air, where immense glaciers exhibited their frozen horrors, and eternal snow whitened the summits of the mountains. They often paused to contemplate these stupendous scenes, and, seated on some wild cliff, where only the ilex or the larch could flourish, looked over dark forests of fir, and precipices where human foot had never wandered, into the glen—so deep, that the thunder of the torrent, which was seen to foam along the bottom, was scarcely heard to murmur. Over these crags rose others of stupendous height, and fantastic shape; some shooting into cones; other impending far over their base, in huge masses of

[1] 3rd edn., 1761, 96–7. [2] Collection of Mr James Oakes.
[3] Tate Gallery. [4] Ashmolean Museum, Oxford.
[5] 1794, I, ch. iv.

granite, along whose broken ridges was often lodged a weight of snow, that, trembling even to the vibration of a sound, threatened to bear destruction in its course to the vale. Around, on every side, far as the eye could penetrate, were seen only forms of grandeur—the long perspective of mountain-tops, tinged with ethereal blue, or white with snow; vallies of ice, and forests of gloomy fir. The serenity and clearness of the air in these high regions were particularly delightful to the travellers; it seemed to inspire them with a finer spirit, and diffused an indescribable complacency over their minds. They had no words to express the sublime emotions they felt . . . The deep silence of these solitudes was broken only at intervals by the scream of the vultures, seen cowering round some cliff below, or by the cry of the eagle sailing high in the air; except when the travellers listened to the hollow thunder that sometimes muttered at their feet. While, above, the deep blue of the heavens was unobscured by the lightest cloud, half way down the mountains, long billows of vapour were frequently seen rolling, now wholly excluding the country below, and now opening, and partially revealing its features. Emily delighted to observe the grandeur of these clouds as they changed in shape and tints, and to watch their various effect on the lower world, whose features, partly veiled, were continually assuming new forms of sublimity.

British Romantic painters tended to look for grandeur and sublimity nearer home than the Pyrenees, although Livy's "horrid Alps"[1] remained an important source of inspiration. But Scotland, Wales, and especially the Lake District, supplied the majority of the actual settings. It is true that Turner and some others went to the continental mountains for much of their subject matter, but to some the mountains of the Lake District could be just as sublime and equally terrifying. And not only mountains—gloomy caves, and fissures like Gordale Scar in Yorkshire, could provide a setting as dramatic, as terrific as anything in the work of Salvator Rosa. That is demonstrated by James Ward's great composition of Gordale Scar with cattle, now in the Tate Gallery (Plate 17), which might be an illustration of Thomas Gray's description of the Scar in his *Journal*[2]

. . . it is the rock to the right under which you stand to see the fall, that forms the principal horror of the place. From its very base it begins to slope forwards over you in one black and solid mass without any crevice in its surface; and overshadows half the area below with

[1] Livy, Book XXI, lviii. [2] 13 October 1769.

its dreadful canopy. When I stood at (I believe) full 4 yards' distance from its foot, the drops which perpetually distill from its brow fell on my head, and on one part of the top more exposed to the weather there are loose stones that hang in air, and threaten visibly some idle spectator with instant destruction . . . The gloomy uncomfortable day well suited the savage aspect of the place, and made it more formidable. I stay'd there (not without shuddering) a quarter of an hour, and thought my trouble richly paid, for the impression will last for life.

Not all Romantic landscape art was sublime or terrific. There was for instance the work of Constable, dwelling on the details of his beloved East Anglia; and there was that of Palmer, in which the little hills, valleys and cornfields around Shoreham, in Kent, are charged with an intense mystical ecstacy. These artists were indisputably Romantics; like Blake, they held infinity in the palm of their hand.[1] And, through their art, they enabled others to do likewise.

As in landscape, so, in the more detailed aspects of Nature, Romanticism found rich material, for Nature provided an escape from the conventional world into the elemental wonders of creation. But it must be Nature on its own terms, unrestrained by Man, although that did not preclude it from showing Man his own soul:

> *A Robin Red breast in a Cage*
> *Puts all Heaven in a Rage.*
> *A dove house fill'd with doves & Pigeons*
> *Shudders Hell thro' all its regions.*
> *A dog starv'd at his Master's Gate*
> *Predicts the ruin of the State.*
> *A Horse misus'd upon the Road*
> *Calls to Heaven for Human blood.*
> *Each outcry of the hunted Hare*
> *A fibre from the Brain does tear.*
> *A Skylark wounded in the wing,*
> *A Cherubim does cease to sing.*
> *The Game Cock clip'd & arm'd for fight*
> *Does the Rising Sun affright.*
> *Every Wolf's & Lion's howl*
> *Raises from Hell a Human Soul.*
> *The wild deer, wand'ring here & there,*

[1] *Auguries of Innocence*: Keynes, 431.

Keeps the Human Soul from Care.
The Lamb misus'd breeds Public strife
And yet forgives the Butcher's Knife.
The Bat that flits at close of Eve
Has left the Brain that won't Believe.
The Owl that calls upon the Night
Speaks the Unbeliever's fright.
He who shall hurt the little Wren
Shall never be belov'd by Men.[1]

The attitude of the Romantics towards Nature was identical with that of Maurice Maeterlinck towards the bees,[2] of Gilbert White towards the birds,[3] of Audubon towards their plumage:[4] Man—like Jacob with the Angel —struggling with Nature to discover and define its essence and to understand its meaning in relation to his own existence and psyche.[5]

Such an attitude had nothing in common with artificial and "decorative" manifestations of Nature, like Marie Antoinette's pretty rococo farm, or like the modern woman's clipped poodle, which is little more than a fashion accessory. The Romantics were satisfied with no less than rapport with Nature itself. In some ways Virgil provided the prototype; his *Bucolics* and *Georgics*, singing as they do of the joys of pastoral and rural life, were popular among Romantic artists, many of whom, in particular Blake and Palmer,[6] illustrated them.

And just as landscape produced poets, like Dyer and Thomson, so Nature produced poets, like the peasants Stephen Duck,[7] and Clare; the

[1] ibid.

[2] Belgian playwright: his *La Vie des abeilles* was published in 1901.

[3] In *The Natural History of Selborne* (1789), White recorded his detailed observations of bird life and other natural phenomena.

[4] Audubon's greatest work is his *Birds of America* (1817–38), which contains many minutely observed and accurately detailed illustrations, from water-colours.

[5] This is, incidentally, an attitude that has prevailed to the present day, as may be seen in such remarkable books as *The Goshawk* by T. H. White (1951); *Animals in splendour* by E. L. Grant Watson (1967); *The Peregrine* by J. A. Baker (1967); and *The Kingfisher* by Rosemary Eastman (1969).

[6] *The Pastorals of Virgil . . . adapted for schools* ed. by Dr Robert John Thornton, London, 1821, contained wood-engravings by Blake. Palmer illustrated with etchings his own translation of Virgil, *An English Version of the Eclogues of Virgil*. It was published posthumously 1883/84.

[7] 1705–56, Wiltshire poet.

shoemaker Bloomfield; and, later, the country parson, William Barnes. The idea of the simple natural life could hardly be better conveyed than in Barnes's poems, written in the Dorset dialect:[1]

> *Though ice do hang upon the willows*
> *Out bezide the vrozen brook,*
> *An' storms do roar above our pillows,*
> *Drough the night, 'ithin our nook;*
> *Our evenen he'th's a-glowen warm,*
> *Drough wringèn vrost, an' roaren storm.*
> *Though winds mid meäke the wold beams sheäke,*
> *In our abode in Arby Wood.*
>
> *An' there, though we mid hear the timber*
> *Creake avore the windy raïn;*
> *An' climen ivy quiver, limber,*
> *Up ageän the window peäne;*
> *Our merry vaïces then do sound,*
> *In rollen glee, or dree-vaïce round;*
> *Though wind mid roar, 'ithout the door,*
> *Ov our abode in Arby Wood.*

Barnes achieves in verse what Thomas Bewick achieves in the wonderful little head and tail pieces of his *Quadrupeds* (1790) and *British Birds* (1797 and 1804) (Plate 82): he instils poetry into the particulars of both nature and the rural life.

Another aspect of Nature is shown in the work of Gerard Manley Hopkins, who seems to illuminate the very spirit in his subjects, in the same way that George Stubbs, in his tigers, lions and horses, illuminates the very quintessence of fierceness, aggression, panic, or timidity. Hopkins's poem "The Windhover" which, although written with a religious motive (it is inscribed "To Christ our Lord"), also illustrates the essential character and nobility of the great hawk:[2]

I caught this morning morning's minion, king-
 dom of daylight's dauphin, dapple-dawn-drawn Falcon, in his riding
Of the rolling level underneath him steady air, and striding
High there, how he rung upon the reign of a wimpling wing

[1] "Our abode in Arby Wood": Jones, Bernard (ed.), *The Poems of William Barnes*, 1962, I, 280–81.

[2] *The Poems of Gerard Manley Hopkins* (ed. W. H. Gardner and N. H. Mackenzie) fourth edn, 1967, 69. Reprinted by permission of Oxford University Press, by arrangement with the Society of Jesus.

In his ecstasy! then off, off forth on swing,
 As a skate's heel sweeps smooth on a bow-bend: the hurl and gliding
 Rebuffed the big wind. My heart in hiding
Stirred for a bird,—the achieve of, the mastery of the thing!

Brute beauty and valour and act, oh, air, pride, plume, here
 Buckle! AND the fire that breaks from thee then, a billion
Times told lovelier, more dangerous, O my chevalier!

 No wonder of it: shéer plód makes plough down sillion
Shine, and blue-bleak embers, ah my dear,
 Fall, gall themselves, and gash gold-vermilion.

Hopkins's religious viewpoint is itself Romantic. Many Romantics saw Nature as divinity, or at least as the expression of divinity. Philip Henry Gosse was one such; that is why his drawings are so detailed, so close to the original subject. Gosse made them that way deliberately, for, Nature being the expression of divinity, any attempt to alter, modify or "interpret" it was sacriligious.

In some Romantics, Nature stirred doubts and gave rise to puzzlement. Much of the thought in Blake's *Songs of Innocence and of Experience* is founded on such feeling. The Little Lamb of Innocence is contrasted with the terrible Tyger of Experience: "Did he who made the lamb make thee?"[1] As the Romantic era moved to its climax, such questions and doubts, accentuated by scientific discoveries and theories, became more strident and insistent, until we find Tennyson writing of Man:[2]

 Who trusted God was love indeed
 And love Creation's final law—
 Tho' Nature, red in tooth and claw
 With rapine, shriek'd against his creed.

All of these aspects of Nature are reflected in Romantic painting. Stubbs, Bewick, Gosse and Blake we have mentioned—though Blake's genius was not at its happiest thus expressed: his engraved Tyger is like a mild Noah's ark toy. But there were many others—James Ward, whose bulls, horses and wild animals are charged with dynamic energy; Edwin Landseer in his early work, before he declined into sentimentality; Samuel Palmer, whose wheat and trees are sacramental; and hosts of minor artists who, imbued

[1] Keynes, 214. [2] *In Memoriam LVI.*

with the same spirit, illustrated natural-history books, botanical magazines, annuals and textbooks: Thomas Martyn's *Universal Conchologist* (1784) and *Aranei, or a Natural History of Spiders* (1793); Sir William Hooker's *The Botanical Magazine* (1827–65); and Thomas Moore's *Nature-Printed British Ferns* (1859–60), in which exactitude was carried to the lengths of printing the plates from the actual objects illustrated, a not uncommon method at the time.

But, after all, the Romantic vision of Nature was in the imagination: to see the One in the Many:

> *To see a World in a Grain of Sand*
> *And a Heaven in a Wild Flower,*
> *Hold Infinity in the palm of your hand*
> *And Eternity in an hour.*[1]

Not only was this vision in the imagination, but it was a key by which may be reached further heights of imaginative creation. As a spirit sang in Shelley's *Prometheus Unbound*:

> *On a poet's lips I slept*
> *Dreaming like a love-adept*
> *In the sound his breathing kept;*
> *Nor seeks nor finds he mortal blisses,*
> *But feeds on the aërial kisses*
> *Of shapes that haunt thought's wildernesses.*
> *He will watch from dawn to gloom*
> *The lake-reflected sun illume*
> *The yellow bees in the ivy-bloom,*
> *Nor heed nor see, what things they be;*
> *But from these create he can*
> *Forms more real than living man,*
> *Nurslings of immortality!*[2]

Romantics also culled "nurslings of immortality" from the past, for, just as they were fascinated with contemporary developments in industry and science, they were also fascinated with history: what Shelley called "the episodes of that angelic poem written by Time upon the memories of men. The Past, like an inspired rhapsodist, fills the theatre of everlasting generations with their harmony."[3] This fascination was one which the

[1] Blake, *Auguries of Innocence*: Keynes, 431. [2] Act I, l. 737.
[3] *A Defence of Poetry.*

Romantics shared with the Neoclassicists, who, however, looked back only
to the classical world for their inspiration. The Romantics cast their net
over a wider area. In painting, Martin was inspired by Biblical times;
Calvert and Palmer by the classical world; Rossetti by the Middle Ages. In
literature, Swinburne found much in Elizabethan England and classical
Greece; Tennyson was inspired by both Greece and the Middle Ages;
Coleridge wrote of Kubla Khan. And Keats, in his *Ode on a Grecian urn*,
wrested the latent Romanticism from a classical work of art:[1]

> *Who are these coming to the sacrifice?*
> *To what green altar, O mysterious priest,*
> *Lead'st thou that heifer lowing at the skies,*
> *And all her silken flanks with garlands drest?*
> *What little town by river or sea shore,*
> *Or mountain-built with peaceful citadel,*
> *Is emptied of this folk, this pious morn?*
> *And, little town, thy streets for evermore*
> *Will silent be; and not a soul to tell*
> *Why thou art desolate, can e'er return.*

The Romantics were so much fascinated with the past, as to attempt to
bring it into their own lives. Writing to Samuel Gale in 1728, William
Stukeley gives a remarkable account, in this sense, of Romanticism, so to
speak, in action:[2]

My wife miscarried 3 days after your letter to me, the second time.
The embrio, about as big as a filberd, I buryd under the high altar in
the chappel of my hermitage vineyard; for there I built a niche in a
ragged wall oregrown with ivy, in which I placed my roman altar, a
brick from Verulam, and a water pipe lately sent me by my Lord
Colrain from Marshland. Underneath is a camomile bed for greater
ease of the bended knee, and there we enterrd it, present my wives
mother, and aunt, with ceremonys proper to the occasion. If you
enquire what I am about: I am making a temple of the druids, as I call
it, 'tis thus; there is a circle of tall filberd trees in the nature of a
hedg, which is 70 foot diameter, round it is a walk 15 foot broad,
circular too, so that the whole is 100 foot diameter. This walk from
one high point slopes each way so gradually, till you come to the

[1] The *Ode on a Grecian urn* was published in 1820. For a full discussion of the
works of art that inspired it, see Jack, Ian, *Keats and the mirror of Art*, Oxford,
1967, Chapter xiii.

[2] *Family Memoirs of William Stukeley*, 1882–87.

lowest which is the opposite point, and there is the entrance to the temple, to which the walk may be esteemed as the portico. When you enter the innermost circle or temple, you see in the center an antient appletree oregrown with sacred mistletoe; round it is another concentric circle of 50 foot diameter made of pyramidal greens, at equal intervals, that may appear verdant, when the fruit trees have dropt their leaves. These pyramidals are in imitation of the inner circles at Stonehenge. The whole is included within a square wall on all sides, except that where is the grand avenue to the porticoe, which is a broad walk of old apple trees. The angles are filled up with fruit trees, plumbs, pears, walnuts, apple trees, and such are likewise interspersed in the filberd hedg and borders, with some sort of irregularity to prevent a stiffness in the appearance, and make it look more easy and natural. But in that point where is the entrance from the portico into the temple is a tumulus, which was denominated snowdrop hill, being in Christmas time covered ore with that pretty, and early, flower, but I must take it for a cairn or celtic barrow.

That was fascination with the past in the ante-natal period of Romanticism. The fascination lasted throughout the era, not only in artistic expression, but, as in the case of Stukeley, in the Romantics' everyday life. Writing of Calvert, Sir William Blake Richmond[1] recalled, "it was not without a thrill that I saw in his little back garden an altar erected to the honour of the great god Pan, and received from the mouth of the ancient sage many a picturesque vision in words of the relationship of the ancient gods with the modern world!"

History itself, of course, provided the Romantics with much subject-matter, especially from its strange or exotic manifestations: the story of Fair Rosamund, courtesan of Henry II, which was painted by Stothard, Rossetti and Burne-Jones;[2] or William the Conqueror viewing Harold's

[1] Son of George Richmond, friend of Blake, Calvert and Palmer. Quoted from papers written between 1914 and 1921. Stirling, A. M. W., *The Richmond Papers*, 1926, 99.

[2] I do not know the whereabouts of Stothard's "The Fall of Rosamund"; it was engraved by Blake in 1783. See Keynes, Geoffrey, *Engravings by William Blake: The Separate Plates*, Dublin, 1956, 65. Rossetti's "Fair Rosamund" is in the National Museum of Wales, Cardiff; a chalk drawing of the same subject is in the Cecil Higgins Museum, Bedford. Burne-Jones's "Fair Rosamund" is in a private collection. It is illustrated in Maas, Jeremy, *Victorian Painters*, 1969, 144.

body, as imagined by Ford Madox Brown;[1] or the strange drawing, by Millais, of the disentombment of Queen Matilda.[2] But true history was not enough. So fascinated were the Romantics with the past, that some of them even invented or forged their own source material—like Thomas Chatterton, who wrote poems which, he claimed, were the work of a fifteenth-century Bristol monk, Thomas Rowley; but Rowley had never existed. Yet, although they were forgeries, they were good enough to deceive eminent scholars. They were exposed by Thomas Tyrwhitt some seven or eight years after the seventeen-year-old Chatterton had, in 1770, poisoned himself.

A fraud of a different kind was made by James Macpherson, who published a number of epics which were claimed to have been the work of a Gaelic poet named Ossian. Many, including Goethe, admired them, although Samuel Johnson doubted their authenticity. After Macpherson's death in 1796, a committee was appointed to investigate them, and it was found that he had, with considerable licence, edited genuine Gaelic poems, adding passages of his own, and that he had forged the original manuscripts from which he claimed to have worked.

The frauds were symptoms of the interest that Romantics were taking in mediaevalism, which they saw as the antithesis of classicism, and which they called by the generic name of "Gothic".[3] Indeed, Romanticism and the Gothic were in the early days of the Romantic era synonymous terms. Gothic was evident in all kinds of places: in Horace Walpole's house at Strawberry Hill, which he decorated and furnished throughout in that style; in William Beckford's enormous but jerry-built house at Fonthill; in Scott's mock-baronial pile at Abbotsford; and in the pretty little chapel at Audley End in Essex.

It is true that Gothic in such places as these was only a form of decoration; it had little or no structural significance, such as it possessed in the Middle Ages, or was to have in the later period of the Gothic Revival, under the puritanical influence of Ruskin, Cockerell, Gilbert Scott and their contemporaries. For this reason alone, the Gothic architecture of the early part of the era was more Romantic than that of its end. Plaster tracery,

[1] City of Manchester Art Galleries. [2] Tate Gallery.

[3] Similar frauds were perpetrated in many branches of art and history. Typical were the bogus medieval tokens, badges, seals and medallions made about 1857 by two shoremen, with the assistance of an antiquary. See Peale, Christopher, 'Billie and Charlie Tokens', *Seaby's Coin and Medal Bulletin*, April 1966.

pinnacles, pendants and crockets, inset with pieces of mirror and stained glass, are more Romantic than the great lumps and piles of stone which the Victorians copied almost chip for chip from mediaeval buildings and with which they lumbered the earth: they are more Romantic because they are the expression of individual taste, whereas the later, more earnest work, is based on authority. The later work was Neoclassicism in Gothic dress.

The Gothic spirit found expression in literature, particularly in novels, of which Horace Walpole's *Castle of Otranto* (1764) was the archetype, with its hauntings, a princely usurper, a virtuous peasant who is really a prince, a beautiful and innocent girl, and a giant. *Otranto* was, in a way, in the class of literary frauds, as it at first claimed to be a translation "by William Marshal, Gent. from the original Italian of Onuphiro Muralto, canon of the church of St. Nicholas at Otranto." Later, however, the true authorship was acknowledged.

Sir Walter Scott's historical novels also added something to the genre, although, strictly speaking, they were not Gothic; but they must have suggested themes and treatment to many authors and painters of Gothic subjects. Indeed, much of the general preoccupation with Scotland, showed by Romantic artists of all kinds, was due largely to Scott's influence. He undoubtedly provided material for many theatrical works: *The Bride of Lammermoor* became *Lucia di Lammermoor*, *Kenilworth* became *Elisabetta al castello di Kenilworth*, both by Donizetti; *The Fair Maid of Perth* was made into an opera by Bizet.

Gothic novels may be numbered in hundreds. They varied from poor, unconvincing tales, to powerful and moving works like *The Monk* by Matthew Gregory Lewis, *The Mysteries of Udolpho* by Mrs Ann Radcliffe, and Mary Shelley's *Frankenstein, or the modern Prometheus* (1818).

Prometheus figures abound, as in Shelley's juvenile romance *Zastrozzi* (1810), where, in Chapter I, the hero Verezzi, "was chained to a piece of rock which remained immoveable . . . Oh! what ravages did the united efforts of disease and suffering make on the manly and handsome figure of Verezzi! His bones had almost started through his skin; his eyes were sunken and hollow; and his hair, matted with the damps, hung in strings upon his faded cheek. The day passed as had the morning—death was every instant before his eyes—a lingering death by famine—he felt its approaches: night came, but with it brought no change. He was aroused by a noise against the iron door: it was the time when Ugo usually brought

fresh provisions. The noise lessened, at last it totally ceased—with it ceased all hope of life in Verezzi's bosom. A cold tremor pervaded his limbs—his eyes but faintly presented to his imagination the ruined cavern—he sank, as far as the chain which encircled his waist would permit him, upon the flinty pavement . . ."

Evil frequently triumphs, innocent heroines are released from their sufferings only by death, supernatural events overshadow the stories, accompanied sometimes with logical explanations, but as often continuing in complete mystery. Sometimes evil is overcome by good, and the heroine marries her love. But always there is emotional, heady exaggeration, often accompanied by repulsive details:

> The dead body of a woman hung against the wall opposite to the door she had entered, with a coarse cloth pinned over all but the face; the ghastly and putrefied appearance of which bespoke her to have been some time dead. Laura gave a fearful shriek, when a tall figure, dressed only in a checked shirt, staggered towards her. The face was almost quite black; the eyes seemed starting from the head; the mouth was widely extended, and made a kind of hollow guttural sound in attempting to articulate.[1]

Naturally this kind of material much affected painting. The work of Fuseli, that most Gothic of painters, is packed with such exaggerated horror and supernatural details, as in his well-known "Nightmare"[2] and "Succubus"[3] (Plates 18 and 19). Blake's frontispiece to Gottfried Augustus Bürger's poem *Leonora*,[4] shows a ghostly fire-breathing horse and its rider, with Leonora holding on to his waist, streaking across the firmament with evil spirits above, and the dead bursting from their graves below, while imps and spectres dance before gallows by moonlight. Another twist to the horrific may be seen in the water-colour by John Hamilton Mortimer, "Skeleton of a sailor and vultures on a shore".[5]

The Gothic spirit entered and flourished in the theatre. Stage adapta-

[1] *The Horrors of Oakendale Abbey* "By the author of Elizabeth", 1797.
[2] Goethe Museum, Frankfurt am Main. There are, however, several versions.
[3] Also known as "Nightmare", but not to be confused with the subject of the better-known picture just mentioned. Kunsthaus, Zürich.
[4] Published 1796. Translation by J. T. Stanley.
[5] British Museum, London.

[47]

tions were made of Lewis's *Monk* and other novels,[1] but the most attractive manifestations of Gothicism in the theatre, many of which may still be seen today, are in ballet and opera, which swarm with wilis, sylphs, water-sprites, devils, virtuous peasants and villainous nobles. Such were the ballets *Giselle ou les Wilis*,[2] *Ondine ou la Naiade*,[3] and *La Sylphide*;[4] and, although these were the work of foreign musicians and choreographers, they were performed over here; and sometimes, as with *Ondine*, they even had their première in London. Sometimes they were set in British scenes: the action of *La Sylphide* took place in Scotland, and its hero was James Reuben, a Scotch peasant. The ballets had an impact on English art, for they provided subject matter for a brilliant series of lithographs by artists, who included A. E. Chalon (Plate 66), J. F. ("Spanish") Lewis and others.

Two further, closely related groups of prints, inspired by the theatre, are "penny-plain, twopence-coloured" toy-theatre prints, and tinsel portraits of individual actors in character. In fact they are more redolent of the Gothic novels, which had given rise to the plays from which they were taken, than much other, more sophisticated work. For many of the novels contain characters that are no more than pasteboard, situations that are stilted and unreal, settings that are no more than stage properties.

To find a deeper theatrical influence on historical painting, we must turn to Shakespeare, who not unnaturally, and like Milton, has always fascinated English artists. Moreover, his work has many of the ingredients that a Romantic would seek, especially that of concentration on the individual psyche.

Great impetus to Shakespearian Romantic art was provided by the engraver and publisher, John Boydell, who in 1789 opened a Shakespeare Gallery of thirty-four paintings by leading British artists (Plate 24). The venture was greeted with rapture at that year's Academy dinner, when the

[1] For example, a ballet *Raymond and Agnes* (1797) and a play of the same title (1809) were both based on *The Monk*. See Summers, Montagu, *The Gothic Quest* (reprint, New York, 1964) 228 *et seq* and *passim*.

[2] Book by Vernoy de Saint-Georges, Théophile Gautier and Jean Coralli; choreography by Jean Coralli; music by Adolphe Adam. First produced, Paris, 1841.

[3] Book and choreography by Jean Perrot and Fanny Cerrito; music by Cesare Pugni. First produced, London, 1843.

[4] Book by Adolphe Nourrit; choreography by Filippo Taglioni; music by Jean Schneitzhoeffer. First produced, Paris, 1832.

Prince of Wales proposed a toast to "an English tradesman who patronises art better than the Grand Monarque, Alderman Boydell, the Commercial Maecenas."

From 1791 onwards, Boydell published, in parts, an edition of Shakespeare's plays, illustrated by prints of the pictures in the 1789 Shakespeare Gallery, plus others that were later added to the collection. The parts were finally brought together in a total of nine bound volumes. The artists participating included Reynolds, Romney, Fuseli and Northcote. Many of them were Romantics, and, even among the work of the others, Romantic elements are present, even in that of Reynolds, the President of the Academy: his "Puck", with its overtones of perversion, is an undeniably Romantic picture[1] (Plate 24).

By its example, Boydell's venture pointed the way to many other Romantics. Thereafter we find a rich seam of Shakespearian Romantic art, not only by Fuseli and the other "Boydell" Romantics, but by painters, to mention only a few, such as Blake, John and Alexander Runciman, Mortimer, Stothard, Martin, Maclise, Smetham, Rossetti, and Arthur Hughes.

The Bible, of course, was obvious source material for the Romantic preoccupation with the past; Biblical subjects occur in Romantic painting at least as frequently as those from Shakespeare. The variety of interpretations was enormous, and ranged from Martin's exercises in vastness, like "The Plains of Heaven",[2] to Blake's exercises in horror, like "The number of the Beast is 666"[3] (Plate 25), or in humanity, like "The woman taken in adultery".[4] And in Blake it overflowed into his poetry and thought, as in *The Everlasting Gospel*:[5]

> *The Vision of Christ that thou dost see*
> *Is my Vision's Greatest Enemy:*
> *Thine has a great hook nose like thine,*
> *Mine has a snub nose like to mine:*
> *Thine is the friend of All Mankind,*
> *Mine speaks in parables to the Blind:*
> *Thine loves the same world that mine hates,*
> *Thy Heaven doors are my Hell Gates.*

[1] Painted in 1789. Collection of the Earl Fitzwilliam.
[2] Mrs Robert Frank Collection.
[3] Rosenbach Memorial Gallery, Philadelphia.
[4] Museum of Fine Arts, Boston.
[5] Keynes, 748.

> *Socrates taught what Meletus*
> *Loath'd as a Nation's bitterest Curse,*
> *And Caiphas was in his own Mind*
> *A benefactor to Mankind:*
> *Both read the Bible day & night,*
> *But thou read'st black where I read white.*

The work of many later Romantic painters fell into sentimentality. The sharpness of the early work became blurred as people's minds turned away from Romantic fervour into bourgeois respectability, conformity and literal realism. Blake's pungency is replaced by Holman Hunt's "Light of the World";[1] Fuseli's Gothic nightmares by Poynter's "Israel in Egypt";[2] the visionary landscapes of Turner by Birket Foster's "The Hillside";[2] Stubbs's noble animals by Landseer's "Dignity and Impudence".[3] It is not our purpose either to condemn or to glorify these new developments, but merely to record that they came, and that, with their coming, Romanticism waned. Our purpose will now best be served by considering in some detail the main categories in which British Romantic painting was expressed.

[1] Keble College, Oxford.
[2] Both Guildhall Art Gallery, London.
[3] Tate Gallery.

CHAPTER TWO

Man the Measure of all Things

The proper study of mankind is man.

Pope, *An Essay on Man*[1]

AS I have stressed in Chapter One, the Romantic spirit is concerned with the particular, especially with the particular in the human individual, and this implies concern with the individual's psychological composition. That is one reason why some of the greatest Romantic poems are primarily psychological studies: Byron's *Don Juan*, for instance, and, above all, Wordsworth's *The Prelude*. But these are psychological studies, not so much of some extraneous subject, as of the artist himself. This is obvious in *The Prelude*, which is subtitled "Growth of a poet's mind", but not quite so obvious in *Don Juan*; though nobody with knowledge of Byron could doubt that the hero of that poem is closely equated with its author.

Throughout much Romantic art, the artist, in his creations, is mirroring himself, bringing out of his subject, whatsoever it may be, Narcissus-like reflections of his own emotions and feelings. This is particularly true of much Romantic portraiture. The sitter's likeness of course appears, and, in a good portrait the artist will have brought out his character; but the artist's character is present also, sometimes to the exclusion even of that of the subject. Partly because of this, the whole range of portraits by certain artists is curiously uniform. The similarity in feeling in portraits by Etty, in the small group of miniatures by Blake,[2] and in portraits by Francis Hayman, is not to be completely explained by consistency in the artist's idiosyncrasies, style and technique, or by family likenesses in a group of sitters, or, like Waterhouse's nymphs,[3] by the fact that the same model was used throughout. But in the Romantic portraits about which I am writing,

[1] Ep. II, l. 2.

[2] See article by Sir Geoffrey Keynes: "Blake's Miniatures", *Times Literary Supplement* V. 59, 1960, 72. Reprinted, with illustrations, in Keynes *Blake Studies* (2nd ed., 1971), 111–12.

[3] "Hylas and the Nymphs". City Art Gallery, Manchester.

[51]

each subject, in passing through the filter of the artist's conception, has become transfigured, so that artist and sitter have become mingled in the process—in much the same way that in marriage a man and a woman will acquire traces of one another's characteristics. It is as if the portrait has acquired the identity of the artist's *Doppelgänger*, giving it dramatic depths similar to Rossetti's sinister drawing, "How they met themselves"[1] (Plate 50).

The reflection of the artist in his subject may be illustrated by Blake's miniature of the Rev. John Johnson (a relation of William Cowper),[2] painted when Blake was living at Felpham in Sussex under the patronage of the minor poet, William Hayley, who wrote of it: "[Blake] executed some portraits in miniature very happily, particularly a portrait of Cowper's beloved Relation, the Revd Dr Johnson [Johnny of Norfolk]³", (Plate 26). The miniature shows Johnson seated, leaning on a book with his left arm; in the background is a symbolic church-tower and spire. I say "symbolic" because it was probably intended to indicate that Johnson was a clergyman and a rector; but he was Rector of the combined parishes of Yaxham with Welborne in Norfolk, each of which has its own church, but neither of which has a tower resembling that shown in the miniature. The tower and spire painted by Blake are, in fact, of a type sometimes used by him in his symbolic works—for example on plates 46 and 84 of his illuminated book *Jerusalem*. So here, in the background of the portrait, we find Blake's personality obtruding; there is no question of literalness, as there would have been with a pre-Romantic or post-Romantic painter—or as the sitter may have preferred.

Of the portrait itself, it is impossible to know how far, if at all, Blake may have altered Johnson's appearance. It is a fact that few portrait painters produce a likeness in the photographic sense of the word. Hayley, as we have seen, said it was executed "very happily", so no doubt it was a good likeness. But that does not concern us; what does concern us here is what of himself Blake put into the portrait. Johnson's intelligent, alert expression may provide a clue, for Blake admired, almost above all other things, intellectual beauty:

1 Fitzwilliam Museum, Cambridge.
2 Collection of Miss Mary Barham Johnson. For Johnson, see DNB X, 907–8.
3 Bentley, G. E., junior, *Blake Records*, Oxford 1969, 88.

The Beauty that is annexed and appended to folly, is a lamentable accident and error of the mortal and perishing life; it does but seldom happen; but with this unnatural mixture the sublime Artist can have nothing to do; it is fit for the burlesque. The Beauty proper for sublime art is lineaments, or forms and features that are capable of being the receptacles of intellect; accordingly the Painter has given in his beautiful man, his own idea of intellectual Beauty. The face and limbs that deviates or alters least, from infancy to old age, is the face and limbs of greatest Beauty and perfection.[1]

I think in this tiny work of art we may discern something of Blake's "own idea of intellectual Beauty," and consequently, in Johnson, much of Blake himself. It is a portrait that might have been painted according to Fuseli's dictum: "In following too closely a model, there is danger in mistaking the individual for Nature herself; in relying only on the schools, the deviation into manner seems inevitable: what then remains, but to transpose *yourself* into your subject."[2]

I need hardly add that, important though they are, such subjective portrayals of sitters by no means comprise the whole of Romantic portraiture. For another aspect, let us examine another miniature, one that has already been mentioned in Chapter One, and one in which the psychology of the sitter predominates: the portrait of an unknown man (Plate 11) by Ebenezer Gerard, an almost completely unknown painter, whose main speciality appears to have been cheap portraiture (including silhouettes), and theatrical portraits of very mixed quality. But once, and perhaps no more, for I have seen nothing else of his to compare with it, he painted a minor masterpiece. It was cheap enough: a label pasted on its back states that Gerard would paint a miniature for a guinea.

Nothing is known of the sitter. Or it would be true rather to say that everything is known except his name; for that brooding astigmatic gaze, those deep facial creases, great nose, curled mouth, cynically raised eyebrow and untidy mop of hair tell us all we want to know of their owner's personality. He was a farmer, or perhaps a craftsman or a shopkeeper, but of that class certainly; but his class, as in most Romantic portraits, is of little account compared with his psyche. He was dour and introspective, and that jutting lower lip indicates that he was overbearing, even some-

[1] *A Descriptive Catalogue*: Keynes, 579–80.
[2] *Aphorisms chiefly relative to the Fine Arts*, 1788–1818. Aphorism 144.

thing of a bully, an impression fortuitously reinforced by the sinister cast of the eye. He has in him something of Heathcliff, something of Michael Henchard, something of Magwitch[1] too, for the face is not entirely devoid of humour, and there is even a dash of wry kindness to be discerned. The whole conception is based, even if subconsciously, on interiority; it is a probe into the psychological depths of an introverted, unsure man, into the *Sturm und Drang* of his inner world; it is a survey, in miniature, of the inner world of Man.[2] It is that same world which had been penetrated on a vaster scale, by Blake in his prophetic books:

Dost thou not see that men cannot be formed all alike,
Some nostril'd wide, breathing out blood. Some close shut up
In silent deceit, poisons inhaling from the morning rose,
With daggers hid beneath their lips & poison in their tongue;
Or eyed with little sparks of Hell, or with infernal brands
Flinging flames of discontent & plagues of dark despair;
Or those whose mouths are graves, whose teeth the gates of eternal death.[3]

In a minor way, Gerard belonged to that fairly numerous company of Romantic artists who expressed themselves in both writing and painting, the poet-painters, whom we have already noticed,[4] for in 1825 he published a book entitled *Letters in Rhyme*. He had left Norwich in 1821 and settled in Liverpool. Between 1821 and 1825 he was forced to abandon painting, after a fever had caused a major weakness in his arms, and he wrote *Letters in Rhyme* in an attempt to raise money, with what success, if any, is unknown. The rhymes are poor stuff, but they do at least place him in the group.

The fact that we have taken for our point of departure in Romantic portraiture, two miniatures, one by a great artist and one by an all but unknown painter, illustrates the pervasiveness of the Romantic spirit. It was also present in the minor art of the profile shade, or silhouette as it is more popularly known. Various techniques were used in making shades, one of the commonest being the unlikely medium of scissor-cutting. I say "unlikely" because one would perhaps not expect scissor-cuts to produce such

[1] Characters in *Wuthering Heights* by Emily Brontë, *The Mayor of Casterbridge* by Thomas Hardy, and *Great Expectations* by Charles Dickens.
[2] See *The Inner World of Man* by Frances G. Wickes (New York, 1938).
[3] *Tiriel*: Keynes, 109. The passage was in fact deleted by Blake in the ms.
[4] See p. 24.

fine gradations of character as brushwork. In most cases that is true, yet the best silhouettist ever to produce portraits concentrating upon character, was a cutter—the French *émigré* Augustin Edouart, who spent the major part of his life working in England.

Edouart's work is sometimes repetitive; it contains irritating idiosyncracies, and it is often wooden. The feet, which show little variation from sitter to sitter, are weak, and would hardly support the bodies above them; legs dangle lifelessly on the end of bodies, themselves like lay figures made to a formula. Yet the head and face are, almost invariably, perfect delineations of character. They concentrate upon the essential, eliminating everything but what is necessary to convey the character and the very presence of the sitter. That the bodies are not invariably lifeless is shown in Edouart's portrait of Miss Emma Engleheart, daughter of George Engleheart, the miniature painter (Plate 13).[1] In this, the hand holding the reticule is full of lively tension, and the whole stance and conception of the body are convincing. But even here, Edouart was unable to overcome his weakness in portraying his sitter's feet.

The silhouette is a reminder of a powerful influence on Romantic portraiture—that of the Swiss clergyman and writer of Zürich, Johann Kaspar Lavater, whose *Fragmente zur Beförderung der Menschenkenntniss und Menschenliebe* was published between 1775 and 1778. This work was widely distributed in England, as *Essays on Physiognomy, designed to promote the knowledge and the love of mankind.* It was profusely illustrated and one edition[2] contained several plates after Fuseli, and three engravings by Blake. It contains also a number of silhouettes, and a long section dealing with this art form, in the course of which Lavater pays this tribute to it:[3]

> Silhouettes alone have extended my physiognomical knowledge, more than any other kind of portrait; they have exercised my physiognomical feeling, more than the contemplation even of Nature, always varied and never uniform.
>
> The silhouette arrests the attention: by fixing it on the exterior contours alone, it simplifies the observation, which becomes by that more easy and more accurate . . .

[1] Private collection. Another portrait of Emma Engleheart appears f.p.28 in Williamson G. C. and Engleheart, H. L. D., *George Engleheart* 1902.

[2] 1810. Translated by Henry Hunter.

[3] II, 177–8.

But the silhouette represents only a small sector of Lavater's interest. His work ranges over every aspect of the human face and, most interesting of all for our present purpose, he devotes a long section to portraiture, from which the following extracts are taken, and which illustrate his essentially Romantic viewpoint:[1]

What is the *Art of Portrait painting?* It is the representation of a real individual, or of a part of his body only; it is the reproduction of our image; it is the art of presenting on the first glance of the eye, the form of man, by traits, which it would be impossible to convey by words . . . The soul is painted on the face; it must be perceived in order to be transmitted to the canvas: and he who is incapable of catching this expression, never will become a portrait painter.

Every well painted portrait is an interesting picture, because it brings us acquainted with the soul and character of a particular individual. In it we see him think, feel, reason. We discern in it the peculiar character of his propensities, of his affections, of his passions; in a word, the good and the bad qualities of his heart and mind. And in this respect the portrait is even still more expressive than Nature, in which nothing is permanent, where every thing is only a rapid succession of movements infinitely varied; rarely does Nature present the human face in a light so advantageous as a skilful Painter can procure for it . . .

"The representation of a real individual", "the soul and character of a particular individual"—this is the very distillation of Romanticism. In the pages following, Lavater analyses and elaborates on a series of portraits, some real and some imaginary, of which his description of Fuseli's "portrait" of Satan is typical (Plate 20). It will, incidentally, be noted how the writer implies the projection of the artist into his work: the artist as "a man filled with his subject"[2]:

What a singular production! It proves at least beyond contradiction the extraordinary powers of the Artist; it announces a man filled with his subject, pressing towards the mark, and making every effort to attain it; prompt in seizing an idea, and eager to bring it forward. You feel at once what must have passed in his mind at the moment when he gave himself up to this composition; but the smallest reflection is sufficient to the calm Observer to discover its faults: he finds in it a borrowed and affected manner: that original sin of all Painters who have genius, or who imagine they have it.

[1] 1810 ed. II, 240–1. [2] ibid. II, 285.

One is easily persuaded that this image represents a Being powerful, extraordinary, more than human, the sworn enemy of every thing that belongs to gentle simplicity and dignity of sentiment.

Harshness and obstinacy are engraven on that front of brass.

The same character is visible also in the eye-brow, if that name may be given to the capricious trait which the Painter has substituted in its place.

The eyes are menacing with rage and malignity; but they are at the same time disturbed by fear. That look indicates agitation from some unexpected discovery.

The upper part of the nose expresses violence; the lower announces a judicious mind—but ought to express more malignity and fury.

The Mannerist is apparent in the mouth. In this copy it is weak, though it be not so in the Original: here it expresses fear rather than contempt. The under lip is far too good.

The chin too ought to have been better characterized: compared with that terrible forehead, it is too gentle and attractive; it should have been broader, firmer, a little awry, and projecting.

Under these disfigured traits you cannot however but distinguish the fallen Angel: you perceive still, some traces of his ancient greatness—and in this consists, if I am not mistaken, the principal merit of the piece.

Such portraiture, whether of real or fictitious characters or people, is far distant from the mere "recordings" of people's appearances that had preceded the Romantic era. There had been imaginative portraiture in pre-Romantic days—the highly symbolic and formal Elizabethan court portraiture for example—but there had never been quite the same intense concentration upon individual psychology as now obtained. Moreover, much imaginative learning was inherent in Romantic portraiture and in the Neoclassical portraiture that preceded it. That much is evident in such highly "intellectual" works as Reynolds's "Lady Bunbury sacrificing to the Graces,"[1] and "Three ladies adorning a term of Hymen".[2] How different in feeling is the same artist's "Age of Innocence",[3] all learned overtones shed, with its Romantic preoccupation with childlike purity: a sentimental but charming representation of that same spirit expressed by Blake in *Songs of Innocence and of Experience*:

[1] Art Institute of Chicago. [2] National Gallery.
[3] Tate Gallery.

Youth of delight, come hither,
And see the opening morn,
Image of truth new born.
Doubt is fled, & clouds of reason,
Dark disputes & artful teazing.
Folly is an endless maze,
Tangled roots perplex her ways.[1]

How different, too, from Reynolds's portraits are those of Thomas Gainsborough. It is true that many of Gainsborough's portraits are as stately and ceremonious as those of Reynolds. "Mrs Graham"[2] induces much the same feeling as Reynolds's "Duchess of Rutland"[3], despite its greater softness; it is more concerned with the social status of its subject than with her psychology. Yet in some of his pictures, Gainsborough's *oeuvre* shows much deeper concern with the sitter's individuality and character than is evident in that of Reynolds. This is illustrated by his portrait of Johann Christian Bach[4] (Plate 34). It has the fashionable elegance of its period, but it has much more, as may be seen by looking for a moment at the thoughtful preoccupied face and the set of the mouth, as if the sitter were humming to himself a melody that he has been reading from the score in his hand.

Zoffany's work shows considerable preoccupation with character, although this artist, also, is often busy with fashion and stateliness. Sometimes, however, there is a brilliant flash of Romanticism, as in the penetrating study, "John Cuff with an Assistant"[5] (Plate 36). Cuff was an instrument maker, and Master of the Spectacle Makers Company in 1748. Here indeed is concentration on the individual, and how different it is from that shown in Gainsborough's portrait of J. C. Bach! Here we have the practical craftsman in his workshop, in workaday attire, surrounded by the tools of his trade. His hands are beautifully rendered (in the Gainsborough portrait of Bach they are weak), and, appropriately in a craftsman, are as important

[1] "The Voice of the Ancient Bard": Keynes, 126.
[2] National Gallery of Scotland, Edinburgh.
[3] The original was destroyed in a fire at Belvoir Castle in 1816. But a contemporary copy exists in a private collection and it was mezzotinted by Val Green.
[4] Two versions exist. The first is in the Civico Museo Bibliografico Musicale, Bologna.
[5] Collection of HM the Queen.

a part of the portrait as his face. The strong, sensitive fingers, holding a lens in one hand and a polishing pad in the other, suggests confidence. Cuff's direct, plain gaze is uncomplicated, even amused that anybody should want to paint his portrait. Yet another aspect of character is evident in the portrait of his assistant, who looks diffidently, but appreciatively, over his master's shoulder, ready to resume work as soon as he can.

Dutch influence is present in the brilliant painting of the surroundings, tools and accessories: a reminder that Dutch painting was concerned with the lives of craftsmen, workmen and peasants, years before the dawn of the Romantic era. It may therefore, to this extent, be classed among the precursors of the Romantic movement, the portraiture of which, as we have already noted, was occupied, not with painting men in their social class, but in their human character. To the Romantic this was as interesting in a craftsman as in a nobleman; in a beggar as in a duke; in the individual, in short, whatever his standing.

Another dimension is added to Romantic portraiture by a group of artists which included Stubbs, Agasse, John Fernley, Henry Walton, and Julius Caesar Ibbetson. Their work springs in part from the picturesque, for much of it is set against a background of attractive scenery, somewhat removed from the humanized scenery of the Romantics. In these pictures, the Romantic element is reserved for the portraits themselves, as in that by Agasse, of John Gubbins Newton and his sister[1] (Plate 37). This is an interesting character study, especially of the young boy astride his horse, his timid, serious face an armature on which his adult character will be built. But what is most impressive about this picture, and about others in the same class, is its conception as a series of areas, almost planes, of colour, some bright and some sombre. It is almost as if the picture had been conceived as a series of silhouettes, although a closer examination of its delicate modelling belies this impression. The artist, in short, has provided another variation on Romantic vision, by taking the more abstract qualities of Neoclassicism, and bathing them in a clear Vermeer-like silvery light, in order to focus attention upon individual essences.

One of the greatest of all Romantic portrait painters was Sir Thomas Lawrence. His portrait of Pope Pius VII[2] (Plate 39) is typical of the dramatic overtones in his work. Pius was the Pope who, after signing a concordat

[1] Collection of Mr and Mrs Paul Mellon. [2] Windsor Castle.

with France, later excommunicated Napoleon for annexing the Papal States. Napoleon had Pius arrested and ordered him to be imprisoned at Fontainebleau, where the Pope remained until the fall of the Empire, when he returned to Rome and re-established the Jesuit order. In this portrait, the broad handling of the colour, the draping of the papal costume, the pose of the sitter, the encircling shades and bright distance, in which the Apollo Belvedere may be discerned, are all typical of the effects used by Lawrence to throw into relief the sitter's personality.

This is the portrait of a man who, in the midst of the pomp and glory of his high pontifical position, still remained a simple Benedictine who did not forsake the virtues of humility and principle. It is the portrait of a man who, almost dying from the brutal treatment accorded him by his captors, could yet, in the midst of his suffering, say of Napoleon, "May God pardon him, since, for my part, I have already pardoned him." It is the portrait of a man who, later, hearing of Napoleon's alleged hardships in exile on St. Helena, could instruct his secretary of state "to write on Our behalf to the allied sovereigns, and in particular to the Prince Regent. He is your dear and good friend, and We wish you to ask him to lighten the sufferings of so hard an exile. Nothing would give Us greater joy than to have contributed to the lessening of Napoleon's hardships. He can no longer be a danger to anybody. We would not wish him to become a cause for remorse."

It is interesting and enlightening to contrast Lawrence's portrait of Pius with that of the same sitter by David, in his painting of Napoleon's coronation.[1] In David's picture, Pius is shown seated behind Napoleon, who is in the act of crowning Josephine. There is here none of the drama present in the Lawrence portrait. The figure of Pius could be exchanged with any of the other ecclesiastics depicted, without detracting from such atmosphere as this ostentatious work possesses. The Neoclassic David was more interested in portraying the pomp of power than in portraying the personalities of those taking part in the scene.

Romantic portraiture was sometimes concerned with that typical figure of Romanticism, the Outcast or Solitary Man, who carried his individuality to such lengths as to place him apart from other men. Not necessarily because he wished consciously to ostracise himself, but because he could not help it. Blake was one such, and Clare and Cowper were others:

[1] The Louvre.

I was a stricken deer, that left the herd
Long since; with many an arrow deep infixt
My panting side was charg'd, when I withdrew
To seek a tranquil death in distant shades.
There was I found by one who had himself
Been hurt by th' archers. In his side he bore,
And in his hands and feet, the cruel scars.
With gentle force soliciting the darts,
He drew them forth, and heal'd, and bade me live.
Since then, with few associates, in remote
And silent woods I wander, far from those
My former partners of the peopled scene;
With few associates, and not wishing more.
Here much I ruminate, as much I may,
With other views of men and manners now
Than once, and others of a life to come.
I see that all are wand'rers, gone astray
Each in his own delusions; they are lost
In chase of fancied happiness, still woo'd
And never won. Dream after dream ensues;
And still they dream that they shall still succeed.
And still are disappointed. Rings the world
With the vain stir. I sum up half mankind,
And add two thirds of the remaining half,
And find the total of their hopes and fears
Dreams, empty dreams. The million flit as gay
As if created only like the fly,
That spreads his motley wings in th' eye of noon,
To sport their season, and be seen no more.[1]

It is a Christ-like state: "He came into his own, and his own received him not."[2] It is a state the Romantic artist shared with the pervert and the prostitute; with Cain, with the scapegoat of Leviticus; with Hamlet, with the Wandering Jew; with Dostoievsky's Idiot—even with Satan, if we accept the Blake/Shelley assessment of him as an outcast hero.

This aspect of Romantic portraiture is typified by the portrait of Shelley in the Baths of Caracalla, painted by Joseph Severn.[3] It shows the young poet, smooth-faced like a girl, wearing an expression of great sadness, with

[1] William Cowper, *The Task*, Book III, l. 108.
[2] *John* I, 11.
[3] Keats-Shelley Memorial House, Rome.

a full, slightly drooping mouth and large, limpid eyes. The isolation of this almost androgynous figure, seated with a pen in his hand and an open book on his knee, is accentuated by the immensity of the ruin which surrounds him, an immensity which we have already heard described in Dyer's *Rome*. It is a penetrating portrait of a sensitive young man with a Romantic compulsion to suicide; who had once plunged into a pool in the Arno and lain at the bottom, making no attempt to save himself, so that his friend Trelawney had been compelled to drag him out to prevent him from drowning.[1] This is the uninhibited young exile who was expelled from Oxford for publishing a pamphlet entitled *The Necessity for Atheism*; who married against his father's will; who eloped with a second woman, whom he married after his first wife had committed suicide; who showed homosexual tendencies towards his friend, Thomas Jefferson Hogg, whom, in a remarkable example of *Wahlverwandtschaften*, he encouraged into an affair with his second wife. All of which indicates the Outcast—especially in the context of Shelley's times. It is all appropriately characteristic of the young man who wrote *Alastor, or the Spirit of Solitude*, with its prophetic hints of the poet's own early death:

> *There was a Poet whose untimely tomb*
> *No human hands with pious reverence reared,*
> *But the charmed eddies of autumnal winds*
> *Built o'er his mouldering bones a pyramid*
> *Of mouldering leaves in the waste wilderness:—*
> *A lovely youth,—no mourning maiden decked*
> *With weeping flowers, or votive cypress wreath,*
> *The lone couch of his everlasting sleep:—*
> *Gentle, and brave, and generous,—no lorn bard*
> *Breathed o'er his dark fate one melodious sigh:*
> *He lived, he died, he sung, in solitude.*[2]

Like Goethe's anti-hero in *The Sorrows of young Werther*, Shelley found the problems of life too much to grapple with. Young Werther shot himself, and Shelley's death by drowning was suspiciously like suicide.[3]

[1] Trelawney, Edward John, *The Last Days of Shelley and Byron*, 1858, ch. vii.
[2] l. 50.

[3] The influence of Goethe's *Werther* was widespread. One *objet d'art* still seen in antique shops is the pottery group "Charlotte mourning at the tomb of Werther". It was made for many years, beginning about 1775, at several potteries, including Worcester and Leeds.

That other turbulent exile and outcast, Byron, was a favourite subject among Romantic artists, and appears in picture after picture. Sometimes he is the subject of straightforward portraits, but frequently his likeness is used, often thinly disguised, but as often not, in book illustrations. It appears in the portrayals of Ferdinand in the 1824 edition of *The Mysterious Warning* by Eliza Parsons,[1] and, understandably, in Colin's illustrations for *Don Juan*.[2]

Of actual portraits of Byron, one of the most typical is the highly dramatised representation by Richard Westall in the National Portrait Gallery (Plate 40). In this Byron is shown wearing an open-necked shirt (which he did not wear in real life),[3] his chin resting on his right fist, his eyes staring upwards as if at a vision. This sensuous, one might almost say lascivious face, epitomizes the Satanic solitary, the incestuous and homosexual satyr, the suffering reprobate, the misunderstood poet and seer, the club-footed Apollo, the sadist who told his wife that he hoped both she and her baby would perish in childbirth, the aristocrat who could write of his native country:

> I am sure my bones would not rest in an English grave, or my clay
> mix with the earth of that country. I believe the thought would drive
> me mad on my deathbed, could I suppose that any of my friends
> would be base enough to convey my carcass back to your soil.[4]

This is the Romantic poet whose *Cain: a mystery*,[5] an impugnment of the goodness of the Creator, prompted Blake to write *The Ghost of Abel*, and dedicate it:

> To LORD BYRON in the Wilderness:
> What doest thou here, Elijah?
> Can a Poet doubt the Visions of Jehovah? Nature has no Outline,
> but Imagination has. Nature has no Tune, but Imagination has.
> Nature has no Supernatural & dissolves: Imagination is Eternity.[6]

[1] d. 1811.

[2] Alexandre Marie Colin (1798–1875), French painter and lithographer.

[3] Trelawny *op. cit.*, ch. iv.

[4] Letter to the publisher John Murray (1778–1843), 7 June 1819. Howarth, R. G. (ed), *The Letters of George Gordon, 6th Lord Byron*, 1933, 252.

[5] 1821.

[6] Keynes, 779.

For the sake of accuracy, it should be added that, in some respects, this view of Byron as a Romantic hero is one-sided; he had much of the classic in him as well. He drank wine from a cup fashioned from a human skull, yet owned a classical helmet to wear in battle in Greece; he saw himself as an Augustan rather than a Romantic. He did not see himself as a "misanthropical and gloomy gentleman . . . but a facetious companion . . . and as loquacious and laughing as if I were a much cleverer fellow . . . I suppose now I shall never be able to shake off my sables in public imagination."[1]

The conception of Westall's portrait of Byron has much in common with that of Blake by Thomas Phillips, also in the National Portrait Gallery. This was engraved by Louis Schiavonetti as a frontispiece to Cromek's edition of Blair's *Grave*.[2] It is probably little like Blake, at least if one measures it by his life-mask. But it is undoubtedly a Romantic conception, portraying the visionary, "the Divine Blake" who, according to his young friend, John Giles, "had seen God, sir, and had talked with angels."[3]

But let us now turn to an altogether different kind of portraiture, one which embraces the wilder human passions, often portrayed by sitters in theatrical roles. One of its best exponents was George Romney who, while able to paint portraits that met the requirements of fashion as brilliantly as those of Reynolds and Gainsborough, could at the same time paint works, as elemental as "Sidonian recollections"[4] (Plate 41), and as full of feminine pathos as his sketch of Lady Hamilton as Miranda[5] (Plate 42).

The title, "Sidonian recollections", is derived from the name of the actress Sarah Siddons,[6] who is here shown in three poses, as Lady Macbeth, each head being a study of expression (terror, fear and death) that would be worthy of taking its place among those in Lavater's *Physiognomy*. The expressions are exaggerated, but in two of them hardly more than would be expected from an actress during performance. The top one goes further;

[1] Letter to Tom Moore, 10 March 1817. See Buxton, John, *The Poetry of Lord Byron*, 1970, 3, 10–11, 15. Howarth, *op. cit.*, 190.

[2] The edition in which Blake's illustrations were used appeared first in 1808.

[3] Calvert, Samuel, *A Memoir of Edward Calvert*, 17. John Giles was a cousin of Samuel Palmer. He died in 1880.

[4] Collection of Mr and Mrs Thomas J. McCormick.

[5] Philadelphia Museum of Art, John H. McFadden Collection.

[6] 1755–1831.

it has something of that hysterical, exaggerated terror so often present in the works of Fuseli. It is as if a manic horror has descended upon the actress, as if she is watching the animation of putrefying flesh, the articulation of dry bones, an innocent child drained by a vampire—or the irremoveable stain:

> Out damned spot! out, I say! One; two; why, then, 'tis time to do't. Hell is murky! Fie, my Lord, fie! a soldier and afeard? What need we fear who knows it, when none can call our power to account? Yet who would have thought the old man to have had so much blood in him? . . . The Thane of Fife had a wife: where is she now? What! will these hands ne'er be clean? No more o' that, my lord, no more o' that: you mar all with this starting . . . Here's the smell of blood still: all the perfumes of Arabia will not sweeten this little hand. Oh! oh! oh![1]

"Lady Hamilton as Miranda" is conceived in an entirely different mood; it shows the pathos of a girl looking upward, apprehensive about a coming storm:

> *If by your art, my dearest father, you have*
> *Put the wild waters in this roar, allay them.*
> *The sky, it seems, would put down stinking pitch,*
> *But that the sea, mounting to th*e *welkin's cheek,*
> *Dashes the fire out.*[2]

This head was a study for a large picture of *The Tempest*, now destroyed, originally painted by Romney for the Boydell Gallery. The freshness of the study is remarkable; the sitter's great beauty, rendered by the painter in highly poetic terms, is used with superb effect to convey the pathos of her apprehensions. One can imagine her cry, following the above lines: "O! I have suffered With those that I saw suffer. O! the cry did knock Against my very heart."[3] It is a Romantic portrait *par excellence*, combining pathos, fear and a dramatic situation expressed through the "minute particulars" of a single human face of outstanding beauty.

Similarly strong emotions occur in Fuseli's portraits, for, although he was not primarily a portrait painter, he brought to these works the same *Sturm und Drang* that motivates the remainder of his *oeuvre*. His brooding, somewhat sinister self-portrait in the National Portrait Gallery illustrates

[1] *Macbeth* V, i, 38. [2] *Tempest* I, ii, 1. [3] ibid. l. 5.

this. It shows him, hunched over an open book, his chin resting on his hands, his eyes looking up towards the viewer; it is a predatory face, well suited to its owner, who was known to his contemporaries as "Principal Hobgoblin Painter to the Devil." Yet it is a one-sided interpretation of the man's character, for Fuseli's eccentric personality had also a distinctly endearing side. According to Thomas De Quincey, he ate raw meat so as to induce splendid dreams.[1] He poured scorn on the work of nearly every other painter, although he admitted that Blake was "damned good to steal from". His temper and maledictions were legendary; when Mary Wollstonecroft had suggested, unsuccessfully, that she should live with the Fuselis as the artist's "mental concubine", and Mrs Fuseli had not unnaturally flown into a rage about it, Fuseli had said, "Sophia, my love, why don't you swear?—you don't know how it would ease your mind."[2]

Of this side of Fuseli there is nothing in the self-portrait. Yet it remains a perfect piece of Romanticism, as it concentrates upon what might be termed the deeper and more turbulent side of Fuseli's character; and it is true that Romanticism is singularly free of humour.

A different mood is presented in Fuseli's chalk portrait—one of a series of this sitter—of Martha Hess, a member of an old Zürich family[3] (Plate 100). This is a prototype of many faces in Fuseli's subject pictures; the profile is found repeated many times in both male and female characters. One of the series was directly engraved by T. Holloway, labelled "Mary Sister of Martha" and published in Lavater's *Physiognomy*.[4] It has a serenity not present in the self-portrait we have just been discussing. Although the young woman is no conventional beauty, Fuseli has given her an appearance of considerable feminine gentleness and attractiveness, combined with a certain pathos. It is also drawn with great skill: out of a sketchy background, the details take shape gradually, until the sitter's face itself becomes rendered with full plasticity. It is—almost—like the shaping of a vision. It is even more—a demonstration of the magnificent technique of which Fuseli was, at his best, master.

[1] *Confessions of an English Opium Eater*; ed. Richard Garnett, 1885, 136 ("The Pains of Opium").

[2] Cunningham, Allan, *The Lives of the most eminent British Painters, Sculptors, and Architects*, 1830, II, 282.

[3] Pierpont Morgan Library.

[4] 1810 edition; between 282 and 283.

That Fuseli should be successful in painting women need not surprise us; he was highly susceptible to them, if at times somewhat cynical in his attitude, which was, however, nothing if not Romantic:

> Your account of the Nunneries you have visited confirms Hamlet's verdict: "Frailty, thy name is woman!" How self-contradictory, that the "animal of beauty", as Dante calls woman, should exchange her claims to social admiration and pleasure, and the substantial charms of life, for the sterile embrace of a crucifix or of some withered sister, by the dim glimmer of cloistered light,—lost to hope, and marked by oblivion for her own! Tyranny, deception and, most of all, that substitute for every other want, "the undistinguished space of woman's will", can alone account for such phenomena.[1]

So far, this chapter has been concerned with the human face. But that is only part of "the divine Humanity", for there is also the human body, which in Romantic art is sometimes more effective than portraiture in expressing the minute particulars of humanity and of Man in his world: human ecstasy, energy, pathos, inspiration and passion; Man's grandeur and smallness; his dominance and quiescence; his beauty and ugliness; his co-ordinations and perversions; his feelings, senses, intellect and sensations. All of these things are expressed in Romantic art through portrayals of the human body. It may be in a tiny speck of a figure, almost lost in a landscape of overwhelming apocalyptic destruction by Martin; or a vast and dominating figure in a study by Fuseli, absorbing its surroundings like a flame. It may be a frantic figure, crazed with malignant dreams, in a group by Richard Dadd; or the slim figure of a love-lorn girl in a lyrical study by Arthur Hughes. It may be a luxuriant and erotic nude by Etty or Mulready, or a cold and sickly nude by Burne-Jones; an *écorché* by Stubbs or a ballet dancer by A. E. Chalon. Most of all it may be a vision of Man by Blake, for Blake saw in humanity the key of all creation:

> *Thou art a Man, God is no more,*
> *Thy own humanity learn to adore*
> *For that is my Spirit of Life.*[2]

[1] Letter to his biographer, John Knowles, 31 August 1809. Knowles, John, *The Life and Writings of Henry Fuseli*, 1831, I, 297.

[2] *The Everlasting Gospel*: Keynes, 752–53.

That triumphant cry is given visual form in Blake's engraving, "The Dance of Albion"[1] (Plate 15), in which Albion ("Eternal Man", or in some contexts, "England"), in splendid and innocent nudity, dances against a background of clouds and a bursting sun, in accompaniment to the lines:

Albion rose from where he labour'd at the Mill with Slaves:
Giving himself for the Nations he danc'd the dance of Eternal Death.[2]

Albion, in an attitude probably derived from an engraving of the Vitruvian man by Scamozzi,[3] balances on his left foot, which treads on a chrysalis, from which a moth, signifying rebirth, has just escaped. It is thought by some that the whole concept symbolizes the spirit of Man, which, by a sacrifice ("Eternal Death"), is rising above the mundane implications of the Industrial Revolution. That is probably true; but, whatever the context in which it is set, the figure itself symbolizes the Divine Humanity revelling in its own beauty and power. Its open gesture and proud stance are as masterful, as fateful, as the opening bars of Beethoven's Fifth Symphony, or as confident as Blake's vision of the reborn Los (or Urthona) in *Vala or the Four Zoas*:[4]

The Sun arises from his dewy bed, & the fresh airs
Play in his smiling beams giving the seeds of life to grow,
And the fresh Earth beams forth ten thousand thousand springs of life.
Urthona is arisen in his strength, no longer now
Divided from Enitharmon, no longer the Spectre Los.

A back view of the same pose is used by Blake in another of his great conceptions, on plate 76 of the illuminated book, *Jerusalem*, in which Albion stands before Jesus crucified on the Tree of Mystery, or of Knowledge of Good and Evil (Plate 28). By outstretching his arms as if crucified, Albion makes a gesture of sacrifice, far removed from the triumphant pose of "the Dance of Albion". It is a measure of Blake's strength that he is able to convey two such contrasting ideas from the same pose. Part of his success in this lies in his technique. "The Dance of Albion" is realised in black lines, by means of line engraving; in this, ink is forced into the en-

[1] Formerly called "Glad Day".

[2] Keynes, 160. The inscription is not present on all impressions.

[3] This engraving is an illustration in *L'Idea dell' Architettura Universale* by Vincenzo Scamozzi published in 1615. An English translation was published in 1669. [4] Keynes, 379.

graved lines, and then printed by having damp paper pressed on to the plate. In the *Jerusalem* illustration, the plate itself is used as the printing surface, so that the background is printed in colour, with the engraved lines showing white against a coloured background. This gives it a more mysterious and sombre atmosphere than that of the "Dance of Albion", and I feel sure that this is one of the reasons why Blake employed it in this instance; in other words the effect was calculated and not fortuitous. And of course, the design itself, by associating the stance of Albion with the figure of the crucified Jesus, gives a different connotation from the figure in the other engraving. Finally, the back view of the one figure is of different psychological symbolism from the front view of the other. A man comes forward in confidence, and retreats in submissiveness: "I gave my back to the smiters, and my cheeks to them that plucked off the hair; I hid not my face from shame and spitting."[1]

Blake uses the human body to express almost every conceivable nuance of human character and feeling. In his colour prints "Nebuchadnezzar" and "Newton",[2] we have the quintessence of haunted brutishness in the one, and of cold intellect in the other. In the frontispiece of his prophetic book, *Europe*, is a figure, known as "The Ancient of Days" or "God creating the Universe", but really a representation of Urizen creating the material world (Plate 30). This naked kneeling figure of an ancient man reaches, with a pair of dividers in his left hand, from the cloud-encircled orb that contains him, subjecting creation to measurement. Here the human figure is used, as by Michelangelo in the Sistine Chapel, to symbolize an abstract or philosophic idea. Such examples occur throughout Blake's work. But, so far as concerns the expression, through the human figure, of the human psyche, the richest of Blake's work is, appropriately, that which many believe to be his masterpiece, *Illustrations of the Book of Job* (1825; Plate 29). In this, Man, in the person of Job, is shown through a whole gamut of emotions, from initial innocence, developing into experience, and finally in sacrifice of the selfhood, whereby error is cast out and spiritual regeneration attained through the Divine Man in Christ. Everywhere in the Job engravings, Jehovah is shown with Job's own face and form, symbolizing Blake's belief that, throughout creation, Man's spirit is the greatest thing that Man can discern: "Thou art a Man, God is no more."[3]

[1] *Isaiah* L, 6. [2] Tate Gallery. [3] *The Everlasting Gospel*: Keynes, 750.

In contrast with Blake's figures, the nudes of Etty are devoid of all but the crudest symbolism. To compensate for this they have a certain fleshly richness, and some eroticism—desperately little, though, when compared with the works of such great masters of the nude as Titian, Tintoretto or Veronese.[1] Nevertheless, they are truly Romantic in their preoccupation with the nude, present to no such extent in the work of any other British painter. There is also about these nudes, whether they are male or female, a certain innocence, even naïvety. What other artist, for instance, would have shown a reclining nude Magdalen, complete with earrings, contemplating a skull and a crucifix?[2] Etty's paintings may show Cupid and Psyche embracing;[3] a boatload of nudes, "Youth on the prow and Pleasure at the helm", dubbed by Constable "Etty's bum boat";[4] Mars and Venus on a bedizened pleasure boat, drifting on the waters;[5] Hylas and the nymphs,[6] a bacchante, or a warrior. Whatever their subject, their nakedness is less that of a Byronic abandonment than that of an Arcadian innocence (Plate 43). They contain much of that quality mentioned by Calvert: "Giorgione gives innocence to naked figures in golden glades."[7] Notwithstanding this, that they have some eroticism cannot be denied; perhaps its restraint may be accounted for in the supposition that Etty died a virgin.[8]

Yet their cool quality was not always apparent to their conventional contemporaries, many of whom looked upon such pictures as a species of moral degradation. In a sense this may well accentuate their Romantic significance, but it is difficult, at this distance in time, to understand the mentality of a critic in *The Spectator* who described Etty's inoffensive "The Sirens and Ulysses"[9] as "a disgusting combination of voluptuousness and loathsome putridity—glowing in colour and wonderful in execution, but conceived in the worst possible taste".[10] Or the *Times* critic who wrote of

[1] Paolo Caliari, called Paul Veronese (1528–88), Veronese painter, but belonging to the Venetian school.
[2] Victoria and Albert Museum, London.
[3] Lady Lever Art Gallery.
[4] National Gallery.
[5] Lady Lever Art Gallery.
[6] Fairhaven Collection.
[7] *Memoir of Calvert* 120.
[8] cf. Levy, Mervyn, *The Moons of Paradise*, 1962, 95.
[9] Manchester City Art Galleries.
[10] *The Spectator*, 6 May 1837.

"To arms, to arms, ye brave",[1] that "Mr Etty should know better than to paint such nonsense. Here is a parcel of half-naked people struggling and tussling, without any motive, and exposing their persons in a way that calls for the interference of the police."[2] But even Romantics were not always broad minded: Samuel Palmer was careful to keep hidden in an envelope his impression of Calvert's "The Chamber Idyll."[3]

In the context of European painting, Etty is most closely paralleled by Delacroix and Géricault. His work has something of their rich impasto and handling, something of the luxuriousness of their conception; yet his work could be by nobody but an Englishman. There is nothing in it of the violent turbulence so often present in the work of those French masters, nothing of their revolutionary fervour. And though, superficially, we may be reminded of Etty in Delacroix's "Death of Sardanapalus" or in Géricault's "Raft of the Medusa",[4] there runs through his work a cool, northern stream, by which violence is quenched, and replaced by an innocent eroticism, richer and at the same time less intense than that which is present in the early work of his friend, Edward Calvert. Calvert was, in his middle and later years, much influenced by Etty, so much so that some of his work is almost indistinguishable from Etty's;[5] but in his early engravings his originality was complete.

Real eroticism is present in these tiny works; in the line-engraving "The Bride" for instance, where the erotic joins with religious symbolism in giving a further dimension to the meaning of the human body (Plate 5). I will quote a description of this that I wrote some years ago:[6]

A lush pastoral landscape stretches before the eye. The sun has set and the Evening Star shines prominently in the sky at the right. To the right of the centre, in the distance, a shepherd drives his large flock home across the hills. Nearer to us, at the right, a naked shepherd, his crook over his shoulder, a basket in his hand, strides off to take up his night's duties with his flock . . . Beside the path, along which he is walking, some beehives sit peacefully on their

[1] Victoria and Albert Museum.
[2] *The Times*, 4 May 1841.
[3] Letter from A. H. Palmer to F. L. Griggs, 27 July 1923.
[4] The Louvre.
[5] See Lister, Raymond, *Edward Calvert*, 1962, 41–2, pls. XVIII and XLIX.
[6] *Edward Calvert* 76–7.

boards amidst a profusion of flowers and herbs; nearby a group of five trees sway as if dancing together in the gentle evening breeze. A peaceful stream meanders between the hills; it is spanned by a rustic bridge before winding out of sight.

At the left is a pretty rustic cottage with lattice windows, set in a wattle-fenced garden. It nestles into its surroundings, and its domed, thatched roof seems to echo the slope of the hills. Two large trees frame the design, giving the effect of a composition by a Florentine master, one of them richly hung with vines on which bunches of grapes of fantastic size await a hand to pluck them and throw them into the wine press. So rich is one bunch that drops of luscious juice are dripping from it. The central figure, a naked woman of great beauty of form, leads a sheep who looks up at her. The flower-flanked path along which they are walking leads to the cottage. Lettering along the border reads: "O GOD! THY BRIDE SEEKETH THEE. A STRAY LAMB IS LED TO THY FOLDS" . . .

It is as if we are looking into the Garden of Eden before the Fall, or are eavesdropping upon the Song of Songs. "The voice of my beloved! behold, he cometh leaping upon the mountains, skipping upon the hills. My beloved is like a roe or a young hart: . . . My beloved is mine, and I am his: he feedeth among the lilies. Until the day break, and the shadows flee away, turn my beloved, and be thou like a roe or a young hart upon the mountains of Bether."

Yet another, even more brilliant example of the erotic theme appears in Calvert's masterpiece, the little wood engraving "The Chamber Idyll".[1] Here there is nothing of the religious element, but much of the innocent delight of the simple country life, so admired by many Romantics, and as sung by Virgil in the *Eclogues* and *Georgics*. Indeed we may take the last line of the *Eclogues* with which to begin our description: *ite domum saturae, venit Hesperus, ite capellae*: "Get ye home, my full-fed goats—the Evening-star comes—get ye home!"[2] And in their master's rustic home the Chamber Idyll begins:

We are eavesdropping on a moment of idyllic intimacy, the first delicious rapture of a honeymoon. On a rough rustic bed sits a naked shepherd; he has turned back the bed-clothes, and gently pulls his beautiful wife towards him by lightly grasping the translucent dress which has nearly dropped from her comely form. He holds up his face to hers, ready to kiss her. His crook, a sickle and other implements and household utensils hang from beams that frame the composition.

[1] Plate 4. [2] *Eclogue* X, l. 77.

A basket of apples is on the floor, and other apples are scattered about. A bunch of lavender hangs from one beam, and this, with the apples, suggests an atmosphere sweet with the scent of herbs and freshly gathered fruit. Through latticed windows, one of which stands open, for it is late summer, a tree and crescent moon are seen, while a little plant growing in a pot stands on the window ledge.

At the right-hand side of the engraving the cottage stands open to the warm night. A cow and sheep (one of them has a bell on its neck) are peacefully penned, and nearer to us, in a little granary, sheaves of wheat are piled on freshly threshed corn. Beyond is a valley with a path leading through it and flanked with trees. On the horizon a plough is silhouetted against the night sky, in which bright stars shine (they could be part of the Plough constellation). It is a scene of peaceful love before sweet repose, after the labour of harvest and plough.[1]

There is a poignant variation on the theme of "The Chamber Idyll", in the painting "The Eve of Separation" by George Richmond, a friend of Calvert (Plate 44).[2] In this, beneath a waxing crescent moon, and in a fragrant landscape, a young couple embrace. In contrast with the joyfulness of Calvert's engraving, it is a scene of bitter-sweet nostalgia, as tender and as fugitive as a poem by Tom Moore:[3]

> *At the midhour of night, when stars are sleeping, I fly*
> *To the lone vale we lov'd, when life shone warm in thine eye;*
> *And I think oft, if spirits can steal from the regions of air,*
> *To revisit past scenes of delight, thou wilt come to me there,*
> *And tell me our love is remember'd, even in the sky.*

Nobody could doubt that Calvert's view of human sexuality was healthy. But there was another voice of sex that, throughout the Romantic era, tried to make itself heard: homosexual love. Homosexuals had felt, at the time of the French Revolution, that they, too, were entitled to share in the Rights of Man; they regarded themselves as a persecuted minority, and tried to claim a legitimate place in society. The whole artistic output of the Romantic era teems with homosexual accents, both disguised and apparent. In Matthew Gregory Lewis's *The Monk*, for instance, there occurs a passage of great tenderness, between Rosario, a novice, and the monk, Ambrosio.

[1] *Edward Calvert* 87–8.
[2] Ashmolean Museum.
[3] "At the Mid Hour of Night" from *Irish Melodies* (1807–35).

It is true that the novice turns out to be a woman, Matilda, in disguise; but that does not alter the fact that Ambrosio was willing to show such tenderness to one whom he believed to be a youth.[1] A similar device was used many years later in the novel, *The Desire and Pursuit of the Whole* by Frederick Rolfe, Baron Corvo,[2] a known pederast. Lewis was himself a homosexual, and had many affairs, of which the most passionate was with the fourteen-year-old William Martin Kelly, son of the novelist, Mrs Isabella Kelly.[3] William Beckford, too, was a pederast; but he had also a mistress—his cousin's wife, Louisa Beckford, whom he quickly made his ally in adventures of perversion. "We will," he told her, "lie in wait for souls together." And she called him her "lovely infernal". Romney painted her portrait, sacrificing, appropriately, "to the Goddess of the Underworld."[4]

Many twists and turns are given to the subject, from the pederasty of Grant's "Master Fraser" (Plate 9) to the Lesbianism, flagellation, transvestism and incest of Swinburne's almost unreadable fragmentary novel, *Lesbia Brandon*.[5] Lesbianism is inherent in that strange picture by Fuseli, "The Succubus,"[6] in which two naked women are couched together, while the Succubus flies through the window on a hell-steed (Plate 18). Apart from the fact that two women are bedded together in some abandon, the very title gives the clue to the meaning of the work. The Succubus is a demon in *female* shape which couples with men in their sleep; the male demon is an Incubus.

There is much pederasty in Pre-Raphaelite painting, which forms a kind of envoy to the Romantic movement. It is present in Walter Crane's *The Renaissance of Venus*[7] for example, in which a boy was used as a model for the central figure; although here the homosexual element is probably fortuitous, as Crane's wife would not allow him to use female models, and he had perforce to use a boy, an Italian named Alessandro di Marco. No doubt Crane did his best to transform Alessandro into a woman, but his Venus nevertheless has a strangely masculine beauty.

[1] *The Monk*, I, ch. ii.
[2] Published posthumously in 1934.
[3] Summers, *Gothic Quest*, 263–67 and *passim*.
[4] Lady Lever Art Gallery.
[5] It was first published in 1952.
[6] Kunsthaus, Zürich. See p. 47, n. 3. [7] Tate Gallery.

There is much feeling of pederasty in Burne-Jones's paintings: "Phyllis and Demophoön",[1] "Garden of Pan",[2] and "The Feast of Peleus"[3] come to mind immediately. But strangest of all are Burne-Jones's boyish women, as in "Pygmalion and the Image: the soul attains",[4] "Pan and Psyche",[5] "The Three Graces";[6] and especially in "Perseus slaying the Serpent"[7] (Plate 46), in which a willowy Andromeda stands with her back towards us with long slender legs and small, boyish buttocks. Such accents must owe something to the supple ephebes drawn by the Pre-Raphaelites' Nazerener predecessors, Olivier and Schnorr,[8] or those in Romantic pictures like Joseph Severn's "Ariel"[9] (Plate 97), Girodet's "Endymion"[10] and Gérard's "Cupid and Psyche".[11]

Simeon Solomon's paintings, such as "The Singing of Love" (Plate 48) and "Night of Sleep",[12] are completely homosexual in conception and expression: "The lips are scarcely roughened to indicate a man, the throats scarcely lengthened to indicate a woman."[13] They form one of the closest parallels in English art to the work of Gustave Moreau,[14] in which "lovers look as though they were related, brothers as though they were lovers, men have the faces of virgins, virgins the faces of youths; the symbols of Good and Evil are entwined and equivocally confused. There is no contrast between different ages, sexes, or types: the underlying meaning of this painting is incest, its most exalted figure the Androgyne, its final word sterility."[15] It is as if we are reading a prophecy of those strange, sad young boys, the "kytais" of Singapore, who with the help of glycerine breasts,

[1] City Museum and Art Gallery, Birmingham.

[2] Whereabouts unknown. Reproduced in Cecil, David, *Visionary and Dreamer*, Washington, 1969, pl. 100.

[3] City Museum and Art Gallery, Birmingham. [4] ibid.

[5] Fogg Art Museum, Harvard University, Cambridge, Mass.

[6] City Art Gallery, Carlisle. [7] Southampton Art Gallery.

[8] Friedrich Woldemar Olivier (1791–1859); Julius Schnorr von Carolsfeld (1794–1872); German painters.

[9] Victoria and Albert Museum.

[10] The Louvre. [11] ibid.

[12] City Museum and Art Gallery, Birmingham.

[13] Symonds, A., *From Toulouse-Lautrec to Rodin*, 1929, 151.

[14] Gustave Moreau (1826–98), French painter.

[15] Praz, Mario, *The Romantic Agony* (trans. Angus Davidson), 2nd ed., 1954, 290–91. Reprinted by permission of Oxford University Press.

make-up, and injections of female hormones, become transformed into a twilight sex, and work as prostitutes.[1]

But the androgyne has another side in psychology and art, symbolizing Man in his unfallen state, in his undivided spiritual body, or as an archetype of the collective unconscious,[2] in which Man's bisexual nature should exist in harmony: "God created man, in the likeness of God made he him; Male and female created he them."[3] At first Adam was androgynous, but later, when Eve was born, his female portion was separated from him, and this marked a stage in the Fall. And because Adam was made in God's image, God in His unity must be androgynous. His two sexes are manifest throughout Creation, but are ever attempting to re-unite, so that Man may again, and finally, regain the complete androgynous state. It is a state that was for a brief earthly moment manifest in Jesus, "the second Adam", when, during the crucifixion, he received the wound in His side. This wound symbolized the female genitals, and it was through this that Christ, in the view of some Romantics, gave symbolic birth to the Mother Church.

It will be seen from the foregoing that the androgyne is different in quality from the hermaphrodite. The hermaphrodite is a being with the organs of both sexes, and symbolizes a warring and unreconciled state; or is like Satan in Blake's *Illustrations of the Book of Job*, who, in his nakedness, stands smiting Job with boils, his own genitals missing and his loins grown over with saurian scales (Plate 29). Here indeed is

> *a Vast Hermaphroditic form*
> *Heaving like an Earthquake lab'ring with convulsive groans*
> *Intolerable; at length an awful wonder burst*
> *From the Hermaphroditic bosom. Satan he was nam'd,*
> *Son of Perdition, terrible his form, dishumaniz'd, monstrous,*
> *A male without a female counterpart, a howling fiend*
> *Forlorn of Eden & repugnant to the forms of life,*
> *Yet hiding the shadowy female Vala as in an ark & Curtains,*
> *Abhorr'd, accursed, ever dying an Eternal death,*
> *Being multitudes of tyrant Men in union blasphemous*
> *Against the Divine image, Congregated assemblies of wicked men.*[4]

The androgyne was, particularly in the second half of the nineteenth

[1] *The Sunday Times*, 22 November 1970, 11.

[2] Jung. C. G. *Psychology and Alchemy*, 1953, 289n, 319n, 333, 443 and *passim*.

[3] *Genesis* V, 1–2. [4] *Vala or the Four Zoas*: Keynes, 347.

century, used also to symbolize perversions: homosexuality, sadism, masochism, demoniality, incest and onanism. It was, in this context, not far removed from Walter Pater's description of Leonardo's "Head of St. John the Baptist", "—one of the few naked figures Leonardo painted—whose delicate brown flesh and woman's hair no one would go out into the wilderness to seek, and whose treacherous smile would have us understand something far beyond the outward gesture or circumstance."[1] Something of that quality is present in the face of Grant's "Master Fraser" (Plate 9), although one must make considerable allowance for the fact that Grant's artistic power compared with Leonardo's is of about the same magnitude as a candle compared with the sun.

The androgyne may be seen also, as it is equally male and female, as a symbol of female emancipation, a matter that occupied the minds of many Romantics, although many women would have gone further and demanded absolute dominion over man. As a corollary to this, Romanticism provides a niche also for the passive man who yields in love to a woman who dominates him in the sexual act, as in certain erotic drawings by Fuseli.[2] The passive man may even invert his male impulses completely, yielding to his mistress, who may be a *femme fatale*, or a sadistic virago like Fuseli's woman with a switch,[3] or the giantess in his picture, "The Fireplace"[4] (Plate 21): which returns us to the chained hero Prometheus and the eagle eternally devouring his liver.

Prometheus: the naked hero. He is the gigantic Christ in Michelangelo's Last Judgement; the crucified Jesus; St Sebastian impaled by arrows on his tree; Blake's Fuzon, in *The Book of Ahania*, nailed "on the accursed Tree of Mystery";[5] David Scott's "Philoctetes left in the isle of Lemnos by the Greeks."[6] And the naked hero symbolizes the Divine Man, attacked or forsaken by the gods: Marsyas flayed; St Erasmus disembowelled; St Lawrence roasted; prostitutes flogged in the pillory; patients undergoing unanaesthetised operations.[7]

[1] *The Renaissance*: "Leonardo da Vinci".
[2] See Todd, Ruthven, *Tracks in the Snow*, 1946, pl. 24.
[3] Kunsthaus, Zürich. [4] Collection of Brinsley Ford Esq.
[5] Keynes, 252. [6] National Gallery of Scotland.
[7] Keats doubtless witnessed such operations when he was a medical student. He may have immortalized the sufferings of the patients in the torments of the Titans in *Hyperion*. See Gittings, Robert, *John Keats*, 1968, 50.

But the Divine Man will be unbound and Albion will dance the dance of Eternal Death in England's green and pleasant land. The Romantic, through the investigation of the minute particulars of the human psyche; through normality and abnormality; through Man in all his aspects, spiritual and physical; through all of these he endeavours to show Man his true destiny:

> *All Human Forms identified, even Tree, Metal, Earth & Stone: all Human Forms identified, living, going forth & returning wearied Into the Planetary lives of Years, Months, Days & Hours: reposing, And then Awaking into his Bosom in the Life of Immortality.*[1]

[1] Blake, *Jerusalem*: Keynes, 747.

The Visionary Universe

. . . Believe thou, O my soul,
Life is a vision shadowy of Truth;
And vice, and anguish, and the wormy grave,
Shapes of a dream! The veiling clouds retire,
And lo! the Throne of the redeeming God
Forth flashing unimaginable day
Wraps in one blaze earth, heaven, and deepest hell.
 Coleridge, *Religious Musings*[1]

AS with other aspects of Romanticism, so with vision: each man's vision is, or should be, his own. "As a man is, So he Sees," remarked Blake to a worldly parson.[2] Vision, in this sense, has no necessary connexion with the supernatural or with hallucinations. There are, in Romantic art, dream paintings, occult paintings, even fairy paintings; these may, I suppose, be classed as visionary art and have a place in our discussion. But vision — artistic vision, Romantic vision, religious vision, humanist vision—is something different. It is the ability of a man, through his own psyche, to see the truth, the essential in all things. Modern jargon calls it eidetic imagery. It is something literally seen by the beholder, but not actually present in a physical sense; the artist paints it, thus enabling the beholder to see what he has seen.

Gerard Manley Hopkins, with a greater sense of style, called this essential content, "inscape" and "instress". The inscape of a thing is its "oneness", what the medieval philosopher Duns Scotus called "thisness", or, in Hopkins's own words, "the very soul of art".[3] But it is also something personal to its observer, something experienced by A and not by B. One man may see a tree, and see nothing but bark, moss, wood and leaves;

[1] "A desultory poem, written on the Christmas Eve of 1794". *The Poetical and Dramatic Works of Samuel Taylor Coleridge*, 1880, I, 108.

[2] Letter to Dr John Trusler: Keynes, 793.

[3] Abbott, Claude Colleer (ed.), *The Correspondence of Gerard Manley Hopkins and Richard Watson Dixon*, 1955 (revised edn.), 135.

another man, like Palmer, sees "the grasp and grapple of the roots, the muscular belly and shoulders, the twisted sinews"[1]—the tree's inscape, according to Palmer. Similarly, Blake was conscious of the inscape of a thistle:

> *With my inward Eye 'tis an old man grey;*
> *With my outward, a Thistle across my way.*[2]

Instress is the sensation induced by inscape, an illumination as it were: "But such a lovely damasking in the sky today I never felt before. The blue was charged with simple instress."[3] It is a species of ecstasy, akin to Blake's "fourfold vision", the summit of human perception, with each sense fully alert and participating:

> *Now I a fourfold vision see,*
> *And a fourfold vision is given to me;*
> *'Tis fourfold in my supreme delight*
> *And threefold in soft Beulah's night*
> *And twofold Always. May God us keep*
> *From Single vision & Newton's sleep!*[4]

Briefly, the single vision, from which Blake prayed to be kept, is purely unimaginative "physical" vision—if such it can be called; twofold vision is the level at which human value may be perceived in all things; threefold vision is the level at which artistic creation and sexual ecstasy are reached—"soft Beulah's night", being a

> *. . . mild & pleasant rest*
> *Nam'd Beulah, a soft Moony Universe, feminine, lovely,*
> *Pure, mild & Gentle . . .*[5]

Highest of all is the "supreme delight" of fourfold vision, which is akin to religious ecstasy, so intense as to be insupportable for an extended period, causing the visionary quickly to fall back for relief into the threefold vision of Beulah:

[1] Palmer, A. H., *Life and Letters of Samuel Palmer*, 174.

[2] Letter to Thomas Butts: Keynes, 817.

[3] *Journals and Papers of Gerard Manley Hopkins* (ed. Humphrey House and Graham Storey), 1959, 207. Reprinted by permission of Oxford University Press, by arrangement with the Society of Jesus.

[4] Letter to Butts: Keynes, 818.

[5] *Four Zoas*: Keynes, 266.

But others of the Sons of Los build Moments & Minutes & Hours
And Days & Months & Years & Ages & Periods, wondrous buildings;
And every Moment has a Couch of gold for soft repose,
(A Moment equals a pulsation of the artery),
And between every two Moments stands a Daughter of Beulah
To feed the Sleepers on their Couches with maternal care.
And every Minute has an azure Tent with silken Veils:
And every Hour has a bright golden Gate carved with skill:
And every Day & Night has Walls of brass & Gates of adamant,
Shining like precious Stones & ornamented with appropriate signs:
And every Month a silver paved Terrace builded high:
And every Year invulnerable Barriers with high Towers:
And every Age is Moated deep with Bridges of silver & gold:
And every Seven Ages is Incircled with a Flaming Fire.
Now Seven Ages is amounting to Two Hundred Years.
Each has its Guard, each Moment, Minute, Hour, Day, Month & Year.
All are the work of Fairy hands of the Four Elements:
The Guard are Angels of Providence on duty evermore.
Every Time less than a pulsation of the artery
Is equal in its period & value to Six Thousand Years,
For in this Period the Poet's Work is Done, and all the Great
Events of Time start forth & are conciev'd in such a Period,
Within a Moment, a Pulsation of the Artery.[1]

As the writings of some of the well-known mystics indicate, it is usually difficult—nay, impossible—for the mystic to convey to another person the essence of his experience. It is therefore of tremendous interest and importance when such experiences are described and illustrated by a man like Blake, who was one of the only great artists to speak much about his work.[2] He was not only a poet-painter, but a poet-painter-philosopher, whose philosophy embraced aesthetics, art technique, and psychology.

In view of the range and brilliance of Blake's mind, it is a little odd to find some people still adhering to the idea that he was mad. Nikolaus Pevsner, for instance, in his book *The Englishness of English Art* makes some curiously inaccurate statements about Blake, and writes of "the uncomfortable closeness of some of his graphic work to the art of the insane".[3] But then, in fairness, it must be admitted that Blake is so peculiarly English,

[1] *Milton*: Keynes, 516.
[2] cf. Malraux, André, *The Voices of Silence*, 1954, 346–47.
[3] Peregrine edn., 1964, 149.

that it is sometimes difficult for others to appreciate him. Blake's visionary work is not conceived from the vision of insanity. It is, on the other hand, conceived from the vision of an unusually intelligent man, who probed and touched the heartstrings of human nature, and then expressed it in paintings, poetry and prophecies, endeavouring to provide Man with a framework, within which his "Eternal Great Humanity Divine"[1] might be realized, as it once had been before, in "England's green and pleasant Land".[2] The Holy Lamb of God was seen in England's pleasant pastures, because Ancient Man, or Albion, partook of the divine nature of Jesus; therefore Jesus, the Holy Lamb of God, appeared here in Albion, and, by virtue of that fact, Jerusalem, the spiritual holy city, was built here too. This idea is given visual form in the engraving which appears on plate 76 of *Jerusalem*, with, as we have already seen, Albion standing in a sacrificial posture before Jesus (Plate 28). And, the sacrifice of selfhood having been made, the Daughters of Albion will dance in joy with him on the chalk hills and in the beech groves and orchards of England, as in Calvert's visionary wood-engraving of the Cyder Feast (Plate 3):

> *And all the daughters of the year shall dance!*
> *Sing now the lusty song of fruit and flowers.*[3]

Indeed Blake's whole visionary outlook was conditioned by England: "All things begin and end in Albion's Druid Rocky Shore."[4] Addressing Spring, he sang, "turn Thine angel eyes upon our western isle",[5] thus symbolizing a mystical westering of the spirit towards its home, the return of the Lamb of God to the English Jerusalem, where Jesus will overcome Druidic error in Albion's breast:

> *England! awake! awake! awake!*
> *Jerusalem thy Sister calls!*
> *Why wilt thou sleep the sleep of death*
> *And close her from thy ancient walls?*

> *Thy hills & valleys felt her feet*
> *Gently upon their bosoms move:*
> *Thy gates beheld sweet Zion's ways:*
> *Then was a time of joy and love.*

[1] *Milton*: Keynes, 481. [2] ibid.
[3] *Poetical Sketches*: Keynes, 2. [4] *Milton*: Keynes, 486.
[5] *Poetical Sketches*: Keynes, 1.

> *And now the time returns again:*
> *Our souls exult, & London's towers*
> *Recieve the Lamb of God to dwell*
> *In England's green & pleasant bowers.*[1]

More than any other English artist, Blake can powerfully express what it is like to experience illumination, to perceive the world through twofold, threefold and fourfold vision. This is shown especially in the little wood engravings he made to illustrate the First Eclogue in Thornton's *Virgil* (Plate 31), in which the landscape is transformed, in the words of his friend Samuel Palmer, into "visions of little dells, and nooks, and corners of Paradise . . . They are like all that wonderful artist's works the drawing aside of the fleshly curtain, and the glimpse which all the most holy, studious saints and sages have enjoyed, of that rest which remaineth to the people of God."[2] Yet they are uncomplicated, even crude; but they are also intense and poignant. "They are done", said Edward Calvert, "as by a child; several of them careless and incorrect, yet there is a spirit in them, humble enough and of force enough to move simple souls to tears."[3]

The Virgil engravings are nevertheless but one aspect of Blake's work, almost the whole range of which is visionary,[4] from the imaginative portraits which he drew for his friend John Varley, to such titanic conceptions as "The Ancient of Days", "The Dance of Albion", and the frontispiece to his prophetic book, *America* (Plates 30, 15 and 27).

The imaginary portraits, or "visionary heads", are a series of portraits of historical characters Blake made at night, in the presence of the literal-minded Varley, who sat straining his eyes to see the "visitors". But they are on an entirely different level from his truly visionary work, and were probably executed with his tongue in his cheek. He hinted how such "visions" came to him, during a conversation with a lady whom he had met at a party. "The other evening," he said, "taking a walk, I came to a meadow and, at the farther corner of it, I saw a fold of lambs. Coming nearer, the ground blushed with flowers; and the wattled cote and its woolly tenants were of an exquisite pastoral beauty. But I looked again, and

[1] *Jerusalem*: Keynes, 718.

[2] Palmer, *Life and Letters*, 15–16.

[3] Calvert, *Memoir*, 19.

[4] I write here of his original work; not of the many "journeyman" engravings after other artists, which provided him with most of his income.

it proved to be no living flock, but beautiful sculpture." "I beg pardon, Mr Blake," said the lady, "but *may* I ask *where* you saw this?" "*Here*, madam", said Blake, placing his finger on his forehead."[1] Blake is at some pains to repudiate this kind of "vision", when he writes:

A Spirit and a Vision are not, as the modern philosophy supposes, a cloudy vapour, or a nothing: they are organized and minutely articulated beyond all that the mortal and perishing nature can produce. He who does not imagine in stronger and better lineaments, and in stronger and better light than his perishing and mortal eye can see, does not imagine at all. The painter of this work asserts that all his imaginations appear to him infinitely more perfect and more minutely organized than any thing seen by his mortal eye.[2]

Such vision could inspire work like the frontispiece to *America, a Prophecy*, which Blake published in 1793. This engraving shows a colossal winged figure, chained and seated in a breached wall, its great head sunk in despair between its knees; at one side sits a sorrowful nude woman, embracing her children; broken weapons, remnants of a battle, lie around. It is uncertain what, if anything, in the Prophecy, the plate illustrates, but it is thought that these lines, spoken by Orc, might be related to it:

Let the inchained soul, shut up in darkness and in sighing,
Whose face has never seen a smile in thirty weary years,
Rise and look out; his chains are loose, his dungeon doors are open;
And let his wife and children return from the oppressor's scourge.[3]

Whatever may be the truth of this, the engraving does combine the Romantic concepts of the chained and naked hero (the main figure), pathetic humanity (the woman and children), revolt (the breached wall, the broken weapons), and fate (the threatening clouds louring above the scene). It is Blake's vision of humanity's *Sturm und Drang*, his visionary warning of what contemporary trends in human behaviour could lead to, indeed had led to, in the American War of Independence. Few artists have equalled Blake's gift of compressing so much earth-shaking human grandeur into a space of a few square inches. Such conceptions occur throughout his prophetic books, which together present a wide-ranging interpretation of the turbulence of the human soul.

[1] Gilchrist, Alexander, *Life of William Blake* (Everyman ed.), 1942, 317.
[2] Keynes, 576–77. [3] Keynes, 198.

Beside them, the visionary work of such artists as Alexander Runciman, Fuseli, and Thomas Young Ottley is shallow; but they, too, have their place here, even if their vision is usually twofold, rarely threefold, and hardly ever fourfold.

Ottley was, and is, best known for his facsimiles of old-master drawings and engravings. But he also made a set of visionary aquatints of subjects from the Book of Genesis,[1] some of which are so close to Blake's work (though inferior to it) that it seems likely that Ottley was acquainted with it (Plate 51).[2] Runciman, some of whose visionary work possesses strength, almost certainly influenced the work of Fuseli, whom he had known in Rome, although so close are the conceptions of some of their works, that it is difficult to be sure who has influenced whom. Some of the best of Runciman's work is contained in his few etchings,[3] especially in his Ossianic plate of Cormar attacking the Spirit of the Waters (Plate 52).

Fuseli's vision is to a small extent like Blake's, in that it probes the inner world of man. But it is much more limited; Blake embraces the whole of that world, Fuseli only a fraction of it, and that fraction is pathological. To take an example, Blake saw Promethean man as a symbol of defiance; in Fuseli's work, Prometheus becomes a prostrate woman, with a malignant goblin seated on her chest and a hell-steed glaring at her through a parted curtain.[4]

Another contrast between the two artists lies in their attitude towards sexual freedom. Blake's personages are urged to sacrifice selfhood and to embrace sexual liberty, "in lovely copulation, bliss on bliss."[5] Fuseli's personages are wanton, self-indulgent, cynical, perverted: Titian's heterosexual "Venus and the organ-player"[6] is used by Fuseli to provide the composition for a picture, full of Lesbian overtones, of a nude woman listening to a girl playing upon a spinet[7] (Plate 22). The spinet-player is a

[1] See Appendix I.

[2] It is known that Ottley and Blake met in 1827, and Sir Geoffrey Keynes thinks that Ottley's work seems to have influenced Blake. Certainly it would be surprising if there was no influence in one or other direction. See Keynes, Sir Geoffrey, *Blake Studies* (new edn.), Oxford, 1971, 219.

[3] See Appendix II.

[4] "The Nightmare", Plate 19.

[5] *Visions of the Daughters of Albion*: Keynes, 195.

[6] The Prado, Madrid. [7] Offentliche Kunstsammlung, Basel.

sinister figure, with her hair dressed so as to give the impression of a pre-
datory animal, a fox perhaps, or a praying mantis. Considerable emphasis is
placed on the hands of the two figures, and one could imagine those of the
musician playing over the erogenic zones of the luxuriant form of her
companion, exciting desire as skilfully as she extracts music from her
instrument.

In the "Nursery of Shakespeare"[1] (Plate 23), there is a certain malig-
nancy, particularly noticeable in the figure of Comedy, with her evil smile
and cruel hands, holding captive a fluttering butterfly, which she is using
to amuse the baby dramatist. There is also a curious sexual accent in this
figure, for she is fondling her bare left breast with her fingers, as if titillat-
ing herself. She appears to be deriving some perverse pleasure, both from
the cruelty she is inflicting on the beautiful insect, and from her gesture,
which imitates that of Tragedy, who holds her nipple to the infant's mouth.

Truly, there is something both unpleasant and unhealthy about Fuseli's
vision, powerful though some of it is. Erasmus Darwin recognised this, as
his lines on Fuseli's "Nightmare" will show:[2]

> *So on his NIGHTMARE through the evening fog*
> *Flits the squab Fiend o'er fen, and lake, and bog;*
> *Seeks some love-wilder'd Maid with sleep oppress'd,*
> *Alights, and grinning sits upon her breast.*
> *—Such as of late amid the murky sky*
> *Was marked by FUSELI'S poetic eye;*
> *Whose daring tints, with SHAKESPEAR'S happiest grace,*
> *Gave to the airy phantom form and place.—*
> *Back o'er her pillow sinks her blushing head,*
> *Her snow-white limbs hang helpless from the bed;*
> *While with quick sighs, and suffocative breath,*
> *Her interrupted heart-pulse swims in death.*
> *—Then shrieks of captur'd towns, and widows' tears,*
> *Pale lovers stretch'd upon their blood-stain'd biers,*
> *The headlong precipice that thwarts her flight,*
> *The trackless desert, the cold starless night,*
> *And stern-eyed Murderer with his knife behind,*
> *In dread succession agonize her mind.*
> *O'er her fair limbs convulsive tremors fleet,*
> *Start in her hands, and struggle in her feet;*

[1] Courtauld Institute of Art, London.
[2] *The Botanic Garden*: "The Loves of the Plants", Canto III, l. 51.

[86]

In vain to scream with quivering lips she tries,
And strains in palsy'd lids her tremulous eyes;
In vain she wills to run, fly, swim, walk, creep;
The WILL presides not in the bower of SLEEP.
—On her fair bosom sits the Demon-Ape
Erect, and balances his bloated shape;
Rolls in their marble orbs his Gorgon-eyes,
And drinks with leathern ears her tender cries.

There is in Romantic art a visionary aspect of "normal" sexuality, as is illustrated by Calvert's "Chamber Idyll", "The Bride" and "The Cyder Feast" (Plates 4, 5 and 3). That Blake was aware of it is apparent throughout his *oeuvre*: there it is as definite as in the symbolism of the Hindus, who have for ages perceived in *mithuna*, or the mingling of lovers in copulation, a means of brief, but true ecstatic union with the divine. But this is, in Fuseli's work, inverted into a kind of Satanism. His contemporaries were aware of this side of Fuseli's own character. Benjamin Robert Haydon wrote of him in his diary:

> The Engines in Fuzeli's Mind are Blasphemy, Lechery, and blood. His women are all whores, and men all banditti. They are whores not from a love of pleasure but from a hatred, a malignant spite against virtue, and his men are villains not from a daring desire of risk, but a licentious turbulence of moral restraint; with the look of demons, they have the actions of galvanized frogs, the dress of mountebanks, and the hue of pestilential disease. Such a monstrous imagination was never propagated on lovely women. No. Fuzeli was engendered by some hellish monster, on the dead body of a speckled hag, some hideous form, whose passions were excited & where lechery was fired at commingling with fiery rapture in the pulpy squashiness of a decaying corpse.[1]

Allowance must be made for Haydon's hysterical character, but Fuseli's work certainly often gives an uncomfortable feeling; and it is therefore not surprising that, as a man, he impressed many of his contemporaries

[1] Pope, Willard Bissell, *The Diary of Benjamin Robert Haydon*, Cambridge, Mass., 1960, I, 488–89 (3 December 1815). Earlier, on 7 December, 1808, Haydon had written of Fuseli "I do not know any body I feel a greater affection or reverence for"; but on 27 November 1815, he added this footnote to the entry: "I have since found Fuzeli a Traitor—mean, malicious, cowardly & debauched." ibid. 38.

unfavourably. On the other hand the percipient Blake liked him, did not doubt his goodness, and admired his work. To the critic Robert Hunt, he wrote this epigram:[1]

> *You think Fuseli is not a Great Painter. I'm Glad:*
> *This is one of the best compliments he ever had.*

Occasionally Fuseli painted quietly poetic work like "'Women of Hastings",[2] with its dancing and billowing forms, and his beautiful "Solitude in twilight"[3]—reminiscent of Richmond's "Eve of Separation" (Plate 44)—with its crouching figure, asleep against a sky containing a waxing moon, with a tiny moth for companion. Here, for once, Fuseli has cast aside erotic fantasies, and allowed this dreamy figure to show another face of Romanticism, a mood akin to the nostalgia of Field's nocturnes,[4] of Moore's *Irish Melodies*—even of Blake's threefold vision of Beulah. Perhaps the moth symbolizes the higher perfection released from its chrysalis by the sleeper's dreams.

Dreams figure large in Romantic visionary art. One aspect we have seen in Fuseli's "Nightmare". In literature, Walpole's *Castle of Otranto* originated in a dream; Coleridge's *Kubla Khan* took shape in an opium dream; De Quincey wrote of his dreams in his *Confessions of an English opium eater* (1822); and the dream as a literary device was widely used. Some of the imagery is memorable and packed with visionary experience:

> The fifth canto of Dante pleases me more and more—it is that one in which he meets with Paolo and Francesca. I had passed many days in rather a low state of mind, and in the midst of them I dreamt of being in that region of Hell. The dream was one of the most delightful enjoyments I ever had in my life. I floated about the whirling atmosphere as it is described with a beautiful figure to whose lips mine were joined, as it seemed for an age—and in the midst of all this cold and darkness I was warm—even flowery tree tops sprung up and we rested on them sometimes with the lightness of a cloud, till the wind blew us away again. I tried a Sonnet upon it—there are

[1] Ms. note-book 1808–11. Keynes, 538. Hunt was art critic for Leigh Hunt's *Examiner*. He severely criticised an exhibition of Blake's, and Blake assumed that he had written also an earlier article attacking Fuseli. ibid. 911.

[2] Private collection, Zürich.

[3] ibid.

[4] John Field (1782–1837), Irish composer.

fourteen lines but nothing of what I felt in it—O that I could dream it every night.[1]

Something similar occurs in the paintings of John Austen Fitzgerald, although the content varies considerably, and a certain crudity of invention is frequently mixed with some genuinely dream-like passages. Several of his pictures are conceived on a repeated theme—a sleeping figure surrounded by the imagery of his dreams. This imagery contains goblins and monsters, some of which are worthy of the inventiveness of a Bosch[2] or a Brueghel,[3] while others are merely comic, or reminiscent of Richard Doyle's elves on the old cover of *Punch*; sometimes there are lovers, ghosts, dragons, knights or fairies. There is, too, eroticism and sadism, curiously reminiscent of that which is present in the *oeuvre* of Fitzgerald's contemporary, Gustave Moreau. These are evident in one of Fitzgerald's most powerful works, "The Chase of the White Mice"[4] (Plate 56), a small painting (10 by 18 inches), as minutely and delicately painted as a miniature, in which a mouse is being hunted, baited and chivvied by a crowd of malignant fairies, armed with thorns. The elemental little people are beautiful, decked with flowers and berries, and butterfly and dragonfly wings, coruscating with light and colour. One of them is mounted on a bird, itself crested with berries, its feathers delicate and soft, yet with eyes as beady and cold as a snake's, and a beak as hard and cruel as steel. It is all very disturbing and frightening, but most perturbing is the apparently childlike innocence on the faces of two of the fairies, those who are wielding their thorns with the greatest energy. It is an evocation of that infantile destructiveness and sadism which will dismember a favourite doll or pull the wings from a living fly. In its way, this painting is as haunting as Fuseli's "Nightmare" (Plate 19).

Similar elements appear in paintings by Daniel Maclise, Sir Joseph Noël Paton, Edward Hopley, R. Huskisson, and, most powerful of all, in those of the mad painter, Richard Dadd, whose "The Fairy Feller's Master Stroke"[5] (Plate 54) is one of the strangest and most malignantly menacing

[1] Keats, letter to George and Georgiana Keats, 16 April 1819. Rollins, *Letters of John Keats*, II, 91.

[2] Hieronymus Bosch (*c.* 1462–1516), Dutch painter.

[3] Pieter Brueghel the younger (1564–1637), Flemish painter.

[4] Collection of K. J. Hewett, Esq.

[5] Tate Gallery.

paintings of the Romantic era. It is painted even more minutely than Fitz-gerald's "Chase", and it is easy to believe the tradition that it occupied the painter for nine years.

The scene is set behind a tangle of grass stems, and contains dozens of tiny figures, each only two or three inches high, some very much less: images from the schizophrenic mind of their poor demented creator. It is impossible, in the space at our disposal, to make a minute analysis of the possible meaning of this strange scene; even if we did, we could not be confident of its accuracy. But obviously, everything hinges on the central figure with uplifted hammer, about to smash a nut that lies on the ground in front of him.[1] Perhaps, as the picture took so long to paint, there is a whole series of symbols, each little group of figures having its own inner meaning. Powerful it certainly is, a deep and alarming view from a frantic mind, in which dreams and reality are inextricable. It is visionary, but it is diseased vision. This is evident in almost every figure, especially in the two ballerina-like women with their vast calves and arrogant faces; in the man, with his hands on his knees, to the right of the main hammer-wielding figure, with his expression of crazed concentration; in the personage, im-mediately above the main figure, with its subnormal insectile face; and in the little old man with a beard, his eyes haunted with horror, looking at the nut which is about to be cracked. Many of the faces in Dadd's picture could be paralleled among the subjects of photographs of maniacs, in the book *Mad Humanity* by L. Forbes Winslow (1898), itself a product of the Romantic attitude; or in that frightening portrait of mad John Clare, painted in 1844 by Thomas Grimshawe[2] (Plate 55). Indeed, "The Fairy-Feller's Master Stroke" forcibly illustrates the truth of Charles Lamb's exclamation: "Dream not Coleridge, of having tasted all the grandeur and wildness of fancy till you have gone mad!"[3]

Madness apart, there was in the Romantic era a general tendency to hysteria. In March 1803, at Covent Garden, Mrs Litchfield recited a mono-drama, *The Captive* by "Monk" Lewis, in which is depicted, on the verge of madness, a prisoner chained in a dungeon. Not only did two members

[1] According to one theory, the figures are under a spell, from which they will be released when the nut is cracked. Reynolds, Graham, *Victorian Painting*, 1966, 40.

[2] Northampton Public Library.

[3] *Letters of Charles Lamb*, 1917, I, 16.

of the audience plunge into fits of hysteria, but the actress herself almost fainted with self-induced horror. So violently did terror run through the audience, that the performance was never repeated in London.[1]

The fascination of madness persisted; it was another aspect of individuality, and the Romantic wanted badly to know how the madman's mind worked, how he looked at things, what hallucinations he experienced, what he looked like. James Ward once painted a mad lead-miner in Derbyshire;[2] Gilbert White wrote a description of a demented boy living at Selborne, who caught bees, removed their stings, and sucked their bodies, "for the sake of their honey bags";[3] and there were mad poets like Cowper and Clare:

> *I am—yet what I am none cares or knows,*
> *My friends forsake me like a memory lost;*
> *I am the self-consumer of my woes,*
> *They rise and vanish in oblivious host,*
> *Like shades in love and death's oblivion lost;*
> *And yet I am . . .*[4]

Not far removed from dreams of madness are those induced by opium, a drug widely used among Romantics, especially poets. Sometimes the dreams were incoherent or abstract:

> *a dusky light—a purple* flash
> *crystalline splendor—light blue—*
> Green *lightnings—*
> *in that eternal and delirious misery*
> *wrath fires—*
> *inward desolations*
> *an horror of great darkness*
> *great things—on the ocean*
> *counterfeit infinity—*[5]

Sometimes they were sad or tragic, sometimes horrific, sometimes splendid; but sometimes they were ghastly visions of rotting corpses, vampires and

[1] Summers, *The Gothic Quest*, 262.

[2] *A Descriptive Catalogue of pictures painted by James Ward, Esq., R.A. now exhibiting at No. 6 Newman Street*, 1822.

[3] *Natural History of Selborne*, Letter xxvii.

[4] "I am" by John Clare. The poem was written in Northampton Asylum, and was published in 1865 in *The Life of John Clare* by F. Martin.

[5] Samuel Taylor Coleridge, *Gutch Memorandum Book*, 1795–98.

putrefying giants.¹ Southey records in his commonplace book: "Laudanum visions. I saw last night one figure whose eyes were in his spectacles; another, whose brains were in his wig. A third devil whose nose was a trumpet."²

Opium dreams, it is claimed, sometimes induced synaesthesia, in which sense perceptions are exchanged; so that sounds may be tasted or smelt, smells and colours may be heard or felt. Sometimes they were full of exotic imagery, as in *Kubla Khan*, or in parts of De Quincey's *Confessions of an English Opium Eater*:

> Under the connecting feeling of tropical heat and vertical sunlights, I brought together all creatures, birds, beasts, reptiles, all trees and plants, usages and appearances, that are found in all tropical regions, and assembled them together in China or Hindostan. From kindred feelings, I soon brought Egypt, and her gods under the same law. I was stared at, hooted at, grinned at, chattered at, by monkeys, by paroquets, by cockatoos. I ran into pagodas, and was fixed for centuries at the summit, or in secret rooms; I was the idol; I was the priest; I was worshipped; I was sacrificed. I fled from the wrath of Brama through all the forests of Asia; Vishnu hated me; Siva lay in wait for me. I came suddenly upon Isis and Osiris: I had done a deed, they said, which the ibis and the crocodile trembled at. Thousands of years I lived and was buried in stone coffins, with mummies and sphinxes, in narrow chambers at the heart of eternal pyramids. I was kissed, with cancerous kisses, by crocodiles, and was laid, confounded with all unutterable abortions, amongst reeds and Nilotic mud.³

Even if among Romantic painters, opium addiction was far less frequent than among writers, its imagery had its effect upon their work. It is present in John Martin's dizzy prospects which, for instance, like Piranesi's views inside prisons,⁴ or Berlioz's vast musical compositions, are inducive of agoraphobia and seem charged with elemental forces of destruction. The French poet, Baudelaire, himself an addict, wrote that Martin's pictures

¹ Hayter, Alethea, *Opium and the Romantic Imagination*, 1968, ch. iii.
² ibid., 80.
³ Part III. "The Pains of Opium".
⁴ (1720–78), Venetian architect. His *Invenzioni, Capricci de Carceri all 'acqua forte*, a series of etchings, was first published about 1745.

faithfully rendered "the colour of an opium landscape", and went on to say that "here indeed are the dull sky and veiled horizon which over-shadow the brain enslaved by opium."[1] They are indeed views of an opium landscape, like that seen by Coleridge in his description of Xanadu:

> *But oh! that deep romantic chasm which slanted*
> *Down the green hill athwart a cedarn cover!*
> *A savage place! as holy and enchanted*
> *As e'er beneath a waning moon was haunted*
> *By woman wailing for her demon-lover!*
> *And from this chasm, with ceaseless turmoil seething,*
> *As if this earth in fast thick pants were breathing,*
> *A mighty fountain momently was forced:*
> *Amid whose swift half-intermitted burst*
> *Huge fragments vaulted like rebounding hail,*
> *Or chaffy grain beneath the thresher's flail:*
> *And 'mid these dancing rocks at once and ever*
> *It flung up momently the sacred river.*
> *Five miles meandering with a mazy motion*
> *Through wood and dale the sacred river ran,*
> *Then reached the caverns measureless to man,*
> *And sank in tumult to a lifeless ocean:*
> *And 'mid this tumult Kubla heard from far*
> *Ancestral voices prophesying war!*

That passage may remind us somewhat of Martin's terror-ridden illustration of the Deluge (Plate 57) in which beasts, people and giants are overwhelmed by an appalling disaster, with lightning, deluge, earthquake and flying rocks driving God's victims to death by crushing or drowning. But mostly by drowning, for the terrible flood waters pour from the sky in torrents, transforming mountains and chasms into vast overwhelming cataracts that carry thousands of shrieking living souls with them into bottomless, churning lakes far below. Here is *terror antiquus*, a vision of destruction, as it could have haunted the dreams of a drug addict. And it is a rendering of the destructive wrath of the tyrannous Urizen, the persecuting god who endowed Man with a fallible nature, entrapped him into breaking the moral law, and then punished him for it. It is a picture of the wrath of the Ancient of Days who, in different guises, flayed Marsyas,

[1] "Paradis Artificiels", *Œuvres completes de Baudelaire*, Paris, 1961, 422. Quoted in Hayter, *op. cit.*, 92.

chained Prometheus, destroyed Sodom and Gomorrah, and accepted the sacrifice of Jephthah's daughter. It is

The land of darkness flamed, but no light & no repose:
The land of snows of trembling & of iron hail incessant:
The land of earthquakes, and the land of woven labyrinths:
The land of snares & traps & wheels & pit-falls & dire mills:[1]

There was madness in the Martin family. John's elder brother, William, was the author of two hundred pamphlets, in which he described his some-times practicable inventions; but he was crazed nevertheless. When he was introduced to William Bell Scott he said, "Gratified to meet you, sir! I am the philosophical conqueror of all nations, that is what I am!" Martin's third brother, Jonathan, in 1829 started a fire in York Minster, which caused extensive damage.[2] He was incarcerated in Bedlam, where he was once seen making a drawing of a seven-headed bishop running into the open jaws of a crocodile. Jonathan's son, Richard, also showed signs of an un-balanced mind: he became convinced that he had contracted typhus, that his breath was turning his friends black, and he committed suicide. John Martin was himself called "Mad Martin", but he remained sane, however much his pictures seem to indicate a fevered mind.

Martin's picture of the Deluge is now known only through a mezzotint, taken from the oil painting of 1826. All of Martin's mezzotints originated as paintings, but the medium of the mezzotint seems particularly to suit his nightmarish vision. The mezzotint plate begins as a uniformly black sur-face, produced by a tool, called a rocker, being applied all over it. The light parts of the engraving are made by scraping away the rocked surface to various depths. This may have symbolized for Martin the extraction of light (vision) from darkness (the unconscious). This may seem far-fetched, but few people realize how important an artist's technique can be in developing his vision. Art is not created merely by using a technique as a mechanical means to realize an aesthetically conceived idea; technique is an integral, inseparable part of the conception. Here Martin has used it effectively to help him convey that deep, dark, inner world of man that we have men-tioned before; just as Blake had used his method of relief etching to print "in the infernal method, by corrosives, which in Hell are salutary and

[1] Blake, *Jerusalem*: Keynes, 634.
[2] Balston, Thomas, *The Life of Jonathan Martin*, 1945.

medicinal, melting apparent surfaces away, and displaying the infinite which was hid."[1] Similarly, Samuel Palmer, in middle life, turned to etching to recapture some of the visionary magic he had lost since the days of his youth at Shoreham in Kent, when he had painted some of the most poignant landscapes in English art[2] (cf. Plates 16 and 95).

Another aspect of visionary Romantic art that may have been influenced by what the artist had heard of drugged dreams, appears in the work of John Hamilton Mortimer. Mortimer's drawings, "Nebuchadnezzar recovering his reason"[3] (Plate 60), "Skeleton of a sailor and vultures on a shore," and "The Orchestra of demons",[4] each contains horrific ideas. Nebuchadnezzar, with clawed hands and feet, his body covered with thick, matted feathers, is less horrific than Blake's colour-printed drawing of the same subject.[5] But it has its terrible aspect notwithstanding, for the divine curse has not yet departed from the king: "he was driven from men, and did eat grass as oxen, and his body was wet with the dew of heaven, till his hairs were grown like eagles' feathers, and his nails like birds claws." Yet Mortimer has shown the divine light dawning upon Nebuchadnezzar, and soon he will cry that he has lifted "my eyes unto heaven, and mine understanding returned unto me."[6] The vultures near a sailor's skeleton have unpleasant associations; but there is real malignancy in "The Orchestra of demons," in which putrid corruption, necrophily, moral degeneracy and hallucinatory furies combine in a cacophony of the pit. The personages give an impression as horrid as the tomb-flies that were seen at Lewes in 1805:

> In preparing for the foundation of the New Church at Lewes, it became necessary to disturb the mouldering bones of the long defunct, and in the prosecution of that unavoidable business a leaden coffin was taken up, which, on being opened, exhibited a complete skeleton of a body that had been interred about sixty years, whose leg and thigh bones, to the utter astonishment of all present, were covered with myriads of flies (of a species, perhaps, totally unknown to the naturalist) as active and strong on the wing as gnats flying in the air, on the finest evening in summer. The wings of this non-descript are white, and for distinction's sake, the spectators gave it the name of

[1] *The Marriage of Heaven and Hell*: Keynes, 154.
[2] See Lister, Raymond, *Samuel Palmer and his etchings*, 1969, ch. iii.
[3] British Museum. [4] ibid.
[5] Tate Gallery. [6] *Daniel* IV, 33–34.

the coffin-fly. The lead was perfectly sound, and presented not the least chink or crevice for the admission of air. The moisture of the flesh had not yet left the bones, and the fallen beard lay on the under jaw.[1]

Having discussed dreams as an aspect of Romantic visionary art, we may now take a short step from "death-counterfeiting" sleep[2] to the Romantic vision of death itself: a vision which sees bodily death as a gateway to a greater experience, as a fascinating mystery, and as a sister of beauty. It is this aspect of death that we may see symbolized in a beautiful predator—a lion, a falcon or an eagle; in Stubbs's Greenland falcon[3] (Plate 61) or Blake's Tyger.[4] It is also that other aspect which was demonstrated by Berlioz when, at the funeral of a young woman in Florence, he seized the hand of the corpse and covered it with kisses.[5]

Romantics were, because of this preoccupation, intoxicated with those direct gateways into the hereafter—suicide and premature death:

> *Flowers shall hang upon the palls,*
> *Brighter than patterns upon shawls,*
> *And blossoms shall be in the coffin hid,*
> *Sadder than tears on grief's eyelid,*
> *Garlands shall hide pale corpses' faces*
> *When beauty shall rot in charnel places,*
> *Spring flowers shall come in tears and sorrow*
> *For the maiden goes down to her grave tomorrow.*[6]

There were many suicides, and some of them provided subject-matter for Romantic painters. Chatterton for one; his suicide was painted in an imaginary scene by Henry Wallis, which shows the young poet—he was not yet eighteen—stretched Prometheus-like on a window-seat in a garret, after taking arsenic.[7] His manuscripts are torn into tiny fragments and litter the floor.

[1] Southey, Robert, *Omniana*, 1812, I, 75–6.
[2] *Macbeth* II, i, 81.
[3] Collection of Mr and Mrs Paul Mellon.
[4] *Songs of Experience*: Keynes, 214.
[5] *The Memoirs of Hector Berlioz* (trans. by David Cairns), 1969, 206–7.
[6] John Clare, "Death", v.1.
[7] Chatterton's pose in this picture was used again in 1892, by Onslow Ford, for the naked figure of Shelley on the memorial in University College, Oxford.

But this picture is hardly a visionary view of death. That may be provided by Blake's twelve illustrations for Blair's *Grave*, which, as we have seen, were engraved by Louis Schiavonetti. They show: Christ descending into the grave; the descent of Man into the Vale of Death; Death's door; the Death of the strong wicked man; the Death of the good old man; the Soul hovering over the body, reluctantly parting with life; the Soul exploring the recesses of the grave; the Counsellor, king, warrior, mother and child in the tomb; the Skeleton re-animated; the Reunion of the soul and the body; the Meeting of a family in heaven; the Last Judgment.

These designs must be considered, not as mere illustrations to the poem, but as a work of art in their own right.[1] Fuseli, who wrote the foreword to the book, probably wrote also the unsigned terminal notes on the engravings, in which this passage occurs: "These Designs, detached from the Work they embellish, form of themselves a most interesting Poem." They are indeed a visual poem, an attempt to show "the regular progression of Man, from his first descent into the Vale of Death, to his last admission into Life Eternal."

They are full of Blakean motifs, some of which he used in other works. "Death's Door", for instance, shows an ancient man on crutches entering a tomb, while his regenerated form sits above, with a rising sun behind. Parts of this appear in plate 21 of *The Marriage of Heaven and Hell*, plate 6 of *America*, and plate 15 of *The Gates of Paradise*. "The soul exploring the recesses of the grave" is a symbol of Man's imagination searching for a key to the mystery of death. This has much in common with the theme of Blake's *The Book of Thel*, in which the heroine, Thel, symbolizing the unborn soul, laments the transience of innocence, despite attempts to reassure her by a Lily, a Cloud, a Worm, and the "matron Clay". The matron sings of the joyfulness of motherhood, and invites Thel into the world of experience. Thel enters experience, and wanders through dark valleys, eventually finding herself seated beside her own grave. She shrieks, jumps up, and rushes back into her spiritual world. Thus we are shown the soul in a state of death (in the spiritual world) fearing life (in the material world). The fear and fascination of death by the living is simply the same thing reversed.

Blake's own death was a visionary experience. Few others—even saints

[1] cf. Damon, S. Foster, *Blake's Grave*, Providence, R. I., 1963.

—can have welcomed so joyfully the onset of the unknown universal mystery: "He said He was going to that Country he had all his life wished to see & expressed Himself Happy, hoping for Salvation through Jesus Christ—Just before he died His Countenance became fair. His eyes Brighten'd and He burst out into Singing of the things he saw in Heaven. In truth He Died like a Saint as a person who was standing by Him Observed."[1] It was death as a song of innocence, death as a vision of joy after experience.

There were Romantics who took their dealings with the supernatural a great deal further than Blake, yet much of them remain unconvincing, even rather silly. Blake's "visions", whether one takes them literally or not, are nearly always on a sound psychological plane. But among other Romantics, as in their visions of love, we are apt to find a more fanciful, and sometimes a definitely pathological accent:

> Shelley and party here. Mrs. S called me her brother (younger). Began my ghost-story after tea.[2] Twelve o'clock, really began to talk ghostly. L[ord] B[yron] repeated some verses of Coleridge's *Christabel*, of the witch's breast; when silence ensued, and Shelley, suddenly shrieking and putting his hands to his head, ran out of the room with a candle. Threw water in his face, and after gave him ether. He was looking at Mrs. S, and suddenly thought of a woman he had heard of who had eyes instead of nipples, which, taking hold of his mind, horrified him.[3]

That is on the same level of terror as Rossetti's *Doppelganger* picture, "How they met themselves" (Plate 50). No doubt each of those visions, the eyes in the nipples, and the *Doppelganger*, are so terrifying, because they are true psychological manifestations. Fuseli realised this, when he wrote of his painting of Macbeth and the witches:[4] "When Macbeth meets with the witches on the heath, it is terrible, because he did not expect the supernatural visitation; but when he goes to the cave to ascertain his fate, it is no longer a subject of terror: hence I have endeavoured to supply what is

[1] George Richmond in a letter to Samuel Palmer, 15 August 1827. Gilchrist, *op. cit.*, 353.

[2] Probably *The Vampyre*, published in April 1819 as a pamphlet and in the *New Monthly Magazine*. It was at first attributed erroneously to Byron.

[3] *Diary of John William Polidori* (ed. W. M. Rossetti), 1912, 127–28.

[4] In the collection of Lord Egremont, Petworth House.

deficient in the poetry. To say nothing of the general arrangement of my picture, which in composition is altogether triangular, (and the triangle is a mystical figure,) I have endeavoured to shew a colossal head rising out of the abyss, and that head Macbeth's likeness. What, I would ask, would be a greater object of terror to you, if, some night on going home, you were to find yourself sitting at your own table, either writing, reading or otherwise employed? would not this make a powerful impression on your mind?"[1]

But the picture itself, though painted with dramatic sensibility, fails to excite; it is far less disturbing than Rossetti's drawing. This is because, in Fuseli's picture, the psychological content is swamped with the attendant trappings of black magic, which give it a fairy-tale, make-believe atmosphere. In the Rossetti drawing the simple statement suffices: the two lovers see their other selves and are terrified. The same simplicity of statement occurs in Fuseli's "Nightmare", in which too, despite being far-fetched, the apparitions are the kind of horrors that might really occur in a pathological dream (Plate 19).

The supernatural is more happily expressed in literature—where the reader's imagination may be more easily involved—than in the visual arts. This is one reason why book illustrations provided an ideal medium for the Romantic portrayer of the supernatural. Their size also was a help: a small illustration, covering an area of only a few square inches, makes a far-fetched or supernatural subject more easily acceptable than it would be on a large canvas, where its irrational character is magnified beyond credibility. Technique helped, too; my remarks on mezzotinting apply here, for although these illustrations are usually etchings, wood engravings or lithographs, those media may be used so as to give a mysterious depth, if not so intense as that of the mezzotint.

One of the greatest of Romantic illustrators was George Cruikshank, whom few others could emulate in portraying the supernatural. Among his masterpieces are his etchings of the ghostly figure, Herne the Hunter, in Harrison Ainsworth's *The Romance of Windsor Castle* (1843; Plate 53), and in particular in that at the end of the first book, in which Herne is shown, mounted on a horse and accompanied by an owl and a sable hound. "As the wild huntsman reached the brink of the lake, he placed a horn to his mouth, and blew from it a bright blue flame, which illumined his own dusky

[1] Knowles, *op. cit.*, I, 189–90.

and hideous features, and shed a wild and unearthly glimmer over the surrounding objects. While enveloped in this flame, the demon plunged into the lake, and apparently descended to its abysses, for as soon as the duke could muster courage to approach its brink, nothing could be seen of him, his steed, or his hounds."

Some of Cruikshank's illustrations are really frightening. One of these, "The Giant Ogre discovers Hop'o my Thumb and his Brothers," in *George Cruikshank's Fairy Library* (1853) shows the menacing Ogre, his lips baring his fangs, glaring hungrily at the tiny hero, whom he holds in one hand, while he grasps a wicked-looking knife in the other.

Daniel Maclise used supernatural themes less dramatically than Cruikshank, and gave them a somewhat poetic interpretation in his outline illustrations to Moore's *Irish Melodies*, published in 1846. These are cool and gentle, as suits the nostalgia of Moore's poems.[1] Some, such as that accompanying "The Origin of the harp," have great charm (Plate 65); but the feeling remains that Maclise's supernatural beings are decorative rather than real, and it is unlikely that he could, with success, have illustrated stronger literary meat than these melodies. Yet he was sometimes capable of deeper interpretations. His "Undine"[2] is an example; it shows that heroine, accompanied by the knight Huldbrand and a monk, riding through a forest, surrounded by goblins, elves and fairies, and overshadowed by the sinister figure of her uncle, Kühleborn, the spirit of the waters.

But, generally speaking, the supernatural in painting is rarely completely convincing. This is illustrated by a small painting by Alexander Runciman of the Witch of Endor, and, as a piece of painting or composition, it is excellent; but as a portrayal of the witch it is tame.[3] A few lines in the authorized version[4] conveys twenty times the depth, because, by the very act of reading, the reader is involved. The painting gives the impression of stage properties, of a cloaked ghost, clouds and brimstone; but the mind will not believe what the eye sees. But when the Witch's statement is read, "I saw gods ascending out of the earth", the mind assimilates the state-

[1] Moore's poems, however, were not always nostalgic; many had a distinctly martial tone. Berlioz recalled hearing his setting of Moore's "War Song—Remember the Glories of Brien the Brave" in Paris during the July Revolution of 1830. *Memoirs of Hector Berlioz*, 132.

[2] Collection of HM the Queen. [3] Private collection.

[4] I *Samuel* XXVIII, 7–20.

ment, evolving a mental image which, being one's own, is acceptable. In order that visual representations of the supernatural may move us, they must be conceived and executed by a visionary of the stature of Blake. Otherwise they remain merely theatrical.

The theatre, in fact, provided an excellent medium for artistic representations of the occult. The Romantic ballet was largely concerned with fairies, wilis, sylphides and other mythological beings, and it endeavoured to portray them with every illusion of spirituality. The dancing *sur les pointes* that was widely used at this time (it was probably first used by the ballerina Geneviève Gosselin, in 1815, in the ballet *Flore et Zéphire*)[1] was particularly apt in giving the effect of the movement of weightless beings, lightly skimming over the surface of the earth. These beings, with the assistance of wires and hidden machinery, even flew, in defiance of gravity. This happened in the second act of *La Sylphide*—the subject of several lithographs by A. E. Chalon (Plate 66)—in which Marie Taglioni and some fifteen *danseuses* soared among trees in a forest grove. It is true that there were times when the illusion was shattered. Writing in 1838, of a revival of *La Sylphide*, Théophile Gautier related how, "At the beginning of the ballet, there took place a little accident which, fortunately, had no serious consequences, but which at first alarmed us: at the moment when the Sylphide disappears through the fireplace . . . Mlle Fanny Elssler, being carried too quickly by the counter-weight, knocked her foot violently against the frame of the chimney-piece. Fortunately she did not hurt herself . . . At the performance given for Mlle Taglioni's benefit, two sylphides remained suspended in mid-air, it was impossible to pull them up or lower them down; people in the audience cried out in terror; at last a machinist risked his life and descended from the roof at the end of a rope to set them free."[2]

We, with productions of *Peter Pan* in mind, may scoff at such devices as crude and artificial. But to most theatregoers in the Romantic era, they provided a visionary magic, affording them a glimpse into a world of new dimensions. "*La Sylphide*", wrote De Boigne,[3] "borne on the wings of

[1] Guest, Ivor, *The Romantic Ballet in Paris*, 1966, 17.

[2] *The Romantic Ballet as seen by Théophile Gautier*, trans. Cyril W. Beaumont, 2nd edn, 1947, 28.

[3] *Petits Mémoires de l'Opéra*. Quoted in Beaumont, *Complete Book of Ballets*, 102.

Taglioni, soared to the skies." And so we may see her in the little wood-engravings, made under the superintendence of Charles Heath, in *Beauties of the Opera and Ballet* (1845), itself a monument of Romantic book production: engravings which are yet another demonstration that the supernatural in Romantic visual art is most convincing in this medium.

But true vision is, in the end, that innocence which can "see a heaven in a wild flower";[1] it was an innocence which, on various levels, many Romantic artists possessed. "I feel really frightened when I sit down to paint a flower",[2] said William Henry Hunt; Palmer quoted this in one of his letters,[3] after saying, "The painter's and the poet's struggles are solitary and patient, silent and sublime." The solitary, the outcast: these are the patient, the silent ones, to whom are given the sublimities of vision, that instress by which may be seen in stars the powder on a willow, and beyond them the titanic hero:

> *Look at the stars! look, look up at the skies!*
> *O look at all the fire-folk sitting in the air!*
> *The bright boroughs, the circle-citadels there!*
> *Down in dim woods the diamond delves! the elves'-eyes!*
> *The grey lawns cold where gold, where quickgold lies!*
> *Wind-beat whitebeam! airy abeles set on a flare!*
> *Flake-doves sent floating forth at a farmyard scare!—*
> *Ah well! it is all a purchase, all is a prize.*
>
> *Buy then! bid then!—What?—Prayer, patience, alms, vows.*
> *Look, look: a May-mess, like on orchard boughs!*
> *Look! March-bloom, like on mealed-with-yellow sallows!*
> *These are indeed the barn; withindoors house*
> *The shocks. This piece-bright paling shuts the spouse*
> *Christ home, Christ and his mother and all his hallows.*[4]

[1] Blake, *Auguries of Innocence*: Keynes, 431.

[2] Stephens, F. G., *Memorials of William Mulready*, 1867, 37.

[3] 17 March 1881. In the collection of Miss Joan Linnell Ivimy.

[4] Gerard Manley Hopkins, "The Starlight Night", *Poems*, 1967, 66–7. Reprinted by permission of Oxford University Press, by arrangement with the Society of Jesus.

Time the Consecrator,
Distance the Enchanter

> Time consecrates;
> What is grey with age becomes religion.
> > Schiller, *Die Piccolomini*[1]
> > *Trans.* Coleridge.
>
> '*Tis distance lends enchantment to the view,*
> *And robes the monster in its azure blue.*
> > Campbell, *Pleasures of Hope*[2]
>
> *The "good old times"—all times when old are good.*
> > Byron, *The Age of Bronze*[3]

WHEN men are dissatisfied with the present—and they usually are—they tend to look with longing towards a golden age situated either (and more usually) in the remote past, or in the remote future. This was emphatically true of the Romantics. The Neoclassicists saw their golden age in the heyday of Greece, Rome, Egypt or Babylon: in eras of what they saw as law and order. On the other hand the Romantics saw theirs either in such remote barbaric periods as those of Druidic Britain and the Gael, or, even more, in the Middle Ages, the various aspects of which they lumped together as "Gothic".

What they saw as the art of the Druids and of the Gaelic races, such as the circles of Avebury and Stonehenge, the dolmens of Ireland, the tumuli of the chalk hills; what they saw as Gothic art, such as the wool churches of East Anglia, the cathedrals of the north: these represented to them the styles of freedom as opposed to the measured perfection of classical architecture. They did not realize, or did not choose to realize, that everything in a mediaeval cathedral, and even the megaliths at Stonehenge, were as carefully calculated, with even a mathematical precision, as the details of the Parthenon.

[1] Act IV. Sc.4. [2] Part I. l. 7. [3] I. l. 1.

Stonehenge and Avebury had for long fascinated scholars, who, working on the few classical references to the Druids and their customs, and allowing, in various degrees, their imagination to run riot, unhesitatingly ascribed a Druidic origin to the structures. Others, equally unhesitatingly, but more curiously, ascribed to them a Roman origin.

As long ago as 1136, Geoffrey of Monmouth, had, in his mythical *History of the Kings of England*, seen Stonehenge not only as a memorial erected by King Aurelius Ambrosius to British earls and princes betrayed by Hengist, but also as the burial place of Aurelius himself. Merlin, "Vortigern's prophet", assisted by the King's brother, Uther Pendragon and 15,000 men, had used his magical powers to bring the stones from "the Dance of the Giants that is in Killaire, a mountain in Ireland."[1] Following this, some historians copied what Geoffrey had said, while others, more honestly, said they did not know what the stones were for or how they had got there. Inigo Jones, in his *The most notable Antiquity of Great Britain, vulgarly called Stone-heng* (1655), expressed the opinion that the structure was Roman, and this remained a fashionable opinion for some time. Others, like Dr Walter Charleton in his *Chorea Gigantum* (1663), considered it to be the work of Danes; some thought it was Saxon, some that it was Phoenician. But from the time of the antiquary, John Aubrey[2] author of *Monumenta Britannica*,[3] the idea that it was of Druidic origin gained credence; the strongest momentum for this came from William Stukeley, whose *Stonehenge A Temple restor'd to the British Druids* and *Abury, a Temple of the British Druids* were published in 1740 and 1743. To Stukeley, Stonehenge was "as the metropolitan church of the chief Druid of *Britain*. This was the *locus consecratus* where they met at some great festivals of the year, as well to perform the extraordinary sacrifices and religious rites, as to determine causes and civil matters."[4] Elsewhere, and in contrast with those Romantics who saw salvation in agriculture, he feared the destructiveness of farming upon Stonehenge: ". . . the several views I have drawn of it, will give us nearly as good a notion of the whole, as we can at this day

[1] It is now known that the stones came from the Prescelly Mountains in Pembrokeshire; but whether they were brought hence by glaciation or by human effort is still uncertain.

[2] 1626–97.

[3] Bodleian ms. Gen. Top.C24. See also Bodleian ms. Aubrey 12, 13.

[4] *Stonehenge*, 10.

expect, and perhaps preserve the memory of it hereafter, when the traces of this mighty work are obliterated with the plough, which it is to be fear'd, will be its fate. That instrument gaining ground too much, upon the ancient and innocent pastoritial life; hereabouts, and everywhere else in *England*: and by destructive inclosures beggars and depopulates the country."[1]

Some antiquaries, like William Cooke in his *An Enquiry into the Patriarchal and Druidical Religion Temples &c* (1754), tried even to show Druidism as an affirmation of the same ancient patriarchal religion as that of the Jews and Christians. Writing of Avebury, he asserts: "That it was really a Temple sacred to the ever-blessed and undivided Trinity."[2] John Cleland, in *The Way of Things by Words* (1766), even went so far as to claim that the Christian mass took its Latin name (*missa*) from the Druidic mistletoe.

Needless to say, all of this appealed to the Romantic mind, which continued to elaborate and refine upon the contemporary ideas of Druids and Druidism, until an almost wholly new tradition was established. The Romantics saw the Druids as "noble savages", like the Red Indians or South Sea Islanders. They built follies in their gardens in imitation of Stonehenge. Such is the "Druid Temple", built in the 1820s by William Danby at Ilton, in the West Riding of Yorkshire. They founded secret societies and orders, based on what they thought was Druidism, and they portrayed it in their art.

The Gorsedd of Welsh bards, roughly as we know it today in *eisteddfodau*, originated in a ceremony held on Primrose Hill in London in 1792, itself partly an offshoot of genuine assemblies of bards and harpists in Wales, but mainly an invention of Edward Williams, or Iolo Morganwg, as he called himself, who forged documents to support his claims that the ceremony came from a genuine tradition. Nevertheless the idea proved popular, and became well established. It still survives, with the officiating Archdruid dressed in clothes and regalia derived in part from an aquatint in *The Costume of the original inhabitants of the British Islands* by Sir Samuel Rush Meyrick and C. H. Smith (1815), but designed in detail by Sir Hubert Herkomer and Sir Goscombe John. Another Druidic survival from the Romantic era is a quasi-masonic friendly society known as the Ancient Order of Druids, some of whose officers wear false beards like Father

[1] ibid., 35. [2] *Enquiry*, 37.

Christmas—who is himself a strange Romantic figure in whom paganism and christianity are blended.

The world of Romantic make-believe also found expression in such societies and orders as the Foresters, Shepherds and Oddfellows, all claiming to be "ancient". Freemasonry also, which had been derived in part from mediaeval trade ceremonies, erupted into societies, or "side degrees", such as the Royal Order of Scotland, the United Religious and Military Orders of the Temple and Hospital, the Antient and Accepted Scottish Rite, and the Order of the Secret Monitor. Several of these were Jacobite in sympathy: the Royal Order of Scotland, which had a ritual in verse, had as its grand master "The Hereditary King of Scotland", and a vacant throne was left for him in the lodge room, with crown, sceptre and robe ready for him to wear, should he appear. The Scottish Rite (*Rite Ecossais*) also had Jacobite associations, as had the numerous "Scotch" degrees with which Freemasonry was diversified during the Romantic period.

Many other orders claimed to be the successors, or descendants, of the Knights Templar. Such were the Orders of the Temple and Hospital, which I have just mentioned, and the Rite of the Strict Observance, initiated by the German Baron C. G. von Hund (1722–76). Even these have a supposed Scottish background, for it was claimed that some Templars, when their order was suppressed, fled to Scotland and, in association with Freemasons, re-founded it. Thus again, as in the poems of Macpherson and Chatterton, the Romantic yearning for the long ago and far away, found expression in fantasy and historical distortion.

Little of Freemasonry appears in Romantic visual art, and the reason is not difficult to find. It was a "secret" society, whose main fascination for outsiders was contained in the fact of its mysteriousness. Those who belonged to the orders did not wish to publicise their childish passwords and signs, or their shallow ceremonies; artists either did not know what they were, or, even if they learnt something of them from the "exposures" that were occasionally printed, they realized from their content, that they provided little inspiration for artistic expression. Such masonically-inspired art and artefacts as did exist—engraved lodge-summonses, decorated glass and china, and a few prints and portraits—were of little importance.

On the other hand, bards, Gaels and Druids provided Romantic art with a rich seam of subject-matter. Blake, much influenced by the engravings in Stukeley's *Stonehenge*, portrayed trilithons in *Jerusalem*, in *Illustra-*

tions of the Book of Job, and in *Milton,* in one plate of which (no. 6) a horseman is shown between a rocking stone (another type of supposed Druidic remains) and a trilithon, that must tower fifty feet above him, and which brings to the composition some of that feeling of vertigo found later in Martin's *oeuvre.* Druids and Druidism figure in many parts of Blake's prophetic books, where they symbolize Deism or Natural Religion, a philosophy fashionable during the Age of Reason, and one about which Blake had grave reservations.

Stonehenge itself is the subject of one of the most dramatic of John Constable's water-colours[1] (Plate 67), in which, in Romantic spirit, the great circles of stones are contrasted with the transient effects of Nature, in the weather and in the atmosphere. This work is a practical demonstration of Constable's dictum, that landscape was "cradled in the lap of history."[2]

Druidism appeared also in the theatre, as in Bellini's opera *Norma* (1831), which was popular in England throughout the 1830s. In this tragedy of the love of a Gaulish priestess for a Roman, a Druidic stone circle forms the scene of some episodes. There was a chorus of Druids, who appeared with wreaths on their heads, and these "Norma wreaths" soon became a fashionable rage, with women wearing them at balls, concerts and gala performances.

Imaginative anecdotal pictures with Druidic themes had some popularity. Henry Perronet Briggs painted a picture of "The Romans teaching the Ancient Britons the Mechanical Arts",[3] in which half-naked Britons sprawl at the feet of Romans, one of whom is pointing to some figures on a scroll of parchment; a suspicious-looking Druid watches, against a background of trilithons. Another aspect of the theme is given in Holman Hunt's minutely-painted picture of "A Converted British family sheltering a Christian priest from the persecution of the Druids" (1850).[4] The artist could not, in this case, resist pointing a moral, for a biblical inscription on the frame reads:

The time cometh, that whosoever killeth you will think he doeth God service

[1] Victoria and Albert Museum.
[2] Leslie, C. R., *Memoirs of the Life of John Constable* (Phaidon Press ed.), 1951, 292.
[3] Hull Archaeology Museum.
[4] Ashmolean Museum.

Their feet are swift to shed blood; For whosoever shall give you a cup of water to drink in my name, because you belong to Christ, verily I say unto you, he shall not lose his reward. I was a stranger and ye took me in.

This imagined confrontation of Druid and Christian may take us into the mainstream of Romantic historicism—the Gothic Revival. Indeed there were those who saw in woodlands or in the sacred groves of the Druids the origins of Gothic architecture. Stukeley, for example, wrote in his *Itinerarium Curiosum* (1724), "it is the best manner of building; because the idea of it is taken from a walk of trees, whose branching heads are curiously imitated by the roof."[1]

It was, of course, in building that the Romantic Gothic spirit found its most spectacular outlet, even if its source was at first literature. There had been, ever since the close of the Middle Ages, a continuing trickle of Gothic architecture, flowing more or less from the main tradition. The Gothic Revival, except in a purely stylistic sense, had nothing to do with this: it was Gothic style, not Gothic art. The main tradition used Gothic architecturally; so indeed did the revivalists, but their impulse was Romantic, an endeavour to express in architecture, in decoration and in painting, the spirit of mystery and terror that motivated the Gothic mood of novelists like Horace Walpole, Ann Radcliffe and "Monk" Lewis; of poets like Dyer, Beattie,[2] Gray, Blair, or the minor figure, David Mallet:

> *Hark! through the aerial vault the storm, inflam'd,*
> *Comes nearer, hoarsely loud, abrupt and fierce,*
> *Peal hurl'd on peal incessant, burst on burst;*
> *Torn from its base, as if the general frame*
> *Were tumbling into chaos—There it fell,*
> *With whirlwind wing, in red diffusion flash'd:*
> *Destruction marks its path. Yon riven oak*
> *Is hid in smouldering fires; surpris'd beneath,*
> *The traveller ill-omen'd prostrate falls,*
> *A livid corse. Yon cottage flames to Heav'n,*
> *And in its farthest cell, to which the hour,*
> *All horrible, had sped their steps, behold!*
> *The parent breathless lies, her orphan babes*

[1] Quoted from the second edn. (1776), I, 68.
[2] James Beattie (1735–1803).

> *Shuddering and speechless round—O Pow'r divine!*
> *Whose will, unerring, points the bolt of Fate,*
> *Thy hand though terrible, shall man decide*
> *If punishment or mercy dealt the blow?*[1]

Yet, strangely, such "terrors" as are contained in this and in works like *The Castle of Otranto*, were paralleled in architecture by what seems to us to be a pretty rococo Gothic style, like that of the magnificent Eaton Hall in Cheshire (Plate 69). This building was designed by William Porden, and built between 1804 and 1812 for the Earl of Grosvenor. It was arranged in pinnacled terraces, like something from a vision by Martin, and was, at first sight, more like a sacred fane than a nobleman's seat. Yet there was, to judge from a contemporary print, something prettily toy-like about it; and it bore little resemblance to true Gothic work, for its windows were made of cast iron, and much of its tracery of plaster.[2] Plaster ceilings, too, simulating Gothic tracery and inlaid with coloured glass, were used in Walpole's house, Strawberry Hill, and in the chapel at Audley End (*circa* 1770), decorated by a Mr Hobcraft, and with stained glass windows by William Peckitt of York.

To their contemporaries, such structures no doubt recalled all the gloom and mystery of the imaginary mediaeval world of Otranto. At the height of the Romantic era there can have been hardly a building without some Gothic detailing—a window, a door, or maybe some furnishings or fittings —hardly a garden without its Gothic gazebo, folly or seat. Stoves were made in the shape of suits of armour. Well might Scott's Antiquary exclaim, "Lord deliver me from the Gothic generation! A monument of a knight-templar on each side of a Grecian porch, and a madonna on the top of it!"[3]

The Gothic spirit was present, especially, in ruins, which the Romantics saw as architecture expressing transience instead of permanence, caprice instead of harmony. Ruins were expressive of melancholy; their ivy-shrouded stones, decaying tracery and grass-grown courtyards were reminders of the impermanence of all things. In the theatre they were peopled

[1] "The Excursion", in *The Poetical Works of David Mallet*, ed. Thomas Park, 1805, 70. Mallet's dates are 1705?–1765.

[2] The house was largely remodelled in 1870, when much of its character was destroyed. It was demolished in 1963.

[3] *The Antiquary*, ch. xvi.

by sylphides and wilis; in novels they were the abodes of hermits or malignant ecclesiastics; in real life they harboured adders or toads, or were swept by storms:

> Ruins are best seen in wintry weather, when storms and thunder are abroad, and the woods are bare of leaves. Such was the fourteenth of October, when some years back, the narrator, saw for the first time, that dilapidated portion of Winfield Castle [Queen Mary's Tower]. The rain had been exceeding heavy in the night, and the wind blew a perfect hurricane, making the tall trees groan and sway, beneath its fury, and driving the autumn leaves in shoals upon the ground. But the rain had ceased, and the loud wind was still, except when it came in gusts, moaning over the wide heath, and around the ancient castle, with that wailing sound which is heard only in places where men have dwelt, as if singing the wild requiem of departed greatness.[1]

Insufficient genuine ruins existed to satisfy the demands of the Romantics, and they did not hesitate to make their own, and to set hermits to live in them. On at least one occasion, such a ruin was made by mishap and not by design. This was on 21 December 1825, when the 250 feet high central tower of Fonthill, the Gothic mansion built by James Wyatt for William Beckford, crashed to the ground, destroying much of the house, and for several minutes darkening with dust the surrounding area. But not before John Martin had drawn it in all its immensity.[2]

Romantic travellers roamed all over the world to see ruins. Captains Irby and Mangles, dressed as Bedouins, visited the ruins of Petra in Jordan in 1818, where they noted the contrasts between the sublimity of the surrounding rocks and those of the ruins themselves: "[the summits of the rocks show] nature in her most savage and romantic form, while their bases are worked out in all the symmetry of art".[3] Another writer, William Henry Bartlett, visiting the same place in the 1840s, ate his supper and slept in one of its tombs.[4] Nearer home, at Poblet, Augustus Hare was impressed by its "very abomination of desolation . . . the most utterly ruined ruin that can exist. Violence and vengeance are written on every stone. The vast

[1] Roberts, Mary, *Ruins and old Trees, associated with memorable events in English History*, n.d., 58–9.

[2] Balston, Thomas, *John Martin*, 1947, 76.

[3] Macaulay, Rose, *Pleasure of Ruins*, 1966, 88.

[4] ibid, 89.

walls, the mighty courts, the endless cloisters, look as if the shock of a terrible earthquake had passed over them . . . Surely no picture that the world can offer of the sudden destruction of human power can be more appalling than fallen Poblet, beautiful still, but most awful in the agony of its destruction."[1]

But for the essential symbolism of ruins, let Shelley have the last word:

> *I met a traveller from an antique land*
> *Who said: Two vast and trunkless legs of stone*
> *Stand in the desert. Near them, on the sand,*
> *Half sunk, a shattered visage lies, whose frown,*
> *And wrinkled lip, and sneer of cold command,*
> *Tell that its sculptor well those passions read*
> *Which yet survive, stamped on these lifeless things,*
> *The hand that mocked them, and the heart that fed:*
> *And on the pedestal these words appear:*
> *"My name is Ozymandias, king of kings:*
> *Look on my works, ye Mighty, and despair!"*
> *Nothing beside remains. Round the decay*
> *Of that colossal wreck, boundless and bare*
> *The lone and level sands stretch far away.*[2]

But let us return to the Gothic Revival. In its later years it became earnest; it became bound up with religion, in particular with the Oxford Movement. Barry's Houses of Parliament, begun in 1840, marked the turning-point; for this structure marked both the end of the purely decorative aspect of Gothic, and the beginning of its "serious" manifestations, which were to lead to such depressing piles as George Gilbert Scott's Albert Memorial (1864) and Waterhouse's additions to Gonville and Caius College at Cambridge (1870–89); and also, it must be confessed, to some pretty fantasies, such as the buildings of Holly Village at Highgate, erected by Angela Burdett-Coutts in 1865.[3] The turning point was symbolized also by that tragi-comic event of 1839, the Eglinton Tournament, at which the thirteenth Earl of Eglinton organized a contest in which fourteen knights, in full armour, jousted in lists, before a large crowd and a presiding Queen

[1] ibid., 369.

[2] "Ozymandias". First published in *The Examiner* in 1818.

[3] See McIntosh, Christopher, "Victorian Fantasy in Highgate", *Country Life*, 5 December 1968, 1491–94.

of Beauty, all dressed in appropriate costume. But not for long; the occasion was swamped by torrential rain.

A not dissimilar event had taken place in 1800, when Nelson was entertained at Fonthill at a grand dinner. The attendants included hooded figures holding wax torches, and sideboards and tables filled with gold plate in the Gothic taste. Music was played by an orchestra hidden behind a shrine, in a room furnished with reliquaries and religious statuary. The same spirit was evident in many details of the Coronation of George IV in 1821, such as the Gothic costume specially designed to be worn by the Duke of St. Albans in his role of hereditary Grand Falconer.[1]

Many minor applications of Gothic appeared in smaller artefacts and *objets d'art*. In 1836 were published Gothic style maps by Thomas Moule the antiquary; and, with high Romantic sentiment, William Godwin, Shelley's father-in-law, suggested in his *Essay on Sepulchres* (1809) that there should be sepulchral maps, showing "where the monuments of eminent men had been, and where their ashes continue to repose."[2] Other Gothic printing included "illuminated" books, bound in moulded *papier mâché* covers, made to look like carved bog oak: *A Record of the Black Prince* by Henry Noel Humphreys (1849); *The Good Shunammite*, illustrated by Lewis Gruner (1847); and, with lighter bindings, *The Song of Songs which is Solomons*, illuminated by Owen Jones (1849); and *The Penitential Psalms*, illuminated by Humphreys (1861).[3] Messenger stamps of Oxford and Cambridge, issued between 1871 and 1886, to prepay correspondence carried for their members by the porters of certain colleges, illustrate how the Revival affected even the smallest products of trade engraving.[4] Hundreds of book illustrations show its influence: H. K. Browne's frontispiece to *The Pickwick Papers* (1836–37) is set within a Gothic arch decorated with comic heads; Thomas Onwhyn's frontispiece to Cockton's *Valentine Vox* (1840) has a similar setting; and Cruikshank's illustrations to the novels of Harrison Ainsworth abound in Gothic detail (cf. Plate 53).

Some attractive illustrated books, full of the antiquarian and Gothic

[1] Now in the Museum of Costume in the Assembly Rooms, Bath.

[2] pp.112–13.

[3] Maclean, Ruari, *Victorian book design and colour printing*, 1963, 67, 73, 75, 78, 127, 151.

[4] Lister, Raymond, *College Stamps of Oxford and Cambridge*, Cambridge, 1966.

spirit, were assembled by the antiquary, Joseph Ritson, who gathered together several collections of ancient songs and ballads, which were published with illustrations by leading Romantic artists. *Robin Hood, a collection of all the ancient poems, songs, and ballads now extant related to that celebrated English outlaw*, with illustrations by Bewick, was published in 1795; *A Select Collection of English Songs*, with illustrations by several artists, some of them engraved by Blake, was published in 1783; *Ancient Songs from the time of King Henry the Third to the Revolution* was issued in 1792, with vignettes by Stothard. These illustrations, and others, were inspired by Romantic antiquarianism. The same may be said of Fuseli's emotion-charged illustrations for Charles Allen's *A New and Improved History of England* (1798).

Another sympton of historical Romanticism was a preoccupation with "antiquarian" natural history, especially with the wild white cattle of England, such as still exist at Chillingham in Northumberland, and which flourished in those days in many parks. These cattle were thought to have been used by the Druids; according to one theory, the modern herds are descended from the Celtic shorthorn breed, said to have been introduced into Britain by Neolithic man. They are the subject of some interesting wood-engravings in the Rev. John Storer's[1] *The Wild White Cattle of Great Britain* (1877), and the Chillingham bull is shown in one of Bewick's most famous wood-engravings. Closely related to this study is Evelyn Philip Shirley's *Some Account of English deer parks* (1867), in which the Romanticism of the chase is blended with that of antiquarianism and legend: "Travelling some years since, I met on the road near Royston a herd of about twenty bucks following a bagpipe and violin, which, while the music played, went forward, when it ceased, they all stood still; and in this manner they were brought out of Yorkshire to Hampton Court."[2]

Romantics really believed that they were reviving the Gothic spirit, and endeavoured to order their lives and surroundings accordingly. They even altered their names: Bridges, for example, became Brydges, and many tried to give the impression of Norman lineage by adopting the prefix "de". A revival of interest in heraldry, hawking and archery took place. Christmas

[1] 1811–76; the book was published posthumously. cf. Whitehead, G. Kenneth, *The Ancient White Cattle of Britain and their descendants*, 1953.
[2] 253.

was celebrated with a Yule log, boar's head and malmsey. Even children became infected with the fantasies: when William Morris was a boy, he played games of knights and damsels in distress, and was frequently seen riding through Epping Forest, dressed in a suit of toy armour. He recalled those days in a lecture he delivered in 1882:

> How well I remember as a boy my first acquaintance with a room hung with faded greenery at Queen Elizabeth's Lodge by Chingford Hatch, in Epping Forest . . . and the impression of romance it made upon me; a feeling that always comes back on me when I read, as I often do, Sir Walter Scott's *Antiquary*, and come to the description of the Green Room at Monkbarns, amongst which the novelist has with such exquisite cunning of art imbedded the fresh and glittering verses of the summer poet Chaucer; yes, that was more than upholstery, believe me.[1]

In painting, the Gothic spirit flourished, finding expression in such works as the two versions of Chaucer's Canterbury Pilgrims, one by Blake, the other by Stothard (Plates 32 and 33); the first a magnificent evocation of Gothicism, the second a pretty, but weak rendering of the scene.[2] Gothicism in painting reached its climax in the work of the Pre-Raphaelites. It was an escapist art, a view of the mediaeval world as seen through a distorting glass—not a Gothic survival, not even, really, a Gothic revival, but a Romantic view of knights, maidens, castles and flowery meads, as remote from reality as Stukeley's imaginings of the Druid world. Much of it was inspired by the poetry of Keats and Tennyson. Such are "The Lady of Shalott"[3] by Holman Hunt and "Mariana"[4] by Sir John Everett Millais (Plate 72). "Mariana" was exhibited at the Royal Academy in 1851, and was based on Tennyson's lines:

> *She only said, "My life is dreary,*
> *He cometh not," she said;*
> *She said, "I am aweary, aweary,*
> *I would that I were dead."*[5]

[1] "The Lesser Arts of Life," *The Collected Works of William Morris*, ed. May Morris, 1910–15, XXII, 235–69.

[2] Blake's painting is in the collection of Sir John Stirling Maxwell; Stothard's version is in the Tate Gallery. Each version was engraved, Blake's by himself, Stothard's by Schiavonetti.

[3] Manchester City Art Galleries. [4] Collection of Lord Sherfield.

[5] "Mariana" was first published in *Poems, chiefly lyrical* (1830).

Much work, also, was inspired by Malory's *Le Morte d'Arthur*; like Burne-Jones's "The Beguiling of Merlin",[1] "The Madness of Sir Tristram",[2] Rossetti's "Sir Galahad at the Ruined Castle"[3] and G. F. Watts's "Sir Galahad".[4] Other paintings were inspired by Chaucer; like Burne-Jones's "Love and the Pilgrim",[5] a subject taken from *The Romaunt of the Rose*;[6] and by Dante, as in Rossetti's "Dante drawing an angel on the anniversary of Beatrice's death."[7]

But the Pre-Raphaelites are usually at their most effective when their own imaginings are allowed full rein, unfettered by a borrowed theme. This is evident in the poetic "Bower Meadow" by Rossetti,[8] and "The Mill" by Burne-Jones[9] (Plates 49 and 47). In each of these, dreamy and ripe maidens dance, and play on stringed instruments. There is an atmosphere of latent eroticism. In the Rossetti picture in particular, the accentuation of long, swelling necks, thick, sensuous lips and voluptuous, supple hands, should be full of excitement. Yet there is an atmosphere of sultry boredom, a certain perversity. Two girls dance together, and another, in the distance, hurries towards them; the two players stare into nothingness. It is a sexual daydream, in a chaste mediaeval setting. No man is present, and the theme could be interpreted as a longing for sexual completion; or it could be a Lesbian fantasy.

Burne-Jones's "Mill" is less erotic, but has much the same nostalgic atmosphere. Three girls dance, while a fourth plays a musical instrument. In the background, bathed in a golden light, is a water mill, and distant naked bathers are seen, ready to plunge into the mill stream. Perhaps the dancers, too, will soon strip and lower their pink forms into the golden and green depths of those quiet waters (for the mill wheels are still). It has

[1] Lady Lever Art Gallery.

[2] Present whereabouts unknown.

[3] City Museum and Art Gallery, Birmingham.

[4] Private collection.

[5] Tate Gallery.

[6] Poem attributed to Chaucer but probably only partly written by him. It is basically a translation of a French poem *Roman de la Rose* begun by Guillaume de Lorris and continued by Jean de Meung.

[7] Ashmolean Museum.

[8] City Art Gallery, Manchester.

[9] Victoria and Albert Museum.

something of the feeling of Burne-Jones's description of a mediaeval vision
he claimed to have seen in 1854:

> The day had gone down magnificently; all by the river's side I came
> back in a delirium of joy, the land was so enchanted with bright
> colours, blue and purple in the sky, shot over with a dust of golden
> shower, and in the water, a mirror'd counterpart, ruffled by the
> light west wind—and in my mind pictures of the old days, the abbey,
> and long processions of the faithful, banners of the cross, copes and
> crosiers, gay knights and ladies by the river bank, hawking-parties
> and all the pageantry of the golden age—it made me feel so wild and
> mad I had to throw stones into the water to break the dream.[1]

But Burne-Jones really made no attempt to paint the Middle Ages; his
vision was a Victorian view of what he would have liked the Middle Ages
to have been. "I want a shield or a crown or a pair of wings or what not, to
look real," he said. "Well, I make what I want, or a model of it, and then
make studies from that. So that what eventually gets on to the canvas is a
reflection of a reflection of something purely imaginary."[2] In such ways
was the mediaeval world distorted and tortured by Romantic art, in order
that it should fulfil the Romantic ideal.

But there is another aspect of the long ago and far away of Romanticism:
Chinoiserie, the vision of Cathay, a continent or country of the imagina-
tion, set in a period that never existed in time. It is Coleridge's Xanadu, the
world of the Spice Islands, the Land of Silk and Lacquer. It provided for
the Romantics an escape from contemporary industrialism, from the
exploitation of child labour, from political cynicism, into a world as remote
from theirs as is that of the planets from today's world. It is a land of poetic
landscapes, semicircular bridges hung with lanterns; of pavilions and
pagodas hung with bells, and divided by jade walls. The breeze is laden
with the scent of flowers, incense and spices. It is a leisured land, its people
as unaffected by events as the Lotophagi of the *Odyssey*. What better means
of escape than this was offered to the Romantics? It was a beautiful opium-
dream, without the drug.

Manifestations of the Chinoiserie style were seen everywhere—in
jewelry, porcelain, needlework, interior decoration, furniture and bijou-
terie. Women dressed in adaptations of Oriental and Middle Eastern styles,

[1] Burne-Jones, Georgiana, *Memorials of Edward Burne-Jones*, 1904, I, 97.
[2] ibid., II, 261.

as are shown on fashion plates, with young ladies arrayed in turbans, Circassian bodices, Armenian head-dresses, and in cloaks made of Chinese cord and American velvet.

Pagodas and tea-houses sprang up in the English landscape, beginning with the "House of Confucius", built at Kew about 1745 to the design of Joseph Goupy. This has now disappeared, but there remains a ten-storey pagoda, erected before 1763, on which George III, in his periods of madness, had a strong fixation. Another pagoda, built about 1824, forms a fountain at Alton Towers in Staffordshire; it was designed by Robert Abraham. At Woburn there is a fine Chinese dairy, built in 1787 to a design by Henry Holland; it has been recently restored. On 1 August 1814, a pagoda on a Chinese Bridge in Hyde Park was illuminated as part of a scene of national rejoicing. It was lit by gas and lanterns that were reflected in glass panels built into its sides. But it caught fire and, like the tower at Fonthill, crashed in ruins.

But attractive though some of these structures and ideas may have been, they all fall into insignificance beside the greatest and most extravagant of all English exotic buildings, the Prince Regent's Royal Pavilion at Brighton (1815–22; Plate 70) built in a mixture of Chinese, Hindu and Muslim styles. The Pavilion as we know it today is an adaptation, by John Nash, of an existing building. The profusion of its decoration and contents is breathtaking. There are supporting columns in the form of palm trees (their trunks made of cast iron, their leaves of sheet copper); there are vast crystal chandeliers decorated with serpents, dragons and flowers, and surmounted by palm leaves; there are painted Chinese wallpaper, simulated bamboo furniture and decorations; there are porcelain, metalwork, lacquer, carpets and hangings, some of them genuinely oriental, but most of them imitative.

Into this pleasure dome, the portly English Kubla could escape from the worries of state, with his court, friends, and especially his mistress, Mrs Fitzherbert. There he could imagine himself in a Romantic pagoda-land, and think perhaps of *Vathek*, "ninth Caliph of the race of the Abassides", who, "surpassed in magnificence all his predecessors."[1]

In contrast, some Romantics did not look upon the exotic as mere escape. To some it represented commerce—the East India Company traded

[1] From the opening paragraphs of William Beckford's *Vathek, An Arabian Tale* (1786).

in India, China and other parts of the Far East; other merchants, sometimes less profitably, traded in the New World. Many "shook the pagoda tree" in other ways, exploiting remote quarters of the globe, writing about or painting what they saw. Their works were sent home, where they helped further to fire the imaginations and fantasies of the Coleridges and Prince Regents. Such were Lady Mary Wortley Montagu,[1] the writer, and the painters, John Smart, George Chinnery, and the Daniells: Thomas and his nephews, Samuel and William.

The Daniells brought home portraits and pictures of exotic landscapes and architecture, of native villages, native costume, and wild animals; such things as a view of the Taj Mahal from the opposite side of the Jumna, as dramatic as a picture by Martin;[2] or a picture of a spotted antelope in its native habitat, flanked by a pineapple and colourful birds, in a composition worthy of Audubon (Plate 73).[3]

The exotic studies of the Daniells were mainly restricted to British Asia and Africa, but other artists went elsewhere. William Hodges brought home studies from the South Seas; George Chinnery from Bengal and China; John Frederick Lewis, David Roberts and Holman Hunt from the Middle East. John Smart brought back miniatures of maharajas and sahibs; George French Angas published first-class lithographs of natives, fauna, and views of Australia. George Catlin[4] exhibited living North American Indians in London and published engravings of his paintings of Indian costumes and customs. In Piccadilly, a Mr Bullock exhibited a collection of stuffed animals, birds and reptiles, supplemented by palm trees, suits of armour and other curiosities.[5] Live exotic animals were exhibited at the Menagerie in the Tower of London, and, from 1828, at the Zoological Gardens in Regent's Park.

All of these things had their effect on the Romantic imagination, all afforded an escape into a world of colourful buildings and landscapes, of noble savages in brilliant costumes, and of strange animals and birds. Their

[1] 1689–1762, traveller and writer.

[2] Queen Victoria Memorial Hall, Calcutta.

[3] Plate 2 from *Picturesque Illustrations of the Island of Ceylon* (1807). An impression is in the British Museum.

[4] 1796–1872, American artist. See McCracken, Harold *George Catlin and the Old Frontier*, New York, 1959.

[5] A view of the exhibition was published in Ackermann's *Repository of Arts*.

widespread effect was assisted by engravings, which enabled an exotic air to be brought into the homes of hundreds of families, who could not otherwise have participated in their heady pleasures.

One of the most successful of the engraving processes used, and one in which the Daniells were adept, was aquatint, which, because it employed tones, was particularly useful for reproducing water-colour drawings. In brief, it is a method of etching on metal plates, through a closely-spread porous and acid-resisting ground, consisting of resin dust, or of a deposit from a prepared spirit. The ground is fixed by gently heating the plate. The tones are produced by allowing different periods of exposure in the acid bath: white areas are stopped out with a resist before biting, while the darkest tones are those exposed longest.

Aquatint was invented in the eighteenth century, and refinements were added by Paul Sandby, who demonstrated the applications and possibilities of the process in such works as *Twelve Views in Aquatinta from drawings taken on the spot in South Wales* (1775), *Four Views of Warwick Castle* and *Five Views of Windsor Castle* (both 1776). In this way, in time, were made possible works such as the Daniells' *African Scenery and Animals* (1804–5), *Interesting Selections from Animated Nature* (1807–12) and *A Picturesque Voyage to India by way of China* (1810). Impetus was provided by the enterprising publisher Rudolph Ackermann, who seized on the possibilities of the medium, in order to publish a brilliant series of views and studies for which he is still justly famed.

Although it was a later invention than aquatint, lithography also made its contribution to this diffusion. It consists of printing from a plane surface, usually stone, but sometimes zinc. The printing surface is made chemically clean, and thus sensitive to grease; the design is drawn on the surface with lithographic chalk or ink. Those parts of the stone without drawn areas or lines are then desensitised by the application of gum arabic and dilute nitric acid. The stone is moistened, ink is applied from a roller, and it adheres only to the drawn parts. Paper is applied in a press and thus a print is obtained. Multi-coloured prints are made from a succession of stones, one for each colour.

The lithograph is notable for its softness of tone, which made it particularly suitable for a certain kind of Romantic expression, one that sought to clothe historical and exotic subjects in an atmosphere of mystery. Good examples of this are Angas's *South Australia Illustrated* (1846), Edward

Lear's *Views in the Seven Ionian Islands* (1863), John Richard Beste's *The Wabash* (1855), and Samuel White Baker's *Eight Years Wanderings in Ceylon* (1855).

The reference to Lear's views of Ionia is a reminder that Europe, too, provided food for the Romantic mind. It was then much more remote than now, when an hour or two in an airplane will take us to the extremities of the Continent, to Byron's Italy and Greece:

> *The isles of Greece, the isles of Greece!*
> *Where burning Sappho loved and sung,*
> *Where grew the arts of war and peace,*
> *Where Delos rose, and Phœbus sprung!*
> *Eternal summer gilds them yet,*
> *But all, except their sun, is set.*[1]

Many Romantic artists derived inspiration from classical antiquity. Theirs was a different view from that of the Neoclassicists, for it concentrated on the pastoral qualities of the ancient world, partly under the inspiration of such artists as Claude and Poussin, partly under that of such classical romances as Longus's *Daphnis and Chloe*[2] and Xenophon's *An Ephesian Tale*.[3] The later work of Edward Calvert, when he became personally involved in classical idealism, is full of it. But the idea of the pastoral mode is best expressed in Calvert's early engravings: the lithograph, "Ideal Pastoral Life", for example, in which, in a calm moonlit landscape, a shepherdess stands awaiting the return of her lover, who may be discerned in the distance, bringing with him a stray sheep (Plate 6). The primitive innocence of the scene is accentuated by the nakedness of the two figures, "Bearing the burden of a shepherd song."[4]

There were other expressions of the classical spirit in Romantic art. In Runciman's etchings, for instance, which contain the subjects, "Perseus, assisted by Minerva, killing Medusa", "Ariadne", and "Agrippina with the ashes of Germanicus". But these are from a series that also includes "St Margaret landing", "The Marriage of St Margaret and King Malcolm", and subjects from Ossian, and both in his treatment and conceptions, one

[1] *Don Juan*, Canto III, lxxxvi, I.

[2] Probably 2nd century AD. Nothing is known of Longus.

[3] About 2nd or 3rd century AD. Nothing is known of Xenophon of Ephesus. He should not be confused with the Athenian Xenophon (*c*. 430–*c*. 355 BC).

[4] Keats, *Endymion* I, l.136.

feels that Runciman was more sympathetic with these wilder northern themes than with those from the classical world.[1]

Yet there was, in Europe, much besides the classics to fascinate Romantics. The wild Alps, mixture of horror and sublimity; Venice, the sea-city, looking to both east and west, and with a history reaching into mediaeval times and earlier; ruins, like those of the Forum, the Colosseum and the Acropolis, vaster than any in Britain; mediaeval towns like Bruges,

[1] Runciman's preoccupation with northern themes was appreciated by his contemporaries, as is illustrated by "Verses to the Memory of Mr Alexander Runciman, History Painter, Edinburgh", published in *The Scots Magazine*, 1785, XLVII, 504:

> *Genius of Ossian! Whither art thou fled?*
> *Where hangs the harp attun'd to plaintive lays?*
> *Stoop from yon cloud where rests thy sacred head,*
> *And aid the Muse to sing thy Painter's praise.*
>
> *Ye River Gods! who dwell on Fortha's shore,*
> *Bend o'er your urns, and drop the pearly tear:*
> *Ye Silvan Nymphs, he'll paint your haunts no more,*
> *Nor make your sweet poetic scenes appear.*
>
> *For all that sweetest Fancy cou'd inspire,*
> *He form'd with taste and elegance of art;*
> *The noble groupe with animated fire,*
> *Or scenes of woe, to wake the feeling heart.*
>
> *To blame the age shall be no talk of mine;*
> *I leave it to some Bard of future time;*
> *We'll call it fate;—he calmly did resign,*
> *Tho' form'd to soar on Fancy's wing sublime.*
>
> *But yet Fame's monument his name shall save,*
> *And make his worth to other ages known,*
> *Whilst Fancy oft shall dress her Painter's grave,*
> *And Genius sit and weep upon his stone.*
>
> *He taught my young ideas first to flow;*
> *He pointed out to art the clearest way;*
> *His soothing manner height'ned Friendship's glow;—*
> *'Twas love of art and friendship wove this lay.*
> Hampstead, Middlesex, Oct. 30. F.L.

Abbeville and Heidelburg; Moorish Spain, Turkish Greece and the Moham-
medan Balkans. These beckoned the imaginative seeker for historic sur-
vivals and exotic incursions.

One of the most indefatigable searchers for such subjects was J. M. W.
Turner. Turner expressed himself both in oils and water-colours, and was a
virtuoso in each, bringing to his oil painting something of the lightness and
brilliance which he had learned to use in water-colour. But to some, his
water-colours have a freshness and urgency often missing from his oils.
Certainly they have suffered less from the passage of time, and remain as
brilliant as when they were first painted, while his oil paintings often have
the finger of time on them. His water-colours are so lightly painted, so
apparently effortless, that one feels that the artist has, like the Aeolian
harp, been touched by the breath of inspiration, and has almost flicked his
colour on to the paper in a moment. Yet that would be a misleading assump-
tion, for Turner was a strong and highly competent craftsman, who
had acquired his technique by long and constant application and prac-
tice.

Turner painted light. The whole of his colour and composition are
conditioned by that. Every detail, even to the tiniest nuance, is a reflection,
a dance, as it were, in accompaniment to sunrays, moonbeams, prismatic
raindrops, candlelight, or the glow of fireworks. In this way, he displayed
the Continental world as it had never been shown before. Sharp, defining
lines blur as the glare of light touches them, Venice dissolves in sunsets,
and Rome in the glow of flames. A silver rocket climbs above the Grand
Canal, with the Dogana and Santa Maria della Salute glowing below,
momentarily distinct in a blue night (Plate 74). Or, the whole Venetian
city glows like a blue shadow, as the sunrise, in indescribable shades of pink
and yellow, bathes the lagoon in morning light. It is as if the painter, in
terms of light, is showing the Continental scene set in the drama of a Byron,
combined with the gentle tones of a Chopin, yet with a steely strength of
his own.

As to European landscapes, there are Turner's studies of the Alps,
such as his oil painting of Monte Rosa from Val d'Aosta;[1] his water-colour
of Fluelen, Lake of Lucerne;[2] and his dramatic "Cottage destroyed by an

[1] Fitzwilliam Museum.
[2] Cleveland Museum of Art, Cleveland, Ohio.

avalanche in the Grisons"[1] (Plate 75), which was listed in the catalogue of
an 1810 exhibition with these lines of verse, written by the artist:

> *The downward sun a parting sadness gleams,*
> *Portentous lurid thro' the gathering storm;*
> *Thick drifting snow, on snow,*
> *Till the vast weight bursts thro' the rocky barrier;*
> *Down at once, its pine clad forests,*
> *And towering glaciers fall, the work of ages*
> *Crashing through all! extinction follows,*
> *And the toil, the hope of man—o'erwhelms.*

Here is a striking example of the Romantic combination of nature, beauty
and horror, a thousand times more effective than such extreme renderings
as Martin's "Great day of His Wrath",[2] or "The Deluge" (Plates 58 and
57), because it showed an event in nature, painted free from hysterical or
over-dramatised human accompaniment.

Many others followed Turner in depicting such scenes. There was a
great fashion for album pictures, and more serious topographical studies,
of remote parts of Europe, some of them highly attractive, like the Rev.
Jerome J. Mercier's[3] *Mountains and Lakes of Switzerland and Italy*, pub-
lished in 1871, and illustrated with coloured lithographs. Elijah Walton
painted a series of excellent water-colours for a book, *Peaks and Valleys of
the Alps* (1868); these were more precise and topographically "correct"
than Turner's studies, and it is an indication of how little Turner was
understood at this period, to recall that Walton accused him of exaggera-
tion and lack of strength. Yet Walton was himself a Romantic, revelling in
the vast and sublime natural wonders of his subjects, even though he saw
them, unlike Turner, more in terms of mass and outline than in those of
light.

Many Romantic artists were drawn to the Continent: the Rev. Edward
Thomas Daniell, to France, Italy and Switzerland; Ruskin to the Alps and
Italy; Palmer to Italy; William Wyld to France and Venice; Bonington to
France and Italy; Thomas Shotter Boys, Ambrose Poynter, John Scarlett
Davis, Samuel Austin and Alfred Downing Fripp—such artists are legion.
With many, as with Ruskin and Bonington, the Continent brought out the

[1] Tate Gallery. [2] Tate Gallery.

[3] I have been unable to trace any details of Mercier, beyond the fact that he
was the author of this book.

finest flower of their genius; to others it brought a touch of artistic death. To Palmer for one; after the magic of his Shoreham studies, his Italian water-colours, are tame, and it was only, later, in his etchings, that there was another glimmer of genius.

Some artists found their *genius loci* nearer home, in Wales, Ireland, and especially in Scotland, made popular by the novels of Sir Walter Scott, and in such specimens of Scottish Gothic as Ann Radcliffe's *The Castles of Athlin and Dunbayne* (1789), William Child Green's *The Prophecy of Duncannon, or, The Dwarf and the Seer* (1824), and T. J. Horsley Curties's *The Scottish Legend, or The Isle of St. Clothair* (1802). Views of Scotland by Turner were engraved by various craftsmen and printed in editions of Scott's poetry, to indicate the settings in which the action takes place. One of the most Romantic of them all is a view of Fingal's Cave by moonlight on the title page of *The Lord of the Isles*.[1] But they all show that blend of vastness, power of nature, and fascination with distant places, that are dominant features in this type of Romantic painting. And all breathe the essential wildness and ruggedness of the northern world:

> *O Caledonia! stern and wild,*
> *Meet nurse for a poetic child!*
> *Land of brown heath and shaggy wood,*
> *Land of the mountain and the flood,*
> *Land of my sires! what mortal hand*
> *Can e'er untie the filial band*
> *That knits me to thy rugged strand!*[2]

The fascination of Scotland was later given a further impetus by the visits of Queen Victoria and the Prince Consort to Balmoral. Tartan became an indispensable part of dress and decoration. It appeared even on linoleum, on local postage stamps, issued by Clark and Co. of Edinburgh,[3] and on snuff boxes made by Robert Brydone. Scottish themes were popular in the theatre, and, as we have seen, Scottish sentiments penetrated deep into Freemasonry and its allied orders. Scottish subjects occur throughout

[1] Engraved by E. Goodall. The book appeared in a Gothic binding, and was published at Edinburgh in 1857.

[2] Scott, *The Lay of the Last Minstrel*, Canto VI.

[3] Beyond the fact that its headquarters were at 10 Calton Street, little is known of this firm. On both Clark and Co. and Brydone, see Patton, Donald, *Farthing Delivery*, 1960, 18.

Romantic painting; Landseer's "Monarch of the Glen"[1] and "The Challenge" (Plate 7), showing Highland scenes with no man present, and dominated by great antlered stags; Wilkie's "Going to the drawing room, Holyrood House"[2] which records a scene during the visit to Edinburgh in 1822 of George IV, who appeared in Highland costume, with his legs encased in pink tights; the colourful plates in John Sobieski Stolberg Stuart's *The Costume of the Clans* (1845); Fanny Ellsler in a lithograph by Haguental, in the ballet *La Gypsy*, with Edinburgh Castle in the background.

Scotland, Greece and Italy; Cathay and Hindoostan; monks, knights, bards and druids; these are the distances and remotenesses of Romanticism, which gave rise to a Taj Mahal beside the sea in Sussex, and a fairy abbey in Wiltshire; to a myriad exotic views of wonders and horrors; to a ceremony at sunrise on Salisbury Plain; and to trilithons confronting an English Jerusalem.

[1] In the possession of John Dewar and Sons Ltd.
[2] National Gallery of Canada, Ottawa.

CHAPTER FIVE

Science and Industry

While bright-eyed science watches round.
Thomas Gray, *Ode for music*[1]

It is the Age of Machinery, in every outward and inward sense of
that word.
Thomas Carlyle, *Signs of the Times*[2]

POLITICS did not provide the only revolutions during the Romantic
period. No less shattering in its effect upon contemporary life and art
was the revolution that, aided and abetted by science, was taking place in
industry.

The Industrial Revolution was not a sudden event, but the culmination
of many separate and often gradual movements. Among these were the
development of the iron and steel industries—which itself helped to make
possible the development of the steam engine—and the development of the
textile industry, which led to the manufacture of machinery such as the
spinning jenny, invented by James Hargreaves in 1767; the water frame,
invented by Sir Richard Arkwright in the following year; and the spinning
mule, invented by Samuel Crompton in 1775. Communications were
developed also, so that there was a whole new network of roads, canals
and, later, railways, by means of which the products of the new industries
could be distributed.

The social consequences of such developments, as is well known, while
enriching some, brought much impoverishment and suffering to many
others. Many Romantics, who, as we have seen, were so often on the side
of the outcast, were aware of this, and sought in their art to bring it to the
attention of others: to show how the noble spirit of Man, Prometheus-like,
was chained down to the rock of economics; to show, as Thomas Hood
showed in *The Song of the Shirt*, the evils of forced labour:

[1]. l. 11.
[2] Written in 1829, and published in the *Edinburgh Review*, No. 98. See Carlyle,
Thomas, *Critical and Miscellaneous Essays*, 1872, II, 233.

> *Work—work—work!*
> *My labour never flags;*
> *And what are its wages? A bed of straw,*
> *A crust of bread—and rags.*
> *That shatter'd roof,—and this naked floor—*
> *A table—a broken chair—*
> *And a wall so blank, my shadow I thank*
> *For sometimes falling there!*
>
> *O, but to breathe the breath*
> *Of the cowslip and primrose sweet!—*
> *With the sky above my head,*
> *And the grass beneath my feet;*
> *For only one short hour*
> *To feel as I used to feel,*
> *Before I knew the woes of want*
> *And the walk that costs a meal!*[1]

Some took a wider view of the evils of industrialization; they tried to show its effect on the soul of mankind—the brutal, mechanistic rationalization that Blake saw tearing into Man's soul, like horrors from Pandora's box:

> *First Trades & Commerce, ships & armed vessels he builded laborious*
> *To swim the deep; & on the land, children are sold to trades*
> *Of dire necessity, still laboring day & night till all*
> *Their life extinct they took the spectre form in dark despair;*
> *And slaves in myriads, in ship loads, burden the hoarse sounding deep,*
> *Rattling with clanking chains; the Universal Empire groans.*[2]

And, at the side of another, somewhat similar passage, in *Jerusalem*, there is a long steel chain, a device symbolising the "inchained soul".[3] It is only by sacrifice of the selfhood that this chain may be broken, allowing Man to realize his destiny, as symbolized later in the same work, by Albion's gesture before the crucified Jesus.[4]

But not every Romantic saw the new developments in this way. Some saw them as a gateway to salvation, to a golden age. Erasmus Darwin for one, who sang the praises of Thomas Savery's steam engine, and prophesied its future wonders:

[1] v. 6, 9. [2] *Four Zoas*: Keynes, 333.
[3] cf. *America*, pl 6, l. 8. [4] *Jerusalem*, pl. 76 (Plate 28).

NYMPHS! you erewhile on simmering cauldrons play'd,
And call'd delighted SAVERY to your aid;
Bade round the youth explosive STEAM aspire
In gathering clouds, and wing'd the wave with fire;
Bade with cold streams the quick expansion stop,
And sunk the immense of vapour to a drop.—
Press'd by the ponderous air the Piston falls
Resistless, sliding through its iron walls;
Quick moves the balanced beam, of giant-birth,
Wields his large limbs, and nodding shakes the earth.

Soon shall thy arm, UNCONQUER'D STEAM! afar
Drag the slow barge, or drive the rapid car;
Or on wide-waving wings expanded bear
The flying-chariot through the fields of air.[1]

Darwin's sentiments are a far cry indeed from Blake's remark, when shown a copy of the *Mechanic's Magazine*, "Ah, sir, these things we artists HATE!"[2] Nevertheless, despite the grave forebodings of Romantics like Blake, euphoria continued in possession of others. Optimism was reflected even on the trade tokens which were issued in the eighteenth and nineteenth centuries, to compensate for a shortage of official copper coinage. Craftsmen are shown on them, happily and industriously at work: weavers, spinners, drop forgers, blacksmiths and others. There are allegories of trade and prosperity; armorial bearings and topographical views; portraits of industrialists; and on many there appears a druid's head, with a long beard and cowl, sometimes flanked by branches of oak.

Optimism was shown also by Richard Trevithick, maker of the first railway locomotive, who, to celebrate the passing of the Reform Bill, planned to erect a gilded cast iron monument of conical shape, one thousand feet high, one hundred feet in diameter at the base, twelve feet in diameter at the top, and weighing six thousand tons. Perhaps it is fortunate for posterity that the earth was not after all encumbered with this erection.

Even as late as 1864, Charles Tennyson Turner, elder brother of Alfred Tennyson, could write of the electric light on the South-Foreland:

[1] *The Botanic Garden*, Part I, "The Economy of Vegetation", Canto I, l. 253, 289.

[2] Gilchrist, *Life of Blake*, 325.

From Calais pier I saw a brilliant sight,
And from the sailor at my side besought
The meaning of that fire, which pierced the night
With lustre, by the foaming billows caught.
"'Tis the South Foreland!" I resumed my gaze
With quicker pulse, thus, on the verge of France,
To come on England's brightness in advance!
There! on the waters! In those far-seen rays
I hail'd the symbol of her fame in fight:
But, by a change akin to that which brought
The lightning under rule, the martial thought
Flash'd itself out, transform'd to quiet light;
I turn'd to all the good she did and taught,
Her shining honour and her moral might.[1]

One of the greatest English artists to express the euphoric aspect of Romantic industrialism was Joseph Wright of Derby, of whose work, the *Blacksmith's Shop* of 1771[2] is typical (Plate 101). The bright white heat of the iron on the anvil, lighting up the faces and forms of the workmen around it, and causing one of the onlooking children to hide her face in fear, illustrates both Wright's optimistic view of industry and technology, and his painterly interest in the portrayal of light and shadow and their effects. These effects were as impressive in their way as, in theirs, are those achieved by Caravaggio,[3] Gerard von Honthorst,[4] and Georges de La Tour.[5] The classical ruin in which the scene is set is unlike any blacksmith's shop likely to have existed in England, but it accentuates the Romantic conception of the work, in that it reminds the viewer of the past, as well as showing him wonders of industry.

There is often, as here, a timid or fearful figure in Wright's pictures; perhaps it was intended to symbolize a more doubtful view of science and industry. One of the best known examples of this is his "Experiment with an air pump",[6] in which a little girl is weeping at the fate of a bird, which will die when the air is pumped out of the glass globe in which it is

[1] *Collected Sonnets*, 1864, 131.
[2] British Museum. There are other versions of the subject by the same artist.
[3] Michelangelo Merisi da Caravaggio (1573–1610), Italian painter.
[4] 1590–1656, painter of the Utrecht school.
[5] 1593–1652, painter of the French school.
[6] Tate Gallery.

fluttering (Plate 98). But the fearful figure is not invariably present; in "A philosopher giving a lecture on the orrery",[1] everybody portrayed, including three children, watch with wrapt interest; but here there is no life-and-death drama, no latent threat, only a demonstration of a theoretical machine.

Wright's subject matter was widespread, ranging from portraits to volcanic eruptions, from allegories like "The Old Man and Death" (Plate 10), to an imaginative subject, like that meticulously entitled: "The Alchymist in search of the Philosopher's Stone, discovers Phosporus, and prays for the successful conclusion of his operation, as was the custom of the Ancient Chymical Philosophers."[2] But nearly everywhere Wright's paintings are dominated by the artist's fascination with the effects of light, and his enthusiasm for science and industry.

Science exercised a powerful influence also on the painter George Stubbs, who, even without his magnificent portraits and studies of horses, would be sure of an important place in any history of English art, because of his great engravings of anatomical studies, published in Dr John Burton's *An Essay towards a Complete New System of Midwifery* (1751; Plate 64), his own *The Anatomy of the Horse* (1766), and the unfinished *A Comparative Anatomical Exposition of the Structure of the Human Body, with that of the Tiger and Common Fowls*, published posthumously in 1817. Stubbs's Romanticism was centred in realism, and took form as an accurate record of what he found in nature, which for him provided wonders sufficient, without the addition of imaginative glosses. And to achieve this, he braved the stench and putrescence of dead animal corpses hanging from the rafters of his kitchen.

Others were less keen on anatomy, whether in dissection of corpses or surgery on the living. Blake, for instance, in *An Island on the Moon*, poked fun at the surgeon Dr John Hunter, who appears under the not inappropriate pseudonym of "Jack Tearguts":

"Ah!" said Sipsop, "I only wish Jack Tearguts had had the cutting of Plutarch. He understands anatomy better than any of the Ancients. He'll plunge his knife up to the hilt in a single drive, and thrust his fist in, and all in the space of a Quarter of an hour. He does

[1] Derby Museum and Art Gallery.
[2] ibid.

not mind their crying, tho' they cry ever so. He'll swear at them & keep them down with his fist, & tell them that he'll scrape their bones if they don't lay still & be quiet. What the devil should the people in the hospital that have it done for nothing make such a piece of work for?"[1]

Not unrelated in spirit to Stubbs's anatomical drawings were engineering technical drawings, in which machinery was drawn in detail and analysed (Plate 102). They were as different as could be imagined from the dry-as-dust dye-line and blueprints of our own age. The engineering drawings of the Romantic age were wash-coloured, each metal or substance having a standard colour or pattern, by which it could be immediately recognized. Nor were the draughtsmen averse to showing such unfunctional details as great flames of fire in boiler fireboxes, or spectators standing by—thus linking man with this aspect of his environment.

The industrial scene, although not always immediately obvious, appears in the work of John Martin, whose apocalyptic views of ancient Babylon, Nineveh and Canaan, and of Pandaemonium, are inspired in part by scenes in industry and by its products. The glowing landscapes in his "Sadak in search of the water of oblivion"[2] and "The great day of His Wrath" (Plate 58) are derived from the smoky, glowing atmosphere of foundries, smelting works or potteries. The illustration in Milton's *Paradise Lost* of Satan presiding over the council of Pandaemonium,[3] shows the setting illuminated by what are almost certainly rings of gas jets. "The Hollow Deep of Hell",[4] from the same series, could have been inspired by a scene in a coalmine.

The converse may also be true—that Martin's pictures inspired or influenced industrial architecture. "Belshazzar's Feast"[5] and "The Fall of Babylon"[6] may have suggested the design of certain railway stations; the

[1] Keynes, 50.

[2] Private collection.

[3] Present whereabouts unknown. An impression of the mezzotint is in the British Museum.

[4] Present whereabouts unknown. An impression of the mezzotint is in the British Museum.

[5] Private collection. An impression of the mezzotint is in the British Museum.

[6] Present whereabouts unknown. An impression of the mezzotint is in the British Museum.

design of some parts of the Thames Tunnel was remarkably like one of the *Paradise Lost* illustrations: "At the Brink of Chaos"[1] (Plate 59). But Martin's own inspiration for this may have been a work by Hieronymus Bosch,[2] a painter with whose work he was surely acquainted, for in some ways their *oeuvres* are remarkably akin. This is the picture "Paradise and the ascent to the Empyrean", in the Doge's Palace at Venice, in which there is a great eye-like tunnel with winged figures at the end, much as in Martin's picture. But, while allowing for the difference in the stature of the two painters, there is much in Bosch that is almost interchangeable with similar scenes in Martin's *oeuvre*: such are the burning backgrounds in Bosch's "The Garden of earthly delights",[2] the St Julia altarpiece,[3] the Altarpiece of the Hermits,[4] and "The Last Judgement".[5]

Martin's fiery scenes are among his most impressive: the plates from *Paradise Lost*—"Pandaemonium", "Satan on the burning lake"; "Sadak", "The Fall of Babylon", "The Fall of Nineveh", "The Great Day of his Wrath", and many more.[6] These have a smouldering, smoky atmosphere akin to that described by Anna Seward, "the Swan of Lichfield" (1747–1809):

> *Grim WOLVERHAMPTON lights her smouldering fires,*
> *And SHEFFIELD, smoke-involv'd; dim where she stands*
> *Circled by lofty mountains, which condense*
> *Her dark and spiral wreaths to drizzling rains,*
> *Frequent and sullied; as the neighbouring hills*
> *Ope their deep veins, and feed her cavern'd flames;*
> *While, to her dusky sister, Ketley yields,*
> *From her long-desolate, and livid breast,*
> *The ponderous metal.*[7]

Fire, and its industrial and scientific refinements, excited many Romantics. "O! how brightly, whitely vividly beautiful is Oxygen gas!" exclaimed Coleridge. And he described qualities of other substances in fire:

[1] Present whereabouts unknown. An impression of the mezzotint is in the British Museum

[2] Prado, Madrid.

[3] Doge's Palace, Venice. [4] ibid.

[5] Akademie der bildenden Künste, Vienna.

[6] Martin's engravings are catalogued in Balston, *John Martin*, 281–93.

[7] *Poetical Works*, ed. Sir Walter Scott, Edinburgh, 1810, II, 218.

the sparkling of iron wire, the red flame of wood charcoal, the bright violet or crimson blue of tin, the green and blue of copper, the "greenish flame" of silver, the blue, white and purple of sulphur, and the blue flame of cochineal.[1] Charles Dickens wrote some vivid descriptions of fire in the industrial landscape, in *The Old Curiosity Shop* (1840–41):

> But, night-time in this dreadful spot!—night, when the smoke was changed to fire; when every chimney spirted up its flame; and places, that had been dark vaults all day, now shone red-hot, with figures moving to and fro within their blazing jaws, and calling to one another with hoarse cries—night, when the noise of every strange machine was aggravated by the darkness . . .[2]

Martin—and Francis Danby, much of whose work was conceived in a similar spirit[3]—saw Man as a puny being, living at the mercy of vast elemental forces that could become destructive in the twinkling of an eye. Certainly, in the new industrial landscape that inspired Martin, Man proved to be puny enough; those involved seem to have been either exploiters or exploited in a march of savage and menacing greed. The factory furnaces not only reddened the sky; they appeared to be searing the very being of Man. Finally the earth would be deserted, and only one man would remain, an ancient, bearded Lear-like figure on a cliff, surrounded by his dead companions, patiently awaiting oblivion, while the city in the valley below is bathed in fire.[4]

Martin was also influenced by the contemporary scientific climate, and, persuaded by the geologist, Gideon Mantell, he made an oil painting of "The Country of the Iguanadon",[5] which was reproduced in mezzotint as a

[1] *The Notebooks of Samuel Taylor Coleridge*, ed. Kathleen Coburn, 1957 and 1962, I, 1098.

[2] Ch. xlv.

[3] Although it is outside the scope of the present book, the work of the Americans, Washington Allston and Thomas Cole, should not be overlooked in this context. See *Washington Allston* by M. F. Sweetser, Boston, 1879; "Cole, Byron and *The Course of Empire*" by Alan P. Wallace, *Art Bulletin*, December 1968, 375–79.

[4] Martin's picture, "The Last Man", was exhibited at the Manchester Art Treasures Exhibition in 1857. A version was mezzotinted in 1836 by Martin's son, Alfred, and was published with a dedication to Thomas Campbell, the poet.

[5] The present whereabouts of the painting is unknown.

frontispiece to the first volume of Mantell's *The Wonders of Geology* (1840). At about the same time he engraved the frontispiece to Thomas Hawkins's *The Book of the Great Sea-Dragons*.[1] This is a highly imaginative and nightmarish composition, showing pterodactyls feeding on the carcase of a monster, while great saurians, with luminous eyes, fight in the sea, faintly echoing, perhaps, Blake's visions of Behemoth and Leviathan in *Illustrations of the Book of Job*, or the serpent of Nature-worship on the title page of *Europe*. And are those luminous eyes—uncannily like those in Fuseli's "Nightmare" (Plate 19)—a remembrance of that passage in a footnote in Erasmus Darwin's *Botanic Garden*, in which a cavern at Coalbrookdale is recalled: "where the mineral tar exudes, the eyes of the horse, which was drawing a cart from within towards the mouth of it, appeared like two balls of phosphorus, when he was above 100 yards off, and for a long time before any other part of the animal was visible."[2]

Apart from his art, Martin was involved in the industrial and scientific scene, for he drew up various plans for improvements to London, including those for a better water supply and method of sewage disposal. Other schemes he put forward, aimed at purifying the air in coal mines, and at various improvements in railway and shipping equipment. Although he went so far as to form a company to deal with his proposals for metropolitan water and sewage, none of these plans came to fruition.

Such polymathic activities were in themselves a symptom of the Romantic era, when the questing mind searched everywhere for minute particulars. Blake was poet, engraver, prophet, printer and painter; Rossetti, Samuel Palmer and Edward Calvert were each both writer and painter; so, too, was Gerard Manley Hopkins, who was also a Jesuit priest. Sir Edward Poynter was a collector and connoisseur as well as a painter, and for a period was both President of the Royal Academy and Director of the National Gallery. George Darley was poet, critic and mathematician; Sebastian Pether was a landscape painter, and claimed also to have invented the stomach pump; William Dyce extended his activities beyond painting to music, architecture, church ritual, science and industrial art. Sir Robert Ker Porter, besides being a painter (he made a series of twenty-

[1] The present whereabouts of the painting is unknown.

[2] 1791 ed. Part I. "The Economy of Vegetation"; Additional Notes, Note III, 8–9.

six attractive illustrations to Anacreon),[1] was diplomat, traveller, horseman, sportsman and writer. One of the most impressive of all in this context was the Scot, Alexander Nasmyth, who worked as a bridge and roof designer, engineer and painter. He was also the designer of one of the earliest of steamboats, which was given its trial on Dalswinton Loch in 1788, with Robert Burns on board. Nor must we forget Sir Humphry Davy, the natural philosopher and writer on many subjects, including fly-fishing, natural history and travel, whose Romanticism was capable of inspiring him to write this passage, following a description of an idyllic night scene at Tintern:

> No longer connected with the earth, I seemed to mingle with Nature; I pursued the dazzling of the moon-beams; I raised myself above the stars, and gave imaginary beings to the immeasurable paths of ether. But when I cast my eyes on the remains of mortality,—when I considered, that in that deserted spot, where the song of the nightingale and the whispering of the wings of the bat were the only signs of life, thousands of thoughts, an immense mass of pleasureable ideas, had rolled through the minds of a hundred intelligent beings,—I was lost in a deep and intense social feeling. I began to think, to reason, What is existence? What is this eternal series of changes in life, in thought, and sentiment? The globe undergoes no physical revolution, whilst the physical organized beings upon the surface of it are perpetually modifying; the laws by which the physical phenomena of the universe are ruled are always the same: are there no laws by which the moral phenomena are governed? Nothing remains of them but mouldering bones; their thoughts and their names have perished. Shall we, too, sink in the dust? shall we, too, like these beings, in the course of time, be no more? shall that ever-modified consciousness be lost in the immensity of being? No, my friend, individuality can never cease to exist; that ideal self which exists in dreams and reveries, that ideal self which never slumbers, is the child of immortality, and these deep intense feelings, which man sometimes perceives in the bosom of Nature and Deity, are presentiments of a more sublime and energetic state of existence.[2]

Some would claim that polymathic diversity led to fragmentation, with

[1] They were engraved by Giovanni Vendramini, and published between 1803 and 1805 by John P. Thompson. They have many curious affinities to work by Blake. See Appendix III.

[2] Davy, John, *Memoirs of the Life of Sir Humphry Davy*, 1839, 65-6.

consequent loss of direction and impact. But we must beware of judging the activities of past eras in present-day terms. It is possible—although not necessary—that such diversity would now lead to such weakening, for present-day knowledge is so deep that a man may spend his whole life in studying a tiny compartment of a subject. In the Romantic age, knowledge was not so detailed, and it was not difficult for a man to take a more sweeping view. In many ways, we are the losers, for there is no doubt that modern specialization is not a civilizing process; that the now unfashionable breadth of vision is, strange though it may seem, more likely to lead to the minute particulars that the Romantic sought.

But let us look at the effect of industry and science on another Romantic —J. M. W. Turner. It may now seem to us incredible, but at one period, John Martin was put into the same class as Turner, if not somewhat above him. Writing in *The Times* on 23 January 1901, a critic said that "Turner and Martin, one the apostle of light and beauty, the other of sublimity, made a greater advance in painting than any other two men before or since . . . Turner might be described as the apotheosis of Claude, but Martin is unique." Few people would go so far as that today; but it is true that industry had as deep an influence on Turner as it had on Martin. It was inevitable that its special qualities of light and atmosphere would attract a painter so fascinated with them.

Some of Turner's industrial landscapes are almost purely topographical: such is "The Limekiln at Coalbrookdale",[1] although even that is a wonderful painting of fire and its reflections. But in Turner's greatest work, as in "Rain, Steam and Speed—the Great Western Railway",[2] and "Steamer in a Snowstorm"[3] (Plates 77 and 76), we have arrived at the very apotheosis of the Romantic view of industry, in which inventions of the age of iron and steam are shown amidst the atmosphere and light of nature.

Some saw in machinery and industrial building a great beauty. The engineer, Isambard Kingdom Brunel, saw little incongruity between the railway and the landscape, and went so far, when building the Great Western Railway, as to indulge his Romantic tendencies, by leaving a tunnel entrance uncompleted, and training ivy over it, so as to give the impression of a ruined medieval gateway.

[1] Present whereabouts unknown. [2] National Gallery, London.
[3] ibid.

There is no doubt that Thomas Telford's Pont-y-Cysyllte aqueduct is a beautiful thing. It is over a thousand feet long, is supported on nineteen piers of masonry, and carries the Ellesmere Canal from side to side of the Vale of Llangollen, one hundred and twenty-one feet above the River Dee (Plate 78). It was an impressive sight in its heyday, when a small ship in full sail could be seen moving across the aqueduct, almost, it must have seemed, among the clouds.

Among smaller things was that pretty little machine, Jacob Perkins's Improved Rose-engine, described in the patent specification[1] as an "Engine Lathe for Engraving Surfaces, Printing and Coining Presses, &c." It was this machine that engraved the elaborately patterned backgrounds of the first postage stamps, and the engine-turning on banknotes and other documents. Those early stamps included the famous Penny Black and Cape of Good Hope triangulars; the issues of Trinidad, Mauritius and Barbados, engraved with Edward Henry Corbould's figure of Britannia; and the issues of Queensland (Plate 79), Van Diemen's Land, Grenada, Nova Scotia and elsewhere, bearing a portrait of Queen Victoria, based on her coronation portrait by A. E. Chalon.[2] All of them—essentially products of Romantic art wedded to industry—owed much of their beauty to the work of the Rose-engine.

Similar combinations emanated from other departments of the printer's craft—ephemera such as trade-cards, posters, wrappings, billheads, catalogues, forms and druggists' labels. Blake engraved a visiting card (or it may have been intended as a book label) for his friend George Cumberland.[3] Thomas Bewick engraved billheads, book labels and letterheadings; similar

[1] AD 1819. No. 4400. A photograph of the lathe is reproduced in *Postage Stamps in the Making* by F. J. Melville, 1916, 87. Jacob Perkins was an American, born at Newbury Port, Mass. in 1766. He died in 1849. He was helped in the perfection of the Rose-engine by his son, Angier March Perkins (1799–1882), who came to England in 1827. A. M. Perkins patented several other engineering inventions. See Boase, Frederic, *Modern English Biography*, Truro, 1897, Vol. II.

[2] Present whereabouts unknown. The original portrait was presented to the Queen by her mother, the Duchess of Kent. The last record of it was when it was shown at the Jubilee Exhibition in 1897. However, two copies of it were made by Chalon himself, one of which went to the King of Prussia, and the other to the King of Portugal. The King of Portugal's copy was bought by Mr Robson Lowe who still owns it, and who communicated the contents of this note. [3] 1754–184?.

work was produced by the pharmacist and printer, William Davison of Alnwick.[1] But much of such work came from humbler and now unknown men, printers of such unconsidered trifles as small circular watch papers, used for excluding dust from watches, and perfumier's labels within Gothic or floral borders, sometimes decorated with a sprig of the flower that gave the contents its scent. The variety of such ephemera is endless: soup, sauce, pickle, tea and coffee labels; writing paper with a view of the owner's residence; tiny stationers' and bookbinders' labels to stick inside the covers of books; invitations to city feasts, engraved with an allegory of Britannia, surrounded by figures representing trade, empire, defence and plenty.

A new process was used to make the tiny prints on needle-cases: they were printed by George Baxter in his "Oil Colour Picture Printing" process—a woodblock method, which used oil-based printing ink. It was first used for printing the frontispiece of Robert Mudie's *Feathered Tribes of the British Isles* (1834), which showed a Romantic view of an eagle on its nest with its prey, and a vulture flying above.

Baxter's process was the forerunner of many others, which were soon to be used for printing such masterpieces of colour printing as Owen Jones's *Grammar of Ornament* (1856); the book-wrappers of Edmund Evans; H. Noel Humphreys's *Art of Illumination* (1849); and the brilliant *Sacred Annual* (4th edn. 1834), containing coloured reproductions of paintings by Martin, Etty, Haydon and others.

The attempt to aestheticize machinery was taken a stage further by the mathematician and scientific technologist, Charles Babbage, who was also the inventor of a calculating engine that in time led to the development of the modern computer. In 1826, Babbage published, in the *Philosophical Transactions* of the Royal Society, a paper entitled, "On a method of expressing by signs the action of machinery." The method consisted of a form of notation, by means of which the movements and rhythms of machinery could be written down and analysed, as music notation records and analyses sound, and dance notation records and analyses the movements of the human body (Plate 102). Thus mechanical movement was given a language with distinct artistic possibilities, even if they have not yet been realized.

[1] 1781–1858.

Similar analysis was made of the movements of horses, as in *Le Cheval* by E. Cuyer and E. Alix (Paris, 1886), which was published with a set of plates with movable flaps, displaying details of equine anatomy, and with movable figures, that could be placed in various positions, illustrating equine articulation. Some years earlier, in 1852, had been published *La Sténochorégraphie* by Arthur St Léon, which was intended as a method by which ballets could be written down, although, in the event, only a *pas de six* from St Léon's earliest ballet, *La Vivandière*, was thus recorded. Another system was published at Paris in 1892: W. J. Stépanov's *Alphabet des Mouvements du Corps Humaine*;[1] this was more successful than St Léon's system, and it was because certain great classical and Romantic ballets were recorded in it, that it is still possible to dance them in their original form.

These systems of recording animal and human movement were developed from earlier, but similar, eighteenth-century systems, but they do illustrate a certain Romantic preoccupation with scientific analysis, even within the arts. Other subjects, too, were similarly analysed; colour, for instance, by Goethe,[2] and in *The Principles of Harmony and Contrast of Colours*, by M. E. Chevreul, which appeared in an English translation in 1860.[3] These works are French, Russian or German, and therefore really outside the scope of this book, but I know of no similar contemporary English works that illustrate so well this aspect of Romanticism; yet that the spirit of such exercises existed here is evident from the work of men like Stubbs and Babbage, and from some of the activities of Edward Calvert, who worked on a "musical theory" of colour.[4]

The machine was brought into the arts in several ways. There were mechanical musical instruments, which were something quite different, both in conception and operation, from the Aeolian harp, which we have already discussed at some length. That wrested its power from a natural phenomenon, the wind. These took theirs from a purely mechanical source. They were, in their heyday, treated with some seriousness, for even Beethoven

[1] An English translation by the present writer was published in New York in 1969, under the title *Alphabet of Movements of the Human Body*.

[2] Matthaei, Rupprecht (ed.), *Goethe's Colour Theory*, 1971.

[3] A shorter discourse on colour appeared in Charles Hayter's *An Introduction to Perspective, Practical Geometry, Drawing and Painting*, 1845, 203–21.

[4] See Calvert, Samuel, *A Memoir of Edward Calvert*, 1893, 157–73.

composed for them—his *Wellingtons Schlacht bei Vittoria* was originally written for a mechanical organ, and he composed other pieces for a flute-playing clock. On the whole, however, these instruments were Continental rather than British, although they were very popular in this country, and had their place in the Romantic scene. Moreover, there were some proposals to make something of the kind here. One came from Erasmus Darwin who, in a discussion of Newton's *Optics*, proposed a form of semi-mechanical "colour music", which, he wrote, would consist "of successions or combinations of colours, analagous to a tune . . . This might be performed by a strong light, made by means of Mr Argand's lamps, passing through coloured glasses, and falling on a defined part of a wall, with moveable blinds before them, which might communicate with the keys of a harpsichord; and thus produce at the same time visible and audible music in unison with each other."[1] Argand, it should be added, was the Swiss, Aimé Argand (1775–1803), and his lamp was the familiar oil lamp with a glass chimney.

Mechanical methods were used also by painters. Silhouette artists in particular used a variety of machines and mechanical aids, one of which is illustrated in Lavater's *Physiognomy*. Some of them were given high-sounding, pseudo-scientific names, like the Prosopographus, which was operated in Huddersfield, and cut profile likenesses for a shilling; and the Ediograph, invented by John Oldham, the Irish engineer (1779–1840). Most of these machines consisted of a long bar on a fulcrum, with a knife or pencil at one end and a thin rod at the other. The profilist passed the rod around the profile of the sitter, while the other end cut or traced the image on a piece of paper. It is hardly necessary to add that portraits taken in this way lacked the refinement of those drawn or cut freehand.

Optical mechanics were used in some forms of entertainment. The magic lantern brought strange and exotic scenes into the home or lecture room. Martin was probably influenced by the peculiarly luminous effect of magic-lantern projections, for many of his pictures have that softly glowing quality. More elaborate contrivances provided entertainment on a wider scale. Such was that development of the raree-show, the "Eidophusikon;

[1] *Botanic Garden*, Part II, "The Loves of the Plants", 1791 edn., 140. Similar ideas were later put into practice, facilitated by the invention of electricity. See Rimington, A. Wallace, *Colour Music*, 1911.

or, Various Imitations of Natural Phenomena, represented by Moving Pictures." It was invented by the émigré Alsatian painter, Philip James de Loutherbourg, who settled in England in 1771. It was a system in which moving pictures were shown within a proscenium, by means of a combination of Argand lamps, coloured gauzes, lacquered glass and receding planes, which reproduced scenes with realistic atmospheric effects.

It was first shown in February 1781, when, in a darkened auditorium, a moving panorama of London was exhibited under the title, "Aurora: or the Effects of the Dawn, with a View of London from Greenwich Park." Exotic scenes were then exhibited, under the titles of "Noon; the Port of Tangier in Africa, with the distant view of the Rock of Gibraltar", "Sunset; a view near Naples", and "Moonlight; a view of the Mediterranean, the Rising of the Moon contrasted with the Effect of Fire." Each of these was accompanied by songs. Finally there was a "Conclusive Scene, a Storm at Sea, and Shipwreck."

Another typical performance is described in a contemporary advertisement:

EXHIBITION ROOMS, over EXETER CHANGE, STRAND This present MONDAY evening there will be a Representation of Mr. LOUTHERBOURG'S EIDOPHUSIKON, Including the awful, pathetic, and most interesting scene of the STORM and SHIP-WRECK, conveying a striking idea of the late dreadful catastrophe of the HALSWEL EAST-INDIAMAN; and the GRAND SCENE from MILTON'S PARADISE LOST, confessedly the Chef d'Oeuvre of that incomparable artist, with suitable accompaniments.

The pauses necessary to change the scenery will be supplied with English READINGS and RECITALS, BY MR. CRESSWICK.

First seats 3s. Second seats 2s.

The Doors to open at half past seven, and the performance to begin precisely at eight. Places for the first seats may be taken from Ten till Five.

The Days of Exhibition are MONDAYS and FRIDAYS.

The Eidophusikon was a most popular entertainment; its admirers included Gainsborough, who sometimes helped de Loutherbourg in working the effects. Gainsborough possessed a toy model of the contrivance, which was exhibited at the Grosvenor Gallery in 1885. He was said to be "so wrapt in delight with the Eidophusikon, that for a time he thought of

nothing else—he talked of nothing else—and passed his evenings at that exhibition in long succession."[1] Reynolds, too, was fascinated by it, and recommended it to his friends as suitable entertainment for their daughters.

An amazing variety of scenes were shown. In addition to those mentioned above there were thunderstorms, military and naval scenes, Alpine hunting scenes and the Niagara Falls. But some of the most spectacular effects of the Eidophusikon were used in scenes from Milton, one of which, it will be recalled, is mentioned in the advertisement I have just quoted. Here, indeed, in a description of "the region of fallen angels", we may see a precursor of Martin's vision:

> But the most impressive scene, which formed the finale of the exhibition, was that representing the region of the fallen angels, with Satan arraying his troops on the banks of the Fiery Lake, and the rising of the Palace of Pandaemonium, as described by the pen of Milton. De Loutherbourg had already displayed his graphic powers in his scenes of fire, upon a great scale, at the public theatre—scenes which had astonished and terrified the audience; but in this he astonished himself,—for he had not conceived the power of light that might be thrown upon a scenic display, until he made the experiment on his own circumscribed stage. Here, in the foreground of a vista, stretching an immeasurable length between mountains, ignited from their bases to their lofty summits, with many-coloured flame, a chaotic mass rose in dark majesty, which gradually assumed form until it stood, the interior of a vast temple of gorgeous architecture, bright as molten brass, seemingly composed of unconsuming and unquenchable fire. In this tremendous scene, the effect of coloured glasses before the lamps was fully displayed; which, being hidden from the audience, threw their whole influence on the scene, as it rapidly changed, now to a sulphurous blue, then to a lurid red, and then again to a pale vivid light, and ultimately to a mysterious combination of the glasses, such as a bright furnace exhibits, in fusing various metals. The sounds which accompanied the wondrous picture, struck the astonished ear of the spectator as no less preternatural; for, to add a more awful character to peals of thunder, and the accompaniments of all the hollow machinery that hurtled balls and stones with indescribable rumbling and noise, an expert assistant swept his thumb over the surface of the tambourine which produced a variety of groans, that struck the imagination as issuing from infernal spirits.[2]

[1] Pyne, W. H., *Wine and Walnuts*, 1823, I, 295–96.
[2] ibid., I, 302–3.

De Loutherbourg exhibited the Eidophusikon for the last time on 12 May 1786, when, as an extra attraction, guitar music was provided by the Polish dwarf, Boruwlaski.[1] After this, De Loutherbourg sold the Eidophusikon to his manager, a Mr Chapman, who took it on tour. It was burnt down in the early years of the nineteenth century, but it had by then given birth to a whole family of panoramas, dioramas and other offspring, among them Thomas Girtin's Eidometropolis, a panorama of London, which he exhibited in Spring Gardens.[2] These contrivances were among factors leading to the eventual development of the cinema.[3]

Even "pure" science had its Romantic aspect, whether it was concerned with the vastnesses of astronomy or the minutiae of natural history. In the former category, Thomas Wright of Durham ends his *An Original Theory of the Universe* (1750; Plate 88) with this picture of Man, puny in the cosmos, yet with something of a Promethean character, too:

> . . . even in this World, are Joys which our Ideas of Heaven can scarce exceed, and if Imperfection appear thus lovely, what must Perfection be, and what may we not expect and hope for, by a meritorious Acquiescence in Providence, under the Direction, Indulgence and Protection of infinite Wisdom and Goodness, who manifestly designs perfect Felicity, as the Reward of Virtue in all his Creatures, and will at proper Periods answer all our Wishes in some predestined World.
>
> All this vast apparent Provision in the starry Mansions, seems to promise: What ought we then not to do, to preserve our natural Birthright to it and to merit such Inheritance, which alas we think created all to gratify alone, a Race of vain-glorious gigantick Beings, while they are confined to this World, chained like so many Atoms to a Grain of Sand.[4]

At the other end of the scale, and at the later end of the high Romantic era, we have Philip Henry Gosse's descriptions of the infinitely small wonders of nature (cf. Plate 62). In *Evenings at the Microscope* (1859), he writes this description of the scales of the diamond-beetle:[5]

[1] "Count" Joseph Boruwlaski (1739–1837). He was just under thirty-nine inches in height.

[2] See Whitley, W. T., "Girtin's Panorama", *The Connoisseur*, LXIX, 13.

[3] See Cook, Olive, *Movement in Two Dimensions*, 1963; Dobson, Austin, "Loutherbourg, R.A." in *At Prior Park*, 1912, 94–127, 277–81.

[4] p. 84. [5] p. 98.

We see a black ground, on which are strewn a profusion of what look like precious stones blazing in the most generous lustre. Topazes, sapphires, amethysts, rubies, emeralds seem here sown broadcast; and yet not wholly without regularity, for there are broad bands of the deep black surface, where there are no gems, and, though at a considerable diversity of angle, they do all point with more or less precision in one direction, viz. that of the bands.

The microscope must have been responsible, in part at least, for the development of minutely detailed painting in the work of certain Romantic artists, especially during the later years of the movement. Such artists seemed as if afraid to leave out any detail, however small, from their subjects; every blade of grass, every seed case on a plant, every hair on an animal's coat, every glint on an insect's wing. There is much of this in Gosse's illustrations to his works; to him it would have been sacrilegious to leave out of these any detail of the Creator's handiwork. God was perfect, and his creations were perfect, therefore they should, as much as was within the power of the artist, be represented without addition or subtraction.

Such idealism is apparent in the work of Holman Hunt—*The Hireling Shepherd*[1] for instance, in which the death's head moth in the shepherd's hand is as detailed as an entomological illustration (Plate 80). But such detailing extends to every part of the same work, from the apples, grass and wild flowers on the ground, to the leaves on the trees. Nobody ever really sees detail like that: Constable's "impressionist" representations are much closer to experience. But painters like Hunt, Arthur Hughes, Ruskin and Augustus Egg were motivated by a Romantic particularization that found also an outlet in the literature of the period, as in Hopkins's description of *The Peacock's Eye*:

> *Mark you how the peacock's eye*
> *Winks away its ring of green,*
> *Barter'd for an azure dye,*
> *And the piece that's like a bean,*
> *The pupil, plays its liquid jet*
> *To win a look of violet.*[2]

There were those who were as uneasy about science as others were uneasy about industry. Blake was uneasy about both, and when, in the

[1] City Art Gallery, Manchester.

[2] From *Poems of Gerard Manley Hopkins* (fourth edition), p. 128, edited by W. H. Gardner and N. H. Mackenzie.

words of his biographer, Gilchrist, "Some persons of a scientific turn were once discoursing pompously and, to him, distastefully, about the incredible distance of the planets, the length of time light takes to travel to the earth, etc., . . . he burst out: 'It is false. I walked the other evening to the end of the earth, and touched the sky with my finger'; perhaps," adds Gilchrist, "with a little covert sophistry, meaning that he thrust his stick out into space, and that, had he stood upon the remotest star, he could do no more; the blue sky itself being but the limit of our bodily perceptions of the infinite which encompasses us."[1]

Even some scientists had misgivings about the turn developments were taking. Gosse challenged the idea of evolution in *Life in its lower, intermediate, and higher forms: or, manifestations of the Divine Wisdom in the natural history of animals* (1857). In *Omphalos: an attempt to untie the geological knot* (1857), he attempted, with unhappy results, to reconcile the discoveries of geological research with the story of the Creation as it was described in the Book of Genesis.

But despite such misgivings, science was destined to follow its inexorable path, to dominate the spirit of Man more than it has ever before been dominated by any other force, religious, political or artistic. It still dominates him, not yet defeated by its own *hubris*, though that may come; but that consideration is beyond the scope of the present book.

[1] *Life of Blake,* 324–25.

The World of Nature

Nature's unchanging harmony.

Shelley, *Queen Mab*[1]

For nature is one with rapine, a harm no preacher can heal;
The Mayfly is torn by the swallow, the sparrow shear'd by the shrike,
And the whole little wood where I sit is a world of plunder and prey.

Tennyson, *Maud*[2]

AS the Romantics sought the minute particulars of humanity in the study of Man himself, in history, and in science and industry, so, also, they sought them in Nature. Sometimes Nature was a kind of mirror of Man and his psyche; at other times it overwhelmed him. Sometimes it was a world of harmonious beauty and wonder; sometimes it was a world of bloodstained cruelty. Each of these differing aspects is a facet of the Romantic vision.

To some, Nature *was* Man, and Man *was* Nature. The world of Nature was not a thing existing apart from Man. "In your own Bosom", wrote Blake, "you bear your Heaven and Earth & all you behold; tho' it appears Without, it is Within, in your Imagination."[3] Elsewhere he says, "every Natural Effect has a Spiritual Cause, and Not a Natural; for a Natural Cause only seems; it is a Delusion of Ulro & a ratio of the perishing Vegetable Memory."[4] These ideas are reinforced in the design on plate 25 of Blake's *Jerusalem*, where Albion is shown in his fallen state, but still retaining Creation in his essence, for his limbs and torso are seen to contain the Sun, the Moon and the stars. But they will depart if the divine vision is lost. "You have," wrote Blake, addressing the Jews, "a tradition, that Man anciently contain'd in his mighty limbs all things in Heaven & Earth: this you received from the Druids. 'But now the Starry Heavens are fled from the mighty limbs of Albion'."[5]

[1] Canto II, l. 257. [2] Part I, Sec. iv, St. 4.

[3] *Jerusalem*: Keynes, 709.

[4] *Milton*: Keynes, 513. Ulro is, in Blake's mythological system, the material world.

[5] *Jerusalem*: Keynes, 649.

This is also, perhaps, an instance of exotic influence on Blake, for there is a legend of the Blue God, Krishna, who, when he was a little boy, was caught eating some dirt, by his foster mother, Yasoda. She scolded him and ordered him to open his mouth, but upon looking inside, she saw the whole universe.[1]

And, to continue for a moment the exotic note, Man sometimes—all too often—assumed the cloak of one of the persons in the Hindu trinity or Trimurti—Siva the Destroyer. Thus, more than the starry heavens fled from the limbs of Albion, as he destroyed Nature, and with it his own essence.

We have already seen, in Chapter Five, the depredation of science and industry. Destruction, like a famine, spread even wider than was indicated there, and Man saw himself reflected in this, as did Cowper in *The Poplar-Field*:

> *The poplars are fell'd, farewell to the shade*
> *And the whispering sound of the cool colonnade,*
> *The winds play no longer, and sing in the leaves,*
> *Nor Ouse on his bosom their image receives.*
>
> *Twelve years have elaps'd since I last took a view*
> *Of my favourite field and the bank where they grew,*
> *And now in the grass behold they are laid,*
> *And the tree is my seat that once lent me a shade.*
>
> *The blackbird has fled to another retreat*
> *Where the hazels afford him a screen from the heat,*
> *And the scene where his melody charm'd me before,*
> *Resounds with his sweet-flowing ditty no more.*
>
> *My fugitive years are all hasting away,*
> *And I must ere long lie as lowly as they,*
> *With a turf on my breast, and a stone at my head,*
> *Ere another such grove shall arise in its stead.*
>
> *'Tis a sight to engage me, if any thing can,*
> *To muse on the perishing pleasures of man;*
> *Though his life be a dream, his enjoyments, I see,*
> *Have a being less durable even than he.*[2]

[1] Archer, W. G., *The Loves of Krishna*, 1957, 32.
[2] Written in 1784 and published in *Poems*, 1800.

Impermanence and decay are common attributes in Romanticism. Just as there was a Romantic preoccupation with the past and with ruins, so the same motivation is apparent in its interpretations of Nature. There are many signs of it in the vignettes Bewick engraved for his *British Birds*—a man stranded on a rock at sea, kneeling and praying for a safe deliverance; a rotting hull of a boat on a seashore; a rotting sheep's carcase washed up on the bank of a river; a boy, merrily bowling a hoop along, while an old man, close to death, stands reading a crumbling tombstone, on which is written: *vanitas vanitatum omnia vanitas* (Plate 82). There are, in fact, tombstones in abundant variety, and not a few coffins. Here, and elsewhere in Romantic art, there is a feeling of deep melancholy, of Man and his soul reflected in Nature. It is not therefore surprising that decaying autumn was the favourite season of so many Romantics, as was so well expressed by Clare:

> *Come, pensive Autumn, with thy clouds, and storms,*
> *And falling leaves, and pastures lost to flowers;*
> *A luscious charm hangs on thy faded forms,*
> *More sweet than Summer in her loveliest hours,*
> *Who, in her blooming uniform of green,*
> *Delights with samely and continued joy:*
> *But give me, Autumn, where thy hand hath been,*
> *For there is wildness that can never cloy,—*
> *The russet hue of fields left bare, and all*
> *The tints of leaves and blossoms ere they fall.*
> *In thy dull days of clouds a pleasure comes,*
> *Wild music softens in thy hollow winds;*
> *And in thy fading woods a beauty blooms,*
> *That's more than dear to melancholy minds.*[1]

In this world of melancholy and decay, Man, far from being the triumphant Titan envisaged by Blake, is a weak, albeit resilient being, struggling against his fate. Sometimes, like Prometheus, he will break his chains, and triumph. Sometimes, he is a mere indolent cipher, less than the great eagle that circles miles above him, ready to devour his liver, and which

> *. . . unconfin'd*
> *Can make a ladder of the eternal wind,*
> *And poize about in cloudy thunder-tents*
> *To watch the abysm-birth of elements.*[2]

[1] Sonnet lx, *To Autumn*, in *The Village Minstrel and other poems*, 1821.
[2] Keats, *Endymion*, Book III, l. 25.

Even so, to restore our sense of proportion, we must return to Blake's vision of Nature, in which each being has its own qualities, to be usurped or imitated by no other—except by transcendant Man—and where "every thing that lives is Holy":[1]

> *Does the Eagle know what is in the pit?*
> *Or wilt thou go ask the Mole?*
> *Can Wisdom be put in a silver rod?*
> *Or Love in a golden bowl?*[2]

In Romantic art, Nature appears at its most formidable as Nature Triumphant—that great amoral power that contains so much of beauty, so much of cruelty, so much of strength, and so much of wonder. That power is something that Goethe recognized when, as a boy, he made the symbolic gesture described in his autobiography:

His father possessed a beautiful red-lackered music-stand, ornamented with gilt flowers, in the form of a four-sided pyramid, with different elevations, which had been found convenient for quartets, but lately was not much in use. The Boy laid hands on this, and built up his representatives of Nature one above the other in steps, so that it all looked quite pretty and at the same time sufficiently significant. On an early sunrise his first worship of God was to be celebrated, but the young priest had not yet settled how to produce a flame which should at the same time emit an agreeable odour. At last it occurred to him to combine the two, as he possessed a few fumigating pastils, which diffused a pleasant fragrance with a glimmer, if not with a flame. Nay, this soft burning and exhalation seemed a better representation of what passes in the heart, than an open flame. The sun had already risen for a long time, but the neighbouring houses concealed the East. At last it glittered above the roofs, a burning-glass was at once taken up and applied to the pastils, which were fixed on the summit in a fine porcelain saucer. Everything succeeded according to the wish, and the devotion was perfect. The altar remained as a peculiar ornament of the room which had been assigned him in the new house. Every one regarded it only as a well-arranged collection of natural curiosities. The Boy knew better, but concealed his knowledge.[3]

[1] *The Marriage of Heaven and Hell*: Keynes, 160.

[2] *The Book of Thel*: Keynes, 127

[3] *The Auto-biography of Goethe. Truth and Poetry: From My own Life*, trans. John Oxenford, 1848–49, I, 31.

Samuel Palmer, too, recognized the power of Nature, although his gestures were not so histrionic as those of Goethe. One of his surviving sketchbooks contains many lovingly-detailed drawings and notes, showing a dedication, almost religious in its intensity, to the power of Nature. And not in sketches and notes alone, for in the same book he also wrote a poem of strangely haunting quality that illuminated the very soul of Nature as he and many other Romantics saw it:

> *And now the trembling light*
> *Glimmers behind the little hills, and corn,*
> *Lingring as loth to part: yet part thou must*
> *And though than open day far pleasing more*
> *(Ere yet the fields, and pearled cups of flowers*
> > *Twinkle in the parting light;)*
> *Thee night shall hide, sweet visionary gleam*
> *That softly lookest through the rising dew:*
> > *Till all like silver bright;*
> > *The Faithful Witness, pure, & white,*
> > *Shall look o'er yonder grassy hill,*
> > *At this village, safe, and still.*
> > *All is safe, and all is still*
> *Save what noise the watch-dog makes*
> *Or the shrill cock the silence breaks*
> > *—Now and then.—*
> *And now and then—*
> *Hark! —once again,*
> *The wether's bell*
> *To us doth tell*
> *Some little stirring in the fold.*
>
> > *Methinks the lingring, dying ray*
> > *Of twilight time, doth seem more fair,*
> > *And lights the soul up more than day,*
> > *When wide-spread, sultry sunshines are.*[1]

In his sketchbook Palmer grasps at every minute particular. Different kinds of tree-bark are delineated in the finest detail; there are studies of flowers and of leaves, and of the structure of trees. Sometimes they are accompanied by comments, such as: "Looking at grass with our face to the sun, he shines through each blade making masses of the most splendid

[1] Published in full in *Garland*, ed. F. Warner, Cambridge, 1968.

green; inimitably green and yet inimitably warm so warm that we can only liken it to yellow and yet most vivid green."[1]

Such loving care for detail is present in the drawings and notebooks of Gerard Manley Hopkins. On a sketch of waves, "study from the cliff above, Freshwater Gate, July 23 [1863]", he writes: "Note. The curves of the returning wave overlap, the angular space between is smooth but covered with a network of foam. The advancing wave, already broken, and now only a mass of foam, upon the point of encountering the reflux of the former."[2] Hopkins's private writings abound with such observations, whether he is writing of trees, leaves, flowers or lambs:

> The sycomores are quite the earliest trees out: some have been fully out some days (April 15). The behaviour of the opening clusters is very beautiful and when fully opened not the single leaves but the whole tuft is strongly templed like the belly of a drum or bell
> The half-opened wood-sorrel leaves, the centre or spring of the leaflets rising foremost and the leaflets dropping back like ears leaving straight-chipped clefts between them, look like some green lettering and cut as sharp as dice
> The white violets are broader and smell; the blue, scentless and finer made, have a sharper whelking and a more winged recoil in the leaves
> Take a *few* primroses in a glass and the instress of—brilliancy, sort of starriness: I have not the right word—so simple a flower gives is remarkable. It is, I think, due to the strong swell given by the deeper yellow middle
> 'The young lambs bound As to the tabour's sound'.
> They toss and toss: it is as if it were the earth that flung them, not themselves. It is the pitch of graceful agility when we think that.—April 16—Sometimes they rest a little space on the hind legs and the fore-feet drop curling in on the breast, not so liquidly as we see it in the limbs of foals though[3]

And there was James Smetham who, in paintings or etchings, could, when he wished, portray the details of Nature with adroitness; but who, even better, could distil a whole experience of them into a few words in a

[1] *Samuel Palmer's Sketchbook. 1824* (facsimile), with an introduction by Martin Butlin, 1962, 175. Apparently only two of Palmer's sketchbooks have survived—this one, and a smaller one dating from 1819 and containing landscapes and sky studies. Both are in the British Museum.

[2] House, Humphry and Storey, Graham (eds.), *The Journals and Papers of Gerard Manley Hopkins*, 1959, plate 12. [3] ibid. p. 206.

letter. "Such a sky!" he wrote on 24 August 1861. "Such films and threads of infinite tenuity! Such flat roofs of cirri, lying high up in perspective, beyond the reach of science!"[1]

We have already discussed Philip Henry Gosse's books on natural history and his illustrations for them. He also made some books of water-colour studies, one of which—*Entomologia Alabamensis*—despite its brilliance, has never been published. The studies are drawn, as were all of his illustrations, with immaculate precision, and coloured with the greatest clarity and brilliance, yet not deviating a jot from their natural form and colour (cf. Plate 62). Equally brilliant is a book of *trompe l'oeil* water-colour studies by Gosse's brother, William, lettered on the cover: *Wild Flowers and Fruits of Newfoundland from Nature.* Each of these collections of studies is a Romantic combination of Nature, the exotic and science.[2]

This brief reference to the Gosse family may remind us that the Romantic era was an age of magnificent illustrated books. This was especially evident in the opulent colour-plate books of the time, dealing with flowers and birds, those twin summits of colour and form in the world of Nature. And what is so interesting is that, despite the great artistry of the plates, they are usually intended primarily as scientific illustrations, and only secondarily, if at all, as decorative pictures, as the titles of their books will demonstrate: James Bateman's *The Orchidaceae of Mexico and Guatemala* (London, 1837–43), which included two plates by George Cruikshank; William Curtis's *Flora Londinensis* (London, 1817–28); Joseph Dalton Hooker's *Illustrations of Himalayan Plants* (London, 1855); John Gould's *A Monograph of the Trochilidae, or Family of Humming-Birds* (London, 1849–87; Plate 84); and Thomas Lord's *Entire New System of Ornithology* (London, 1791). There are hundreds more,[3] many of them containing illustrations that are of the very quintessence of Romanticism.

[1] Smetham, Sarah and Davies, William (eds.), *Letters of James Smetham*, 1891, 97.

[2] Collection of Miss Jennifer Gosse. A figure from *Entomologia Alabamensis* is reproduced facing page 72 of Stageman, Peter, *A Bibliography of the First Editions of Philip Henry Gosse*, FRS, Cambridge, 1955. See also Lister, Raymond, "William Gosse's Botanical Miniatures", *Gardener's Chronicle*, 26 April, 1952.

[3] See Sitwell, Sacheverell; Buchanan, Handasyde; and Fisher, James, *Fine Bird Books*, 1953. Sitwell, Sacheverell; Blunt, Wilfrid; and Synge, Patrick M., *Great Flower Books*, 1956.

Such, more than any other, is *The Temple of Flora or The Garden of Nature* of Dr Robert John Thornton, which first appeared in parts between 1798 and 1807. It contained a series of thirty-one brilliant plates by various artists and engravers, some purely allegorical stipple engravings, like "Flora dispensing Her Favours on the Earth" or "Cupid, Inspiring Plants with Love"; but most of them, of both great artistic and great botanical value, are in mezzotint or aquatint.[1] The publication all but ruined Thornton, and the total of seventy plates he had intended was never completed. So poor was the public response to the work that he held a lottery to dispose of the whole stock, including the original paintings; even this brought him no success. The work itself remains a monument to Thornton's endeavours to bring out a botanical work which would stand comparison with the best contemporary Continental publications, and which would have as much influence in its sphere as John Boydell's Shakespeare Gallery had had in "literary" painting.

Dr Thornton was more than a publisher. His influence, if not his hand, may be seen in every print in the collection; he even painted one of them, "Roses", an attractive composition, but by no means the best.[2] But let him describe in his own words the thinking behind the plates:

> Each scenery is appropriated to the subject. Thus in the *night-blowing* CEREUS you have the moon playing on the dimpled water, and the turret-clock points XII, the hour at night when this flower is in full expanse. In the *large-flowering* MIMOSA, first discovered in the mountains of Jamaica, you have the humming birds of that country, and one of the aborigines struck with astonishment at the peculiarities of the plant . . . The TULIPS and HYACINTHS are placed in Holland, where these flowers are particularly cultivated, embellishing a level country . . . In the *maggot-bearing* STAPELIA you will find represented a green African snake, and a blow-fly in the act of depositing her eggs in the flower, with the maggots produced from this cause. The clouds are disturbed, and everything looks wild and sombre about the *dragon* ARUM, a plant equally poisonous and foetid.[3]

[1] Some are engraved in mixed techniques of aquatint and line, aquatint and stipple, or aquatint, stipple and line.

[2] The painters included Richard Cosway, Sydenham Edwards, Philip Reinagle, Peter Henderson, and William Pether.

[3] See Grigson, Geoffrey, *Thornton's Temple of Flora*, 1951, 9–10.

Yet Thornton's words hardly do justice to the remarkably dramatic content of the plates: the great, phallic, black and purple mass of the dragon arum, pointing to a wild and louring sky against a mountain background; the group of auriculas among the Alps, with eagles circling above the peaks; the snowdrops and crocuses in a snowbound landscape with a sunset in layers of rose and yellow light. Most impressive of all is the night-blowing cereus, like a golden sunburst, set against a moonlit landscape containing a crumbling Gothic clock-tower, "The Flower by Reinagle, Moon-light by Pether" (Plate 85). It is essentially Romantic in combining Nature, the exotic, the Gothic past and a sense of decay. It is a splendid botanical illustration, but it could almost equally serve as an illustration to a novel by Matthew Gregory Lewis or Ann Radcliffe.[1]

Not all Romantic botanical art was of such brilliance, although many minor works had great charm. One such was the delightful little work *Flowers and Heraldry* by Robert Tyas[2] (London, 1851), who wrote several other books on botany, among them *Flowers from the Holy Land* (1850–51), *Favourite Field Flowers* (1847–50), and *Flowers from Foreign Lands* (1853), each illustrated with colour plates. *Flowers and Heraldry* is a curious mixture of natural history and Gothic Revivalism. The hand-coloured plates are enchanting, and show flowers used symbolically in various achievements, which, if they make strange heraldry, must still have made readers feel that they were re-living the spirit of the Middle Ages. Another, equally delightful book in the same class, was the anonymous *The Language of Flowers* (1841), which contained plates showing flowers in different combinations, expressing various ideas and sentiments. A rose, a tulip and a violet appear on one plate, inscribed, "Your Beauty and Modesty have forced from me a declaration of love"; according to the book, the rose represents beauty, the tulip represents a declaration of love and the violet represents modesty. Yet another aspect of "decorative"

[1] There were two editions of *The Temple of Flora*: the "folio edition" (56 cm by 44 cm), 1799–1807; and the "lottery edition" (37 cm by 31 cm), 1812. See Sitwell and Handasyde *loc. cit*, p. 77. The plates in the "lottery edition" are inferior to those in the "folio edition", and the night-blowing cereus is engraved without its Gothic background. The subject (again without the Gothic background) was again engraved, in miniature format, and printed in Thornton's unsuccessful annual *Remember me!* See Keynes, *Blake Studies*, 144.

[2] *fl.* 1847–53.

botany appeared in *The Hand-book for Modelling Wax Flowers* by John and Horatio Mintorn[1] (1847).

Many lighthearted Romantic books of this kind were published, as also were many minor works of more serious botanical interest, which contained illustrations that unmistakably belonged to, or were influenced by, Romanticism. Such was Shirley Hibberd's *The Fern Garden* (1869), with its coloured and black and white illustrations, and in particular those which illustrate ferns growing in glass globes and cases.

A great craze for ferns flourished during the Victorian period, and it was found that one of the best ways to grow them was in an airtight case, named after, but not actually invented by, Dr Nathaniel Bagshaw Ward.[2] These cases were made in dozens of different designs and were themselves a vehicle for Romantic expression, especially those inspired by Gothic architecture, like the "Tintern Abbey case", made by Ward himself, which contained a replica of the Abbey's west window. Many other designs are shown in another book by Hibberd, itself a milestone in Romantic book production: *Rustic Adornments for Homes of Taste* (1856; Plate 86).

Gothic adornment extended to the design of beehives. Several of these were exhibited at the Great Exhibition in 1851: the "Royal Alfred Hive", with little Gothic castles in the centre and glass bells in front of them, designed so that the honey could be taken out without killing the bees; there was another one, in the form of a little Georgian house, and yet another like a dovecote.[3]

Seaweed was a popular branch of botany, probably due in some measure to the influence of Philip Henry Gosse, whose *Seaside Pleasures* (1853), *A Naturalist's Rambles on the Devonshire Coast* (1853), *The Aquarium* (1854), and other works, were widely distributed, and must have recruited hosts of new enthusiasts. One attractive and interesting little book of this kind was Isabella Gifford's *The Marine Botanist* (1848), illustrated with lithographs and nature-printed plates—plates, that is, printed from the actual

[1] Specimens of the Mintorns' remarkable realistic work are in the Museums at Kew. See Blunt, Wilfrid, *The Art of Botanical Illustration*, 1950, 246 and pl. 44.

[2] 1791–1868.

[3] Hobhouse, Christopher, *1851 and the Crystal Palace* (Revised edition), 1950, 89–90.

specimens illustrated, a form of illustration that was perfected during the nineteenth century.[1] Some were not even satisfied with printing from the original specimens; only the specimens themselves would suffice, and pictures made of real seaweed or shells or both, sometimes in conjunction with a water-colour or the engraved view as a background, were constructed as souvenirs of seaside holidays.

This brings us to the point that some flowers, insomuch as Man propogated, trained and coaxed them into their forms, are in themselves Romantic works of art. This applies especially to many of the old shrub roses; the Bourbon "La Reine Victoria" (1872) for instance, which looks as if it is made of pink shells; the "Old Velvet" moss rose; "William Lobb" (1855)—a breathtaking mixture of wine-dark purple and light lilac-pink, changing in a day or two to almost gray; the white damask "Madame Hardy" (1832). But it was not absolutely necessary for a flower to be specially cultivated in order for Man to see in it the expression of human aspirations, as Barnes knew, when he wrote *The Clote* (the yellow water-lily):

> *O zummer clote! when the brook's a-gliden*
> *So slow an' smooth down his zedgy bed,*
> *Upon thy broad leaves so seäfe a-riden*
> *The water's top wi' thy yollow head,*
> *By alder's heads, O,*
> *An' bulrush beds, O,*
> *Thou then dost float, goolden zummer clote!*

> *The grey-bough'd withy's a-leänen lowly*
> *Above the water thy leaves do hide;*
> *The benden bulrush, a-swaÿen slowly,*
> *Do skirt in zummer thy river's zide;*
> *An' perch in shoals, O,*
> *Do vill the holes, O,*
> *Where thou dost float, goolden zummer clote!*

> *Oh! when thy brook-drinken flow'r's a-blowen,*
> *The burnen zummer's a-zetten in;*
> *The time o' greenness, the time o' mowen,*
> *When in the haÿ-vield, wi' zunburnt skin,*
> *The vo'k do drink, O,*

[1] See Cave, Roderick and Wakeman, Geoffrey, *Typographia Naturalis*, Wymondham, 1967.

Upon the brink, O,
Where thou dost float, goolden zummer clote!

Wi' eärms a-spreaden, an' cheäks a-blowen,
How proud wer I when I vu'st could zwim
Athirt the pleäce where thou bist a-growen,
Wi' thy long more vrom the bottom dim;
While cows, knee-high, O,
In brook, wer nigh, O,
Where thou dost float, goolden zummer clote!

Ov all the brooks drough the meäds a-winden,
Ov all the meäds by a river's brim,
There's nwone so feäir o' my own heart's vinden,
As where the maïdens do zee thee zwim,
An' stan' to teäke, O,
Wi' long-stemm'd reäke, O,
Thy flow'r afloat, goolden zummer clote![1]

Of spectacular bird books produced in Britain, none surpasses those of John Gould, especially his *Trochilidae* (humming-birds). This was illustrated by hand-coloured lithographs by H. C. Richter and William Hart, after drawings by Gould himself, showing these remarkable little birds, some hardly bigger than bumble bees, in all their exotic finery, conveying even an impression of their iridescence, a thing difficult to convey, even in the most brilliant colour photography.[2] Elsewhere, in *The Birds of Europe* (1832–37) and *A Monograph of the Ramphastidae, or Family of Toucans* (1834), Gould used drawings and lithographs of Edward Lear, as also did John Edward Gray in *Gleanings from the Menagerie and Aviary at Knowsley Hall* (1846). But Lear's greatest bird studies were those in his *Illustrations of the Family of Psittacidae, or Parrots*, which was published in London in twelve parts, from 1830 to 1832 (Plate 87).

The most Romantic of all English bird illustrations are Thomas Bewick's wood engravings in his *A History of British Birds*, in which every species of British bird is lovingly detailed, and shown against a background of leaves or rocks, or most pleasing of all, English countryside. This is illustrated by the engraving of a robin in a still and snowy landscape (Plate 81), which could be a perfect accompaniment to Cowper's lines:

[1] Barnes, *Poems*, 1962, I, 125–6.

[2] The finest of such photographs that I have ever seen are reproduced in *Hummingbirds* by Crawford H. Greenwalt, New York, 1960.

No noise is here, or none that hinders thought.
The redbreast warbles still, but is content
With slender notes, and more than half suppress'd:
Pleas'd with his solitude, and flitting light
From spray to spray, where'er he rests he shakes
From many a twig the pendent drops of ice,
That tinkle in the wither'd leaves below.[1]

Bewick's method was first to make a water-colour drawing of his subject, and then to engrave it on wood. It is difficult to decide which are more beautiful, water-colours or engravings, for all are perfectly conceived, and executed with exquisite craftsmanship (Plate 83).

The engravings in his earlier *A General History of Quadrupeds* are not as good as those in the *Birds*, and although he illustrated other works, *British Birds* remains both his masterpiece and a splendid vindication of his own claim: "I have always thought that there was nothing deserving of being called knowledge but a knowledge of nature."[2]

But Nature in Romantic art was not confined to books, for it captured the imagination of some of the greatest painters of the era. Here we may take Stubbs's painting of a Greenland falcon as our starting point[3] (Plate 61). The powerful predatory bird is the embodiment of natural, elemental beauty, yet he is imprisoned on his perch, like Prometheus on his rock, with Man exercising a god-like dominion over him. That restless, proud and piercing eye could be interpreted in human terms, as an unconquered spirit, contemptuous of his captor, as a prince held to ransom. The apparent baubles of bell, jess and leash, add rather than detract from his poignant dignity. This bird possesses a latency, a sense of power held in reserve, as there is also in the same artist's equally powerful "Tiger",[4] a study of brooding, destructive force, like Blake's:

Tyger! Tyger! burning bright
In the forests of the night,
What immortal hand or eye
Could frame thy fearful symmetry?

[1] *The Task*, VI, l. 76.
[2] Williams, Gordon (ed.), *Bewick to Dovaston. Letters 1824–1828*, 1968, 115.
[3] Collection of Mr and Mrs Paul Mellon.
[4] ibid.

In what distant deeps or skies
Burnt the fire of thine eyes?
On what wings dare he aspire?
What the hand dare sieze the fire?

And what shoulder, & what art,
Could twist the sinews of thy heart?
And when thy heart began to beat,
What dread hand? & what dread feet?

What the hammer? what the chain?
In what furnace was thy brain?
What the anvil? what dread grasp
Dare its deadly terrors clasp?

When the stars threw down their spears,
And water'd heaven with their tears,
Did he smile his work to see?
Did he who made the Lamb make thee?

Tyger! Tyger! burning bright
In the forests of the night,
What immortal hand or eye
Dare frame thy fearful symmetry![1]

In Stubbs's "Lion attacking a horse"[2] (Plate 2), latency is transformed into energy, and the horse screams with panic-stricken terror, as the lion leaps on to its back, digging its claws into its skin, and its teeth into its flesh, preparatory to breaking its spine. This concentration of predatory power and destruction is made more sinister by the beauty and serenity of the landscape in which it is set. It is a perfect example of that underlying sadism which appeared in the work of many Romantic painters, although few of them portrayed it so powerfully as Stubbs.

A quieter view of Nature than Stubbs's was afforded by an artist who had been influenced by him, the Swiss Jacques-Laurent Agasse, who worked in England for about fifty years. Agasse painted sporting scenes and historical subjects, but he was at his most brilliant in the portrayal of foreign animals, as is shown in his picture, painted for George IV, of a young giraffe, its two Arab keepers, and the animal importer, Edward Cross[3] (Plate 38).

[1] *Songs of Experience*: Keynes, 214.
[2] Collection of Mr and Mrs Paul Mellon.
[3] In the collection of H.M. the Queen.

The Romantic interest in Nature instilled in many a new sense of responsibility towards wild life. Men tried to understand animals in their own terms and context. William Beckford made Fonthill into a nature preserve, where no hunting, shooting or fishing was allowed. Amateurs, like Gilbert White of Selbourne and Charles Waterton,[1] painstakingly kept notes and journals, trying to understand and unravel the mysteries that Nature contained. This tendency affected painting profoundly: "When I sit down to make a sketch from nature," said Constable, "the first thing I try to do is, to forget that I have ever seen a picture."[2] Others were less enthusiastic. "Damn Nature!—she always puts me out",[3] said Fuseli. Yet Fuseli was also a keen entomologist.[4]

There was also an aspect of Nature in Romantic art that owed something to science, especially to microscopy: this was the derivation of form from natural structures and processes. We have already touched on this in the idea of the resemblance of Gothic architecture to trees; and in fact many artists claimed to base their designs on the structure of such things as shells, crystals, leaves, fruit and flowers. Some stirrings of such ideas appeared in works like the anonymous *Cloud Crystals, a Snowflake Album* (New York, 1864), in which are dozens of pages of magnified white snow crystals, arranged in patterns on brown backgrounds, and accompanied by an anthology of prose and verse. But I mean something less fanciful and more subtle than that: a search for fundamental forms that would help to release artistic expression, as, in more recent years, the dance-philosopher Laban attempted to release the harmonies of human movement by means of spatial scales contained within the icosahedron.[5]

Goethe was striving for something of the kind. He devoted much time to the study of botany, and believed that an artist should do more than merely reproduce, for instance, the appearance of plant life, but should be capable of rendering its very essence, its growth, its environment.[6] He

[1] See *The Squire of Walton Hall* by Philip Gosse, 1940.

[2] Leslie, *Memoir of Constable*, 279. [3] Cunningham, *op. cit.*, II, 286.

[4] Knowles, *op. cit.*, 1831, I, 6, 298, 362 etc. Blake, too, in his *Ghost of a Flea* was probably inspired by entomology. Sir Geoffrey Keynes has shown that in this work he was probably influenced by Dr Robert Hooke's *Micrographia Restaurata*. See Keynes, *Blake Studies* (new ed.) 134–35.

[5] See Laban, Rudolf von, *Die Welt des Tänzers*, Stuttgart, 1920.

[6] See "Simple Imitation of Nature, Manner, Style" in Goethe, *Literary Essays*, a selection in English arranged by J. E. Spingarn, London, 1921, 59–64.

also, with the aid of a microscope, studied and made detailed drawings of protozoa and other minute forms of life. Yet, like other Romantic nature-philosophers, he was never able to reconcile the scientific and aesthetic aspects of Nature, and, in a sense, became as deeply bogged down as Philip Henry Gosse had been in the religious aspects of science.

Generally speaking, this preoccupation with ideal structure and form was a Continental phenomenon. Nevertheless, it did have a certain impact here. Thomas Wright had, in the eighteenth century, worked out a system of ideal forms in the cosmos, which he illustrated in his book *An Original Theory of the Universe*, in a series of remarkable and quite beautiful engravings (Plate 88). Erasmus Darwin shows some awareness of ideal forms in *The Botanical Garden*, as in this passage, describing *zostera* (grass-wrack or eelgrass):

> Stretch'd on her mossy couch, in trackless deeps,
> Queen of the coral groves, ZOSTERA sleeps;
> The silvery sea-weed matted round her bed,
> And distant surges murmuring o'er her head.—
> High in the flood her azure dome ascends,
> The crystal arch on crystal columns bends;
> Roof'd with translucent shell the turrets blaze,
> And far in ocean dart their colour'd rays;
> O'er the white floor successive shadows move,
> As rise and break the ruffled waves above.[1]

Coleridge philosophized on organic form.[2] Thomas Henry Huxley made drawings of various low forms of animal life—radiolarians and jellyfish for instance—in which he showed as much an aesthetic as a scientific approach.[3] William Stuart McLeay, a biologist who collaborated to some extent with Huxley, endeavoured to see in Nature an ideal pattern of concentric circles.

Ruskin and Millais, in their minutely detailed studies, were much influenced by such ideas. Millais used a magnifying glass so as to lose no detail of a leaf or a flower, and Ruskin described how, "On fine days, when the grass was dry, I used to lie down on it and draw the blades as they

[1] Part II. "The Loves of the Plants". Canto I, l. 265.
[2] Coleridge, *The Table Talk and Omniana* (ed. T. Ashe), 1896, 145–46.
[3] See Huxley's *Scientific Memoirs* (ed. Sir Michael Foster and Professor Lankester), 4 vols, 1898–1903.

grew, with the ground herbage of buttercup or hawkweed mixed among them, until every square foot of meadow, or mossy bank, became an infinite picture and possession to me, and the grace and adjustment to each other of growing leaves, a subject of more curious interest to me than the composition of any painter's master-piece."[1]

Samuel Palmer, too, liked to study botanical details. "Nothing would please me more", he wrote in 1875, "than to spend a year in resuming my old studies of botanical minutiae".[2]

But the fuller development and complete synthesis of the aesthetic possibilities of form in Nature have, even now, only just begun to be realized, in the work of artists like Graham Sutherland, Paul Nash, and Ivon Hitchens; but most of all in such works as some little-known, but extremely beautiful engravings by J. G. Lubbock,[3] and Morris Cox.[4] In comparison with neo-Romantic work of this kind, the work produced during the Romantic era was only partly realized, an initial probing into ideas only nebulously imagined.

While these things have their place, the true Romanticism of Nature is more profoundly expressed elsewhere: in a wood-engraving of a woodlark near to an English spinney, in a painting of a stag roaring a challenge in a night of snow and stars,[5] in an aquatint of an Egyptian water-lily with a mosque in the background, and in a vision of vast defiant bulls, like harbingers of fate, rearing their heads in Gordale Scar.[6]

[1] Cook, E. G., *The Life of John Ruskin*, 1911, I, 217–18.

[2] Palmer, A. H., *The Life and Letters of Samuel Palmer*, 1892, 357.

[3] *Aspects of Art and Science*, Leicester, 1969. Limited to 80 impressions.

[4] Cox has published several books containing prints made partly by a form of nature printing. They include *A Web of Nature*, London, 1964 (50 impressions); *Forty-five Untitled Poems*, London, 1969 (50 impressions); and several others.

[5] Plate 7.

[6] Plate 17.

Landscape and the Poetry of Earth

The Poetry of earth is never dead.

Keats.[1]

Here let us sweep The boundless landscape.

Thomson, *The Seasons*[2]

THE Romantic artist remade the landscape in Man's image. He looked at a valley and exalted it, at a mountain or hill and made it low. He wrenched from the Earth the spirits, dreams, enchantments, and aspirations of his very being. He worked, not merely as a Prometheus stealing fire from the gods; he was himself a god.

This was especially true of Romantic landscape painting in Britain, where the basic element of the art, the landscape itself, was, and still is, more varied both in form and in atmosphere, than that of any other comparable area. It is an island landscape, swept from all directions by breezes and winds, drenched in mists and fogs, illuminated by hazy sunlight or gentle moonlight. Here, indeed, was material to inspire the cosmic vision of Turner, the dancing lights and clouds of Constable, Cotman's solitude, the meticulousness of John Middleton, and Samuel Palmer's paradises of moonlight.

It was here that Richard Wilson transformed the type of Continental landscape, the visions of Poussin and Claude, into something essentially British and insular, yet tied as if with an umbilical cord to the landscape bounding the Mediterranean and Aegean. Wilson's earlier work, of which "The Destruction of Niobe's Children"[3] is an example, is hardly distinguishable from that of Continental artists in the European classic tradition. But when we come to examine his portrayal of Cader Idris,[4] here is a difference indeed (Plate 89). In this we can appreciate his claim that everything the landscape painter could want could be found in North Wales.[5]

[1] First line of the sonnet, "On the grasshopper and the cricket" (1816).
[2] "Summer", l. 1408. [3] National Gallery. [4] ibid.
[5] Hardie, Martin, *Water-colour Painting in Britain*, 1967, I, 119.

The great mountain, brightly but subtly illuminated, the tarn like a dark
mirror, the ridge and precipice towering behind it; all demonstrate both
Wilson's virtuosity, and his debt to Claude, for, as in Claude, there is here
a great mass of light at the centre and consistent mood throughout the
composition. The picture demonstrates also the mood that makes some of
Wilson's work not only a precursor of Romanticism, but of the essence of
Romanticism, too. For there is a brooding atmosphere of mystery and
legend about his interpretation of this mountain: the "chair of Idris", a
giant in the legends of the bards. If a man sleeps in this chair for a night it
is said that he wakes either a madman or a poet. Be that as it may, Wilson
has, in this picture, awakened the inner poetic reality of his subject, which
he has joined subtly to its outer and physical form:

> *High on some Cliff, to Heav'n up-pil'd,*
> *Of rude Access, of Prospect wild,*
> *Where, tangled round the jealous Steep,*
> *Strange Shades o'erbrow the Valleys deep,*
> *And holy* Genii *guard the Rock,*
> *Its Gloomes embrown, its Springs unlock,*
> *While on its rich ambitious Head,*
> *An* Eden, *like his own, lies spread.*[1]

In "Cader Idris", Wilson seems to anticipate Blake's conception of the
Sublime: "Singular & Particular Detail is the Foundation of the Sublime;"[2]
"Minute Discrimination is Not Accidental. All Sublimity is founded on
Minute Discrimination";[3] "Without Minute Neatness of Execution The
Sublime cannot Exist! Grandeur of Ideas is founded on Precision of
Ideas";[4] "Broken Colours & Broken Lines & Broken Masses are Equally
Subversive of the Sublime."[5]

These ideas are all present in "Cader Idris"—minuteness of execution,
coupled with unbroken masses and lines, the whole reaching an abstraction
of form and colour akin to that which we have already noticed in the work
of Agasse.

A similar approach, but in water-colours, is present in the work of John
Sell Cotman and Francis Towne. Their work is not so dramatic as Wilson's,
but it is equally Romantic, and is realized in the same kind of abstraction of

[1] William Collins, *Ode on the Poetical Character* l. 55.
[2] *Annotations to Reynolds*: Keynes, 459.
[3] ibid., 453. [4] ibid., 457. [5] ibid., 464.

form and colour. Cotman could derive, from natural landscape forms, that inner poetic reality which we have just noticed in Wilson. It was a poetic reality that could not exist in the landscape without the participation of Man. For in the art of landscape, Romantic Man saw himself reflected, like an image in a Claude glass.[1] "Where man is not," wrote Blake, "nature is barren."[2]

One of Cotman's greatest works is "Greta Bridge",[3] and it demonstrates this idea; for in it, the landscape and the buildings are, without losing their representational reality, transformed into a glittering pattern of lights and rhythms around the chaste arch of the bridge (Plate 90). Just as a musician takes sound and transforms it into music, so the artist has taken shapes and composed them into visual art.

Francis Towne treated landscape in a similar way, although in his work the abstraction is more noticeable. Indeed Towne reduces his forms to areas of colour, rigidly outlined, as if by etching. He worked abroad as well as in England, and his Swiss views are undoubtedly his best (Plate 91); but, like Wilson, he appreciated the beauty of this country, and was among the first English artists to paint it without overtones derived from Poussin, Claude and Rosa.

Towne's art is cool and intellectual: while his Alpine views convince the beholder of their beauty and brilliance, there is little, if anything, of the sublimity or terrors present in the work of most Romantic painters. Despite this, Towne's work has a Romantic aspect, for it showed a new way of looking at landscape, and landscape that was often exotic; his was a vision that sought to reduce the forms of landscape to their basic elements, without loss of the essential minute particulars. It is as if Towne were seeking to demonstrate the view of Romantic art offered by the philosopher David Hartley who, after writing of fear and horror in landscape, continued:

> Uniformity and variety in conjunction are also principal sources of the pleasures of beauty, being made so partly by their association with the beauties of nature; partly by that with the works of art; and

[1] A darkened convex mirror used, especially by amateur artists in England, to reduce a view to the dimensions of a small drawing, and to give it muted colouring, similar to that in some works by Claude. A specimen is in the Science Museum, London.

[2] *The Marriage of Heaven and Hell*: Keynes, 152.

[3] British Museum.

with the many conveniences which we receive from the uniformity and variety of the works of nature and art. They must therefore transfer part of the lustre borrowed from the works of art, and from the head of convenience, upon the works of nature.

Poetry and painting are much employed in setting forth the beauties of the natural world, at the same time that they afford us a high degree of pleasure from many other sources. Hence the beauties of nature delight poets and painters, and such as are addicted to the study of their works, more than others. Part of this effect is indeed owing to the greater attention of such persons to the other sources; but this comes to the same thing, as far as the general theory of the factitious, associated nature of these pleasures is concerned.[1]

Abstraction was used as an inspirational spring-head by some Romantic landscapists. By Thomas Gainsborough, for instance, who loved landscape more than the brilliant portraits from which he derived his income. For a starting point in his compositions, he often arranged pieces of coal, rock, leaves or twigs, and, like a Chinese carver with a piece of jade, would look at them until they suggested a composition. This positively was domination by the mind of Man, seeking even his scenery from within himself. Yet there is nothing in Gainsborough's landscapes to suggest that he worked in this way—every nuance, every detail suggests that they have been painted from actual scenes (Plate 35). Some of them were so painted, but even these are indistinguishable from those composed from abstract parts.

This is not always true of another artist who derived inspiration from abstract forms—Alexander Cozens, who wrote: "I scruple not to affirm, that too much time may be employed in copying the landscapes of nature herself."[2] The method of composition which Cozens used was to cover the paper with blots and to use them as a starting point from which to build an imaginary landscape, usually in monochrome. Despite this odd method, Cozens's work has considerable power, and it had great influence on later painters, including, for example, Bonington and Constable. (Plate 92).

Even greater than the influence of Alexander Cozens was that of his son, John Robert Cozens, who was one of the first water-colourists of the English school to show that the medium need not be merely topographical, but could be a vehicle for the poetic expression of Man's inner being. Be-

[1] *Observations on Man* (1749) Proposition 94.
[2] *A New Method of assisting the invention in drawing original Compositions of Landscape* [1785], 3.

cause of this, he was one of those initially responsible for making water-colour the medium through which English Romantic landscape was mainly realized.

J. R. Cozens painted abroad, in Italy and Switzerland, and, in the studies he made there, was able to express that feeling of solitude and wild grandeur that mountains are capable of implanting in the mind. But he remains completely English, and his views of the Campagna, the Alps, Elba or the Tyrol are painted as only an Englishman would see them (Plate 93). What is even more important, they contain some of those imaginative stirrings that were soon to appear in the work of Girtin, Turner and Constable; and not only in painting, but in poetry:

> *For all things serve them; them the morning light*
> *Loves, as it glistens on the silent rocks;*
> *And them the silent rocks, which now from high*
> *Look down upon them; the reposing clouds;*
> *The wild brooks prattling from invisible haunts;*
> *And old Helvellyn, conscious of the stir*
> *Which animates this day their calm abode.*[1]

In his short life, Thomas Girtin—"by the sword-play of [his] pencil—the hand-stroke of the brush clear, clean, and decisive"[2]—produced work that was to help in the transformation of English landscape art from topography to visual poetry. His contribution to this transformation contained the essential element of strength: "to the poetry of the art, as practised by Cozens", wrote Redgrave, "Girtin added power—power of effect, power of colour and tone, power of execution."[3] And, he might have added, power of observation. For Girtin saw trees as they had never been observed by any previous painter, boldly simplifying their masses of light and shade, yet at the same time preserving their true nature. Here was no over simplification, no formula of loops and squiggles, no niggling detail, under which their poetic form would have been lost.

Both the power of Girtin's work and his treatment of trees are exemplified by his water-colour of the ruins of Kirkstall Abbey, standing in a

[1] Wordsworth, *The Prelude*, Book VIII, l. 63.

[2] Redgrave, Richard and Samuel, *A Century of Painters of the English School*, 1866, I, 393. The remark about Girtin's "sword-play" was, according to Redgrave, made by Frederick Christian Lewis, the landscape painter.

[3] ibid., 400.

vast undulating sweep of landscape, with the shadows of clouds scudding over it[1] (Plate 94). This work gives some indication of the even greater power that might have been developed by Girtin had he lived; but he died when he was only twenty-seven, probably from the effects of asthma and bronchitis. Turner recognized Girtin's potential: "Had Girtin lived I should have starved", he is said to have remarked.[2] Certainly neither Turner's work nor Constable's, nor that of any other nineteenth-century English landscapist, could have developed in quite the same way without Thomas Girtin's example.

But, as it is, Turner remains the greatest landscape painter this country has produced; he is undoubtedly one of the greatest of any country. No other painter has been able so to convey the quality and power of light, of the terror of vastness, of the elemental force of the weather. Some of this has already been discussed, but it is not until Turner's early work has been compared with his later visions that one can begin to appreciate his amazing strength. For he illustrates within his own *oeuvre* the transformation of the vision of the English landscape from a mere record, a snapshot so to speak, to dissolution into colour and light. Turner's later work was not the product of imagination alone. When the Houses of Parliament were burned down in October 1834, he watched the disaster and sketched details of it; when a steam-boat was in difficulties off Harwich in July 1842, he went out on the Admiralty steam-packet *Ariel*, and got the sailors to lash him to the mast for four hours, so that he could make a record of it. Each of these disasters were later worked into pictures: "Burning of the Houses of Parliament"[3] and "Snow Storm" (Plate 76). They are as apocalyptic as anything ever painted by Martin, and a hundred times greater. But whatever Turner painted—in the Lake District, in Scotland, in Italy, in Switzerland —there is always a Romantic preoccupation with the vastness of mountain or precipice, the infinity of the sea, and, dominating everything else, the pervasiveness of light. It is as if Shelley's lines have been given visual form:

> *Beneath is spread like a green sea*
> *The waveless plain of Lombardy,*
> *Bounded by the vaporous air,*
> *Islanded by cities fair;*
> *Underneath day's azure eyes*

[1] British Museum.
[2] Hardie, Martin, *op. cit.* II, 1. [3] Philadelphia Museum of Art.

Ocean's nursling, Venice lies,
A peopled labyrinth of walls,
Amphitrite's destined halls,
Which her hoary sire now paves
With his blue and beaming waves.
Lo! the sun upsprings behind,
Broad, red, radiant, half reclined
On the level quivering line
Of the waters crystalline;
And before that chasm of light,
As within a furnace bright,
Column, tower, and dome, and spire,
Shine like obelisks of fire,
Pointing with inconstant motion
From the altar of dark ocean
To the sapphire-tinted skies;
As the flames of sacrifice
From the marble shrines did rise,
As to pierce the dome of gold
Where Apollo spoke of old.[1]

Constable is nearer to earth than Turner. Nevertheless he belongs to the same tradition in Romantic art: he, too, painted light and weather, colour and shadow. But his work is concerned mainly with the effect of these elements on the landscape; his light is reflected by his subject, it does not, as in Turner, dissolve it. Constable is at his best in quickly-noted sketches and studies (often, like Turner's, in water-colour), in which light dances on the surfaces of things, what Samuel Palmer would have described as "sprinkled and showered with a thousand pretty eyes, and buds, and spires, and blossoms gemm'd with dew."[2] His finished works often lack immediacy, are often too contrived. But in such works as the pencil and sepia-wash "View on the Stour: Dedham Church in the distance" (Plate 71) and "Trees and a stretch of water on the Stour",[3] executed, it would seem, by a few flicks of the brush, there is a conception out of all proportion to their size. In spite of the monochrome in which they are executed (or perhaps because of it), they seem to sparkle with light and

[1] *Lines written among the Euganean Hills* (1818), l. 90. (cf. Plate 74).
[2] Letter to John Linnell, 21 December 1828. Printed in Palmer, A. H., *op. cit.*, 173.
[3] Both in the Victoria and Albert Museum.

atmosphere: a few strokes, and rain pours from the sky, a few blank spaces and the surface of the river mirrors the remaining sunlight. These afford a view of the English countryside combining Nature with a profound visionary sense.

And Constable painted clouds; clouds as no others had previously painted them (Plate 68). In this he was following a Romantic predilection, for clouds had an enchantment for Goethe, who wrote articles and poems on them, and for several other Romantic painters, including the Norwegian, Johan Christian Clausen Dahl (1788–1857), the German, Karl Eduard Ferdinand Blechen (1798–1840), and our own Alexander Cozens—some of whose cloud studies were actually copied by Constable.[1] These artists found them fascinating, not only as elements in landscape, but also because of that growing interest in science (which we discussed in Chapter Five) which caused artists, writers and scientists alike to delve into and to correlate all kinds of natural phenomena. Furthermore the clouds themselves provided a symbol of transience and unattainability. They were a floating mass of changing shapes, in which the Romantic could see his own transient but aspiring spirit buffeted, shaped and sometimes left floating in peace, but always changing at the whim of exterior forces. By studying, therefore, the rules by which clouds are shaped and dispersed, it was hoped that a reflection, and perhaps also some explanation, of the mysteries of the human spirit could be found.

It is doubtful if such speculative ideas had any conscious part in Constable's mind when he painted clouds. But there is little doubt that he considered them to be serious studies of natural phenomena; this is reinforced by his remark: "Painting is a science, and should be pursued as an inquiry into the laws of nature. Why, then, may not landscape painting be considered as a branch of natural philosophy, of which the pictures are the experiments?"[2] But as for the symbolism, it would probably have provoked from him a remark similar to that which he made to Blake, who had said, of a drawing of fir trees on Hampstead Heath in one of Constable's sketchbooks, "Why this is not drawing, but *inspiration*." Constable, with wry East Anglian commonsense, replied, "I never knew it

[1] cf. for example his copies, in the Courtauld Institute of Art (Lee Collection), of cloud studies from Cozens's *New Method*.
[2] Leslie, *Memoirs of Constable*, 323.

before; I meant it for drawing."[1] Constable's cloud studies were intended primarily as studies for his "finished" landscape pictures; yet they are also accurate observations that have passed the scrutiny of expert meteorologists,[2] and they have in their own right a poetic Romantic quality equal to those in Shelley's *Mutability*:

> *We are as clouds that veil the midnight moon;*
> *How restlessly they speed, and gleam, and quiver,*
> *Streaking the darkness radiantly!—yet soon*
> *Night closes round, and they are lost for ever.*[3]

A Romantic view of the English countryside quite different from those of Constable or Turner, or of any other artist so far discussed in this chapter, was initiated by Blake, in a series of little wood engravings, his only work in this medium (Plate 31). These are illustrations for the First Eclogue in Dr Robert John Thornton's *Pastorals of Virgil . . . Adapted for Schools*, published in 1821. There are seventeen of them, all but one measuring about one and a quarter by three inches. (The exception is the frontispiece, which measures two and three-eighths by three and a quarter inches.) Originally they were larger, but they were ruthlessly cut down by the printers to fit on the pages of the book. Proofs exist of some of them, before this was done, and from these we can judge how much was lost in the process. Three were re-engraved by trade engravers, for Thornton was unimpressed by them; and they would all have been so treated had he not been prevailed upon by certain well-known artists (reputed to have included James Ward and Sir Thomas Lawrence), to leave the remainder alone. Even so, Thornton felt that some apology for their appearance was called for, and they were finally published with this prefatory note:

> The Illustrations of this English Pastoral are by the famous BLAKE, the illustrator of *Young's* Night Thoughts, and *Blair's* Grave; who designed and engraved them himself. This is mentioned, as they display less of art than genius, and are much admired by some eminent painters.

Yet their power was not to be resisted, and Blake's young friend, Palmer, whom they were to affect so deeply, wrote of them:

[1] ibid., 280.
[2] Badt, Kurt, *John Constable's Clouds*, 1950, 46–8 and ch. vi.
[3] Verse 1; published in 1816.

I sat down with Mr Blake's Thornton's *Virgil* woodcuts before me, thinking to give to their merits my feeble testimony. I happened first to think of their sentiment. They are visions of little dells, and nooks, and corners of Paradise; models of the exquisitest pitch of intense poetry. I thought of their light and shade, and looking upon them I found no word to describe it. Intense depth, solemnity, and vivid brilliancy only coldly and partially describe them. There is in all such a mystic and dreamy glimmer as penetrates and kindles the inmost soul, and gives complete and unreserved delight, unlike the gaudy daylight of this world. They are like all that wonderful artist's works the drawing aside of the fleshly curtain, and the glimpse which all the most holy, studious saints and sages have enjoyed, of that rest which remaineth to the people of God."[1]

And, as we have already seen, Calvert said: "They are done as if by a child; several of them careless and incorrect, yet there is a spirit in them, humble enough and of force enough to move simple souls to tears."[2]

The most famous of all of Blake's Virgil engravings, one which was to have a particular influence on his followers, was No. VI: a picture of a stout oak tree and a field of corn battered down by a storm, with the moon, in partial eclipse, seen through the clouds (Plate 31). This moon was to appear again and again, as the old moon in the arms of the new, in the early work of Palmer and Calvert. In others, shepherds discourse together, with their flocks grazing, or penned nearby; or, by night, they talk in their cottage; or, sitting alone, they gaze at the moon; sheep feed by a limpid stream with a thatched cottage nearby: heifers, by sunset, are released from their plough; and shepherds and maidens dance and pipe in the English landscape.

It is a pastoral world, a glance into an ideal world of innocence, into an Arcadia that could, if Man's mind were properly organized, be found in "England's green and pleasant land".[3] To Blake, organized innocence was a cleaning of the mind, a spiritual experience. But Palmer and his friends actually found, for a few years, a physical Arcadia in a sweet, nutty little valley at Shoreham in Kent, which looked, said Calvert, "as if the Devil had not yet found it out".[4]

It did not last. The idyllic countryside was itself changing; new methods of agriculture were ousting the old. Farm workers, in desperation, burned down ricks and smashed threshing machines, but all to no avail. The

[1] Palmer, A. H., *op. cit.*, 15–16. [2] Calvert, Samuel, *op. cit.*, 19.
[3] Blake, *Milton*: Keynes, 481. [4] Calvert, Samuel, *op. cit.*, 33.

pastoral mode was departing, and with it the innocence of the old rural life. Experience loomed ever larger, and the "Ancients" (as Palmer and his circle called themselves) were overwhelmed by cares and responsibilities, or seduced by the lure of success. But for a time they foregathered under the moon at Shoreham, swam in the Darent, sang songs in cornfields, and painted pictures as delectable, and as full of poetry as those of Claude and Elsheimer.[1] Their Kent valley, in their vision, became the Promised Land; they painted it as if they were priests painting for the glory of God:

> *January 2nd* [1825].—Now is begun a new year. Here I pause to look back on the time between this and about the 15th of last July. Then I laid by the [*Holy*] *Family* in much distress, anxiety, and fear; which had plunged me into despair but for God's mercy, through which and which alone it was that despondency not for one moment slackened my sinews; but rather, distress (being blessed) was to me a great arousement; quickly goading me to deep humbleness, eager, restless inquiry, and diligent work. I then sought Christ's help, the giver of all good talents whether acknowledged or not, and had I gone on to seek Him as I ought, I had found His name to me as a civet-box and sweeter than all perfume. Notwithstanding, as it was, I think (by Him alone) I improved more since I resolved to depend on Him till now, than in the same time ever before; and have felt much more assistance and consolation. For very soon after my deep humblement and distress, I resumed and finished my *Twilight*, and quickly took up my *Joseph's Dream*, and sketched in my new sketch-book. Mr. L.[2] called, and looking at my *Joseph*, sepias, and sketch-books, did give me indeed sweet encouragement. Soon, by his desire, I went with him to Mr. B. [Blake], who also, on seeing my things, gave me above my hope, over-much praise; and these praises from equally valued judgements did (God overruling) not in the least tend to presumption and idleness, and but little to pride; for knowing my own stupidness (but not alas, to its full) I gave back the praise to God who kindly sent it and, had granted to me desponding, that at eventide it should be light.[3]

Palmer's early water-colours and later etchings, Calvert's early engravings, George Richmond's early engravings and paintings; in all of these that spirit is apparent. The crescent moon rises over the Kent hills; cottage,

[1] Adam Elsheimer (1578–1610), German landscape painter.

[2] John Linnell.

[3] Palmer, A. H., *op. cit.*, 13.

church and stooks of corn are bathed in its light. A sage—perhaps it is a portrait of Calvert—reads a book by the full moon in "The Valley thick with Corn," while bats flit across the moon's disc. The Holy Family rests beneath a Biblical palm-tree at Shoreham, on their flight into Egypt.[1] (Plates 16 and 95). A couple prepare to love in a primitive cottage in Calvert's "Chamber Idyll", free from "the needless Pomp of gaudy Furniture",[2] while outside the moon shines down on a scene of pastoral richness (Plate 4). Richmond's "Shepherd", leans on his crook, his figure like a flame of ecstasy in an English Canaan (Plate 45). The light burns in Palmer's "Lonely Tower" (Plate 96) as shepherds watch it from the fields; and a wagon trundles towards it, while,

> —*the Belman's drowsie charm,*
> *To bless the dores from nightly harm:*
> *Or let my Lamp at midnight hour,*
> *Be seen in some high lonely Towr,*
> *Where I may oft out-watch the* Bear,
> *With thrice-great* Hermes. . . .[3]

But then, there was a sinking into mundane thought and expression. Palmer married the eldest daughter of his friend, John Linnell. The responsibilities of marriage and family life brought an anxiety into Palmer's spirit that completely dampened his original vision. He turned to a conventional style which, while good of its kind, lacked the divine spark of his Shoreham work. For spiritual relief he turned more and more to etching, and in that branch of his work, he recaptured some of his earlier vision, if not his ecstasy.[4]

Calvert, after making his eleven spiritual engravings, decided, for some reason not yet satisfactorily explained, to cast the medium aside, and thereafter concentrated upon painting hazy little studies of an imaginary Greek golden age. Richmond became a fashionable portrait painter and a Royal Academician. The time of the Shoreham Arcady was short indeed.

As the nineteenth century wore on, the Romantic view of landscape became overlaid with sentimentalism and photographic realism. Where

[1] "Late Twilight", "The Valley thick with Corn", and "The Rest on the Flight" by Samuel Palmer, in the Ashmolean Museum.
[2] John Pomfret, *The Choice*, 1699.
[3] Milton, *Il Penseroso*, l. 83.
[4] Lister, Raymond, *Samuel Palmer and his Etchings*, 1969.

Wilson had seen mystery, Cecil Gordon Lawson reported details; where Turner and Constable had painted light, Birket Foster painted pretty but solid bucolic scenes; where Palmer and Calvert had seen paradisical valleys, and orchards flowing with milk and honey, Benjamin Williams Leader saw the flood and mud of this world; where Blake had seen the light of Jerusalem in the land of Albion, Frith saw Epsom on Derby Day.

Man's soul had somehow slipped out of the landscape. He desired it as much as ever, but his love was unrequited. He was, and remains, an imperfect and unsuccessful suitor, protesting his love for natural and scenic beauties, paying lip-service to ideas of preservation, conservation, or whatever the current jargon happens to be. Did he but know it, his being is still reflected there, in the motorways, airfields, electricity pylons and rashes of suburbia, spreading over it like a malignant growth. The Romantic *knew* his spirit was there, and he tried to understand it and to portray it accordingly. Perhaps we might find food for thought in his attitude, and, like Blake, yet see the lark mounting

> *with a loud trill from Felpham's Vale,*
> *And the Wild Thyme from Wimbleton's green & impurpled Hills,*
> *And Los & Enitharmon [rising] over the Hills of Surrey.*[1]

[1] *Milton*: Keynes, 534. In Blake's mythology Enitharmon, Los's female emanation, is spiritual beauty.

REFERENCE SECTION

APPENDIXES

Appendixes I, II and III list three groups of prints of considerable rarity, and the compiler has been unable to examine enough impressions to be able to ascertain if there are various states. The check-lists are intended only as a groundwork for study, and are offered in the hope that they will bring other impressions to light, on which a more thorough study may be based.

APPENDIX I

A check-list of aquatints of Old Testament subjects by William Young Ottley

1. *Inscribed*: So God created man— / Gen. Ch.1. Ver.27. I[1]
 Size of engraved area[2]: $9\frac{1}{4} \times 7\frac{1}{16}$ ins.
 Size of plate: $10\frac{3}{16} \times 7\frac{1}{2}$ ins. (Plate 51.)

2. *Inscribed*: And the rib which the Lord God had taken from man, adem
 he a woman, and brought her unto the man / Gen. Ch.2. Ver.22. II
 Size of engraved area: $7\frac{3}{4} \times 10\frac{1}{8}$ ins.
 Size of plate: $8\frac{9}{16} \times 10\frac{11}{16}$

3. *Inscribed*: So he drove out the man: / Gen. Ch.3. Ver.24. III
 Size of engraved area: $10\frac{1}{16} \times 7\frac{11}{16}$ ins.
 Size of plate: $11\frac{1}{16} \times 8\frac{7}{16}$ ins.

4. Untraced.

5. *Inscribed*: And all flesh died / Gen. Ch.7. Ver.21. V
 Size of engraved area: $10 \times 7\frac{9}{16}$ ins.
 Size of plate: $11 \times 8\frac{3}{16}$ ins.

6. *Inscribed*: I do set my bow in the cloud; and it shall be for a token of a
 covenant between me and the earth— / Gen. Ch.9. Ver.13. VI
 Size of engraved area: $8\frac{1}{16} \times 9\frac{15}{16}$ ins.
 Size of plate: $9\frac{1}{8} \times 10\frac{5}{8}$ ins.

7. *Inscribed*: And Abram took Sarai his wife, and Lot his brother's son, and
 all their substance that they had gathered, and the souls that they had /

[1] In each print, in addition to the inscription given (which is in copperplate
script), there is an inscription in the lower right-hand corner, reading: "Pub-
lished as the Act directs April 1st 1797". With the exception of No. 1, each
print has its number repeated, in Arabic numerals, in the top margin at the right-
hand side. Each print is printed in sepia.
[2] Exclusive of lettering.

gotten in Haran; and they went forth to go into the land of Canaan;— / Gen. Ch.12. Ver.5. VII

Size of engraved area: $8\frac{3}{16} \times 10\frac{1}{2}$ ins.
Size of plate: $9\frac{1}{4} \times 11\frac{3}{16}$ ins.

8. *Inscribed:* And he divided himself against them, he and his servants by night, and smote them and pursued them / Gen. Ch.14. Ver.15 VIII

Size of engraved area: $8\frac{1}{4} \times 10\frac{1}{4}$ ins.
Size of plate: $9\frac{1}{8} \times 10\frac{11}{16}$ ins.

9. *Inscribed:* And they smote the men that were at the door of the house with blindness,— / Gen. Ch.19. Ver.11. IX

Size of engraved area: $10\frac{3}{8} \times 8\frac{5}{16}$ ins.
Size of plate: $11\frac{3}{16} \times 8\frac{7}{8}$ ins.

10. *Inscribed:* And she went and sat her down over against him a good way off, as it were a bowshot: for she said, Let me not see the/death of the child and she sat over against him and lift up her voice and wept— / Gen. Ch.21. Ver.16. X

Size of engraved area: $7\frac{3}{8} \times 9\frac{5}{8}$ ins.
Size of plate: $8\frac{7}{16} \times 10\frac{1}{4}$ ins.

11. Untraced.

12. *Inscribed:* And Aaron and Hur stayed up his hands, the one on the one side, and the other on the other side; and his/hands were steady until the going down of the sun— / Exodus Ch.17. Ver.12. XII

Size of engraved area: $7\frac{3}{8} \times 8\frac{7}{8}$ ins.
Size of plate: $8\frac{7}{16} \times 9\frac{1}{2}$ ins.

Note: The British Museum contains a further set of Biblical engravings after designs by Ottley, viz., *Twelve stories of the Life of Christ engraved by Piroli from the designs of Ottley*, Rome, 1796.

APPENDIX II

A Check-list of the Etchings of Alexander and John Runciman[1]

1. "St. Margaret landing".[2] $9\frac{5}{16} \times 7\frac{3}{16}$ ins.[3]
 Signed on the plate in bottom right-hand corner: A.Runciman inv

2. "Marriage of St. Margaret and King Malcolm". $9\frac{1}{2} \times 7\frac{5}{16}$ ins.
 Signed on the plate in bottom left-hand corner: **AR** Pinxit & fecit.

3. "The finding of Corban Cargloss (*Ossian*)". (After a ceiling at Penicuick House 1772, destroyed by fire 1899.) $6\frac{7}{16} \times 10$ ins.
 Signed on the plate in bottom left-hand corner: **AR** fecit

4. Subject and composition as No. 3, but with the figures reversed. $12\frac{1}{4} \times 15\frac{1}{16}$ ins.
 Unsigned.

5. "Catholda (*Ossian*)". (The figure is the same, but reversed, as that in no.3.) $5\frac{11}{16} \times 3\frac{7}{16}$ ins.
 Signed on the plate in bottom left-hand corner: A.Runciman inv.

6. "Cormar attacking the Spirit of the Waters." $2\frac{15}{16} \times 4\frac{15}{16}$ ins.
 Signed and inscribed on the plate in bottom, to right of centre: **AR**unciman inv. & fecit [vide[4]] Fingal. (Plate 52.)

7. "Perseus, assisted by Minerva, killing Medusa". $6\frac{3}{8} \times 10\frac{1}{16}$ ins.
 Signed and dated on the plate in the bottom right-hand corner: **AR**unciman inv. & fecit 1774.[5]

[1] A collection of these etchings is in the National Gallery of Scotland, Department of Prints and Drawings. A set of numbers 1 to 11 is owned by the Royal Scottish Academy.

[2] The National Gallery of Scotland owns two extra impressions of this plate: a) Without background; b) with partial background, and the remainder of the background inked in.

[3] The sizes are the measurements of the plates, not of the etched surfaces, although in some cases they are the same.

[4] This is unclear. [5] The two figure 7s are reversed.

8. "Ariadne". 4 × 5$\frac{11}{16}$ ins.
 Signed on the plate in the bottom left-hand corner: **AR**unciman fecit

9. "Agrippina with the ashes of Germanicus". 5$\frac{5}{8}$ × 4$\frac{3}{16}$ ins.
 Signed on the plate in the bottom left-hand corner: **AR** inv[1]

10. "Sigismunda weeping over the heart of Tancred". 5$\frac{3}{4}$ × 3$\frac{1}{2}$ ins.
 Signed on the plate in the bottom right-hand corner: **AR**unciman inv: & fecit

11. "Misidora disrobing". 5$\frac{3}{8}$ × 3$\frac{11}{16}$ ins.
 Signed on the plate in the bottom left-hand corner: **AR**unciman inv: & fecit

12. "The Return of Ulysses (?)". 5$\frac{15}{16}$ × 7$\frac{1}{8}$ ins.[2]
 Signed, in reverse, along the bottom edge: Jo[n] Runciman Inv. & fecit

13. "View on the Via Appia", or, "Italian landscape with two horses and two men, and a tower."[3] 4$\frac{1}{8}$ × 5$\frac{1}{8}$ ins.
 Signed on the plate in the bottom left-hand corner: **AR** unciman f:

Note: The National Gallery of Scotland owns also an etching entitled "Milton's allegro v. 69". It is after a work by Runciman, and no engraver is mentioned.

[1] This is followed by a mark that could be part of "fecit".

[2] In the only impression seen by the compiler (it is in the National Gallery of Scotland) the upper plate mark is not visible. It was probably cut within the plate mark.

[3] There is, in some impressions of this etching, a patch of aquatinting on the tower. It is missing from the impression in the National Gallery of Scotland.

APPENDIX III

A Check-list of the engravings by Giovanni Vendramini, after Sir Robert Ker Porter, illustrating Anacreon.[1]

1. *Inscribed, in shaded capitals*: ΑΝΑΚΡΕΩΝ. *Engraved area*: $2\frac{1}{2} \times 2\frac{1}{2}$ ins.[2]

2. *Uninscribed. Engraved area*: $7\frac{1}{4} \times 6\frac{5}{8}$ ins.

3. *Inscribed*: "Give me the harp of epic song,
 "Which Homer's finger thrill'd along;
 "But tear away the sanguine string,
 "For war is not the theme I sing"

 ODE, II.

*The inscription at the bottom reads: London,
Published July 2, 1803, by John P. Thompson, Gt.
Newport Street, and No. 51 Dean Street, Soho,
Printseller to His Majesty, & the Duke & Duchess
of York*
 Engraved area: $7\frac{1}{2} \times 5\frac{1}{4}$ ins.

4. *Inscribed*: "I caught the boy—a goblet's tide
 "Was richly mantling by my side—
 "I caught him by his downy wing,
 "And whelm'd him in the racy spring."

 ODE, VI.

[1] In the only set of these engravings seen by the compiler, each is printed on a sheet $13\frac{5}{8} \times 9\frac{1}{8}$ ins. Unless otherwise stated, each is signed on the left, *Robert Ker Porter del.* and on the right, *John Vendramini sculp.*; and each is inscribed at the bottom, *London Published June 4, 1805, by John P. Thompson, Gt. Newport Street, Printseller to His Majesty & the Duke & Duchess of York.* In each case the engraving illustrates the accompanying inscription.

[2] In each case the extreme measurements of the engraved area are given, but exclusive of the inscription. With the exception of No. 1, all verse inscriptions are in copperplate script.

The inscription at the bottom reads: London,
Published April 16, 1803, by John P. Thompson, Gt.
Newport Street, and No. 51 Dean Street, Soho,
Printseller to His Majesty, & the Duke & Duchess
of York
 Engraved area: 6¾ × 5¼ ins.

5. *Inscribed:* "Alemæon once, as legends tell,
 "Was frenzied by the fiends of hell;
 "Orestes too, with naked head,
 "Frantic pac'd the mountain-head;
 "But 'twas a murder'd mother's shade,
 "That on their guilty bosom prey'd."
 ODE IX.

The inscription at the bottom is as note 1 p. 185, but with the addition of
and No. 51 Dean Street, Soho
 Engraved area: 6¾ × 6 9/16 ins.

6. *Inscribed:* "Array'd with corslet, shield and spear,
 "Pelides' self, I smil'd at fear,
 And (hear it—all you powers above!)
 I fought with Love!—I fought with Love!"
 ODE XIII.

 Engraved area: 6 × 5¾ ins.

7. *Inscribed:* "Tell me, why, my sweetest dove,
 "Thus your humid pinions move,
 "Shedding through the air in showers
 "Essence of the balmiest flowers?"—
 ODE, XV.

The inscription at the bottom is as No. 3.
 Engraved area: 4⅞ × 6¾ ins.

8. *Inscribed:* "Now let a floating, lucid veil
 "Shadow her limbs, but not conceal;
 "A charm may peep, a hue may beam
 "And leave the rest to Fancy's dream."
 ODE, XVI.

The inscription at the bottom is as No. 4.
 Engraved area: $6\frac{5}{16} \times 4\frac{3}{4}$ ins.

9. *Inscribed*: "Bring me wine in brimming urns,
 "Cool my lip, it burns—it burns!
 "Sunn'd by the meridian fire,
 "Panting, languid I expire!
 "Give me all those humid flowers,
 "Drop them o'er my brow in showers."
 ODE XVIII.

 Engraved area: $7\frac{1}{4} \times 6\frac{7}{8}$ ins.

10. *Inscribed*: "Here recline you, gentle maid,
 "Sweet in this embowering shade;
 "Sweet the young, the modest trees
 "Ruffled by the kissing breeze!"
 ODE, XIX.

 The inscription at the bottom is as No. 4.
 Engraved area: 5×6 ins.

11. *Inscribed*: "One day, the Muses twin'd the hands
 "Of baby Love, with flow'ry bands;
 "And to celestial Beauty gave
 "The captive infant as her slave."
 ODE, XX.

 The inscription at the bottom is as No. 3.
 Engraved area: $5\frac{3}{4} \times 6\frac{5}{16}$ ins.

12. *Inscribed*: "Once, to this Lemnian cave of flame,
 "The crested Lord of battles came;
 "'Twas from the ranks of war he rush'd,
 "His spear with many a life-drop blush'd!
 "He saw the mystic darts, and smil'd
 "Derision on the archer-child."
 ODE XXVIII.

 The inscription at the bottom is as No. 5.
 Engraved area: $8\frac{1}{8} \times 7$ ins.

13. *Inscribed*: "'Twas in an airy dream of night,
 "I fancied, that I wing'd my flight
 "On pinions fleeter than the wind,
 "While little Love, whose feet were twin'd
 "(I know not why) with chains of lead,
 "Pursued me as I trembling fled:"

ODE, XXX.

The inscription at the bottom is as No. 5.
Engraved area: 6½ × 6 5/16 ins.

14. *Inscribed*: "Arm'd with hyacinthine rod,
 "(Arms enough for such a god)
 "Cupid bade me wing my pace,
 "And try with him the rapid race.
 "O'er the wild torrent, rude and deep,
 "By tangled brake and pendent sleep."

ODE XXXI.

Engraved area: 6 × 6 13/16 ins.

15. *Inscribed*: "Now let the rose, with blush of fire,
 "Upon my brow its scent expire;
 "And bring the nymph with floating eye,
 "Oh! she will teach me how to die!"

ODE, XXXII.

The inscription at the bottom is as No. 4.
Engraved area: 5¼ × 5⅞ ins.

16. *Inscribed*: "The fatal bow the urchin drew,
 "Swift from the string the arrow flew;
 "It flew as swift as glancing flame,
 "And to my very soul it came!"

ODE XXXIII.

The inscription at the bottom is as No. 3.
Engraved area: 8⅜ × 6⅝ ins.

17. *Inscribed*: "Cupid once, upon a bed
 "Of roses, laid his weary head;
 "Luckless urchin, not to see

[188]

"Within the leaves a slumbering bee—
"The bee awak'd—with anger wild
"The bee awak'd and stung the child."
ODE XXXV.

The inscription at the bottom is as No. 5.
Engraved area: 5¾ × 4¼ ins.

18. *Inscribed*: "And why should I then pant for treasures?
"Mine be the brilliant round of pleasures;
"The goblet rich, the board of friends,
"Whose flowing soul the goblet blends!"
ODE XXXVI.

Engraved area: 6 × 6⅞ ins.

19. *Inscribed*: "Let me imbibe the spicy breath
"Of odours, chaf't to fragrant death;
"Or from the kiss of love inhale
"A more voluptuous, richer gale!"
ODE XXXVIII.

Engraved area: 6⅝ × 5 ins.

20. *Inscribed*: "And with the maid, whose every sigh
"Is love and bliss, entranc'd to lie
"Where the imbowering branches meet—
"Oh! is not this divinely sweet?"
ODE XLI.

Engraved area: 7 × 7¼ ins.

21. *Inscribed*: "A youth the while, with loosen'd hair
"Floating on the listless air,
"Sings, to the wild-harp's tender tone,
"A tale of woes, alas! his own—"
ODE XLIII.

Engraved area: 8 × 6¾ ins.

22. *Inscribed*: "On my velvet couch reclining,
"Ivy leaves my brow entwining,

"While my soul dilates with glee,
"What are kings and crowns to me?"

ODE XLVIII.

Engraved area: 9 × 7⅛ ins.

23. *Inscribed*: "Teach me this; and let me swim
"My soul upon the goblet's brim;
"Teach me this, and let me twine
"My arms around the nymph divine!"

ODE LII.

Engraved area: 8 × 6⅞ ins.

24. *Inscribed*: "Methinks, the pictur'd bull we see
"Is amorous Jove—it must be he!
"How fondly blest he seems to bear
"That fairest of Phœnician fair!
"How proud he breasts the foamy tide,
"And spurns the billowy surge aside!"

ODE LIV.

Engraved area: 6⅜ × 7⅞ ins.

25. *Inscribed*: "Come—within a fragrant cloud
"Blushing with light, thy rotary shroud;
"And, on those wings that sparkling play,
"Waft, oh! waft me hence away!"

ODE LXXVI.

Engraved area: 6 × 6¾ ins.

26. *Inscribed*: "Pretty nymph, of tender age,
"Fair thy silky locks unfold;
"Listen to a hoary sage
"Sweetest maid, with vest of gold!"

ODE LXXVII.

Engraved area: 7 × 6¾ ins.

GENERAL BIBLIOGRAPHY[1]

ABERCROMBIE, LASCELLES *Romanticism* 1926.

ABRAHAM, G. *A Hundred Years of Music* 3rd ed. 1964. reprinted 1966.

ABRAMS, M. H. *The Mirror and the Lamp* 1953.

ANDREWS, KEITH *The Nazarenes* 1964.

ANSTRUTHER, IAN *The Knight and the Umbrella. An Account of the Eglinton Tournament 1839* 1963.

ANTAL, FREDERICK *Classicism and Romanticism with other studies in art history* 1966.

ARTS COUNCIL *The Art of Claude Lorrain* 1969.

—*Berlioz and the Romantic Imagination* 1969.

—*Shakespeare in Art* 1964.

BALL, PATRICIA M. *The Central Self* 1968.

BARNARD, G. V. *Paintings of the Norwich School* 1950.

BARNES, WILLIAM *Poems* (ed. Bernard Jones) 2 vols. 1962.

BATE, WALTER JACKSON *From Classic to Romantic. Premises of Taste in Eighteenth-century England* 1945.

BEAUMONT, CYRIL W. *Complete Book of Ballets* 1937.

—, and SITWELL, SACHEVERELL *The Romantic Ballet in Lithographs of the Time* 1938.

BECKFORD, WILLIAM *Vathek, An Arabian Tale* 1786.

BEERS, HENRY A. A. *A History of English Romanticism in the Nineteenth Century* 1902.

BERLIOZ, HECTOR *Memoirs* (translated by David Cairns) 1969.

BINYON, LAURENCE *The English Romantic Revival in Art and Poetry: a Reconsideration* [1935].

—*The Followers of William Blake* 1925.

—*Landscape in English Art and Poetry* 1931.

BLACKSTONE, BERNARD *The Consecrated Urn. An Interpretation of Keats in Terms of Growth and Form* 1959.

BLAIR, ROBERT *The Grave* 1743.

BLAKE, WILLIAM *Complete Writings* (ed. Sir Geoffrey Keynes) 1966.

[1] Books dealing with particular artists will be found under their entries in the *Check-list of British Romantic Artists.*

[191]

BLAND, DAVID *A History of Book Illustration* 1958.

BLOOM, HAROLD *The Visionary Company* 1962.

BLUNT, ANTHONY *Nicolas Poussin* 3 vols. 1967.

BLUNT, WILFRID *The Art of Botanical Illustration* 1950.

BOASE, T. S. R. *English Art 1800–1870* 1959.

BONNER, STEPHEN *Aeolian Harp* 4 vols. 1970–71.

BOWRA, SIR MAURICE *The Romantic Imagination* 1950.

BRION, MARCEL *Art of the Romantic Era* 1966.

BROCKMAN, H. A. N. *The Caliph of Fonthill* 1956.

BURKE, EDMUND *A Philosophical Inquiry into the Origin of our Ideas of the Sublime and Beautiful* 1757.

BYRON, GEORGE GORDON, LORD *Letters* (ed. R. G. Howarth) 1933

—*Poetical Works* (ed. F. Page. New ed. corrected by John Jump) 1970.

CAVE, RODERICK and WAKEMAN, GEOFFREY *Typographia Naturalis* 1967.

CHATTERTON, THOMAS *Complete Works* (ed. Donald S. Taylor and Benjamin B. Hoover) 1971.

CLARE, JOHN *Poems* (ed. J. W. Tibble) 2 vols. 1935.

CLARK, KENNETH *English Romantic Poets and Landscape Painting* 1943.

—*The Gothic Revival* (revised ed.) 1962.

—*Landscape into Art* 1946.

—*Moments of Vision* 1956.

—*The Nude. A Study of Ideal Art* 1956.

COLERIDGE, SAMUEL TAYLOR *Notebooks* (ed. Kathleen Coburn) 2 vols. 1957 and 1962.

—*Poetical Works* (ed. E. H. Coleridge) 1969.

COLLINS, WILLIAM See under GRAY, THOMAS.

COOKE, WILLIAM *An Enquiry into the Patriarchal and Druidical Religion, Temples etc.* 1754.

COURTHION, PIERRE *Romanticism* (translated by Stuart Gilbert) 1961.

COWPER, WILLIAM *Poetical Works* (ed. H. C. Milford, revised by Norma Russell) 1967.

CUMMINGS, FREDERICK and others *Romantic Art in Britain 1760–1860* 1968.

CUNNINGHAM, ALLAN *The Lives of the most eminent British Painters, Sculptors and Architects* 6 vols. 1829–33.

DALTON, R. and HAMER, S. H. *The Provincial Token-coinage of the 18th century* 3 vols. 1910–17.

DARWIN, ERASMUS *The Botanic Garden* 1789–91.

DAVY, JOHN *Memoirs of the Life of Sir Humphry Davy* 1839.

DELCOURT, MARIE *Hermaphrodite* 1961.

DE QUINCEY, THOMAS *Confessions of an English Opium Eater* (enlarged ed.) 1856.

DICKES, W. F. *The Norwich School of Painting* 1905.

DOBSON, AUSTIN *At Prior Park* 1912.

DYER, JOHN *Grongar Hill* 1726.

—*The Ruins of Rome* 1740.

FLETCHER, IAN *Romantic Mythologies* 1967.

FREDEMAN, WILLIAM B. *Pre-Raphaelitism: a Bibliocritical Study* 1965.

FRYE, NORTHROP (ed.) *Romanticism Reconsidered* 1963.

FURST, LILIAN R. *Romanticism* 1969.

GARDNER, W. H. *Gerard Manley Hopkins* 2 vols. (revised ed.) 1948.

GAUNT, WILLIAM *Bandits in a Landscape. A Study of Romantic Painting from Caravaggio to Delacroix* 1937

—*The Pre-Raphaelite Tragedy* 1942.

GAUTIER, THÉOPHILE *The Romantic Ballet as seen by Théophile Gautier* (translated by Cyril W. Beaumont) 1932.

GERARD, ALBERT S. *English Romantic Poetry* 1968.

GILPIN, WILLIAM *Three Essays: On Picturesque Beauty, On Picturesque Travel, On Sketching Landscape* 1792.

GITTINGS, ROBERT *John Keats* 1968.

GODWIN, WILLIAM *Essays on Sepulchres* 1809

GOETHE, JOHANN WOLFGANG VON *Faust* 1808–32

—*The Sorrows of Young Werther* revised ed. 1787.

—*Truth and Poetry: From My Own Life* (translated by John Oxenford) 1848–49.

GRAF, DIETER *Nineteenth-century German Drawings and Water-colours* 1968.

GRANT, M. H. *A Chronological History of the Old English Landscape Painters* 8 vols. (new ed.) 1957.

GRAY, THOMAS and COLLINS, WILLIAM *Poetical Works* (ed. Austin Lane Poole) 1966.

GRIGSON, GEOFFREY *The Harp of Aeolus* 1947.

GUEST, IVOR *The Romantic Ballet in Paris* 1966.

HALSTEAD, JOHN B. (ed.) *Romanticism* 1969.

HARDIE, MARTIN *Water-colour Painting in Britain* 3 vols. 1966–68.

HARVEY, JOHN *Victorian Novelists and their Illustrators* 1970.

HAUSER, ARNOLD *Rococo, Classicism and Romanticism. The Social History of Art Vol. 3* 1962.

HAYDEN, JOHN O. *The Romantic Reviewers 1802–24* 1969.

HAYDON, BENJAMIN ROBERT *Correspondence and Table Talk* 2 vols. 1876.

—*Diary* (ed. W. B. Pope) 5 vols. 1960–63.

HAYTER, ALETHEA *Opium and the Romantic Imagination* 1968 (reprinted 1971).

HAZLITT, WILLIAM *Conversations of James Northcote R.A.* 1830.

HIPPLE, WALTER *The Beautiful, the Sublime and the Picturesque, in 18th century British Aesthetic Theory* 1957.

HOBHOUSE, CHRISTOPHER *1851 and the Crystal Palace* (revised edn.) 1950.

HODGSON, J. E. and EATON, F. A. *The Royal Academy and its Members 1768–1830* 1905.

HONOUR, HUGH *Chinoiserie. The Vision of Cathay* 1961.

—*Neo-classicism* 1968.

HOPKINS, GERARD MANLEY *Journals and Papers* (ed. Humphry House and Graham Storey) 1959.

—*Letters* (ed. Claude Colleer Abbott; revised ed.) 3 vols. 1955–56.

—*Poems* (ed. W. H. Gardner and N. H. Mackenzie. 4th ed.) 1967.

HOUGH, GRAHAM *The Last Romantics* 1947.

—*The Romantic Poets* (3rd ed.) 1967.

HUNT, WILLIAM HOLMAN *Pre-Raphaelitism and the Pre-Raphaelite Brotherhood* 2 vols. 1905.

HURD, BISHOP *Letters on Chivalry and Romance* 2nd ed. 1762.

HUSSEY, CHRISTOPHER *The Picturesque. Studies in a Point of View* 1927.

HUXLEY, ALDOUS *Heaven and Hell* 1959.

HUXLEY, THOMAS HENRY *Scientific Memoirs* (ed. Sir Michael Foster and Professor Lankester) 4 vols. 1898–1903.

IRONSIDE, R. and GERE, J. A. *Pre-Raphaelite Painters* 1948.
IRWIN, DAVID *Winckelmann Writings on Art* 1972.

JACK, IAN *Keats and the Mirror of Art* 1967.
JACKSON, MRS E. NEVILL *Silhouette Notes and Dictionary* 1938.
JAMES, D. G. *The Romantic Comedy. An Essay on English Romanticism* 1948.
JONES, BARBARA *Follies and Grottoes* 1953.
JUNG, CARL GUSTAV *Psychology and Alchemy* 1953.

KEATS, JOHN *Letters 1814–1821* (ed. H. E. Rollins) 1958.
—*Poetical Works* (ed. H. W. Garrod) 1961.
KENDRICK, SIR THOMAS *The Druids* 1928.
KITTON, F. G. *Dickens and his Illustrators* 1899.
KLINGENDER, FRANCIS D. *Art and the Industrial Revolution* (ed. revised by Sir Arthur Elton) 1968.
KNIGHT, G. WILSON *Starlit Dome: Studies in the Poetry of Vision* (new ed. 1959; paperback ed. 1971).
KNIGHT, RICHARD PAYNE *The Landscape* 1794.
—*An Analytical Inquiry into the Principles of Taste* 1805.

LAVATER, JOHANN KASPAR *Essays on Physiognomy* (translated by the Rev. C. Moore) 5 vols. 1793.
LEVY, MERVYN *The Moons of Paradise* 1962.
LEWIS, JOHN *Printed Ephemera* 1962.
LEWIS, MATTHEW GREGORY *The Monk* 1796.
LISTER, RAYMOND *Victorian Narrative Paintings* 1966.
LONG, BASIL *British Miniaturists 1520–1860* 1929 (reprinted 1966).
LONGYEAR, R. M. *Nineteenth Century Romanticism in Music* 1909.
LOWES, JOHN LIVINGSTON *The Road to Xanadu* 1927.

MAAS, JEREMY *Victorian Painters* 1969.
MCLEAN, RUARI *Victorian Book Design and Colour Printing* 1963.
MACAULAY, ROSE *Pleasure of Ruins* 1968.
[MACPHERSON, JAMES] *The Works of Ossian, the Son of Fingal* 1760–63.
MALINS, EDWARD *English Landscaping and Literature 1660–1840* 1966.
MALRAUX, ANDRÉ *The Voices of Silence* (translated by Stuart Gilbert) 1954.

MELLON COLLECTION *Painting in England 1700–1850 Collection of Mr & Mrs Paul Mellon* 2 vols. 1963.

MERCHANT, W. M. *Shakespeare and the Artist* 1959.

MILTON, JOHN *Poetical Works* (ed. Helen Darbishire) 2 vols. 1967.

MOORE, TOM *Irish Melodies* 1807–35.

MUSGRAVE, CLIFFORD *Royal Pavilion. A Study in the Romantic* 1951.

OWEN, A. L. *The Famous Druids* 1962.

PATER, WALTER *The Renaissance* 1873.

PETIT PALAIS, PARIS *La Peinture Romantique Anglaise et les Préraphaélites* 1972.

PIGGOTT, STUART, *The Druids* 1968.

PIPER, DAVID *Painting in England 1500–1880* 1960.

PIPER, JOHN *British Romantic Artists* 1942.

POINTON, MARCIA R. *Milton and English Art* 1970.

POLIDORI, WILLIAM *Diary* (ed. W. M. Rossetti) 1912.

PRAZ, MARIO *Mnemosyne, the Parallel between Literature and the Visual Arts* (translated by Angus Davidson) 1970.

—*On Neoclassicism* (translated by Angus Davidson) 1969.

—*The Romantic Agony* (translated by Angus Davidson) 1954.

PRICE, SIR UVEDALE *An Essay on the Picturesque* 1794–98.

—*A Dialogue on the Distinct Characters of the Picturesque and the Beautiful* 1801.

PYNE, W. H. *Wine and Walnuts* 2 vols. 1823.

QUENNELL, PETER *Romantic England* 1970.

RADCLIFFE, MRS ANN *The Mysteries of Udolpho* 1794.

RAILO, EINO *The Haunted Castle: a Study of the Elements of English Romanticism* 1927.

READE, BRIAN (ed.) *Sexual Heretics* 1970.

REDDING, CYRUS *Memoirs of William Beckford* 1859.

REDGRAVE, RICHARD and SAMUEL *A Century of Painters of the English School* 2 vols. 1866.

REYNOLDS, GRAHAM *Painters of the Victorian Scene* 1953.

—*Victorian Painting* 1966.

REYNOLDS, SIR JOSHUA *Discourses on Art* 1797.

RITSON, JOSEPH *Robin Hood* 1832.

RITTERBUSH, PHILIP C. *The Art of Organic Forms* 1968.

ROE, F. GORDON *Sea Painters of Britain from Constable to Brangwyn* 1948.

ROGET, J. L. *History of the Old Water-Colour Society, now the Royal Society of Painters in Water-Colour* 2 vols. 1891.

ROYAL ACADEMY OF ARTS *Bicentenary Exhibition 1768–1968. Catalogue* 2 vols. 1968.

RUSKIN, JOHN *Works* (ed. E. T. Cook and Alexander Wedderburn) 39 vols. 1902–12.

SALAMAN, M. C. (ed.) *Shakespeare in Pictorial Art* (*Studio* Special Number) 1916.

SCHULTZE, JÜRGEN *Art of Nineteenth-Century Europe,* 1970.

SCOTT, THEA *Fingal's Cave* 1961.

SHELLEY, PERCY BYSSHE *Letters* (ed. Frederick L. Jones) 2 vols. 1964.

—*Poetical Works* (ed. Thomas Hutchinson) 1968.

—*Zastrozzi* 1810.

SHIRLEY, EVELYN PHILIP *Some Account of English Deer Parks* 1867.

SITWELL, SACHEVERELL *Beckford and Beckfordism* 1930.

—*Narrative Pictures* 1937.

—*Old Fashioned Flowers* 1939.

—*Primitive Scenes and Festivals* 1942.

—BUCHANAN, HANDASYDE and FISHER, JAMES *Fine Bird Books 1700–1900* 1953.

—and BLUNT, WILFRID *Great Flower Books 1700–1900* 1956.

SMITH, JOHN THOMAS *Nollekens and his Times,* 2 vols. 1828.

SPEAIGHT, GEORGE *Juvenile Drama. The History of the English Toy Theatre* 1946.

STORER, REV. JOHN *The Wild White Cattle of Great Britain* [1877].

STUKELEY, WILLIAM *Abury, a Temple of the British Druids* 1743.

—*Stonehenge. A Temple Restor'd to the British Druids.* 1740.

SUMMERS, MONTAGUE *The Gothic Quest. A History of the Gothic Novel* (reprinted 1964).

SWINBURNE, ALGERNON CHARLES *Complete Works* (ed. Sir E. Gosse and T. J. Wise) 20 vols. 1925–27.

TALMON, J. L. *Romanticism and Revolt. Europe 1815–1848* 1967.

TATLOCK, R. A. *English Painting of the XVIIIth–XXth Centuries. A Record of the Collection in the Lady Lever Art Gallery* 1928.

TAYLOR, THOMAS *Selected Writings* (ed. Kathleen Raine and George Mills Harper) 1969.

TENNYSON, ALFRED *Poetical Works* 5 vols. 1875.

THOMAS, GRAHAM STUART *Old Shrub Roses* 1955.

THOMSON, JAMES *Poetical Works* (ed. J. Logie Robertson) 1965.

TODD, RUTHVEN *Tracks in the Snow. Studies in English Science and Art* 1946.

TRAWICK, LEONARD M. (ed.) *Backgrounds of Romanticism. English Philosophical Prose of the Eighteenth Century* 1967.

TRELAWNY, EDWARD JOHN *The Last Days of Shelley and Byron* 1858.

WAKEMAN, GEOFFREY *Aspects of Victorian Lithography* 1970.

WALPOLE, HORACE *The Castle of Otranto* 1764.

WATERHOUSE, E. K. *Painting in Britain 1530–1790* 1953.

WESLING, DONALD *Wordsworth and the Adequacy of Landscape* 1970.

WHITE, GILBERT *The Natural History and Antiquities of Selborne* 1789.

WHITE, GLEESON *English Illustration. "The Sixties"* 1897 (reprinted 1970).

WICKES, FRANCES G. *The Inner World of Man* 1938.

WILLIAMS, I. A. *Early English Water-colours* 1952.

WILSON, A. E. *Penny Plain, Two Pence Coloured* 1932.

WOODFORD, REV. A. F. A. *Kenning's Masonic Cyclopaedia* 1878.

WORDSWORTH, WILLIAM *The Letters of William and Dorothy Wordsworth* (ed. Ernest de Selincourt) 1935.

—*Poetical Works* (ed. by T. Hutchinson; new ed. revised by E. de Selincourt) 1969.

YOUNG, EDWARD *The Complaint, or Night Thoughts* 1742–45.

A CHECK-LIST OF SOME ROMANTIC ARTISTS
OF OR RELATED TO THE BRITISH SCHOOL[1]
WITH BRIEF BIBLIOGRAPHICAL DETAILS OF WORKS
FOR FURTHER READING

Abbreviations

Cunningham = Allan Cunningham *The Lives of the most eminent British Painters, Sculptors and Architects*, 6 vols., 1829–33

DNB = *Dictionary of National Biography*

E = Engraver

Hardie = Martin Hardie, *Water-colour Painting in Britain*, 3 vols, 1966–68

I = Illustrator

Maas = Jeremy Maas, *Victorian Painters*, 1969

Mon. = Monograph

P = Painter

Redgrave = Samuel Redgrave, *A Dictionary of Artists of the British School*, 1878

Reynolds = Graham Reynolds, *Victorian Painting*, 1966

S = Sculptor

Thieme-Becker = Ulrich Thieme and Felix Becker, *Allgemeines Lexikon der Bildenden Künstler*, 37 vols, 1907–50

ABSOLON, John (1815–95)
> P. I.
> Hardie III. Thieme-Becker.

ACKERMANN, Rudolph (1764–1834)
> Bavarian publisher.
> DNB.

AGASSE, Jacques-Laurent (1767–1849)
> Swiss P.
> DNB. Redgrave. Thieme-Becker. Life by C. F. Hardy (1921).

ALLEN, Joseph William (1803–52)
> P.
> DNB. Redgrave. Hardie II. Thieme-Becker.

[1] Also included are artists not of the Romantic school, but whose work has been mentioned in the text, or is relevant in a study of Romantic art.

ALLOM, Thomas (1804–72)
P.
DNB. Hardie III. Redgrave. Thieme-Becker.

ALLSTON, Washington (1779–1843)
P.
Redgrave. Thieme-Becker.

ANDERSON, J. (*fl.* 1803)
E.
Dobson, A., *Bewick and his Pupils* (1884). Redgrave. Thieme-Becker.

ANGAS, George French (1822–86)
P and zoologist.
Hodder, E. *George Fife Angas* (1891).

AUSTIN, Samuel (1796–1834)
P.
DNB. Hardie III. Redgrave. Thieme-Becker.

BAILY, Edward Hodges (1788–1867)
S.
DNB. Redgrave. Thieme-Becker.

BALDWIN, Samuel (*fl.* 1843–58)
P.
Maas.

BARKER, Thomas (1769–1847); "Barker of Bath"
P.
DNB. Hardie I, II. Thieme-Becker.

BARRET, George, I. (1732–84)
P.
DNB. Hardie I, II, III. Redgrave. Thieme-Becker. Bodkin, T., *Four Irish Landscape Painters* (1920).

BARRET, George, II. (1767 or 1768–1842)
P.
DNB. Hardie I, II, III. Redgrave. Thieme-Becker.

BARROW, John (or Joseph) Charles (*fl.* 1789–1802)
P.
Hardie II. Thieme-Becker.

BARRY, James (1741–1806)
P.

Cunningham II. DNB. Hardie I, III. Redgrave. Thieme-Becker. *The Works of James Barry* 2 vols. (1809).

BARTLETT, William Henry (1809–54)

P.

DNB. Hardie III. Redgrave. Thieme-Becker. Lives by W. Beattie (1855) and J. Britton (1855).

BAXTER, George (1804–67)

E.

Thieme-Becker. Lewis, Courtney, *The Story of Picture Printing in England during the 19th century* (1900). Clarke, H. G. and Rylatt, J. H., *The Centenary Baxter Book* (1936).

BEECHEY, Sir William (1753–1839)

P.

DNB. Redgrave. Thieme-Becker.

BENTLEY, Charles (*c.* 1805–54)

P.

DNB. Hardie III. Redgrave. Thieme-Becker.

BEVERLEY, William Roxby (*c.* 1814–99)

P.

DNB. Hardie II. Thieme-Becker.

BEWICK, Thomas (1753–1828)

E. P.

DNB. Redgrave. Thieme-Becker. Autobiography (1862; reprinted 1924 and 1961). Life by M. Weekley (1953). Thomson, D. C., *The Water-Colour Drawings of Thomas Bewick* (1930).

BLAKE, Robert (1767?–87)

P.

Thieme-Becker. Bentley, G. E., Junr. *Blake Records* (1969). Keynes, G. *Blake Studies* (1971).

BLAKE, William (1757–1827)

P. E. poet and visionary.

DNB. Thieme-Becker. Lives by A. Gilchrist (1880; Everyman ed. 1945) and M. Wilson (1927; rev. ed. 1971). Bentley, G. E., junr., *Blake Records* (1969). Bentley, G. E., Junr. and Nurmi, M. K., *Blake Bibliography* (1964). Blunt, A., *The Art of William Blake* (1959). Erdman, D., *Blake, Prophet against Empire* (1954). Keynes, G., *Bibliography of William Blake* (1921; reprinted. 1970), *Blake Studies*

(1949; revised and enlarged edn. 1971), *William Blake Poet Printer Prophet* (1964). Lister, R., *William Blake. An Introduction* (1968). Paley, M. D., *Energy and the Imagination* (1970). Raine, K., *Blake and Tradition* (2 vols., 1969).

The above is only a fraction of the available literature on Blake.

BONINGTON, Richard Parkes (1802–28)

P.

Cunningham V. DNB. Hardie I, II, III. Redgrave. Thieme-Becker. Life by A. Dubuisson and C. A. Hughes (1924). Mons. by M. Gobin (1955), S. Race (1950), G. S. Sandilands (1929), and A. Shirley (1940).

BOYDELL, John (1719–1804)

E. and publisher.

DNB. Redgrave. Thieme-Becker.

BOYS, Thomas Shooter (1804–74)

P.

DNB. Hardie I, II, III. Thieme-Becker.

BRANDARD, Robert (1805–62)

P.

DNB. Hardie III, Redgrave. Thieme-Becker.

BRETT, John (1831–1902)

P.

DNB. Maas. Reynolds. Thieme-Becker.

BRIGGS, Henry Perronet (1791–1844)

P.

Redgrave. Thieme-Becker.

BRIGHT, Henry (1814–73)

P.

DNB. Hardie II, III. Redgrave. Thieme-Becker.

BROCKEDON, William (1787–1854)

P. I.

DNB. Hardie III. Redgrave. Thieme-Becker.

BROWN, Charles Armitage (1786–1842)

Writer and P.

DNB.

BROWN, Ford Madox (1821–93)

P.

DNB. Hardie III. Thieme-Becker. Life by F. M. Hueffer (1896).

BROWN, John (1752–87)

P.

Redgrave. Thieme-Becker.

BROWNE, Hablôt Knight (1815–82); "Phiz"

I. P.

DNB. Thieme-Becker. Life by D. C. Thomson (1884). Mon. by E. Browne (1913). Kitton, F. G., *Dickens and his Illustrators* (1899), Harvey, J., *Victorian Novelists and their Illustrators* (1970).

BUCKNER, Richard (*fl.* 1820–77)

P.

Thieme-Becker.

BURNE-JONES, Sir Edward Coley, Bart. (1833–98)

P. I.

DNB. Maas. Reynolds. Thieme-Becker. Life by G. Burne-Jones (2 vols., 1904). Cecil, D., *Visionary and Dreamer* (1969). Welby, T. E., *The Victorian Romantics—the Early Work of E. Burne-Jones* (1929).

CALDERON, Philip Hermogenes (1833–98)

P.

DNB. Maas. Reynolds. Thieme-Becker.

CALLCOTT, Sir Augustus Wall (1779–1844)

P.

DNB. Hardie II, III. Thieme-Becker. Life by S. Dafforne (1875).

CALVERT, Edward (1799–1883)

E. P.

DNB. Thieme-Becker. Memoir by S. Calvert (1893). Mon. by R. Lister (1962).

CARRUTHERS, Richard (*fl.* 1816–19)

P.

Thieme-Becker.

CATTERMOLE, George (1800–68)

I. P.

DNB. Hardie II, III. Redgrave. Thieme-Becker.

CHALON, Alfred Edward (1780–1860)

P.

DNB. Hardie I, II. Redgrave. Thieme-Becker.

CHALON, John James (1778–1854)
P.
DNB. Hardie II. Redgrave. Thieme-Becker.

CHINNERY, George (1774–1852)
P.
DNB. Hardie II, III. Redgrave. Thieme-Becker. Mon. by H. and S. Berry-Hill (1963).

CHURCHYARD, Thomas (1798–1865)
P.
Thieme-Becker. Life by D. Thomas (1966).

CIPRIANI, Giovanni Battista (1727–85)
Italian P.
DNB. Hardie I. Redgrave. Thieme-Becker.

CLENNELL, Luke (1781–1840)
E. P.
DNB. Hardie II. Redgrave. Thieme-Becker. Dobson, A., *Bewick and his Pupils* (1884).

CLINT, George (1770–1854)
P. E.
DNB. Redgrave. Thieme-Becker.

COLLINS, William (1788–1847)
P.
DNB. Redgrave. Thieme-Becker. Life by W. Collins (1848).

CONSTABLE, John (1776–1837)
P.
DNB. Hardie I, II, III. Redgrave. Thieme-Becker. Life by C. R. Leslie (1843. new ed. 1951). Mons. by K. Badt (1950), J. Baskett (1966), Sir J. D. Linton (1905), and G. Reynolds (1965).

COOPER, Thomas Sidney (1803–1902)
P.
DNB. Thieme-Becker. Autobiography (1890). Life by E. K. Chatterton (1902).

COPE, Charles West (1811–90)
DNB. Thieme-Becker. Life by C. H. Cope (1891).

COPLEY, John Singleton (1737–1815)
American P.
Cunningham V. DNB. Redgrave. Thieme-Becker. Lives by M. B.

Amory (1882), I. W. Bayly (1915). Mon. by J. Prown (2 vols., 1966).

CORBOULD, Edward Henry (1815–1905)

I.

Thieme-Becker.

COSWAY, Richard (1740–1821)

P.

Cunningham VI. DNB. Redgrave. Thieme-Becker. Life by G. C. Williamson (1897, 1905).

COTMAN, Joseph John (1814–78)

P.

DNB. Hardie II. Thieme-Becker. Batchelor, A., *Cotman in Normandy* (1926).

COTMAN, John Sell (1782–1842)

P. E.

DNB. Hardie I, II, III. Redgrave. Thieme-Becker. Diary, ed. by A. Batchelor (1924). Life by S. D. Kitson (1937). Mons. by A. Oppé (1923) and V. Rienacker (1953).

COTMAN, Miles Edmund (1810–58)

P.

DNB. Hardie II, III. Thieme-Becker.

COX, David (1783–1859)

P.

DNB. Hardie I, II, III. Redgrave. Thieme-Becker. Lives by W. Hall (1881) and N. N. Solly (1873). Mons. by T. Cox (1947) and F. G. Roe (1946).

COX, David, II (1809–85).

P.

Hardie II. Thieme-Becker.

COZENS, Alexander (1717–86)

P.

DNB. Hardie I, III. Redgrave. Thieme-Becker. Mon. by A. Oppé (1952). Oppé's book includes a reprint of Cozens's *New Method of . . . drawing original compositions of Landscape.*

COZENS, John Robert (1752–97)

P.

DNB. Hardie I, II, III. Redgrave. Thieme-Becker. Mon. by A. Oppé (1952).

CRAIG, William Marshall (*fl.* 1788–d. 1828)
P.
DNB. Hardie II, III. Thieme-Becker.

CRANE, Walter (1845–1915)
P.
DNB. Thieme-Becker. Autobiography (1907). Mon. by P. G. Konody (1902).

CRISTALL, Joshua (1767–1847)
P.
DNB. Hardie II, III. Redgrave. Thieme-Becker. Life by W. G. S. Dyer (1958).

CROME, John (1768–1821)
P.
DNB. Hardie I, II, III. Redgrave. Life by R. H. Mottram (1931). Mon. by D. and T. Clifford (1968).

CROMEK, Robert Hartley (1770–1812)
E. and publisher.
DNB. Redgrave. Thieme-Becker.

"CROWQUILL, Alfred"—see Forrester, A. H.

CRUIKSHANK, George (1792–1878)
I. P. E.
DNB. Redgrave. Thieme-Becker. Lives by W. Bates (1878), W. H. Chesson (1908), and W. Hamilton (1878). Mons. by R. J. H. Douglas (1903), J. Grego (1904), and R. McLean (1948). Marchmont, F., *The Three Cruikshanks* (1897).

CRUIKSHANK, [Isaac] Robert (1789–1856)
I. P. E.
DNB. Redgrave. Thieme-Becker. Marchmont, F., *The Three Cruikshanks* (1897).

DADD, Richard (1817–87)
P.
Thieme-Becker. Rickett, J., "R. Dadd . . . an attempt at a biography" in *Ivory Hammer 2: The Year at Sotheby's . . .* (1964). Sitwell, S., *Narrative Pictures* (1937).

DANBY, Francis (1793–1861)
P.

DNB. Redgrave. Thieme-Becker. Grigson, G. *The Harp of Aeolus* (1948).

DANBY, Thomas (1818–86)

P.

DNB. Thieme-Becker.

DANIELL, Rev. Edward Thomas (1804–43)

P. E.

DNB. Hardie II. Thieme-Becker. Life by F. R. Beecheno (1889).

DANIELL, Samuel (1775–1811)

P.

DNB. Redgrave. Thieme-Becker.

DANIELL, Thomas (1749–1840)

P.

DNB. Hardie I, III. Thieme-Becker. Mon by T. Sutton (1954).

DANIELL, William (1769–1837)

P.

DNB. Hardie I, II, III. Thieme-Becker. Mon. by T. Sutton (1954).

DAVIDSON, Charles (1824–1902)

P.

Hardie II. Thieme-Becker.

DAVIS, John Scarlett (1804–1844)

P.

DNB. Hardie II. Thieme-Becker.

DAVIS, William (1812–73); "Davis of Liverpool"

P.

Thieme-Becker. Stephen, F. G., "William Davis" in *Art Journal* 1884, 325–28.

DEANE, William Wood (1825–73)

P.

DNB. Redgrave. Thieme-Becker.

DELMAR, William (*fl.* 1831–55)

P.

Thieme-Becker.

DE WINT, Peter (1784–1849)

P.

DNB. Hardie I, II, III. Redgrave. Thieme-Becker. Lives by W. Armstrong (1888), A. De Wint (1900). Mons. by M. Hardie (1929), C. G. E. Bunt (1948).

DIBDIN, Thomas Colman (1810–93)
P.
Hardie III. Thieme-Becker.

DODGSON, George Haydock (1811–80)
P.
DNB. Hardie III. Thieme-Becker.

DOYLE, Richard (1824–83)
I. P.
DNB. Redgrave. Thieme-Becker. Mon. by D. Hambourg (1948).

DUNKARTON, Robert (1744–*c*.1817)
E.
DNB. Redgrave. Thieme-Becker.

DYCE, William (1806–64)
P.
DNB. Maas. Redgrave. Reynolds. Thieme-Becker.

EARLOM, Richard (1743–1822)
E.
DNB. Redgrave. Thieme-Becker.

EAST, Sir Alfred (1849–1913)
P.
DNB. Thieme-Becker. East, Sir A., *Brush and Pencil Notes in Land-scape* (1914).

EASTLAKE, Sir Charles Lock (1793–1865)
P.
DNB. Redgrave. Thieme-Becker.

EDOUART, Augustin Amant (1789–1861)
French Silhouettist.
Thieme-Becker. Jackson, Mrs E. N., *Ancestors in Silhouette* (1920), *Silhouette Notes and Dictionary* (1938). Lister, R., *Silhouettes* (1953).

EDRIDGE, Henry (1769–1821)
P.
DNB. Hardie II, III. Redgrave. Thieme-Becker.

EDWARDS, Sydenham Teak (1768–1819)
P.
DNB. Redgrave. Thieme-Becker.

EGG, Augustus Leopold (1816–63)

P.

DNB. Maas. Redgrave. Reynolds. Thieme-Becker.

ELMORE, Afred (1815–81)

P.

Hardie I, II. Thieme-Becker.

ETTY, William (1787–1849)

P.

DNB. Redgrave. Thieme-Becker. Life by A. Gilchrist (1855). Mons.
by W. Gaunt (1943) and D. Farr (1958).

EVANS, Edmund (1826–1905)

Book designer.

DNB. Thieme-Becker. McLean, R. (ed.), *The Reminiscences of Edmund Evans* (1967).

EVANS, William (1797 or 1798–1877); "Evans of Eton"

P.

DNB. Redgrave.

EVANS, William (1809–58); "Evans of Bristol"

P.

DNB. Redgrave. Thieme-Becker.

FEARNLEY, Thomas (1802–42)

Norwegian P.

Thieme-Becker.

FERNELEY, John E. (1782–1860)

P.

DNB. Redgrave.

FIELDING, Anthony Vandyke Copley (1787–1855)

P.

DNB. Hardie I, II, III. Redgrave. Thieme-Becker.

FIELDING, Nathan Theodore (*fl.* 1775–1814)

P.

DNB. Redgrave (listed as *Theodore Nathan*). Thieme-Becker.

FIELDING, Newton Limbird Smith (1799–1856)

P. E.

DNB. Hardie II, III. Redgrave. Thieme-Becker.

FIELDING, Thales (1793–1837)

P.

DNB. Hardie II, III. Thieme-Becker.

FIELDING, Theodore Henry Adolphus (1781–1851)
P. E. and author.
DNB. Hardie II, III. Redgrave. Thieme-Becker.

FINCH, Francis Oliver (1802–62)
P.
DNB. Hardie I, II, III. Redgrave. Thieme-Becker. Memoir by Eliza Finch (1865). Lister, R., *Edward Calvert* (1962); "F. O. Finch" in *Studies in the Arts* (ed. F. Warner; 1968).

FITZGERALD, John Austen (1832–1906)
P.
Maas. Thieme-Becker.

FLAXMAN, John (1755–1826)
S. and draughtsman.
Cunningham III. DNB. Redgrave. Thieme-Becker.

FORD, Edward Onslow (1852–1901)
S.
DNB. Thieme-Becker.

FORRESTER, Alfred Henry (1804–72); "Alfred Crowquill"
I. P.
DNB. Redgrave. Thieme-Becker.

FOSTER, Myles Birket (1825–99)
P. I.
DNB. Hardie I, III. Thieme-Becker. Life by H. M. Cundall (1906).

FRANCIA, François Louis Thomas (1772–1839)
French P.
DNB. Hardie II. Redgrave. Thieme-Becker.

FREEBAIRN, Robert (1765–1808)
P.
DNB. Redgrave. Thieme-Becker.

FRIPP, Alfred Downing (1822–95)
P.
Hardie II. Thieme-Becker.

FRIPP, George Arthur (1813–96)
P.
DNB. Hardie II, III. Thieme-Becker.

FRITH, William Powell (1819–1909)

P.

DNB. Maas. Reynolds. Thieme-Becker. Autobiography (1887–88).

FUSELI, John Henry (1741–1825); or Fuessli, Johann Heinrich
Swiss P.

Cunningham II. DNB. Redgrave. Thieme-Becker. Life by J. Knowles (1831). Mons. by F. Antal (1956), P. Ganz (1949), N. Powell (1951). Selections of Fuseli's writings were published in *The Mind of H. Fuseli* (ed. E. C. Mason; 1951).

GAINSBOROUGH, Thomas (1727–88)
P.

Cunningham I. DNB. Hardie, I, II, III. Redgrave. Thieme-Becker. Life by P. Thicknesse (1788). Mons. by B. Taylor (1951), E. K. Waterhouse (1958), M. Woodall (1939, 1949) and J. Hayes (1970).

GENDALL, John (1790–1865)
P.

DNB. Hardie III. Redgrave. Thieme-Becker. Pyecroft, *Art in Devonshire* (1883).

GERARD, Ebenezer (1783–4?–1826)
P.

Gerard, E., *Letters in Rhyme* (1825). Lister, R., "Ebenezer Gerard" in *Apollo* Nov. 1960.

GILLRAY, James (1757–1815)
P.

DNB. Hardie I, III. Redgrave. Thieme-Becker. Mon. by D. Hill (1965).

GILPIN, Rev. William (1724–1804)
P. and writer.

DNB. Hardie I, II, III. Redgrave. Theime-Becker. Mon. by C. G. Barbier (1963).

GILPIN, William Sawrey (1762–1843)
P.

DNB. Hardie II. Redgrave. Thieme-Becker.

GIRTIN, Thomas (1775–1802)
P.

DNB. Hardie I, II, III. Redgrave. Thieme-Becker. Mons. by R. Davies (1924), T. Girtin and D. Loshak (1954), and J. Mayne (1949).

GLOVER, John (1767–1849)

P.

DNB. Hardie I, II, III. Redgrave. Thieme-Becker.

GOSSE, Philip Henry (1810–88)

Zoologist, I. and P.

DNB. Life by Edmund Gosse (1890). Bibliography by P. Stageman (1955).

GOSSE, William (*fl.* 1857–after February 1891)

P.

Unpublished diary. Lister, R., "William Gosse's Botanical Miniatures" in *Gardener's Chronicle*, 26 April 1952.

GOULD, John (1804–81)

Ornithologist and P.

DNB. Sitwell, S., *Tropical Birds . . . by J. Gould* (1948). Sitwell, S. and Buchanan, H., *Fine Bird Books* (1953).

GOUPY, Joseph (d. 1763)

P.

DNB. Hardie I, III. Redgrave. Thieme-Becker.

GRANT, Sir Francis (1803–78)

P.

DNB. Mass. Thieme-Becker. Steegman, J., "Sir F. Grant" in *Apollo* LXXXIX 1964, 479–85.

GRIMSHAWE, Thomas (*fl.* 1853–64)

P.

Graves, A., *The British Institution 1806–67* (1908).

GRÜNER, Wilhelm Heinrich Ludwig (or Lewis, or Louis) (1801–82)

E.

Bryan's Dictionary of Painters and Engravers Vol. II. (ed. G. C. Williamson, 1903).

HAGHE, Louis (1806–85)

Belgian P. and E.

DNB. Hardie II, III. Thieme-Becker.

HAMILTON, Gavin (1723–98)

P.

DNB. Redgrave. Thieme-Becker. Irwin, D., "Gavin Hamilton" in *Art Bulletin* LCIV, 1962, 87–102.

HAMILTON, William (1751–1801)
P.
DNB. Hardie I, II. Redgrave. Thieme-Becker.

HARDING, James Duffield (1798–1863)
P. E.
DNB. Hardie I, II, III. Thieme-Becker.

HART, William (1823–94)
P.
Thieme-Becker (under James Hart).

HAVELL, William (1782–1857)
P.
DNB. Hardie II, III. Redgrave. Thieme-Becker.

HAYDON, Benjamin Robert (1786–1846)
P.
DNB. Redgrave. Thieme-Becker. Life ed. by T. Taylor, 3 vols. (1853). Diary ed. by W. B. Pope, 5 vols. (1960–63). Lectures, 2 vols. (1844–46). Mon. by C. Olney (1952).

HAYMAN, Francis (1708–76)
P.
DNB. Redgrave. Thieme-Becker.

HAYTER, Charles (1761–1835)
P.
DNB. Redgrave. Thieme-Becker.

HAYTER, Sir George (1792–1871)
P.
DNB. Redgrave. Thieme-Becker.

HEAPHY, Thomas Frank (1775–1835)
P.
DNB. Redgrave. Thieme-Becker.

HENDERSON, Peter (*fl.* 1799–1829)
P.
Thieme-Becker.

HERKOMER, Sir Hubert von (1849–1914)
Bavarian P.
DNB. Thieme-Becker. Lives by A. L. Baldry (1902) and K. S. Mills (1923).

HILLS, Robert (1769–1844)

P.

DNB. Hardie I, II. Redgrave. Thieme-Becker.

HINE, Henry George (1811–95)

P.

DNB. Hardie II. Thieme-Becker.

HOBCRAFT, Mr (*fl.* 1770)

Builder.

Braybrooke, Lord, *History of Audley End* (1836).

HODGES, William (1744–97)

P.

DNB. Redgrave. Thieme-Becker. Foster, Sir W., *W. Hodges in India* (1925).

HOLLAND, James (1800–70)

P.

DNB. Hardie I, II, III. Redgrave. Thieme-Becker.

HOLLOWAY, Thomas (1748–1827)

E.

DNB. Redgrave. Thieme-Becker. Anonymous memoir (1827).

HOLMES, James (1777–1860)

P. E.

DNB. Redgrave. Thieme-Becker. Storey, A. T., *J. Holmes and J. Varley* (1894).

HOLST, Theodore von (1810–44)

P.

DNB. Redgrave. Thieme-Becker.

HOLWORTHY, James (1781–1841)

P.

DNB. Hardie II. Redgrave. Thieme-Becker.

HOPKINS, Gerard Manley (1844–89)

Poet, priest and draughtsman.

Life by E. Ruggles (1947). Journals and Papers ed. by H. House and G. Storey (1959).

HOPLEY, Edward William John (1816–69)

P.

DNB. Thieme-Becker.

HOPPNER, John (1758–1810)

P.

DNB. Hardie I, II, III. Redgrave. Thieme-Becker.

HUGGINS, William (1820–84)
 P.
 DNB. Maas. Thieme-Becker.

HUGHES, Arthur (1832–1915)
 P.
 DNB. Maas. Reynolds. Thieme-Becker.

HUMPHREYS, Henry Noel (1810–79)
 I. P. and naturalist.
 DNB. Thieme-Becker. McLean, R., *Victorian Book Design* (1963).

HUMPHRYS, William (1794–1865)
 E.
 DNB. Redgrave. Thieme-Becker.

HUNT, William Henry (1790–1864)
 P.
 DNB. Redgrave. Thieme-Becker. Ruskin, J., *Notes on S. Prout and W. H. Hunt* (1879).

HUNT, William Holman (1827–1910)
 P.
 DNB. Thieme-Becker. Mon. by F. G. Stephens (1860). Hunt, W. Holman, *Pre-Raphaelitism and the Pre-Raphaelite Brotherhood* 2 vols. (1905).

HUSKISSON, R. (*fl.* 1832–54)
 P.
 Thieme-Becker.

IBBETSON, Julius Caesar (1759–1817)
 P.
 DNB. Redgrave. Thieme-Becker. Henderson, B. L. K., *Morland and Ibbetson* (1923).

INCHBOLD, John William (1830–88)
 P.
 DNB. Maas. Reynolds. Thieme-Becker. Mander, R., "Inchbold in Springtime" in *Apollo* LXXXV, 1967, 62–3.

JEWITT, Thomas Orlando Sheldon (1799–1869)
 E.

[215]

DNB. Redgrave. Thieme-Becker. Mon. by H. Carter (1962).

JOHN, Sir William Goscombe (1860–1952)

S. E.

DNB. Thieme-Becker.

JOHNSON, Harry John (1826–84)

P.

DNB. Hardie II, III. Thieme-Becker.

JONES, George (1786–1869)

P.

DNB. Thieme-Becker.

JONES, Owen (1809–74)

Architect and designer.

DNB. Redgrave. Thieme-Becker.

JONES, Thomas (1743–1803)

P.

Thieme-Becker.

KAUFFMANN, Angelica (1741–1807)

Swiss P.

DNB. Redgrave. Thieme-Becker. Lives by H. Hardcup (1954) and
Lady V. Manners (1924).

KAY, John (1742–1826)

P.

DNB. Thieme-Becker.

LANDSEER, Sir Edwin Henry (1802–73)

P.

DNB. Redgrave. Thieme-Becker. Lives by J. A. Manson (1902) and
F. G. Stephens (3rd ed., 1880).

LAWRENCE, Sir Thomas (1769–1830)

P.

Cunningham VI. DNB. Redgrave. Thieme-Becker. Lives by Sir W.
Armstrong (1913), K. Garlick (1954) and D. E. Williams (1831).
Goldring, D., *Regency Portrait Painter* (1951).

LAWSON, Cecil Gordon (1851–82)

P.

DNB. Thieme-Becker. Memoir by E. Gosse (1883).

LEADER, Benjamin Williams (1831–1923)
P.
DNB. Thieme-Becker.

LEAR, Edward (1812–88)
P. and author.
DNB. Hardie III. Thieme-Becker. Life by A. Davidson (1938, 1950). Letters (ed. Lady C. Strachey; 1907, 1911). Mons. by P. Hofer (1967) and B. Reade (1949).

LEIGHTON, Frederic, Baron Leighton of Stretton (1830–96)
P. S.
DNB. Maas. Reynolds. Thieme-Becker. Lives by Mrs R. Barrington (1906), Mrs A. Lang (1884), and G. C. Williamson (1902). Gaunt, W., *Victorian Olympus* (1952).

LESLIE, Charles Robert (1794–1859)
P. and biographer.
DNB. Redgrave. Thieme-Becker. Autobiography, 2 vols. (ed. by T. Taylor, 1800).

LEWIS, Frederick Christian (1779–1856)
P.
DNB. Hardie II, III. Redgrave. Thieme-Becker.

LEWIS, John Frederick (1805–76), "Spanish Lewis"
P.
DNB. Hardie I, II, III. Maas. Redgrave. Reynolds. Thieme-Becker.

LINNELL, John (1792–1882)
P.
DNB. Thieme-Becker. Life by A. T. Story (1892). Grigson, G., *S. Palmer, the Visionary Years* (1947). Lister, R., *S. Palmer and his Etchings* (1969). Malins, E., *S. Palmer's Italian Honeymoon* (1969).

LIVERSEEGE, Henry (1803–32)
P.
Cunningham VI. DNB. Redgrave. Thieme-Becker. Memoir by C. Swain (1835). Mon. by G. Richardson (1875).

LOUND, Thomas (1802–61)
P.
DNB. Hardie II. Redgrave. Thieme-Becker.

LOUTHERBOURG, James de (1740–1812)
Alsatian P.

[217]

DNB. Hardie I, II, III. Redgrave. Thieme-Becker. Dobson, A., *At Prior Park* (1912) 94–127, 277–81. Pyne, W. H., *Wine and Walnuts* (1823), I, ch. xxi.

LYNCH, James Henry (*c.* 1815–68)
E. P.
Thieme-Becker.

MACLISE, Daniel (1806–70)
P. I.
DNB. Redgrave. Thieme-Becker. Memoir by W. J. O'Driscoll (1871).

MADDOX, Willis (1813–53)
P.
DNB. Redgrave. Thieme-Becker.

MARTIN, Alfred (1814–72)
Engineer, government official and E.
Balston, T., *John Martin* (1947), *passim*.

MARTIN, John (1789–1854)
P. E.
DNB. Redgrave. Thieme-Becker. Mons. by T. Balston (1947), J. Seznac (1964). Todd, R., *Tracks in the Snow* (1946).

MARTYN, Thomas (*fl.* 1760–1816)
Writer and draughtsman.
DNB.

"MASTER OF THE GIANTS" (*fl.* 1779)
P.
Cummings, F. and Staley, A., *Romantic Art in Britain* (1968), 141.

MIDDLETON, John (1827–56)
P.
DNB. Hardie II. Redgrave. Thieme-Becker.

MILLAIS, Sir John Everett (1829–96)
P. I.
DNB. Thieme-Becker. Lives by A. L. Baldry (1899), J. G. Millais (1899), J. E. Reid (1909). Mon. by M. H. Spielmann (1898). Lutyens, M., *Millais and the Ruskins* (1967).

MILLNER, William Edward (1849–95)
P.

Graves, A., *The Royal Academy* (V, 1906).

MORLAND, George (1763–1804)

P.

Cunningham II. DNB. Hardie I, II, III. Redgrave. Thieme-Becker. Lives by G. Dawe (1807, 1904), J. Hassell (1806). Mons. by Sir W. Gilbey (1907) and G. C. Williamson (1904, 1907).

MORRIS, William (1834–96)

Craftsman, writer and P.

DNB. Thieme-Becker. Morris, *Complete Works*, 24 vols. ed. M. Morris, 1910–15. Lives by J. W. Mackail 2 vols. (1899), E. Meynell (1947) and M. Morris 2 vols. (1936). Mons. by J. B. Glasier (1921) and E. P. Thompson (1955).

MORTIMER, John Hamilton (1741–79)

P.

Cunningham V. DNB. Redgrave. Thieme-Becker. Grigson, G. "Painters of the Abyss" in *Architectural Review,* Oct. 1950, 215–20.

MÜLLER, William James (1812–45)

P.

DNB. Hardie II, III. Redgrave. Thieme-Becker. Memoir by N. N. Solly (1875).

MULREADY, William (1786–1863)

P.

DNB. Maas. Redgrave. Reynolds. Thieme-Becker. Memoir by F. G. Stephens (1867). Mon. by J. Dafforne (1872).

MUNN, Paul Sandby (1773–1845)

P.

DNB. Hardie II, III. Redgrave. Thieme-Becker.

MUNRO, Alexander (1825–71)

S.

DNB. Redgrave. Thieme-Becker.

NASMYTH, Alexander (1758–1840)

P. and engineer.

DNB. Hardie I, III. Redgrave. Thieme-Becker. Autobiography (1883).

NASMYTH, Patrick (1787–1831)

P.

DNB. Redgrave. Thieme-Becker.

NATTES, John Claude (1765–1822)
P.
DNB. Hardie II, III. Redgrave. Thieme-Becker.

NESBIT, Charlton (1775–1838)
E.
DNB. Thieme-Becker. Dobson, A., *Bewick and his Pupils* (1884).

NESFIELD, William Andrews (1793–1881)
P.
DNB. Thieme-Becker.

NICHOLSON, Isaac (1789–1848)
E.
DNB. Redgrave. Thieme-Becker. Dobson, A., *Bewick and his Pupils*, 1884.

NINHAM, Henry (1793–1874)
P.
Hardie II. Thieme-Becker.

NORTHCOTE, James (1746–1831)
P.
Cunningham VI. DNB. Redgrave. Thieme-Becker. Hazlitt, W., *Conversations with Northcote* (1830)

O'NEILL, Hugh (1784–1824)
P. E.
DNB. Hardie III. Redgrave. Thieme-Becker.

ONWHYN, Thomas (d. 1886)
I. E.
DNB. Thieme-Becker.

OTTLEY, William Young (1771–1836)
E. and writer.
DNB. Redgrave. Thieme-Becker.

OWEN, William (1769–1825)
P.
Cunningham V. DNB. Redgrave. Thieme-Becker.

PALMER, Samuel (1805–81)
P. E.
DNB. Thieme-Becker. Memoir (1882) and Life (1892) by A. H.

Palmer. Binyon, L., *Followers of W. Blake* (1925). Grigson, G., *S. Palmer, the Visionary Years* (1947). Lister, R., *S. Palmer and his Etchings* (1969). Malins, E., *S. Palmer's Italian Honeymoon* (1969).

PARROTT, William (1813–69)
P. E.
Thieme-Becker.

PATON, Sir Joseph Noël (1821–1901)
P.
DNB. Thieme-Becker.

PEARSON, William (*fl.* 1798–1813)
P.
Hardie II. Thieme-Becker.

PECKITT, William (*fl.* 1731–95); "Peckitt of York"
Stained-glass artist.
Thieme-Becker.

PETHER, Abraham (1756–1812); "Moonlight Pether", or "Old Pether"
P.
DNB. Redgrave. Thieme-Becker.

PETHER, Sebastian (1790–1844)
P.
DNB. Redgrave. Thieme-Becker.

PETHER, William (1731–95)
E.
DNB. Hardie I, II. Redgrave. Thieme-Becker.

PHILLIPS, Thomas (1770–1845)
P.
DNB. Redgrave. Thieme-Becker.

"PHIZ"—See Browne, H. K.

PICKERING, George (*c.* 1794–1857)
P.
DNB. Hardie II. Thieme-Becker.

POOLE, Paul Falconer (1807–79)
P.
DNB. Thieme-Becker.

PORTER, Sir Robert Ker (1777–1842)
P.
DNB. Hardie II. Redgrave. Thieme-Becker. Barnett, R. D., "Sir

Robert Ker Porter" in *British Museum Society Bulletin* No. 7, June 1971, 8–9.

POWELL, Joseph (formerly called "John") (*c.* 1780–*c.* 1834)

 P.

 DNB. Hardie I, II. Redgrave. Thieme-Becker.

POYNTER, Ambrose (1796–1886)

 P.

 DNB. Thieme-Becker. Mon. by H. M. Poynter (1931).

POYNTER, Sir Edward John (1836–1919)

 P.

 DNB. Thieme-Becker. Mons. by M. Bell (1906) and A. Margaux (1905).

PROUT, John Skinner (1806–76)

 P.

 DNB. Hardie III. Redgrave. Thieme-Becker.

PROUT, Samuel (1783–1852)

 P.

 DNB. Hardie I, II, III. Redgrave. Thieme-Becker. Mons. by J. Quigley (1926) and J. Ruskin (1879).

PUGIN, Augustus Charles (1762–1832)

 Architect and draughtsman.

 DNB. Redgrave. Thieme-Becker.

PUGIN, Augustus Welby Northmore (1812–52)

 Architect, writer and designer.

 DNB. Redgrave. Thieme-Becker. Mon. by P. Waterhouse (1898).

PYNE, James Baker (1800–70)

 P.

 DNB. Hardie II, III. Redgrave. Thieme-Becker.

RAEBURN, Sir Henry (1756–1823)

 P.

 Cunningham V. DNB. Redgrave. Thieme-Becker. Life by W. R. Andrew (1894). Mons. by Sir J. L. Caw (1911), E. R. Dibdin (1925), J. Greig (1911) and E. Pinnington (1904).

REDGRAVE, Richard (1804–88)

 P.

 DNB. Thieme-Becker. Memoir by F. M. Redgrave (1891).

REDGRAVE, Samuel (1802–76)
Writer and P.
DNB. Hardie I.

REINAGLE, Philip (1749–1833)
P.
DNB. Redgrave. Thieme-Becker.

REINAGLE, Ramsay Richard (1775–1862)
P.
DNB. Hardie I, II, III. Redgrave. Thieme-Becker.

REYNOLDS, Sir Joshua (1723–92)
P.
Cunningham I. DNB. Redgrave. Thieme-Becker. Memoirs by J. Farrington (1819) and J. Northcote (2 vols. 1813, 1818). Life by C. R. Leslie and T. Taylor (2 vols. 1865). Mons. by D. Hudson (1958) and E. K. Waterhouse (1941). Reynolds's *Discourses* (ed. R. Wark, 1959).

RICHARDSON, Thomas Miles, I (1784–1848)
P.
DNB. Hardie I, II. Redgrave. Thieme-Becker.

RICHARDSON, Thomas Miles, II (1813–90)
P.
Hardie II. Thieme-Becker.

RICHMOND, George (1809–96)
P. E.
DNB. Thieme-Becker. Binyon, L., *Followers of W. Blake* (1925). Dodgson, C., "The Engravings of G. Richmond and W. Sherman" in *Print Collector's Quarterly* XVII, no.41, 353–62. Stirling, A. M. W., *Richmond Papers* (1926).

RICHTER, H. C. (*fl.* 1833–50.)
E.
Sitwell, S. and Handasyde, B., *Fine Bird Books* (1953).

RIGAUD, Stephen Francis Dutilh (1777–1861)
P.
DNB. Hardie I. Redgrave. Thieme-Becker.

ROBERTS, David (1796–1864)
P.
DNB. Redgrave. Thieme-Becker. Life by J. Ballantine (1866). Mon. by J. Quigley (1926).

ROBSON, George Fennell (1788–1833)

P.

DNB. Hardie II. Redgrave. Thieme-Becker.

ROMNEY, George (1734–1802)

P.

Cunningham V. DNB. Redgrave. Thieme-Becker. Lives by Rev. J. Romney (1830) and W. Hayley (1809).

ROMNEY, John (1786–1863)

E. P.

DNB. Redgrave. Thieme-Becker.

ROSSETTI, Dante Gabriel (1828–82)

P. and poet.

DNB. Maas. Reynolds. Thieme-Becker. Life by E. Waugh (1928). Letters (ed. by O. Doughty and J. R. Wahl; 5 vols. [1 not yet published], 1965–7). Mons. by G. H. Fleming (1967), N. Gray (1947) and O. Doughty (2nd ed. 1960).

ROWBOTHAM, Thomas Leeson, I (1783–1853)

P.

DNB. Hardie II. Thieme-Becker.

ROWBOTHAM, Thomas Leeson, II (1823–75)

P.

DNB. Hardie II. Redgrave. Thieme-Becker.

ROWLANDSON, Thomas (1756–1827)

P.

DNB. Redgrave. Thieme-Becker. Life by B. Falk (1949). Mons. by A. Bury (1949), A. P. Oppé (1923) and F. G. Roe (1947).

RUNCIMAN, Alexander (1736–85)

P. E.

Cunningham V. DNB. Redgrave. Thieme-Becker. Caw, J. L., *Scottish Painting Past and Present* (1908) 40–3.

RUNCIMAN, John (1744–68)

P.

DNB (under Alexander Runciman). Redgrave. Thieme-Becker.

RUSKIN, John (1819–1900)

Writer and P.

DNB. Thieme-Becker. Life by D. Leon (1949). Diaries (ed. by J. Evans and J. H. Whitehouse, 3 vols., 1956–59).

SAMUEL, George (d. 1823)
 P.
 DNB. Redgrave. Thieme-Becker.
SANDBY, Paul (1730–1809)
 P.
 DNB. Redgrave. Thieme-Becker. Life by W. Sandby (1892). Mon. by
 A. Oppé (1947).
SANDERS, George (1774–1846)
 P.
 DNB. Redgrave. Thieme-Becker.
SANDYS, Anthony Frederick Augustus (1829–1904)
 P. I.
 DNB. Maas. Reynolds. Thieme-Becker. White, G., *English Illustra-
 tion "The Sixties"* (reprint ed. 1970).
SCANDRETT, Thomas (1797–1870)
 Draughtsman.
 Hardie III. Redgrave. Thieme-Becker.
SCHIAVONETTI, Louis (1765–1810)
 Italian E.
 DNB. Redgrave. Thieme-Becker.
SCOTT, David (1806–49)
 P.
 DNB. Redgrave. Thieme-Becker. Memoir by W. B. Scott (1850). Mon.
 by J. M. Gray (1884).
SCOTT, William Bell (1811–90)
 P. poet and writer.
 DNB. Thieme-Becker. Scott's memoir of his brother, David Scott
 (1850).
SEVERN, Joseph (1793–1879)
 P. and writer.
 DNB. Thieme-Becker. Lives by W. Sharp (1892), Lady Birkenhead
 (1943). Rollins, H. E., *The Keats Circle* (1948).
SHELLEY, Samuel (*c*. 1750–1808)
 P.
 DNB. Hardie I, II. Redgrave. Thieme-Becker.
SHERMAN, Welby (*fl.* 1827–34)
 E.

Thieme-Becker. Dodgson, C., "The Engravings of G. Richmond and W. Sherman" in *Print Collector's Quarterly* XVII, no. 41, 353–62.

SIMMONS, John (1715–80)

P.

Redgrave. Thieme-Becker.

SKELTON, Percival (*fl.* 1850–61)

E. and P.

Graves, A. *The Royal Academy* (VII, 1906).

SMART, John (1741–1811)

P.

DNB. Redgrave. Thieme-Becker. Long, B., *British Miniaturists* (reprint ed. 1966).

SMETHAM, James (1821–89).

P. and writer.

DNB. Maas. Reynolds. Thieme-Becker. Letters (with a memoir by W. Davies, 1891). Literary works (ed. by W. Davies, 1893). Life by Rev. W. G. Beardmore (n.d.)

SMITH, Joseph Clarendon (1778–1810)

P.

Hardie II. Redgrave.

SMITH, William Collingwood (1815–87)

P.

Hardie I, II. Thieme-Becker.

SOLOMON, Simeon (1840–1905)

P.

DNB. Maas. Reynolds. Thieme-Becker. Busset, A. T. L., "The Image of the Androgyne in the 19th c." in *Romantic Mythologies* (ed. I. Fletcher, 1967). Falk, B., *Five Years Dead* (1937). Solomon, S., *A Vision of Love revealed in Sleep* (1871).

STANFIELD, Clarkson (1793–1867)

P.

DNB. Hardie I, II, III. Redgrave. Thieme-Becker. Life by J. Dafforne (1873).

STANNARD, Joseph (1797–1830)

P.

DNB. Hardie II. Redgrave. Thieme-Becker.

STARK, James (1794–1859)

P.

DNB. Hardie II. Redgrave. Thieme-Becker.

STEPHANOFF, James (*c.* 1787–1874)

P.

DNB. (under Francis Philip Stephanoff). Hardie III. Thieme-Becker.

STEVENS, Alfred (1818–75)

P.

DNB. Redgrave. Thieme-Becker. Mons. by R. Southern (1925), H. H. Stannus (1908) and K. R. Towndrow (1939, 1951).

STEVENS, Francis (1781–1823); "Stevens of Exeter"

P.

DNB. Hardie II. Redgrave. Thieme-Becker.

STOTHARD, Thomas (1755–1834)

P. I.

DNB. Hardie I, III. Redgrave. Thieme-Becker. Life by A. E. Bray (1851). Mon. by A. C. Coxhead (1906).

STUBBS, George (1724–1806)

P.

DNB. Redgrave. Thieme-Becker. Life by Sir W. Gilbey (1898). Mons. by W. S. Sparrow (1929), B. Taylor (1971) and C. A. Parker (1971). Todd, R., *Tracks in the Snow* (1946).

TATHAM, Frederick (1805–78)

S. P.

Thieme-Becker. Binyon, L., *Followers of W. Blake* (1925).

TAYLOR, William Dean (1794–1857)

E.

Redgrave. Thieme-Becker.

THIRTLE, John (1777–1839)

P.

Hardie II. Redgrave. Thieme-Becker.

THURSTON, John (1774–1822)

I. E.

DNB. Redgrave. Thieme-Becker.

TOWNE, Francis (1739 or 1740–1816)

P.

DNB. Hardie I, III. Redgrave. Thieme-Becker. Mon. by A. Bury (1962).

[227]

TURNER, Daniel (*fl.* 1790–1805)
P.
Thieme-Becker.

TURNER, Joseph Mallord William (1775–1851)
P.
DNB. Hardie I, II, III. Redgrave. Thieme-Becker. Lives by W. Thornbury[1] (1862, 1877; reprinted. 1970), A. J. Finberg (1939; revised ed. 1961), J. Lindsay (1968). Mons. by W. Armstrong (2 vols., 1902), M. Butlin (1962), M. Butlin and J. Rothenstein (1964), L. Gowing (1966).
The above is only a fraction of the available literature on Turner.

TURNER, William (1789–1862); "Turner of Oxford"
P.
DNB. Hardie II. Redgrave. Thieme-Becker.

UWINS, Thomas (1782–1857)
P.
DNB. Hardie I, II. Redgrave. Thieme-Becker. Memoir by his widow (2 vols. 1858).

VARLEY, Albert Fleetwood (1804–76)
P.
Hardie II. Thieme-Becker.

VARLEY, Cornelius (1781–1873)
P.
DNB. Hardie II, III. Redgrave. Thieme-Becker.

VARLEY, Edgar John (d. 1888)
P.
Hardie II. Thieme-Becker.

VARLEY, John (1778–1842)
P.
DNB. Hardie I, II, III. Redgrave. Thieme-Becker. Mon. by A. Bury (1946). Story, A. T., *J. Holmes and J. Varley* (1894).

[1] Care should be used in reading this book, which, although valuable in many ways, contains many inaccuracies.

VARLEY, William Fleetwood (*c.* 1785–1856)
 P.
 DNB. Hardie II. Redgrave. Thieme-Becker.
VENDRAMINI, John (1769–1839)
 E.
 DNB. Redgrave. Thieme-Becker.
VOYEZ, G. (*fl.* 1851)
 E.
 Sitwell, S., *Old Fashioned Flowers* (1939).

WAITE, Robert Thorne (1842–1935)
 P.
 Hardie II. Thieme-Becker.
WALLIS, Henry (1830–1916)
 P.
 Maas. Reynolds. Thieme-Becker.
WALTER, Henry (1799–1849)
 P.
 Thieme-Becker. Binyon, L., *Followers of W. Blake* (1925).
WALTON, Elijah A. (1832–80)
 P.
 DNB. Hardie III. Thieme-Becker.
WALTON, Henry (1746–1813)
 P.
 Redgrave. Thieme-Becker.
WARD, James (1769–1859)
 P. E.
 DNB. Redgrave. Thieme-Becker. Life by J. Frankau (1904). Mon. by
 C. R. Grundy (1909).
WATERHOUSE, John William (1849–1917)
 P.
 Maas. Reynolds. Thieme-Becker.
WATERLOW, Sir Ernest Albert (1850–1919)
 P.
 DNB. Hardie II. Thieme-Becker.
WATTS, George Frederick (1817–1904)
 P. S.

DNB. Thieme-Becker. Lives by Mrs R. Barrington (1905) and M. S. Watts (3 vols., 1912). Chapman, R., *The Laurel and the Thorn* (1945).

WELLS, William Frederick (1762–1836)
P.
DNB. Hardie II, III. Redgrave. Thieme-Becker.

WEST, Benjamin (1738–1820)
American P.
Cunningham II. DNB. Redgrave. Thieme-Becker. Life by J. Galt (2 vols., 1820). Mon. by G. Evans (1959).

WESTALL, Richard (1765–1836)
P.
DNB. Hardie I, II. Redgrave. Thieme-Becker.

WHEATLEY, Francis (1747–1801)
P.
DNB. Redgrave. Thieme-Becker. Mon. by F. F. Roe (1938).

WHITE, Henry (*fl.* 1824)
E.
Thieme-Becker. Dobson, A., *Bewick and his Pupils*, 1884.

WILKIE, Sir David (1785–1841)
P.
DNB. Redgrave. Thieme-Becker. Life by A. Cunningham (3 vols., 1843). Mon. by Lord Gower (1902).

WILLIAMS, Edward Ellerker (1793–1822)
Draughtsman.
DNB. Thieme-Becker.

WILLIAMS, Samuel (1788–1853)
I. E.
DNB. Redgrave. Thieme-Becker.

WILLIS, Edward (*fl.* 1835–40)
E.
Dobson, A., *Bewick and his Pupils* (1884).

WILSON, Richard (1714–82)
P.
Cunningham I. DNB. Hardie I, II, III. Redgrave. Thieme-Becker. Life by T. Wright (1824). Mons. by A. Bury (1947), W. G. Constable (1953) and B. Ford (1951).

WINDUS, William Lindsay (1822–1907)
 P.
 DNB. Maas. Reynolds. Thieme-Becker.
WRIGHT, Joseph (1734–97); "Wright of Derby"
 P.
 DNB. Redgrave. Thieme-Becker. Life by W. Bemrose (1885). Mon.
 by B. Nicolson (2 vols., 1964).
WYLD, William (1806–89)
 P.
 Hardie II. Thieme-Becker.

ZOFFANY, Johann (1733–1810)
 German P.
 DNB. Redgrave. Thieme-Becker. Mon. by Lady V. Manners and G.
 C. Williamson (1920).

CHRONOLOGICAL
TABLE

Index

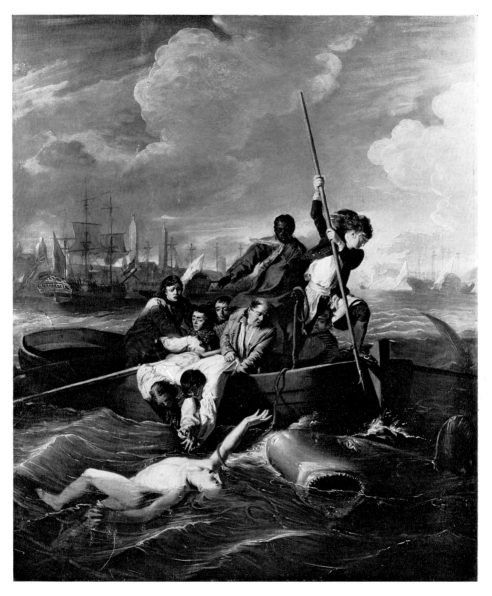

1. J. S. Copley RA *Watson and the Shark* Oil on canvas 36 by $30\frac{1}{2}$ ins. The Detroit Institute of Arts. Dexter M. Ferry Jr Fund.

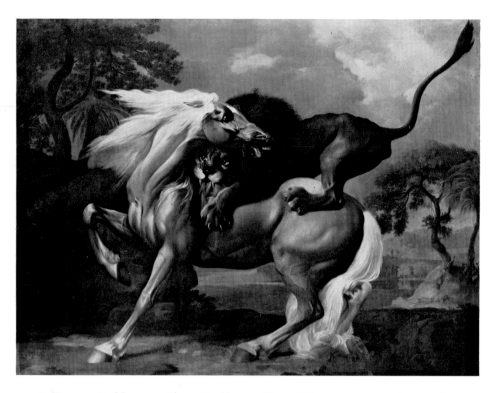

2. George Stubbs ARA *Lion attacking a Horse* Oil on canvas 96 by 131 ins.
Mr and Mrs Paul Mellon.

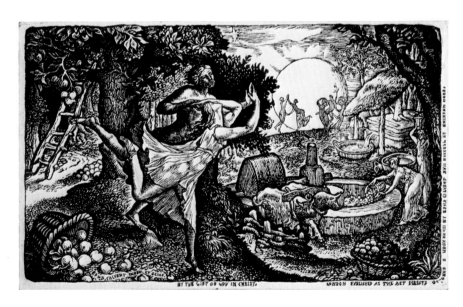

3. Edward Calvert *The Cyder Feast* Wood engraving 3 by 5 ins. Private
collection.

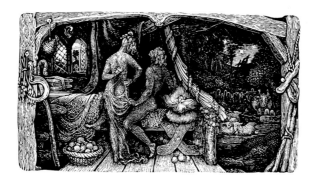

4. Edward Calver *The Chamber Idyll* Wood engraving 1⅝ by 3 ins. Private collection.

5. Edward Calvert *The Bride* Line engraving $4\frac{7}{16}$ by $6\frac{9}{16}$ ins. Private collection.

6. Edward Calvert *Ideal Pastoral Life* Lithograph $1\frac{11}{16}$ by $3\frac{1}{32}$ ins. Private collection.

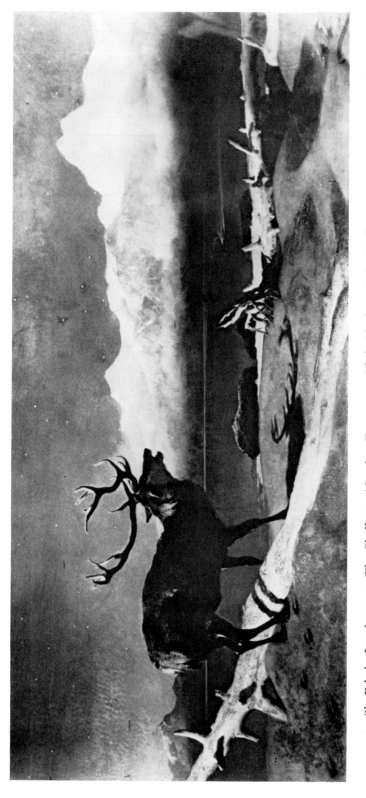

7. Sir Edwin Landseer RA *The Challenge* (*Coming Events cast Their Shadows Before*) Oil on canvas 38 by 83 ins. His Grace the Duke of Northumberland, KG, TD.

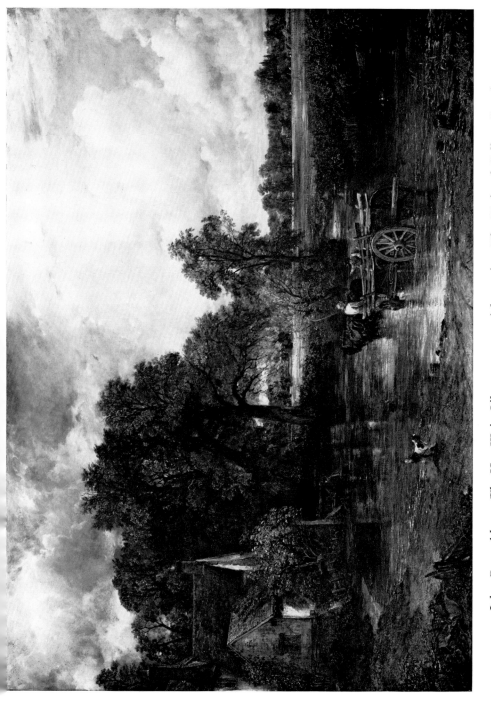

8. John Constable RA *The Hay Wain* Oil on canvas 51¼ by 73 ins. The National Gallery, London.

9. Sir Francis Grant PRA *Master James Keith Fraser on his Pony* Oil on canvas 51 by 60 ins. Mr and Mrs Paul Mellon.

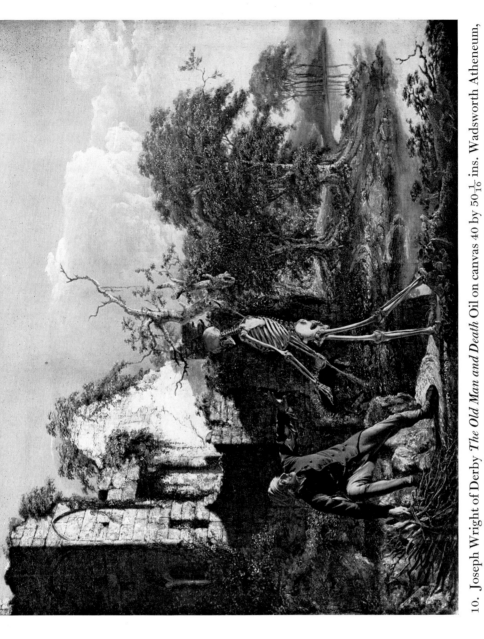

10. Joseph Wright of Derby *The Old Man and Death* Oil on canvas 40 by 50$\frac{1}{16}$ ins. Wadsworth Atheneum, Hartford, Connecticut, The Ella Gallup Sumner and Mary Catlin Sumner Collection.

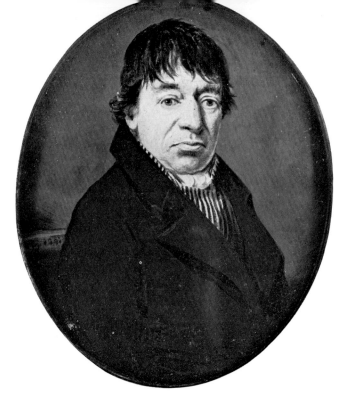

11. Ebenezer Gerard *Portrait of an unknown man* Miniature on card $4\frac{1}{16}$ by $3\frac{3}{8}$ ins. Private collection.

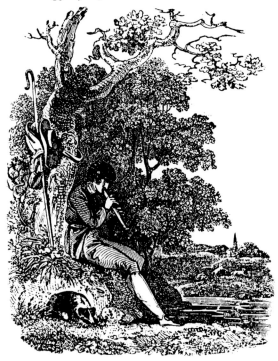

12. Charlton Nesbit, after John Thurston *A Shepherd boy: Frontispiece to The Farmer's Boy by Robert Bloomfield* Wood engraving $3\frac{5}{8}$ by $2\frac{1}{8}$ ins. Private collection.

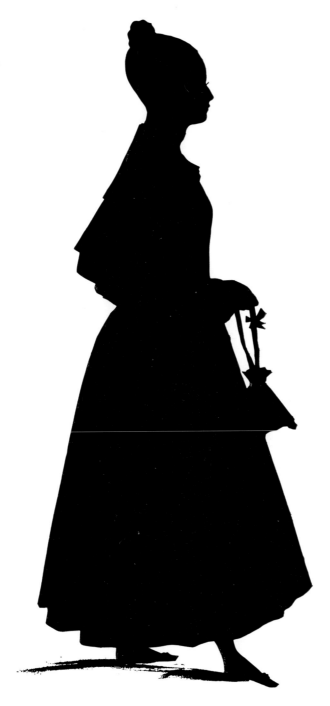

13. Augustin Edouart *Emma Engleheart* Scissor-cut silhouette $8\frac{3}{4}$ by $6\frac{1}{2}$ ins.
Private collection.

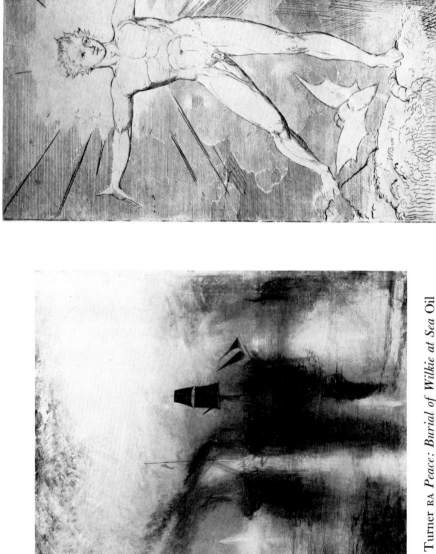

15. William Blake *The Dance of Albion* Line engraving 9¾ by 7 ins. British Museum.

14. J. M. W. Turner RA *Peace: Burial of Wilkie at Sea* Oil on canvas 34¼ by 34⅛ ins. Tate Gallery, London.

16. Samuel Palmer *The Valley Thick with Corn* Water-colour mixed with gum $7\frac{1}{8}$ by $10\frac{7}{8}$ ins. Ashmolean Museum, Oxford.

17. James Ward RA *Gordale Scar* Oil on canvas 131 by 166 ins. Tate Gallery, London.

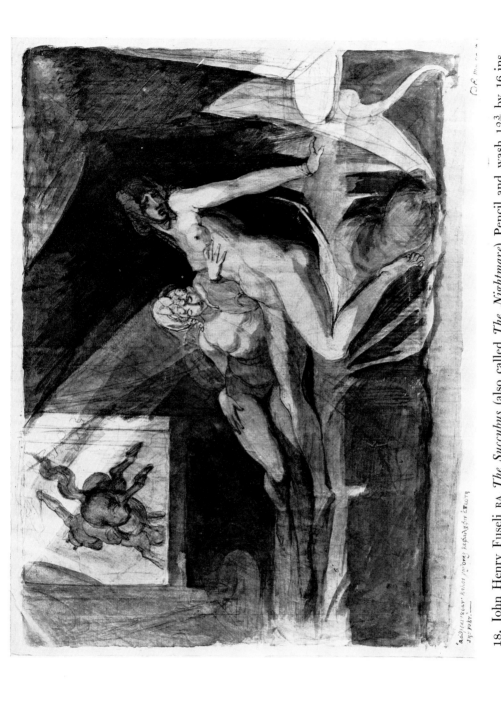

18. John Henry Fuseli RA *The Succubus* (also called *The Nightmare*) Pencil and wash 12⅗ by 16 ins. Kunsthaus, Zürich.

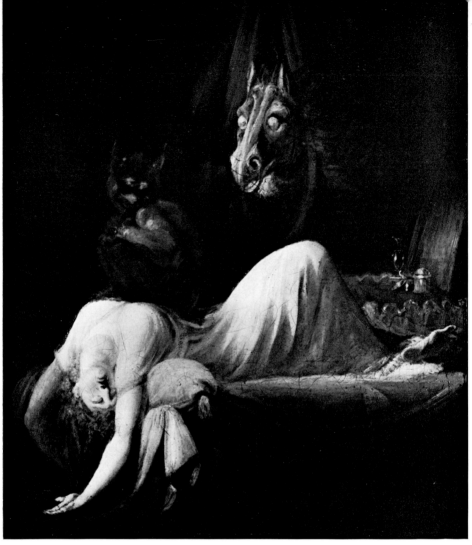

19. John Henry Fuseli RA *The Nightmare* Oil on canvas 29½ by 25⅕ ins. Goethe Museum, Frankfurt am Main.

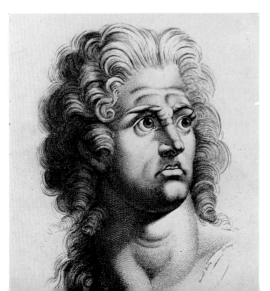

20. John Henry Fuseli RA *Satan* Line engraving (by Thomas Holloway after Fuseli) 9¼ by 7⅝ ins. Private collection.

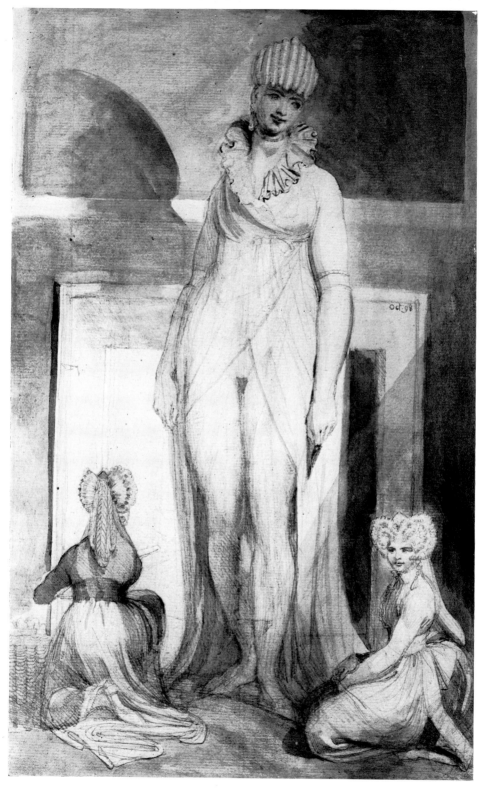

21. John Henry Fuseli RA *The Fireplace* Pencil and wash 13½ by 9¼ ins. Brinsley Ford Esq.

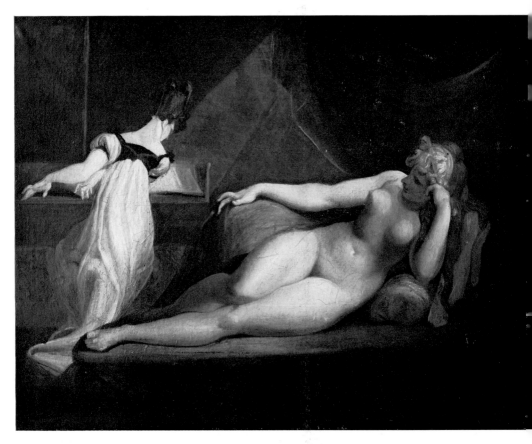

22. John Henry Fuseli RA *Nude Woman listening to a Girl playing upon a Spinet*. Oil 28 by 36¼ ins. Öffentliche Kunstsammlung, Basel.

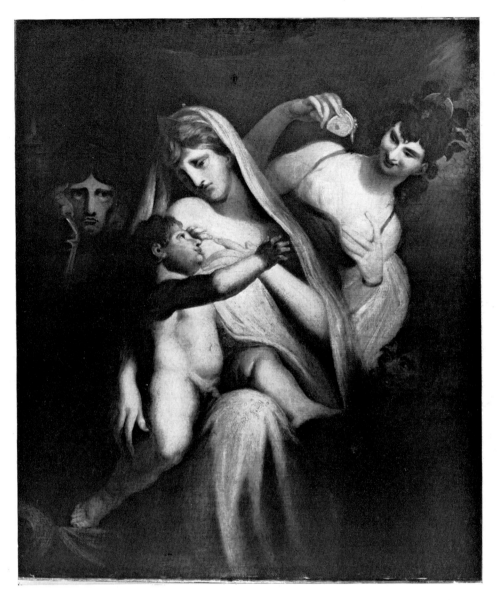

23. John Henry Fuseli RA *Nursery of Shakespeare* Oil on canvas 43 by 36 ins.
Courtauld Institute of Art (On permanent loan from King's College
Medical School, Denmark Hill, London, S.E.5.)

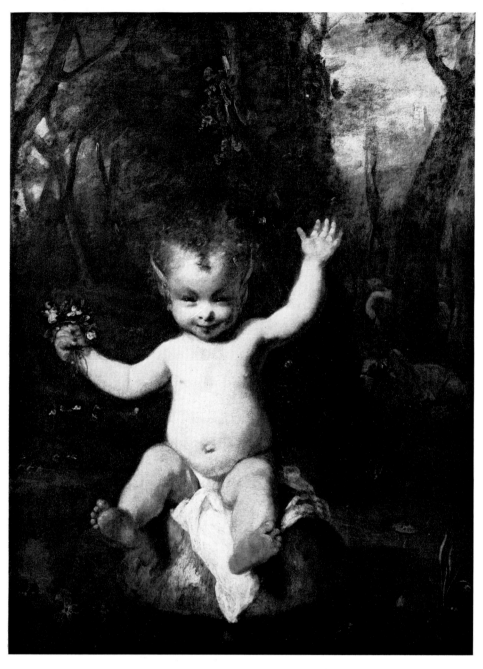

24. Sir Joshua Reynolds PRA. *Puck* (Painted for The Boydell Gallery) Oil on panel 40 by 32 ins. Earl Fitzwilliam.

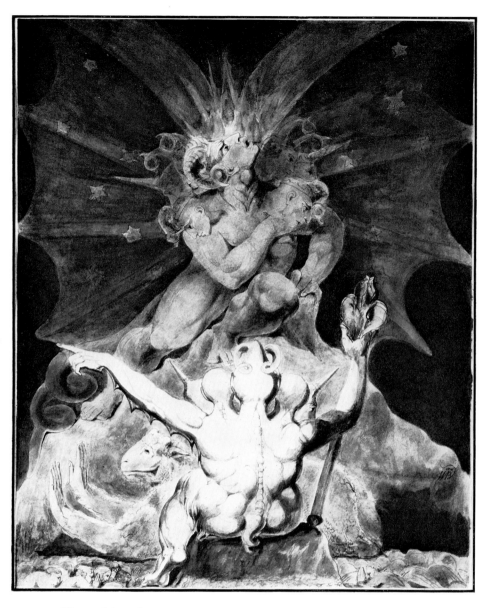

25. William Blake *The Number of the Beast is 666* Water-colour 16¼ by 13⅛ ins. Rosenbach Memorial Gallery, Philadelphia.

26. William Blake *The Rev. John Johnson* Minia-
ture 3¾ by 3 ins. Miss Barham Johnson.

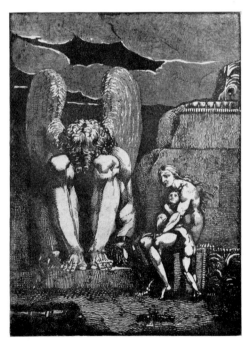

27. William Blake *Frontispiece to "America"* Illu-
minated relief etching $9\frac{3}{16}$ by $6\frac{11}{16}$ ins. Private
collection.

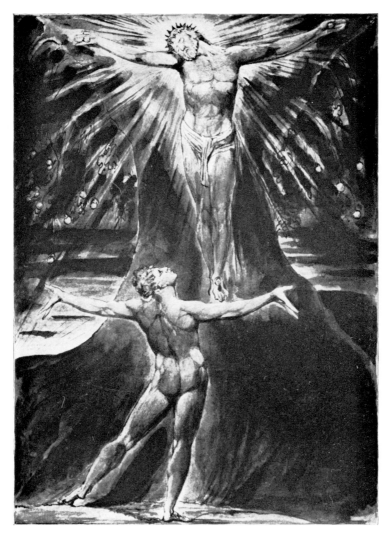

28. William Blake *Albion and Jesus: Plate 76 from "Jeru-salem"* Illuminated relief etching $8\frac{7}{10}$ by $6\frac{3}{10}$ ins. (printed area). Mr and Mrs Paul Mellon.

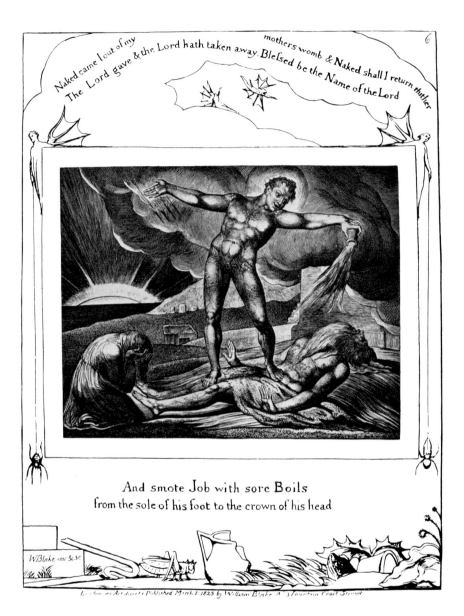

And smote Job with sore Boils
from the sole of his foot to the crown of his head

29. William Blake *Satan Smiting Job with Boils: from "Illustrations of the Book of Job"* Line engraving $8\frac{1}{2}$ by $6\frac{5}{8}$ ins. Private collection.

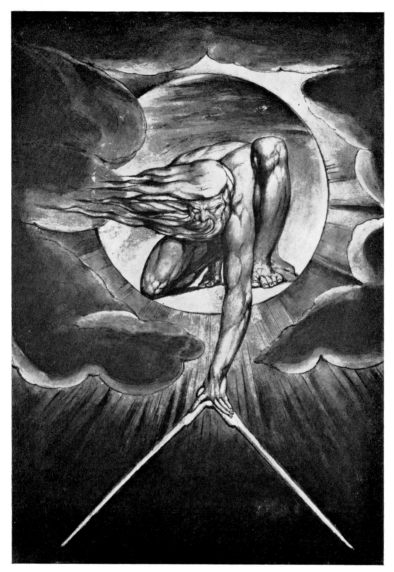

30. William Blake *Frontispiece to "Europe"* Illuminated relief etching
9$\frac{3}{16}$ by 6$\frac{5}{8}$ ins. Fitzwilliam Museum, Cambridge.

31. William Blake *Engraving No. VI from "The Pastorals of Virgil, with
A Course of Reading Adapted for Schools"* by *Robert John Thornton* Wood
engraving 1$\frac{5}{16}$ by 2$\frac{7}{8}$ ins. Private collection.

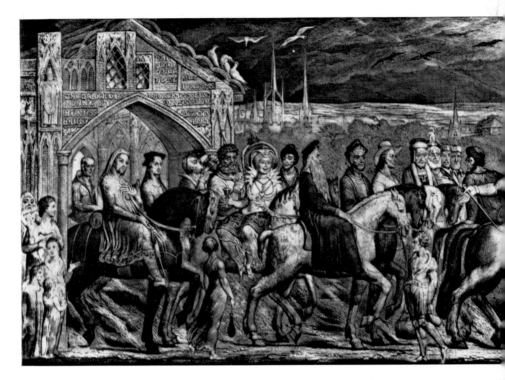

32. William Blake *Chaucer's Canterbury Pil*

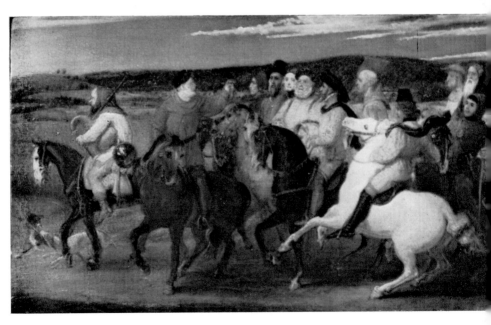

33. Thomas Stothard RA *Pilgrimage to*

e engraving 12 by 37⅛ ins. Private collection.

Oil on panel 12½ by 37½ ins. Tate Gallery.

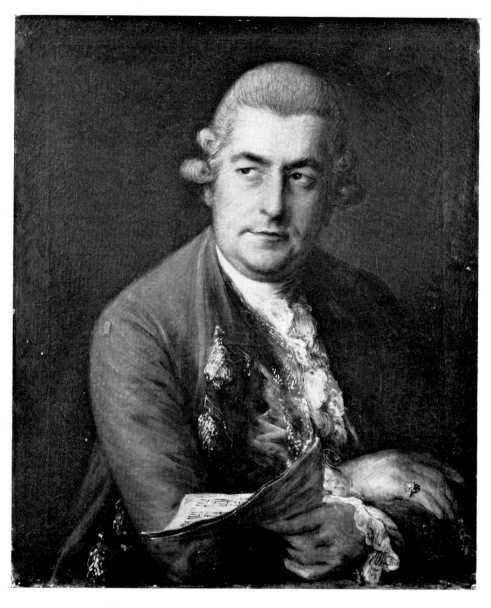

34. Thomas Gainsborough RA *Johann Christian Bach* Oil on canvas 29½ by 24⅜ ins.
Bologna, Civico Museo Bibliografico Musicale.

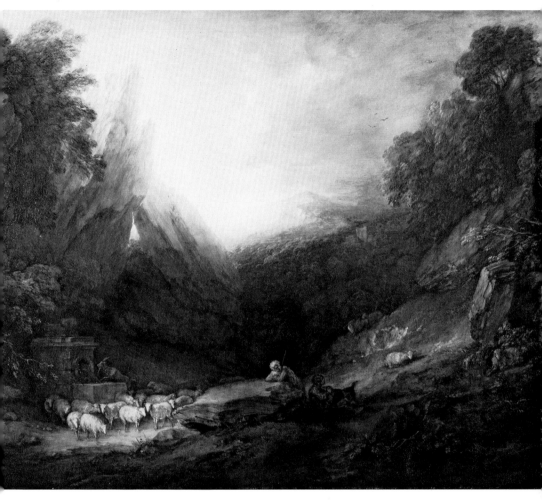

35. Thomas Gainsborough RA *Romantic Landscape with Sheep at a Spring* Oil on canvas
60½ by 73½ ins. Royal Academy of Arts, London.

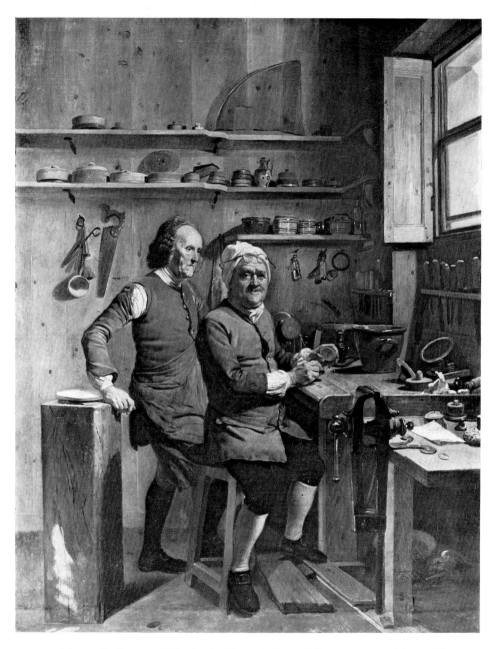

36. Johann Zoffany RA *John Cuff with an Assistant* Oil on canvas 35¼ by 27¼ ins.
Reproduced by gracious permission of Her Majesty the Queen.

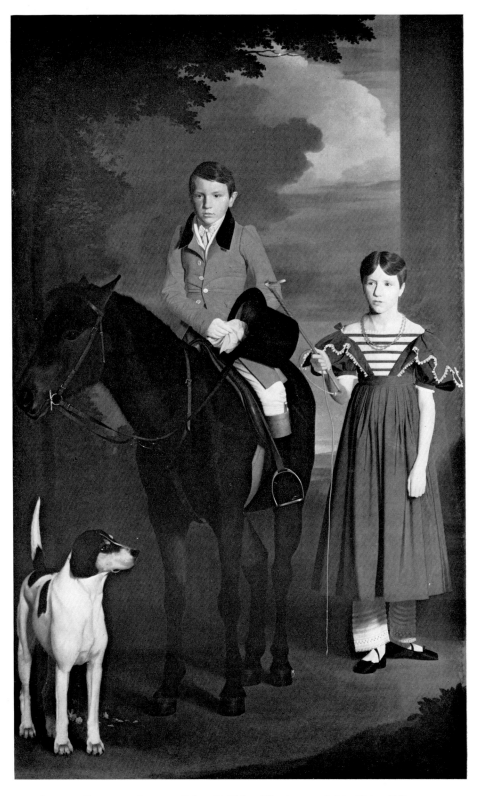

37. Jacques-Laurent Agasse *John Gubbins Newton and his Sister* Oil on canvas
92½ by 56½ ins. Mr and Mrs Paul Mellon.

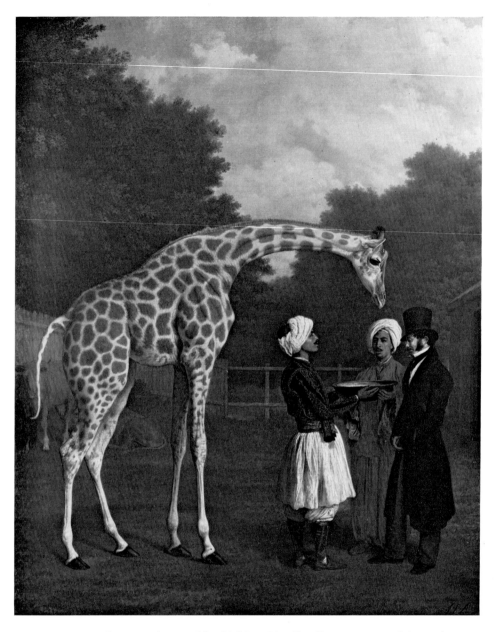

38. Jacques-Laurent Agasse *The Nubian Giraffe* Oil on canvas 50⅛ by 40 ins.
Reproduced by gracious permission of Her Majesty the Queen.

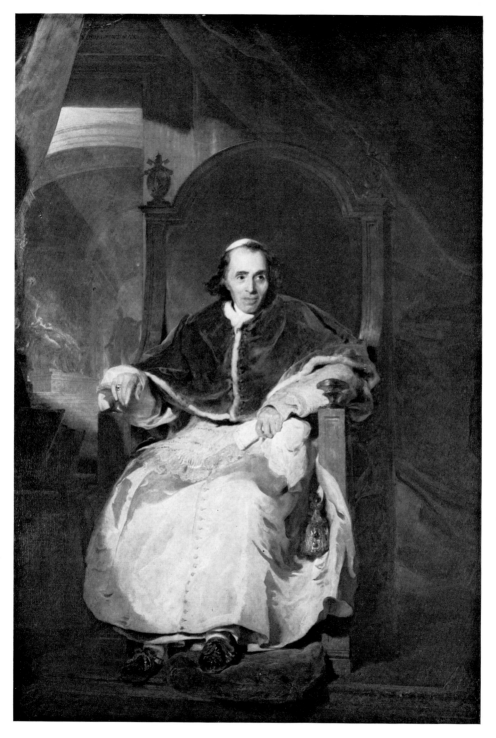

39. Sir Thomas Lawrence PRA *Pope Pius VII* Oil on canvas 104 by 57 ins.
Reproduced by gracious permission of Her Majesty the Queen.

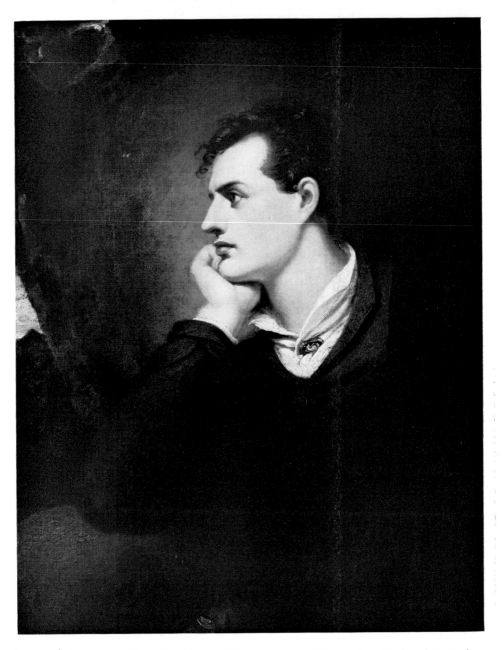

40. Richard Westall RA *Lord Byron* Oil on canvas 36¼ by 28 ins. National Portrait Gallery, London.

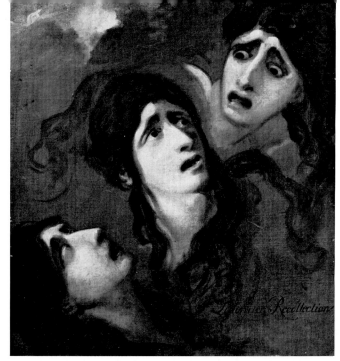

41. George Romney *Sidonian Recollections* Oil on canvas
26½ by 23¼ ins. Mr and Mrs Thomas J. McCormick.

42. George Romney *Lady Hamilton as Miranda* Oil on canvas 14 by 15½
ins. Philadelphia Museum of Art, John H. McFadden Collection.

43. William Etty RA *The Bather* Oil on canvas 25 by 19 ins. Tate Gallery, London.

44. George Richmond RA *The Eve of Separation* Oil on panel 19¼ by 14⅕ ins. Ashmolean Museum, Oxford.

45. George Richmond RA *The Shepherd* Line engraving $6\frac{7}{8}$ by $4\frac{3}{8}$ ins.
Private collection.

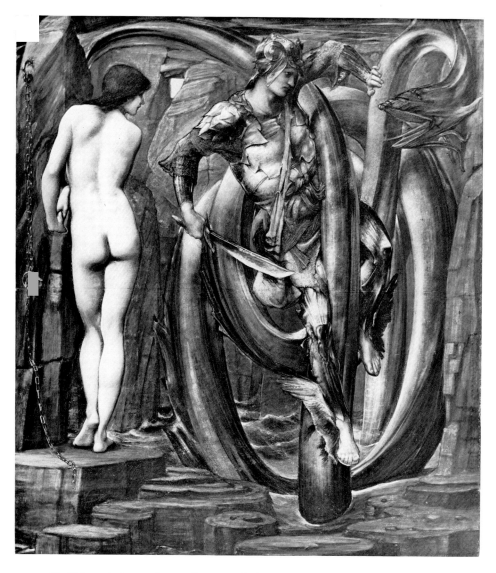

46. Sir Edward Burne-Jones *Perseus Slaying the Serpent* Gouache on paper laid down on canvas 60½ by 54½ ins. Southampton Art Gallery.

47. Sir Edward Burne-Jones *The Mill* Oil on canvas $35\frac{3}{4}$ by $77\frac{3}{4}$ ins. Victoria and Albert Museum, London.

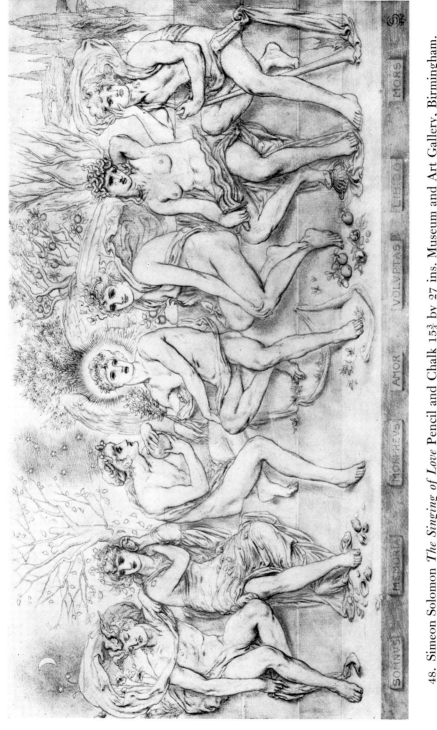

48. Simeon Solomon *The Singing of Love* Pencil and Chalk $15\frac{3}{4}$ by 27 ins. Museum and Art Gallery, Birmingham.

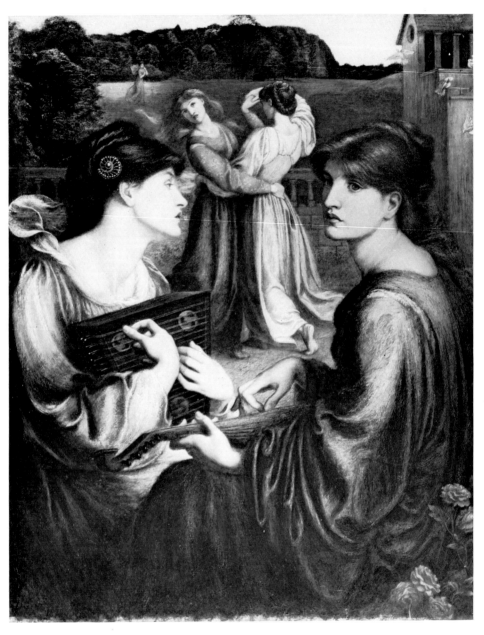

49. Dante Gabriel Rossetti *The Bower Meadow* Oil on canvas 33½ by 26½ ins.
City Art Gallery, Manchester.

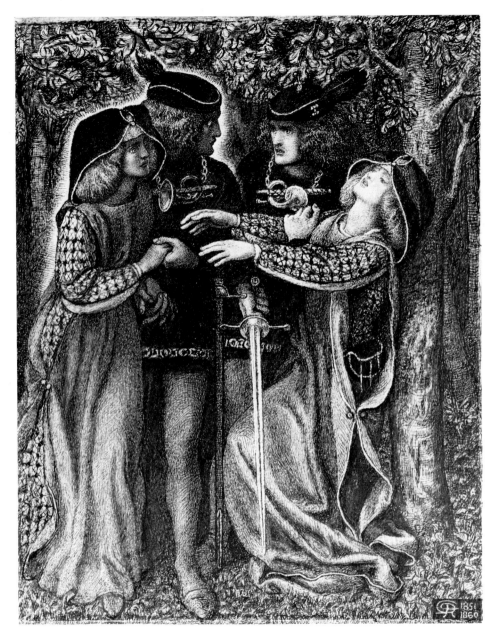

50. Dante Gabriel Rossetti *How they met themselves* Pen and Ink 10⅝ by 8⅜ ins.
Fitzwilliam Museum, Cambridge.

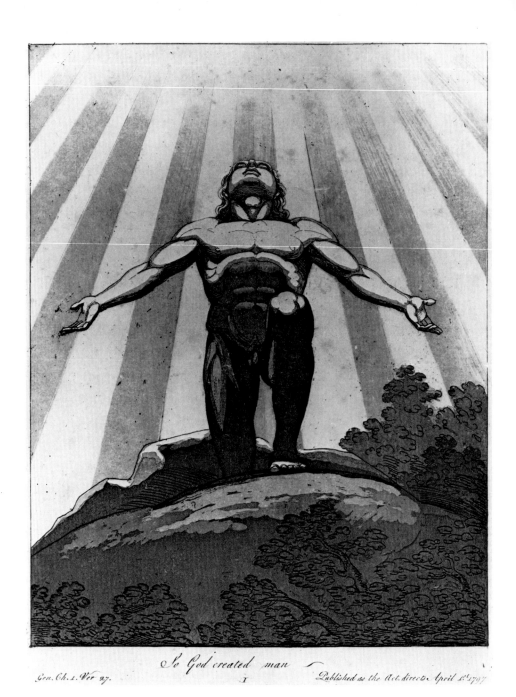

Gen. Ch. 1. Ver 27.

So God created man

I

Published as the Act directs April 1st 1797

51. William Young Ottley *So God created man* Aquatint $9\frac{1}{4}$ by $7\frac{1}{16}$ ins. Private collection.

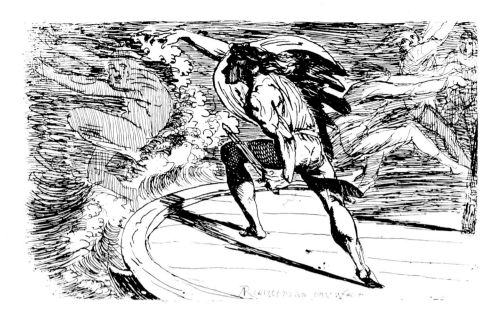

52. Alexander Runciman *Cormar attacking the Spirit of the Waters* Etching $2\frac{15}{16}$ by $4\frac{7}{8}$ ins.
Private collection.

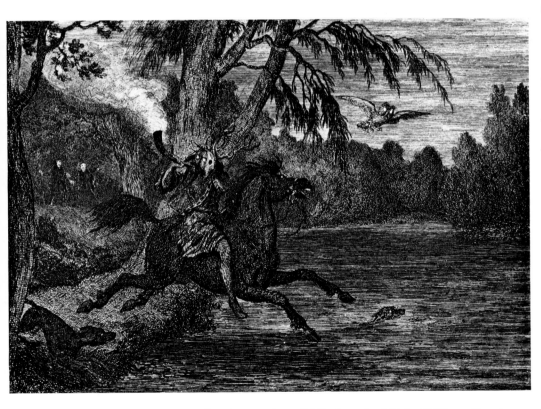

53. George Cruikshank *Herne the Hunter, from "Windsor Castle" by William Harrison*
Ainsworth Etching $3\frac{7}{8}$ by $5\frac{11}{16}$ ins. Private collection.

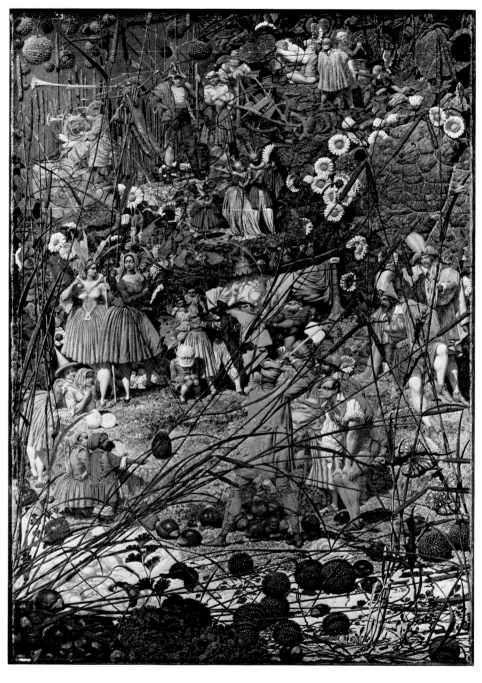

54. Richard Dadd *The Fairy Feller's Master Stroke* Oil on canvas 21¼ by 15¼ ins.
Tate Gallery, London.

55. Thomas Grimshawe *John Clare* Oil on canvas 28¾ by 23⅞ ins. Northampton Public Library.

56. John Austen Fitzgerald *The Chase of the White Mice* Oil on canvas 10 by 18 ins. K. J. Hewett Esq.

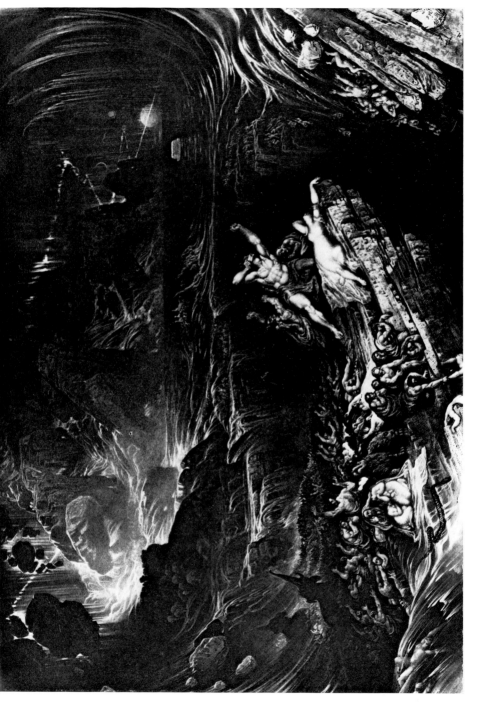

57. John Martin *The Deluge* Mezzotint $7\frac{5}{8}$ by $11\frac{5}{16}$ ins. Private collection.

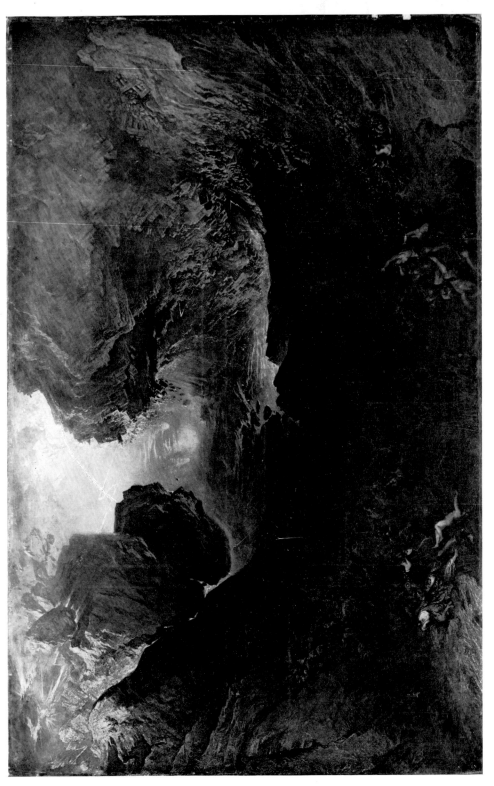

58. John Martin *The Great Day of His Wrath* Oil on canvas $77\frac{3}{8}$ by $119\frac{3}{8}$ ins. Tate Gallery, London.

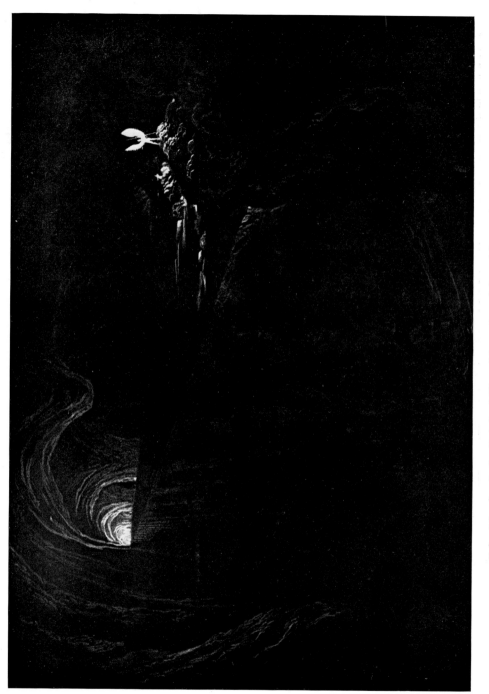

59. John Martin *At the Brink of Chaos* Mezzotint $5\frac{3}{4}$ by $8\frac{1}{4}$ ins. Private collection.

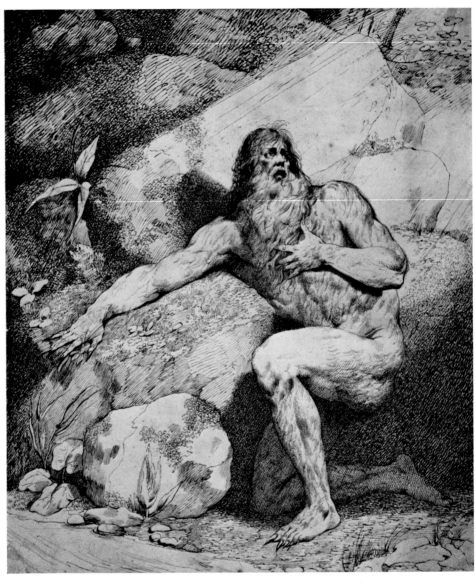

60. John Hamilton Mortimer ARA *Nebuchadnezzar recovering his Reason* Drawing 16 by 14⅛ ins. British Museum.

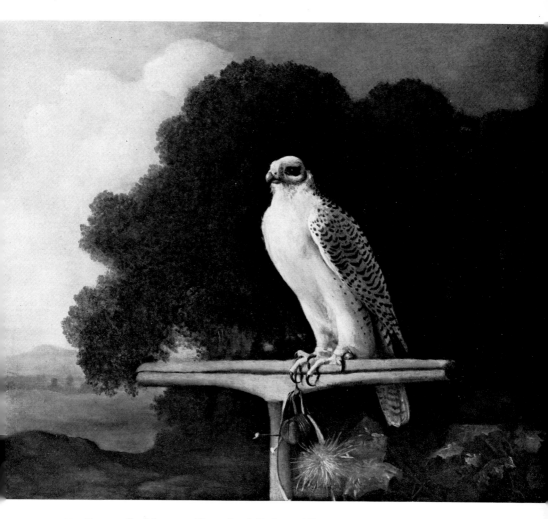

61. George Stubbs ARA *Greenland Falcon* Oil on canvas 32 by 39 ins. Mr and Mrs Paul Mellon.

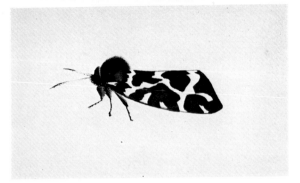

62. Philip Henry Gosse FRS *Arctia Caja or Tiger Moth*
Water-colour on card $2\frac{7}{16}$ by $3\frac{1}{2}$ ins. Private collection.

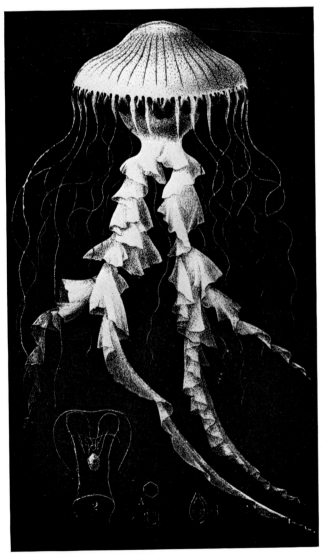

63. Philip Henry Gosse FRS *Chrysaora Cyclonota,
from "A Naturalist's Rambles on the Devonshire
Coast"* Lithograph $5\frac{13}{16}$ by $3\frac{5}{16}$ ins. Private collection.

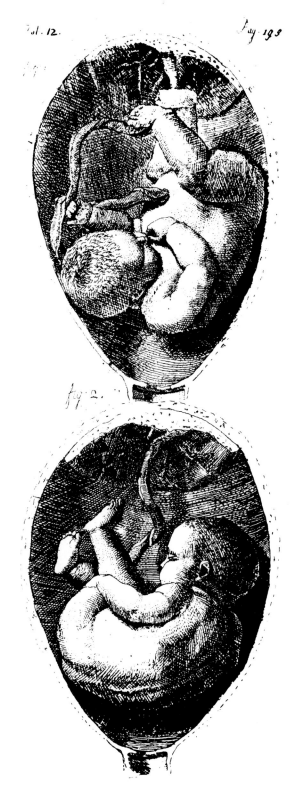

64. George Stubbs ARA *Illustration from "An Essay towards a Complete New System of Midwifery" by John Burton* Etching. Etched area 7 by $2\frac{1}{2}$ ins. British Museum.

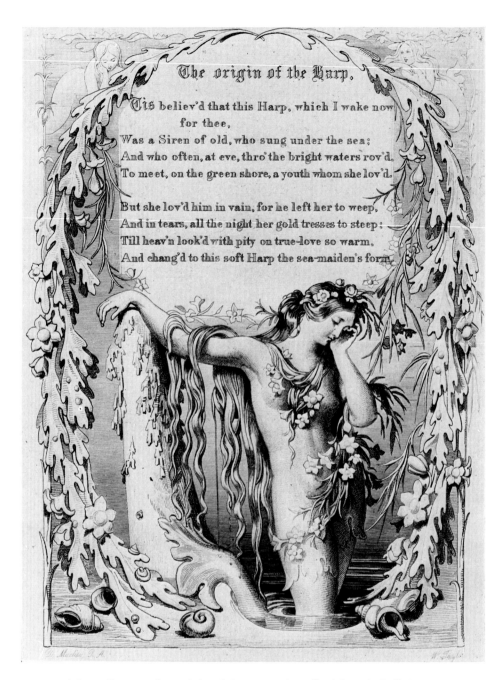

The origin of the Harp.

'Tis believ'd that this Harp, which I wake now
 for thee,
Was a Siren of old, who sung under the sea;
And who often, at eve, thro' the bright waters rov'd,
To meet, on the green shore, a youth whom she lov'd.

But she lov'd him in vain, for he left her to weep,
And in tears, all the night her gold tresses to steep;
Till heav'n look'd with pity on true-love so warm,
And chang'd to this soft Harp the sea-maiden's form.

65. Daniel Maclise RA *The Origin of the Harp, from "Irish Melodies" by Tom Moore*
Etching (by W. Taylor after Maclise) $7\frac{1}{4}$ by $5\frac{1}{2}$ ins. Private collection.

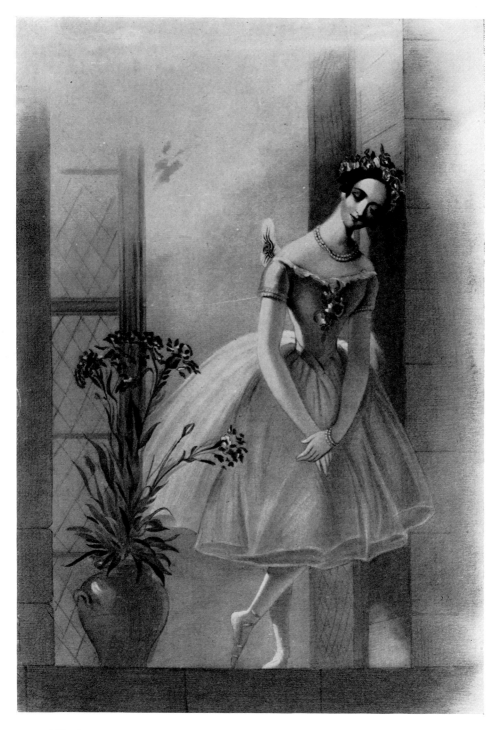

66. Alfred Edward Chalon RA *Marie Taglioni in "La Sylphide"* Lithograph (by J. H. Lynch after Chalon) Octagonal $15\frac{3}{4}$ by $10\frac{7}{8}$ ins. Victoria and Albert Museum, London.

67. John Constable RA *Stonehenge, Wiltshire* Water-colour 11½ by 19 ins. Victoria and Albert Museum, London.

68. John Constable RA *Study of Clouds and Trees* Oil on paper mounted on board $9\frac{1}{2}$ by $11\frac{3}{4}$ ins. Royal Academy of Arts, London.

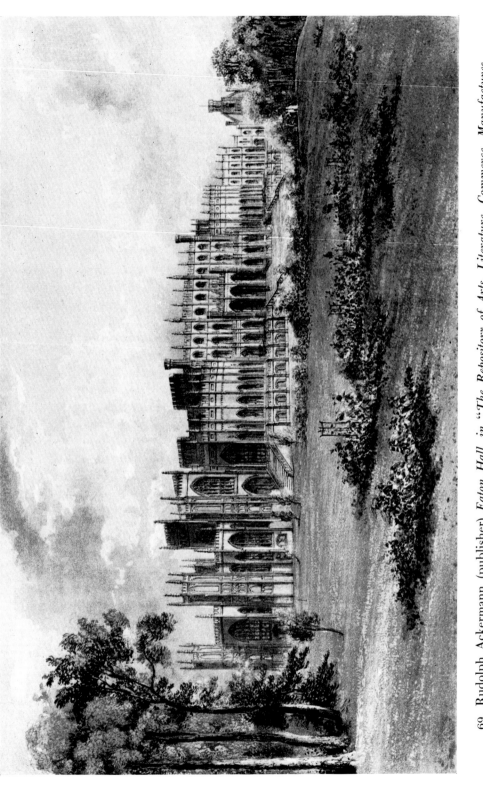

69. Rudolph Ackermann (publisher) *Eaton Hall*, in "*The Repository of Arts, Literature, Commerce, Manufactures, Fashion and Politics*" Aquatint $4\frac{1}{2}$ by $7\frac{1}{4}$ ins.

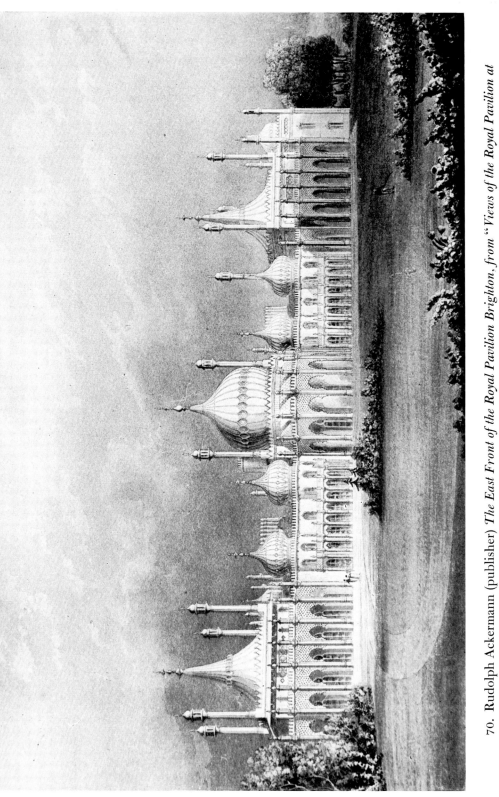

70. Rudolph Ackermann (publisher) *The East Front of the Royal Pavilion Brighton, from "Views of the Royal Pavilion at Brighton" by John Nash* Aquatint $7\frac{1}{4}$ by 12 ins. Royal Pavilion, Brighton.

71. John Constable RA *View on the Stour: Dedham Church in the Distance*
Pencil and sepia wash 8 by $6\frac{5}{8}$ ins. Victoria and Albert Museum.

72. Sir John Everett Millais PRA *Mariana* Oil on panel 23½ by 19½ ins. The Rt Hon. Lord Sherfield GCB, GCMG.

73. Samuel Daniell RA *Spotted Antelope* Aquatint (by William Daniell RA after Samuel Daniell) 12⅝ by 17⅞ ins. British Museum.

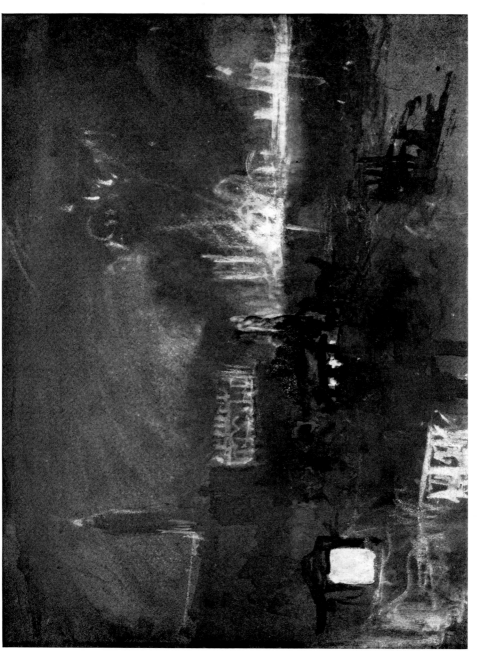

74. J. M. W. Turner RA *Fireworks on the Molo* Water-colour $11\frac{11}{16}$ by $8\frac{7}{8}$ ins. British Museum.

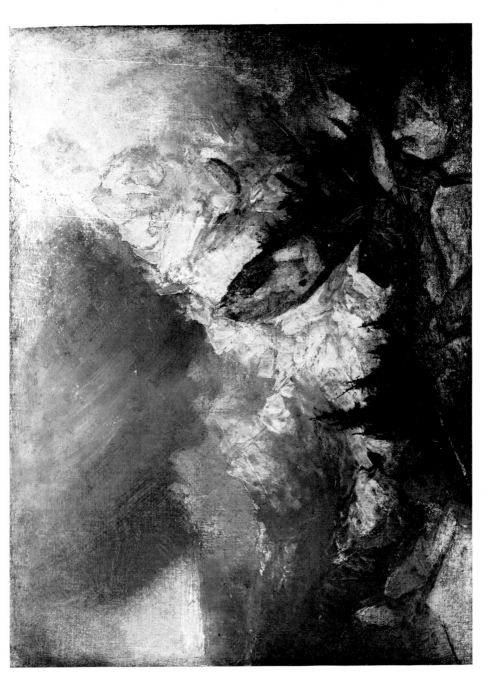

75. J. M. W. Turner RA *Cottage Destroyed by an Avalanche in the Grisons* Oil on canvas $35\frac{1}{2}$ by $47\frac{1}{2}$ ins. Tate Gallery, London.

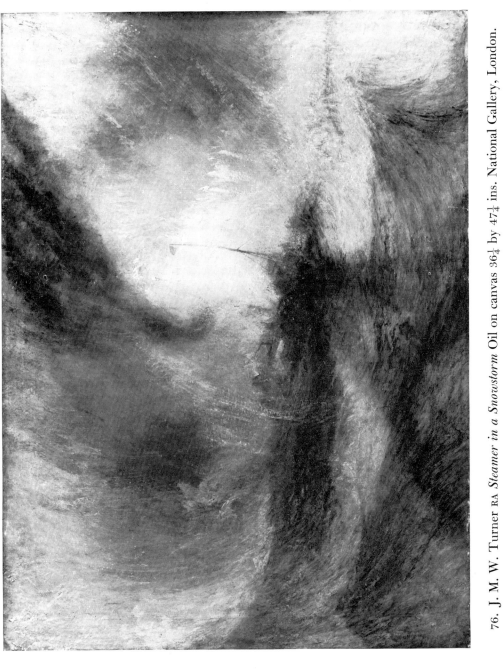

76. J. M. W. Turner RA *Steamer in a Snowstorm* Oil on canvas $36\frac{1}{4}$ by $47\frac{1}{4}$ ins. National Gallery, London.

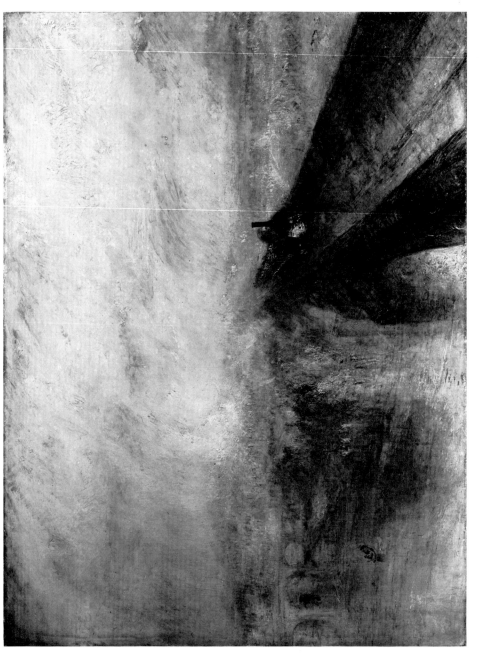

77. J. M. W. Turner RA *Rain, Steam and Speed* Oil on canvas 36 by 48 ins. National Gallery, London.

79. *Postage stamp of Queensland* The portrait is taken from the "Coronation Portrait" of Queen Victoria by A. E. Chalon RA. The die was engraved by William Humphreys and the printing plates, with engine-turned background, were made by Perkins, Bacon and Co of London. Private collection.

78. Percival Skelton *Thomas Telford's Pont-y-Cysyllte Aqueduct* Steel engraving $4\frac{3}{8}$ by 4 ins. Private collection.

80. William Holman Hunt *The Hireling Shepherd* Oil on canvas 30 by 42½ ins. City Art Gallery, Manchester.

BRITISH LAND BIRDS.

THE REDBREAST.

ROBIN-REDBREAST, OR RUDDOCK.

(*Motacilla rubecola*, Lin.—*Le Rouge-gorge*, Buff.)

81. Thomas Bewick *The Redbreast* Wood engraving $1\frac{15}{16}$ by $3\frac{1}{4}$ ins. Private collection.

82. *above right.* Thomas Bewick *Vignette from " A History of British Birds"* Wood engraving $1\frac{7}{16}$ by $3\frac{1}{4}$ ins. Private collection.

83. Thomas Bewick *The Skylark* Water-colour $3\frac{7}{8}$ by $2\frac{3}{8}$ ins. Iain Bain Esq.

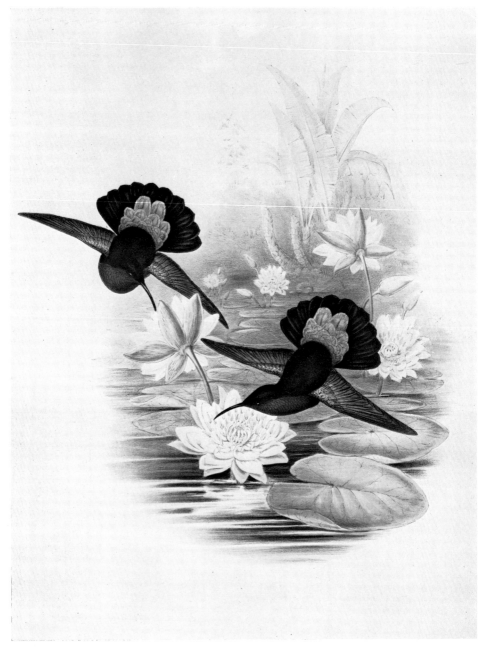

84. John Gould *Eulampis Jugularis, from Vol II of "A Monograph of the Trochilidae"*
Lithograph (by H. C. Richter after Gould) 15 by 12 ins (engraved surface). By permission of the Librarian, University Library, Cambridge.

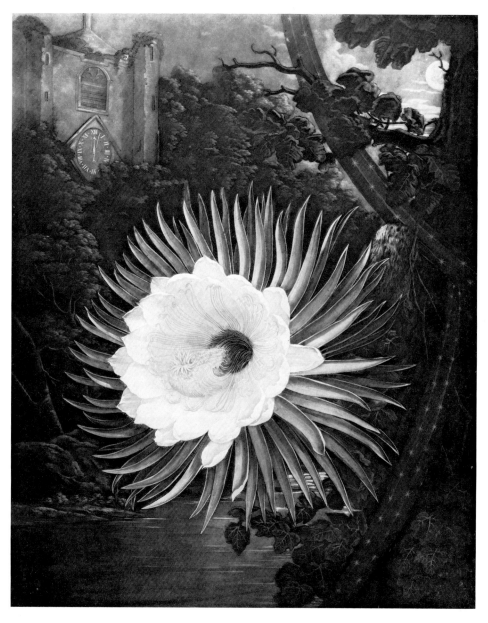

85. Ramsay Richard Reinagle and Abraham Pether *The Night Blowing Cereus, from R. J. Thornton's "Temple of Flora"* Mezzotint (by Robert Dunkarton after Reinagle, who painted the flower, and Pether, who painted the "moonlight") 18 by $14\frac{3}{16}$ ins (engraved surface). Royal Horticultural Society.

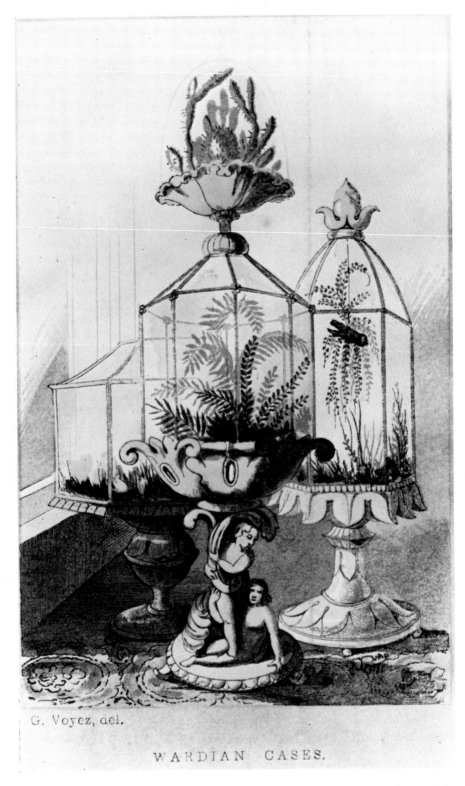

G. Voyez, del.

WARDIAN CASES.

86. G. Voyez *Wardian Cases, from "Rustic Adornments for Homes of Taste" by Shirley Hibberd* Lithograph $4\frac{9}{16}$ by $2\frac{7}{8}$ ins. Private collection.

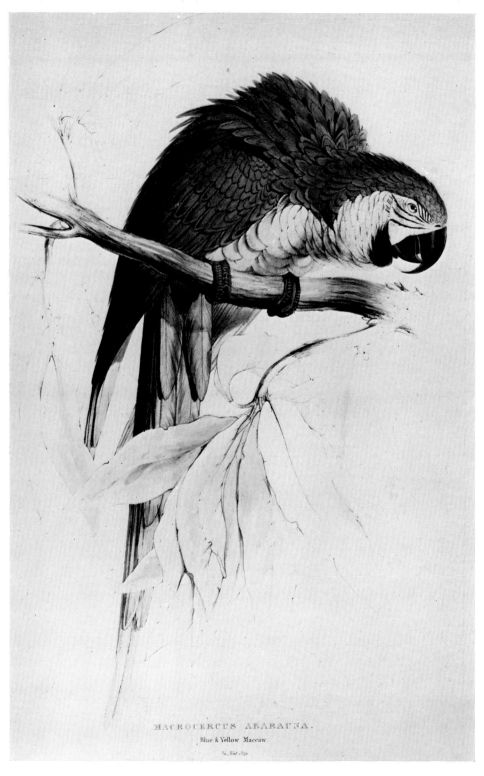

MACROCERCUS ARARAUNA.

Blue & Yellow Maccaw

87. Edward Lear *Blue and Yellow Macaw, from "Illustrations of the Family of Psittacidae"* Lithograph 21 by 14 ins (engraved surface). By permission of the Trustees of the British Museum (Natural History).

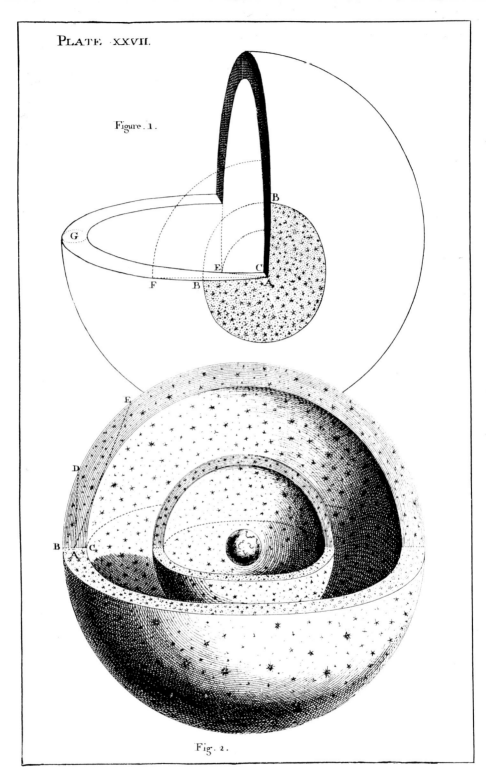

PLATE XXVII.

Figure. 1.

B

G

E C

F B A

E

D

B C

A

Fig. 2.

88. *Plate XXVII from "An Original Theory or New Hypothesis of the Universe"*
by Thomas Wright of Durham Line engraving 8 by 5 ins. By permission of
the Librarian, University Library, Cambridge.

89. Richard Wilson RA *Cader Idris* Oil on canvas $19\frac{3}{5}$ by $28\frac{1}{5}$ ins. Tate Gallery, London.

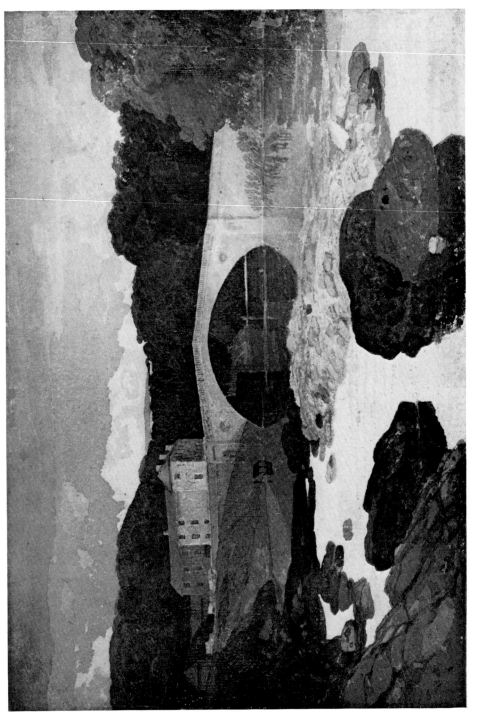

90. John Sell Cotman *Greta Bridge* Water-colour 9 by 13 ins. British Museum.

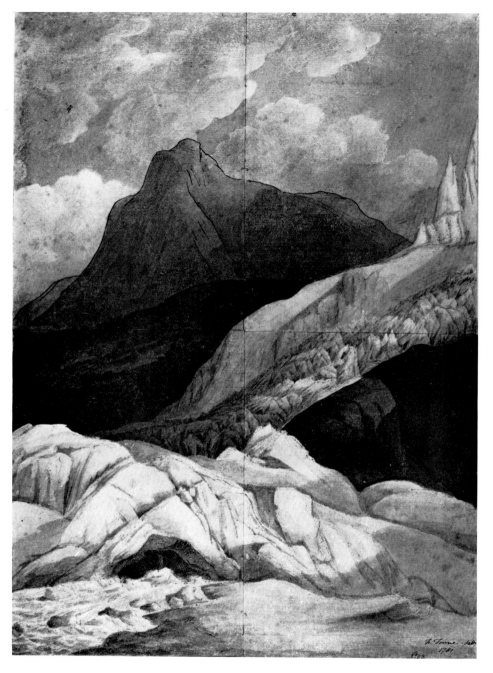

91. Francis Towne *The Source of the Arveyron: Mont Blanc in the background*
Water-colour 16¾ by 12¼ ins. Victoria and Albert Museum.

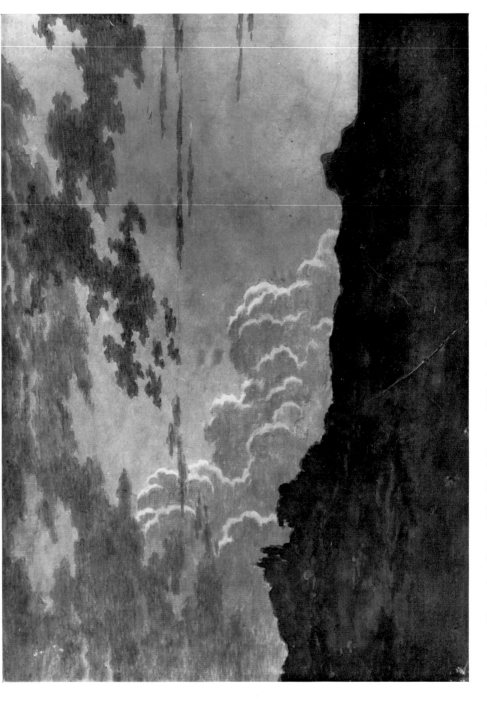

92. Alexander Cozens *The Cloud* Grey and Black washes on India paper $8\frac{1}{2}$ by $12\frac{1}{2}$ ins. Mr D. L. T. Oppé.

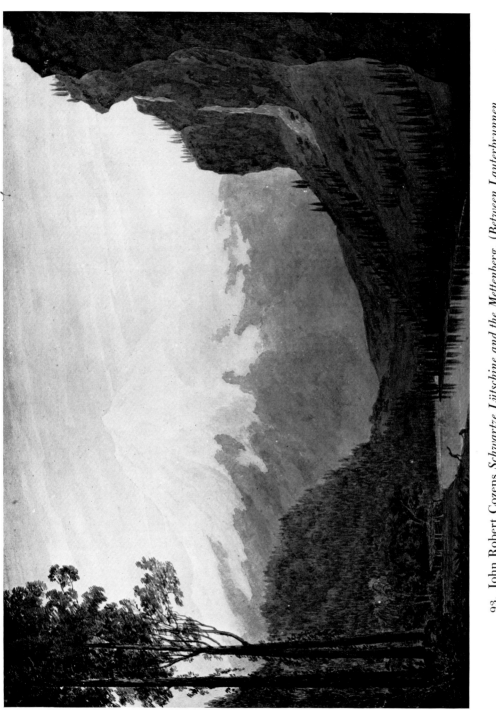

93. John Robert Cozens *Schwartze Lütschine and the Mettenberg. (Between Lauterbrunnen and Grindelwald)* Water-colour $14\frac{1}{4}$ by $20\frac{1}{2}$ ins. Leeds City Art Galleries.

94. Thomas Girtin *Kirkstall Abbey* Water-colour $12\frac{5}{8}$ by $20\frac{7}{16}$ ins. British Museum.

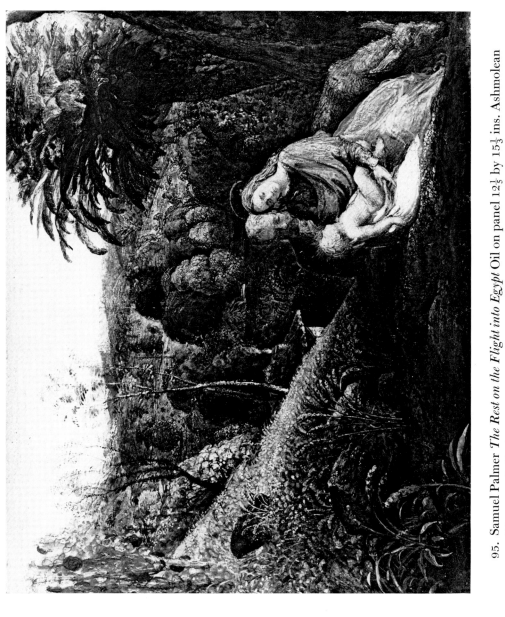

95. Samuel Palmer *The Rest on the Flight into Egypt* Oil on panel $12\frac{1}{5}$ by $15\frac{1}{3}$ ins. Ashmolean Museum, Oxford.

96. Samuel Palmer *The Lonely Tower* Etching $6\frac{1}{2}$ to $6\frac{9}{16}$ by $9\frac{3}{16}$ ins. Private collection.

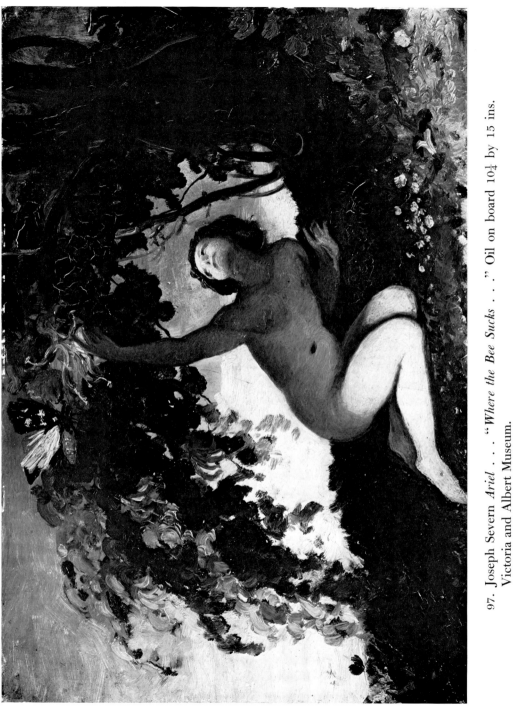

97. Joseph Severn *Ariel* . . . "*Where the Bee Sucks* . . ." Oil on board 10¼ by 15 ins. Victoria and Albert Museum.

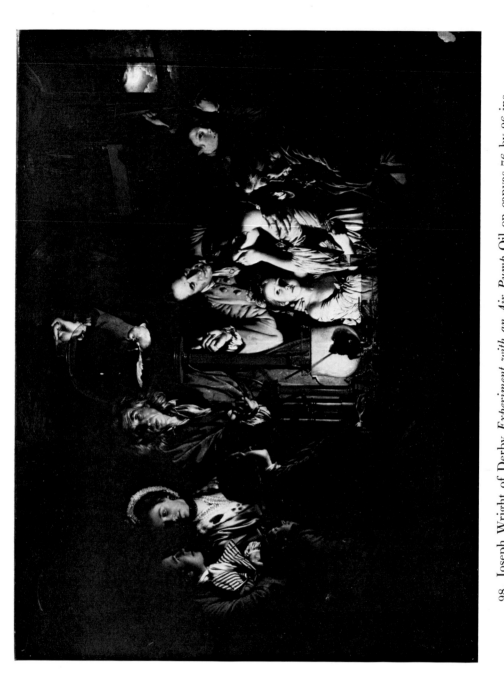

98. Joseph Wright of Derby *Experiment with an Air Pump* Oil on canvas 76 by 96 ins. Tate Gallery, London.

99. Richard Parkes Bonington *The Doge's Palace, Venice* Oil on canvas
31½ by 25½ ins. The National Gallery of Canada, Ottawa.

100. John Henry Fuseli *Martha Hess* Black and White chalk on light brown paper
20¾ by 13⅞ ins. Pierpont Morgan Library.

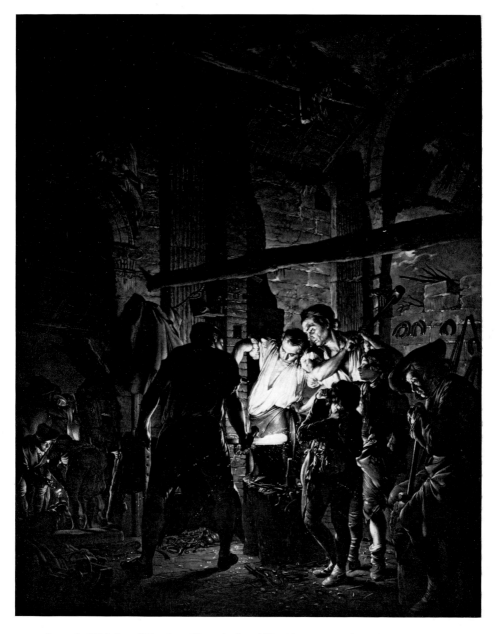

101. Joseph Wright of Derby *The Blacksmith's Shop* Mezzotint (by Richard Earlom after Wright) $23\frac{4}{5}$ by 17 ins. British Museum. (The original oil painting from which it was taken belongs to the Royal College of Surgeons, London.)

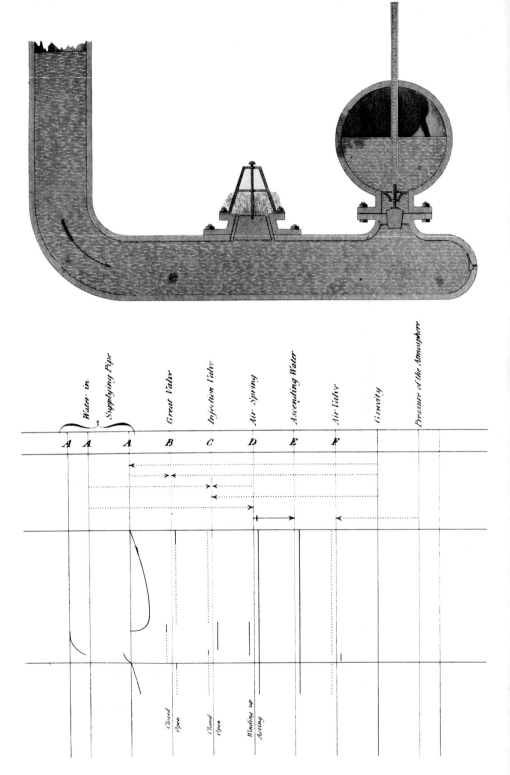

102. Charles Babbage *Notation for the action of a hydraulic ram, from "A Method of Expressing by Signs the Action of Machinery"* Line engraving $9\frac{1}{2}$ by $7\frac{1}{2}$ ins. Private collection.